W9-CFC-187

Diaspora of the Gods

Diaspora of the Gods

Modern Hindu Temples in an Urban Middle-Class World

JOANNE PUNZO WAGHORNE

OXFORD

UNIVERSITY PRESS

2004

OXFORD
UNIVERSITY PRESS

Oxford New York
Auckland Bangkok Buenos Aires Cape Town Chennai
Dar es Salaam Delhi Hong Kong Istanbul Karachi Kolkata
Kuala Lumpur Madrid Melbourne Mexico City Mumbai
Nairobi São Paulo Shanghai Taipei Tokyo Toronto

Copyright © 2004 by Oxford University Press, Inc.

Published by Oxford University Press, Inc.
198 Madison Avenue, New York, New York 10016

www.oup.com

Oxford is a registered trademark of Oxford University Press

All rights reserved. No part of this publication may be reproduced,
stored in a retrieval system, or transmitted, in any form or by any means,
electronic, mechanical, photocopying, recording, or otherwise,
without the prior permission of Oxford University Press.

Library of Congress Cataloging-in-Publication Data
Waghorne, Joanne Punzo.
 Diaspora of the gods : modern Hindu temples in an urban middle-class world / Joanne
Punzo Waghorne.
 p. cm.
 Includes bibliographical references and index.
 ISBN 0-19-515663-3; 0-19-515664-1 (pbk.)
 1. Temples, Hindu—India—Madras. 2. Hinduism—Economic aspects. 3. Middle class—
Religious life. 4. Globalization—Religious aspects—Hinduism. 5. Hindus—England—
London. 6. Hindus—Washington (D.C.) 7. Hindu diaspora. I. Title.
 BL1243.76.M32W34 2004
 294.5'35'09049—dc22 2004007154

9 8 7 6 5 4 3 2 1

Printed in the United States of America
on acid-free paper

In memory of my parents and grandparents, who lived a diasporic experience in America with Italian flair.

Anna Aiena Punzo　　　　*Henry Rocco Punzo*
Jennie LoBiondo Aiena　　*Anthony Aiena*
Carmella Ferraro Punzo　　*Dominic Punzo*

Preface

The Kapaleeswara Temple in the middle of Mylapore in Madras (now Chennai) always seemed welcoming to visitors from abroad. I remember attending a function in the temple in 1967 as the guest of Dr. V. Raghavan, who was my advisor in India at the time. I later discovered that Dr. Raghavan's expertise also benefited Milton Singer, whose soon-to-be published book on Madras would influence the study of culture, religion, and modernization for the next thirty years. Over a decade later I first saw the grand procession of Lord Kapaleeswara in his silver palanquin along South Mada street, one of the four streets that border the temple and its massive tank. The late-afternoon sun shone on Lord Shiva's bronze face as all of his sixty-three devoted servants—the Nayanmar—faced him, two by two and three by three, in their own brightly painted palanquins. At that point I was researching many miles to the south in the former princely state of Pudukkottai, but that sight stayed with me over the next decade. When I returned with my photographer-husband Dick Waghorne in 1986–87, we documented most of the festival cycle of this grand Shaiva temple, funded through a senior fellowship from the American Institute of Indian Studies.

During that year, our interest in rituals led us to the suburbs of the city, where groups of neighbors hired priests to perform elaborate consecration rituals for their new temples just coming up in the "colonies"—the term used, ironically, for subdivisions of old farmland. Much to our surprise, announcements for the same rituals of

consecration greeted us on our return to North Carolina. So every summer for four years we stood with the new devotees of the Sri Siva-Vishnu Temple in suburban Washington, D.C., watching and photographing the consecration of divine images within the temple. First in 1990, an orthodox ritual gave the cosmic breath of life to the stone images of Durga, Hanuman, and Ganesha. Then over the fourth of July weekend in 1991, visiting priests consecrated the sanctuaries of Shiva and Parvati as well as Murugan with his two consorts in an elaborately organized ritual. By 1994, the consecrations of Ananda Padmanabha Swami (a form of Vishnu), and Venkateswara and a series of other Vaishnava deities had completed the temple.

By this time these new Hindu temples had galvanized my interests in globalization and the well-worn problem of modernization. The National Endowment for the Humanities provided me with a much-appreciated faculty fellowship to study the phenomenon of new temples in the city of Madras with comparisons in London and Washington, D.C. In 1994–95, I returned with Dick to Madras—by now very much our home. For twelve months we mapped over 108 temples in the metropolitan area, with return trips to our beloved Pudukkottai. Over the next years I received various grants that allowed research in London. The University Research Council of the University of North Carolina-Chapel Hill supplemented research during the summers of 1996 and 1999, when I visited new temples there and also worked in the Oriental and India Office Collection of the beautiful new British Library. I discovered the old maps of Madras and much of the historical material integrated into the first three chapters of this book. My research funds at Syracuse University allowed a final trip to London in 2003 for photography. The writing of this book was a long process funded in part by a faculty fellowship in Institute for the Arts and Humanities, University of North Carolina-Chapel Hill in the fall of 1997. Syracuse University kindly granted leave for my first semester to finish the manuscript. I also owe my new university a debt of gratitude for their grant to Oxford University Press to allow more photographs to be included in the book.

Both my husband and I have received warm welcomes and help in the many temples that we have visited in the last decade. In Chennai, executive officers in government temples sat for many hours answering my questions, as did the many trustees and devotees wherever we went. Not all of their temples find a formal place in my text, but everything they said ultimately added to my slowly growing understanding of the rise of modern Hindu temples within urban life. I do want to mention two energetic founders of temples whose insights helped shape my thinking: Dr. K. N. Siva Subramanian of the Children's Medical Center of Georgetown University, one of the founders of

the Sri Siva-Vishnu Temple in Lanham, Maryland; and Dr. Alagappa Alagappan, a major force in the construction of new temples worldwide. I also thank Mr. C. T. Pulendran of London, who kindly introduced me to many of the temples and provided very helpful insights to the religious life of Sri Lankan Tamils in the city. My many conversations with Rani Rema Devi Tondaiman of Pudukkottai moved my thought in many ways, and I remain grateful for her friendship.

In Madras, I must mention the enduring help and friendship of Mrs. Mythili Raman and Mr. K. Lakshminarayanan, who has held curatorial positions in government museums in Tamilnadu. For assistance during my research in Madras, I especially thank Dr. G. John Samuel and Dr. Shu Hikosaka, my sponsors in the Institute for Asian Studies, and Dr. Vengopala "Pappu" Rao, Regional Director of the American Institute of Indian Studies. Many people aided me, but I especially remember the kindness of Mr. S. Muthiah, historian of Madras par excellence; Sri Raman Bhattar, priest of the Byragi Matam-Sri Venkatesa Perumal Devasthanam; Mr. G. M. Ramachandran, secretary of the Kanyaka Parameswari Devasthanam; and Dr. K. P. Misra of Jagannath Spiritual Cultural Complex. During the many consecrations that we attended, I almost always spotted and enjoyed conversations with the energetic Dr. Nalli Kuppuswami Chetti, then chairman of the board of trustee of the Kapaleeswara Temple, and Mr. A. N. Srinivasa Rao of the Anantha Padmanabha Swami Temple. I especially remember the kindness of Mr. R. Prabakar of the Adhivyadhihara Sri Bhaktanjaneya Swami Temple, and of Mr. R. Venkatramanan and Mr. C. T. Arumugam of the Virupaksheeswara Temple.

I am fortunate to be a part of a close-knit scholarly community working on South Asian religions. My long-term conversation partners include Indira Viswanathan Peterson, Leslie Orr, Philip Lutgendorf, George Michell, C. J. Fuller, H. Daniel Smith, Karen Pechilis, and my new colleagues Ann Gold and Susan Wadley. I am grateful to Jack Hawley, whose careful reading of the first draft of this book helped me to sharpen my thinking. In North Carolina, I benefited from the many colloquia of the Triangle South Asia Consortium (now the North Carolina Center for South Asian Studies). John Richards and David Gilmartin, as historians, helped to sharpen my focus especially on world history and world-systems theory.

Two chapters in the book are revisions of earlier articles. Chapter 1 appeared in the *Journal of Asian Studies* 58.3 (1999) and is reprinted with their permission. Chapter 3 appears as part of a special issue on modern India and the question of the middle class in the *International Journal of Hindu Studies* 5.3 (December 2001). I thank Sushil Mittal, editor of the *IJHS* and other readers of those drafts for their very helpful comments.

My husband, Dick Waghorne, best described now as an "old India hand," defies the India visa category of accompanying spouse. His photography grounds my work, my thinking, and all of my publications, including this one. With the exception of the maps from the British Library and photos kindly lent by Dr. Alagappan, all of the photographs in this book are his. He first encouraged me to look at temple rituals because of their intrinsic beauty. I later discovered that the gods are ornamented precisely to entice us toward devotion. We both have felt that passion begins with the eye and then moves the heart.

Contents

List of Illustrations

Note on the Transliteration of a Layered Language

Records of the Hindu Religious and Charitable Endowment and many other departments of the Government of Tamilnadu were maintained in English until the late 1970s, so that older temples have well-worn Anglized names, as do ritual and architectural terminology. The long-established and popular English language daily, *The Hindu*, uses a sometimes-updated form of these same names and terms in its extensive coverage of activities at the city's many temples. I have followed the same practice. I use the most common English form of names—where such exist—that appear in the temples' own English publications, the records of Government of Tamilnadu, and *The Hindu*. A few small temples conduct all of their business in Tamil and in these cases I have transliterated their Tamil names, with diacritics in the text. The transliteration of temple names appears in the index where possible. Readers familiar with Sanskrit will notice that some temple names have a long "ē," which exists in Tamil but not in Sanskrit. The transliteration of temple names is complicated because most are derived from Sanskrit but exist only in Tamil form. The name in English often derives from a Tamil transliteration of Sanskrit and the exact form of the original is not always clear. Matters are even more complex because all records in government offices were maintained in English until the late 1970s. Sometimes the name had gone through three iterations. I have seen cases where the old English name of a temple is transliterated into Tamil script on the signboards; in these cases, only the

English form appears in the index. In the case of deities, I use the most common English form of their names and transliterate the names in the index. I also use the most common English form for proper names and place names and transliterate these in the index only in cases of lesser-known persons or places.

In the case of terms, I have used the most common English forms in the text and have indicated the transliterations (with diacritics) from Tamil and/or Sanskrit in the glossary. I diverged, however, from the more usual Anglized word for a series of Tamilized Sanskrit terms called Grantha. In Madras city, for example, the architectural term *vimana* is usually written *vimanam* by Tamil-speaking priests using Sanskrit; I have omitted the final m. For the sake of clarity for readers unfamiliar with Tamilnadu, I also omit the honorific endings usually placed onto Sanskrit names for the temples or deities. I therefore write Kapaleeswara, not Kapaleeswarar. I mean no disrespect, but I feel that this eases reading for a wider audience. Readers will notice some differences when I quote verbatim. In the case of titles of those who were appointed by the British—such as Collector, Dubash, and Merchant—I follow the British custom and capitalize their titles.

The point here is that Madras has a four-hundred-year history of intimate contact with the European world, and the language of the city and its multiethic and multireligious inhabitants reflect this.

Diaspora of the Gods

Introduction

New Houses for the Gods in an Urban World

The southern Indian city of Madras, recently renamed Chennai, never fares well in tourist guidebooks on India. The popular *Lonely Planet Guide* describes Madras "as something of a non-event compared to the marvels elsewhere in the state. The main reason travelers come here is to transact business" (Crowther 1984, 696). This coastal city suffers from the sin of not being ancient, as all good Indian cities should be, at least for the adventure-seeking tourist. The East India Company officials began construction of their trading post here, Fort St. George, in the same decades of the seventeenth century as when the port of Boston opened. Soon groups of Indian merchants began to settle weavers, dyers, and all those needed to produce and sell the bright cottons, the "calicos," that Europeans craved. The fort plus the surrounding settlement became Madras, eventually the colonial capital of the southern "Presidency"—one of three major administrative units for the British Empire in India. All of this is rather dull for those looking for the "real India." And indeed many a British connoisseur of great Indian art and temple architecture found it equally dull at the height of imperial rule. A guide popular in Great Britain still carries the flavor of its original nineteenth-century edition. The guide recommends seeing Central Station, the High Court building, Government House, St. Mary's Church, and St. George's Cathedral, all British architecture (L. F. Williams 1975, 500–509). At least these now give Madras some romantic interest, as colonial buildings metamorphose into the tat-

tered remnants of a bygone empire and suddenly become interesting to art historians, just at the moment of their destruction to make way for modern Chennai (see London 1994). S. Muthiah remarks in the preface to his beautifully illustrated *Madras: The Gracious City* that the razed colonial-era buildings "deserve a memorial if they cannot be conserved. This book is as much a memorial to them as it is a tribute to 350 years of a gracious city" (Muthiah 1990, 7). But even three centuries cannot make Chennai into an exotic tourist site. Chennai still maintains its colonial legacy of single-family houses, with a fine park hugging its white sandy beach. Nonetheless, its air carries the fumes of many new cars produced in the far suburbs, not the ethereal scent of the spiritual. Its streets hold hurrying entrepreneurs, shoppers clutching their bags, shouting hawkers, and buzzing motor rickshaws, not the aura of serene sacrality.

In short, no one ever lists Chennai as a "temple city," in spite of the six hundred large temples and numerous street shrines scattered throughout the metropolis—not to mention the many major churches and mosques. None of these is very old by Indian standards, although a very few temples predate the colonial city. Step out of the taxi or bus almost anywhere in Chennai, and the spire of some temple will peek out between the office buildings and houses. In the large and often affluent suburbs that surround the core city, "temples are mushrooming," as one retired government officer put it at a civic club where I had just described my research: a study of the new temple-building boom in this modern commercial city. In reaction to my talk, members seemed divided in their views of this resurgent interest in temples. Some considered religion "a personal matter," and expressed the idea that they were not members of any religion but did find peace or some special power in certain temples and even in churches. "Temples are only the hardware, but philosophy is the software that makes religion run." Others were even more frank and saw the temples as contrived organizations. Others, especially two, were deeply involved in new temples—one had built a temple in the popular suburb of Besant Nagar and another was a devotee of ISKCON. The "Hare Krishna" movement has come full turn back to India via many American devotees. Members explained that temples were already in the oldest neighborhoods of Georgetown and Mylapore. People there "lived around these temples just as in the villages." But the new temples have come up in the "colonies"—the interesting term Madrasis use for suburban developments—to which many professionals seeking good jobs have migrated from near and far. "Anna Nagar [a very new colony] is 80 percent from the outside." Some members spoke with that refreshing Madrasi cynicism, "Temples occupy the land, it's a way to take over some public space for something else, a place to park auto rickshaws; a place

to do business." Another member mentioned that he noticed temples are "now vying with another for domination of an area by getting the best musicians or trying to get their pujas [worship] on TV. There is a mania for publicity." Others thought that "the building of temples may be a reaction of the middle class against the period of state atheism," referring to the victory of the populist DMK party in 1967, which officially opposed temples as an imposition of old priestly—Brahman caste—authority. Everyone agreed that temple architects and artisans were making a good living these days.

Chennai may not be a temple city, but (sub)urbanites have turned toward temples in a way that many older residents felt was more fervent—for better or worse—than their relationship with temples had been in the decades just after Independence. Not all Madrasis approve of this rush of temple building, as my encounter with the civic club demonstrates. Some educated people remain openly agnostic or stridently atheistic. Others accuse these temple builders of wasting money on unproductive rituals and lavish edifices while the poor go hungry. Many religious people, like my former upstairs neighbor, prefer to pray and meditate in their own quiet rooms set aside for worship at home. Many enjoy religious discourses and silently read sacred texts, but forgo public ritual. But temple building and temple worship increasingly interests the middle class. They opt now for enthusiastic engagement with ritual and public display. They organize and contribute to the construction of new and often innovative temples. In spite of the constant (often hopeful) predictions at the turn of the last century and the hand-wringing of the theologians of the 1950s, the demise of "organized" religion among the educated secular and scientifically minded has failed to materialize. This is as obvious in urban India as in the United States and around much of the world. The temple donors that I met in Chennai, however, are not "fundamentalists," though they do share their educated-middle-class status with many who follow the VHP (Vishwa Hindu Parishad, "world Hindu federation") or RSS (Rashtriya Swamsevak Sangh, "national self-service organization")—the groups that are usually named as "Hindu nationalist" or fundamentalist, and are "credited" with the destruction of a famous mosque in Ayodhya and communal riots through out India. The poor and uneducated cannot engineer the level of organization of the RSS or manage a worldwide network like that of the VHP. The urban middle classes whose religious life centers on temple are constructing another dimension of resurgent religion, but receive much less attention in the press and in the academy.

My photographer-husband and I were left breathless trying to keep up with the surge of consecrations of new temples, with the display of new rituals, and with the activities of building committees for just a single year in this

secular business-minded and technologically savvy city. Several years earlier, while working on a study of an older temple, we first noticed the new temples and decided to return to map them within this urban space. The array of contemporary temples as well as the renovation of older sanctuaries was staggering. Notices of mahakumbhabhisheka, the ritual of consecration for new temples, appeared almost weekly in the daily calendar of the English-language newspaper, *The Hindu,* widely read by middle-class people in the city. The new deities housed within these temples ranged in size from massive to miniature, and many took a new form or a rejuvenated body. In the far southwest suburb of Nanganallur, proud trustees presided over the consecration of a majestic new temple for Hanuman, the divine servant extraordinaire of Lord Rama in the epic *Ramayana,* who takes the form of a monkey. The nationally honored M. Muthiah Sthapati carved the thirty-two-foot-high stone image-body— termed a vigraha or murti—of Lord Hanuman, called Anjaneya in south India, from a single granite rock.[1] At the other end of the scale and of the city, police officers proudly sanctified two diminutive shrines just outside their station. These small temples held the holy images of the two sons of Lord Shiva portrayed as babies. In an outer "colony" established thirty years ago in the western suburbs, "a cross section of the residents . . . met and unanimously decided to have temple for day to day worship," explained a pamphlet distributed at the kumbhabhisheka (consecration ritual) of the eclectic Sri Sankara-Narayana Temple, which literally conjoined the two major sects of Hinduism. In our photos devotees admire the skillfully decorated bronze icon with one-half of its body portraying Shiva and other half Vishnu. A superb stone image of Vishnu still waits with a linga, Shiva's iconic form, to be installed together in the central sanctum. In another "colony" northwest of the center city, trustees of another new temple told a similar story. A "cooperative movement of people belonging to various walks of life, various communities" formed an association and constructed the temple to the ever-popular Lord Venkateswara, a deity "common to all the communities."[2] They still sit laughing together in another photograph. At the city's western edge, near the site of the new central produce center, an older temple shines with newly repaired spires and gate thanks to the efforts of another strong neighborhood association.[3] The renovated temple intensified the general ecumenical spirit of the new colonies. This older temple shared a common courtyard with an ancient temple dedicated to Shiva as the savior of the two sons of King Rama, the incarnation of Vishnu! At the southern edge of the city limits, the state government reopened the renovated ancient Marundeeswara Temple dedicated to Shiva as the divine healer. Rows of black cars carried government officials—from a political party that once eschewed

traditional religion—in a fanfare of newfound devotion, reminding me of their newly pious counterparts in the United States.

Notices of newly instituted festivals, processions, and special rituals filled the pages of *The Hindu*, and these events filled our days. Along the coastal road near Injambakkam, teenagers from educated, moneyed families wore bright red headscarves and yellow shirts, all tied in the fashion of their beloved saint and incarnate deity Sai Baba of Shirdi, a small town near Bombay. They danced out, singing, from the grand temple complex where a massive marble lifelike image of the saint looked down from a central platform in the main building. A young man beating a tambourine, wearing fashionable jeans under his bright amber shirt, still beams enthusiastically out of our photographs (figure I.1). In another affluent neighborhood, other young men with saffron dhotis and bare chests, their sacred thread betraying their status as Brahmans, carried pots of holy milk on their shoulders through the streets as they danced and sang, abandoning high-caste propriety. They moved toward the new temple to Murugan constructed in the courtyard of a nearby house. In an older suburb just across the Adyar River that was once the border of Madras, a group of excited devotees pointed at a small eagle hovering around the pole as they raised the flag to begin their first major festival (figure I.2). That auspicious moment preceded a successful Brahmotsavam—ten days of processions, lectures, and music by the stars of the classical scene in Chennai. The trustees of the Anantha Padmanabha Swami Temple, all successful businessmen, turned their management skills to this complex festival that is usually under-

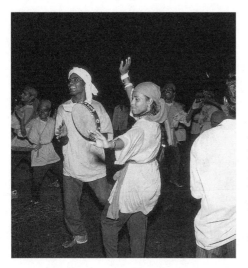

FIGURE I.1. A joyous young man with a saffron-colored tunic topping his fashionable jeans dances in procession in Injambakkam with a young woman, also dressed in imitation of their beloved divine saint Sai Baba of Shirdi. They dance on the road leading to the grand Shirdi Sai Baba Spiritual Center.

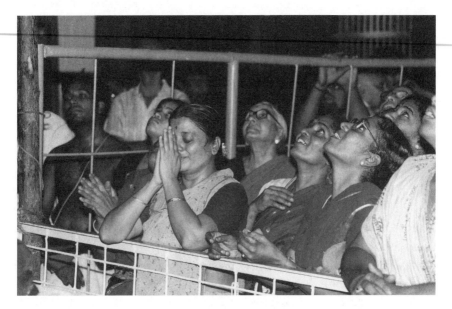

FIGURE I.2. A group of women stand near the sanctum of the
Padmanabha Swami Temple in Adyar, Chennai. They gratefully watch a kite
(small eagle) souring around the flagpole on the opening day of the temple's
first Brahmotsavam—a very auspicious sign.

taken by older well-established and well-endowed temples. Daily, we followed
the intricate decoration of the bronze Lord Padmanabha prior to his procession
around this upscale neighborhood of apartment complexes and fine single-
family houses. Nightly we heard famous musicians and an address by Swami
Dayananda Saraswathi, headquartered in the Arsha Vidya Retreat Center in
Pennsylvania (www.arshavidya.org). English was the cosmopolitan language of
choice in signs, posters, pamphlets, and in speeches for many of these festiv-
ities over the city. Tamil, the official language of the city and the state, usually
appeared alongside or under all printed material.

After locating, visiting, and photographing 108 of the new and renovated
temples, we returned home with hundreds of photographs, temple brochures,
and taped interviews—a mass of mixed media that reveal many new dimen-
sions of Hinduism. I added this collage of images of carved stone, paint, and
patronage to the already large collection of pictures that we had taken of vibrant
rituals and new temples constructed by middle-class professionals and busi-
nessmen who migrated to the United States after 1965. From 1989 to 1993,
my husband and I witnessed the consecration and the establishment of full
ritual services in temples in metropolitan Nashville, Tennessee; Washington,

D.C.; Malibu, California; and in Cary and Raleigh, North Carolina. Here, as in Madras, the building committee and the trustees of the new temples over and over again stated: "Once only kings could build temples, but now we middle-class people are able to do this!" Listening now to their voices, I hear echoes of the newest temple patrons in Chennai. Looking at the Hindu architecture in Nashville, I see the designs of a Hanuman temple in Nanganallur, and carefully scanning the faces of the priests as they pour the holy waters over the newly consecrated temple in Washington, I recognize familiar faces. Later, in London, I added more images of former residents of south India and Sri Lanka who created new temples. Once again I saw the face of the renowned architect Muthiah Sthapati in a proud display of photos in a former pub turned temple. Soon the stone pillars and blocks carved by his shilpis, traditional temple crafts-men, would be assembled as the new London Murugan Temple of East Ham. In another temple in the same East Ham neighborhood, I spotted an image of a newly popular goddess Gayatri. The temple manager mentioned that there was only one other temple in the world with such an image of Gayatri—in Sri Lanka, where many Tamil Hindus from Madras settled in the nineteenth cen-tury. Remarkably, a friend who fled the violence in Sri Lanka to settle in Ra-leigh, was a major supporter of this temple in her homeland. Each full-moon day for many years, she led a group of devotees in worship of Gayatri in the family room-turned-temple of her split-level house in North Carolina. It should be no wonder that the same families of Tamil-speaking origin are building temples here and in Madras, and that the same architects fly back and forth with new plans. A priest I meet in Madras was in Washington in 1993. His nephew serves in the temple in Boston. Another Madras priest gave me the address of his bother-in-law working in London. The same faces inhabit my photographs and the same names appear as patrons in the printed prospec-tuses for new temples, be they there or here. The temple building boom in Chennai stretches to London and Washington, and the borders of this sup-posedly dull secular city expand with it.

"Madras, a modern commercial and administrative metropolis in south India has at least six hundred functioning Hindu temples built or refurbished since its founding in 1638, most of them constructed in the last two decades by educated scientists, physicians, and many other professional and business people! Now Hindus from the same area are building temples as they migrate throughout the world." I reported my findings excitedly to a monthly collo-quium of specialists on South Asia from the three major universities in the Triangle area of North Carolina. I explained that I had selected Madras not only because I knew the city well but also because forty years earlier anthro-pologist Milton Singer first laid out the interrelationship of urbanization, mod-

ernization, and religion with Madras as his centerpiece in his influential *When a Great Tradition Modernizes*. In 1955, when Singer began his work, he provided some descriptions of temples. His concern focused on the processes of cultural change in what he called the "Great Tradition"—a very important term for the next thirty years. His understanding of this Great Tradition at this time in his career centered more on texts than on architecture, more on religious narratives than on religious spaces—an outlook he would modify much later, as I will explain in time. The process of urbanization and modernization, he hypothesized then, led to "a change from ritual and learned orthodoxy to devotion and popular religion" (1972, 144). As sites for what he called "traditionalization" and as centers of ritual, temples drifted out of his purview as he discovered new forms of devotion in popular media and cultural performances. Either much had changed in the intervening forty years, I told my colleagues, or something had kept Singer from seeing the same type of eclectic and often innovative temples that I had found among the very the urban "intelligentsia," the "new social type" credited with taking control of culture in the process of modernization (Singer 1972, 60). Yet a colleague challenged my own excitement at the novelty of this phenomenal growth of temples among the urban middle classes. I had to face the blind spots in my own vision before worrying about those of Milton Singer.

"How many churches have mushroomed in the last decades in an American city of six million?" he asked, and wondered why I was so surprised that successful educated businessmen or administrators were erecting religious structures. We sat talking only a few blocks from the massive Gothic cathedral that James B. Duke had built in his university in 1935 because, he said, "I want the central building to be a church, a great towering church, which will dominate all of the surrounding buildings." I had studied for five years in the shadow of Rockefeller Memorial Chapel at the University of Chicago—another Gothic structure built by a major architect of American capitalism. I realized at that moment that I had to understand this almost frantic construction of Hindu temples in Madras city as well as in metropolitan London or Washington or New York City in the context of a larger history. Trained as a historian of religions, I assumed the worldwide reach of "Religion" and religions, but not in the context of another revived discipline, world history, with its concern for cities and commercial and cultural exchanges. Milton Singer initially understood this wider context. His interest in Madras grew out of an early joint article that he published with his mentor Robert Redfield on "The Cultural Role of Cities" (Singer and Redfield 1954). This long essay marked an important turn in anthropology from exclusive interest in "primitive isolates"—intensive studies of preliterate and simple societies and cultures (Singer 1972,

5–6)—to interest in the city marked by both literacy and heterogeneity. In the context of the increasing dominance of area studies, however, Singer's long-wrought book (seventeen years in the making) and the trajectory of his own later theoretical work so featured India that the global historical and economic context receded in many significant ways. The same myopia that missed the global context of the subcontinent infected "area studies" in general, according to many recent critics.

When Milton Singer chose Madras as his exemplary site to study modernization, he glossed over what I now see as the major fact about the city. Madras, like its fellow port cities of Bombay and Calcutta, was a multicultural global trading center from the first. Madras now bears its presumably more indigenous name of Chennai, like its sister cities of Mumbai (Bombay) and Kolkata (Calcutta), all ironically renamed to white out the legacy of European origins at the very moment when the business-minded in these cities celebrate their return to worldwide commerce. The glitzy Chennai Online Web site developed by Chennai Interactive Business Services nonetheless openly celebrates the city's past and present global status: "Chennai, the present Gateway to the South of India, is, however, only about 350 years old. Chennai is ever growing, changing and pulsating with new activities. . . . The city of today, one of the great metropolitan cities of the world, and the fourth largest city in India, grew from the Fort that Francis Day and his superior Andrew Cogan of the East India Company built on a narrow spit of no man's land that Day's dubash Beri Thimanna negotiated with the local governor of the Vijayanagar Empire" (http://www.chennaionline.com/toursntravel/singaarachennai/city.asp). But the imperial past was not always so openly mentioned. Singer began his study of the city a decade after Independence, when the colonial period was at best an embarrassment. The first prime minister, Jawaharlal Nehru, reoriented—at least ideologically—the economy of India away from its cities as centers of commerce and consumer goods. Eventually adopting a Soviet-style model, Nehru emphasized agricultural development and state-owned large-scale manufacturing. The independence movement under Mahatma Gandhi glorified rural life, where "real India" and by extension "real" Indians lived. This antiurban emphasis suited anthropology's own inclinations. As much as Singer's great book intended to return interest to the city as a site of cultural and religious continuity and change, it was finally as an *Indian* city that Singer reintroduced Madras. Remapping Chennai as "one of the great metropolitan cities of the world" requires a change of consciousness and a new encounter with the city and its temples as well as with its expanding borders that now, in some special way, encompass London, Washington, New York, and points east and west. Thus I take on a double task: first, to put Hindu temples and temple

builders into conversation with the complex study of "religion and the city";[4] and second, to put both modern Hindu temples and world history into conversation with the study of religion. This book abides within that double-edged conversation.

Religion and the City

With the exception of Milton Singer and his mentor Robert Redfield, and a few others whose names will appear throughout this book, anthropology ignored urban life before and then during the first decades of Indian independence. In the British and American world, sociology rather than anthropology focused on cities; issues of dislocation, economic unrest, unemployment, and social welfare dominated. The living contemporary city understood in cultural or symbolic terms—the space that anthropology allotted for religion—was missing in the English-speaking world. In the late 1950s, sociologist Don Martindale offered an edited English translation of Max Weber's influential *Die Stadt* (1921), *The City* (1958), in hope of generating a renewed consideration of the city as a cultural phenomenon. Martindale begins his prefatory remarks, "The theory of the city somehow cannot account for what every journalist, poet, and novelist knows—the city is a living thing." He points out that for much of American sociology, the city was treated as a social problem, not a concept. Observing the urbanization process at the turn of the twentieth century in the United States, the rising field of sociology widely regarded the city as both the site and the cause of social dislocation and "moral decline" (Martindale 1958, 9–19). "While European students had materials available from cities that had been going-concerns for a thousand years, American cities were often not more than a few decades old" (43). The raison d'être for the city's existence, "materialism," supposedly put urban life in contest with enduring moral and spiritual values. Forty years and many postmodern perspectives later, Robert Orsi describes the same situation in popular literature, where the city "rendered as site of moral depravity, lascivious allure, and the terrain of necessary Christian intervention—became an enduring commodity of American popular culture" (Orsi 1999, 6). Although Martindale sharply contrasts European and American scholars, British sensibilities toward the city (consider Dickens) resembled American attitudes. For many, religiousness in the *modern* city remained an oxymoron. That special American-British context adds an irony to any discussion of "religion and the city."

Understanding the nature of a city can be surprisingly complex. People live in close quarters in a village or a town—so what makes a city? To move

beyond conjured images of crime and corruption, as Martindale suggested forty years ago, means changing the way we frame the question. In the last few years the city has become fashionable not only as a place to reside but also for scholars to roam. Now the city appears in a several new volumes as a site for religious innovation and religious transformation, mostly in the United States (Orsi 1999, Sharma 2001, Livezey 2000) or as a special place with almost religious connotations (Miles, Hall, and Borden 2000). Each of these collections of essays provide detailed discussions of changing perspectives on the city but only hint at the reasons for this sudden spurt of interest. Woven into the introductions is often a Hindu temple or a mosque—something that set the rest of those too-familiar-to-notice churches or synagogues in relief, just as they did for me. Diana Eck begins her popular discussion of a new religious America: "The huge white dome of a great mosque with its minarets rises from the cornfields just outside of Toledo, Ohio. . . . A great Hindu temple with elephants carved in relief at the doorway stands on a hillside in the western suburbs of Nashville, Tennessee" (2001, 1). The concept of the city as a built environment—as space—begins to dominate much of the language here. Orsi speaks of "urban landscape, spaces of the city, urban religious cartographies" (1999, 1–62); Livezey maps "places of public religion" (2000, 2); and the editors begin the *Cities Cultures Reader* with the heading "forms and spaces" (Miles, Hall, and Borden 2000). Discussions of social dislocation transform into dis-*location*. Issues of complex urban identities become "maps of being" (Orsi 1999, 51). The relocation of the city into the realm of *space* makes this an ideal era to look again at Hindu temples within modern cities. And the turn toward space as a the venue for discussions of religiosity and sacrality leaves just that little fissure into which any historian of religions worth her pay will quickly slide. But that move must wait.

My initial surprise at the contemporary building boom for Hindu temples focused not only on the urban context but also on the social status of the builders. The space of the city also related in some way to those businessmen and women, engineers, doctors, teachers, and government officers who eschewed mention of a caste identity for themselves or their fellow donors. They often openly called themselves "middle class" when asked to characterize the donors and devotees as a group. I remain determined to take this self-identity seriously in the face of the persistent public vision of the city as the place of the poor. "The urban holy is now encountered in neighborhoods of hard-working, disciplined people just like the rest of us," Orsi can still say of common American attitudes (1999, 12). The many Hindus I encountered were urban middle-class people with religious values in common with their professional counterparts in America or Europe. They work as close as the next

cubicle or as far away as Chennai or London. Just as many modern professionals continue to build new churches or synagogues or mosques, contemporary Hindus attend to the construction and maintenance of their religious institutions wherever their work and life takes them. I do not want to lose this "like us," this shared commonality, in any discussion of Hindu temples and urban space.

At the intersection of urbanization and religion and the rising middle class has stood Max Weber for the last half century. Consciously comparative, Weber wrote of the city in the "occident" and the "orient" and of the relative effects of many of the world's major religions on modernization. It is impossible to by pass or to ignore his influence on perceptions of the rise of the modern city, of processes of secularization and the rise of capitalism, especially in the United States. Writing in his native German just after the First World War, Weber's work arrived in the United States in a time warp. The edited and translated editions of his *Protestant Ethic and the Spirit of Capitalism*, *The Religion of India: The Sociology of Hinduism and Buddhism*, *The Sociology of Religion*, and *The City* all appeared in campus-ready editions during the late 1950s and early 1960s, long after his death in 1921. His introduction into the mainstream American academic world came during the Cold War years, when capitalism equaled democracy. Whatever Max Weber really meant in his German writings—several scholars posit the deliberate mistranslation and misappropriation of his work—Protestantism with its unique "this-worldly asceticism" provided the space for capitalism free from the confining public contours of traditional religions.[5]

In *Protestant Ethic*, Weber—viewed through American eyes—contended that ritualistic Roman Catholicism had restrained Europe. His thesis supposedly extended to Hinduism and Buddhism as restraints on economic development in South Asia, while Confucianism and Taoism held back China. His consideration of "religion" is muted in *The City*, however, which makes it a better place to begin. The subtle contours he paints of the nature of the city at that crucial moment—the rise of modernity—still provides surprisingly fresh perceptions of some key issues. I am bypassing, for the moment, the complex arguments over *modern*—a *very* tricky and much debated term—because Weber's theories shadow much of this debate. What distinguishes a *modern* from a medieval or an ancient city? The question is vital for any study of contemporary urban religious structures and is the source of an irony. Few would question that great temples or cathedrals often centered ancient or medieval cities. Who can forget Rome, Jerusalem, Banaras, and Madurai in south India! But in modern cities, churches or temples often disappear from our consciousness, just as temples did for Milton Singer or churches did for me. We expect

to see a secular city, not a sacred city, in urban centers that rose during that crucial period of European expansion into and eventual dominance of a world-wide trading network variously named "Universal Oekumene" (Redfield and Singer 1954, 56) or the "modern world system" (Wallerstein 1980).

Max Weber begins his discussion with a bold attempt to define "the nature of the city." The difference between a city and other clusters of population such as a village cannot be reduced to trade versus agriculture. Cities often depend as much on agriculture as do villages. Rather, "In those settlements which differ administratively from villages and are thus dealt with as cities only one thing, namely, the kind of regulations of land-owning is customarily different from rural land-owning forms. Economically such cities are differentiated by a special kind of rent situation presented in urban real estate, which consists in house ownership to which land ownership is accessory" ([1921] 1958a, 74–75). He then outlines the basic elements that make a settlement an "urban community," a term which he invests with special significance and which seems to mark the nescient modern city. "To constitute a full urban community a settlement must display a relative predominance of trade-commercial relationships with the settlement as a whole displaying the following features: 1. a fortification; 2. a market; 3. a court of its own and at least partially autonomous law; 4. a related form of association; and 5. at least partial autonomy and autocephaly thus also an administration by authorities in the election of whom the burghers participated." Then he adds the key statement, "The particular political properties of the urban community appear only in the presence of a special stratum, a distinct new estate" (80–81).

Notice that when Weber sets his long-wrought discussions of the processes of modernization in the context of the city, he begins to speak in spatial rather than verbal terms. A major character of the city is its central focus on the built environment. Within this special space of a city, this new urban community gradually gained a semi-independent status free from older social forms bonded through "magical" means (99).[6] This urban community is intricately bound to the rise of those strata that would become the middle class. Here also is a nascent democratic institution, for the cities' laws were "the half-way house between old feudal law and the law of territorial units" (112). So recasting Weber in contemporary terms, an urban community, a modern city, is a populous area coterminous with: the predominance of commercial-trade relationships; a new sense of space dominated by ownership of houses, not land; the stratum that would become the new middle class; and, a sense of common community that transcends older religiously sanctioned social divisions. Moreover, the modern city emerged before the modern nation-state—and in many ways continues to transcend it. Implicit in this Weberian discussion is that

along with the world of exchange exists a general ethos of innovation, of change.

These criteria can be useful in understanding some of the distinctions between a modern and a premodern temple in relationship to urban space, but ultimately Weber assumed that only the "Occidental city" fit these criteria. "Finally measured by this rule, with possible isolated exceptions, the cities of Asia were not urban communities at all even though they had markets and were fortresses" (80–81). In the urban centers of India, "the hereditary caste of India with its ritualistic segmentation of the professions, excluded the emergence of a citizenry and urban community . . . for caste estrangement hindered all inter-caste fraternization" (84). A very good case can be made that Madras at its founding and now fits Weber's criteria for an urban community more exactly than Boston or Manchester. With Fort St. George still the seat of government for the surrounding state of Tamilnadu, with a lively market center in nearby Georgetown, Madras looks the model of a modern city built by and for world trade. Temples now occupy urban residential plots, as I will argue in chapter 1, like houses, not grand estates. And as will become obvious, most new temples are created by and for neighborhood groups—the very multicaste social groups that supposedly cannot exist in caste-controlled India. There are serious challenges to the model of caste that Weber and others have offered (see Fuller 1997; Stern 1993, 84–102). But modern temples also challenge caste as the major social signifier. Significant cultural-religious changes occur in these temples—they are the laboratory for an emerging reconfiguration of Hinduism, with social and cultural consequences that are as important as the much-discussed Hindu nationalism and "fundamentalism."

Looking at modern temples in this way requires that much-touted new business imperative "think out of the box." When read in conjunction with Weber's other work—remember that the translations of most of his work came within five years—the burgher, bourgeoisie, and middle class elide in the caldron that produces the "spirit" of capitalism. Here the new "this-worldly asceticism" with its supposedly austere life style would create the necessary accumulation of "capital." The accelerated process of "rationalization" would end "enchantment," the last vestiges of magic kept alive in expensive rituals and lavish donations to nonproductive gurus or parasitic priests. This is the container that the Anglophone Weber built. Into it went a set of characters and concepts: the middle classes with rationalization, with urbanization. From this black box emerges the stalwart Protestant citizen with his "rationalized" religion tucked into his inner self, pocketed with his Bible and his carefully articulated doctrines, venturing out into the city—into public space neutralized of its "enchantment." This sober Protestant and an imaged wild-eyed Asian En-

chanter struggled openly or obliquely in the pages of American textbooks on world religions into the 1980s and 1990s. A section of one such textbook includes a photo captioned "Portable Deity." Portrayed is a street scene: a cart carrying a deity in a portable shrine with a bedraggled man sitting nearby. The legend explains to the student that the offerings made to this image "provide a living for the owner." This section on Hinduism in modern India then declares, "Modern Hindu liberals regard the hundreds of religious holidays (national, religious, personal) as 'bad news,' for many millions of hours are lost to production and the tasks of nation building. Similarly, absenteeism for the sake of performing pilgrimages is a drain on manpower, and the news that two and a half million pilgrims attended a holy festival for ten days is bad news for the economy" (Converse 1988, 104; see also Waghorne 1999c, 215–224).

But the devotees and donors of new modern temples are not dupes of some priestly class. Newly built temples continue to house ritual life, many deities, and multiple priests, if donations allow. Many also include social services for the poor and sponsor lectures, print pamphlets on religion, and include space for meditation. Again and again, new donors, trustees, and managers emphasize their democratic polity and principles. On the evening before the consecration of their new temple, trustees of Prasanna Venkatesa Perumal in Madras compared their new temple to old temples in the villages, which remained dilapidated and deserted because "the control lies with one particular person, he will not allow others to participate." "Here all efforts are a joint effort. So you have oneness. Here we have some democracy. Here everybody has some rights. Here we are all equal so there is more interest." Clearly many of the devotees experience a more direct and personal involvement with the temple, which in some way is indeed "rooted in the experience and conscience of individuals," as Robert Bellah, the influential sociologist of religion recently summarized a portion of the prevailing concept of modernity (Bellah 2001, 94). The trustees hire the priests, and choose much of the style and format— the software and the hardware of the temple—as individual persons among other persons. Many of those interviewed spoke of long general meetings, as an official of the Ratnagiriswara Temple in prosperous Besant Nagar put it, the elected board has "hot discussions and exchange of ideas." While the presumed stalwart American Protestant guarded his consciousness and his inner priestly power, he (I use the masculine gender consciously) joined a "Meeting House," even avoiding the tainted term "church," with minimal ritual and regalia, more focused on words than sights.[7] But now changes are occurring in "institutional religion." Today in India, as in America, religious people are moving away from many—not all—forms of religious authority, from so-called "organized religion," but not from organizing very concrete public displays of religiosity and

creating new communities in the process (see Rudolph and Piscatori 1997, 13–16). Recent work on urban religion in the United States suggests that "In contrast to the personal growth and self-awareness movements, the prevailing idioms of these efforts are 'relational power' and collective action for the 'common good' "(Livezey 2000, 14). Builders of new Hindu temples in Chennai—and its extensions abroad—stress that theirs is a new polity. Their new community formations as well as other innovations, unlike those of the eighteenth-century stalwart Protestants, are written in elaborate columns, multicolored façades, and sometimes lavish ritual performances, in the same way that many Pentecostal churches are theaters full of sight, sound, and fury signifying much (Kilde 2002).

The Problem of "Tradition" in the Context of Space

To speak of "innovation" in the same breath as "Hindu temple" requires some care. New temple builders and devotees continue in many ways to acknowledge and even provide a prominent stage for certain "ancient" renunciative teachers—acharya (learned), guru (venerable), or swami (master)—and often emphasize religious education within the temple. Ironically, in India and abroad the VHP "fundamentalists" now carry the saffron flag of "rationalization," not the Chennai temple builders. The VHP with its "modernized 'spiritual Hinduism' preaching personal development, success, and this-worldly ethics" (Hansen 1999, 156) seem to have read American Weberians like a technical manual. Its Web site lists among its objectives, "To establish, maintain, help to manage or render assistance to temples, maths [monasteries], and other centres for preaching principles and teaching practices of Hindu Dharma and culture, thus making them centres of social and cultural awakening" (www .vhp.org). Remove the references to "Hindu Dharma" and write "churches" for temples and maths, and no nineteenth-century Protestant social reformer could have put his case better. But the new temples in Chennai, as we will see, are far more than centers of teaching and preaching or of cultural awaking. Their construction of "oneness" and of common community has a much different flavor from the sense of unity promoted by ardent Hindu nationalist organizations. The RSS, calls for "strengthening the society by emphasizing and inculcating a spirit of unity, so that no one can dare challenge it" (www .rss.org). The new temple builders include rationalized teaching, but it is tempered with a renewed ritual life and room for the miraculous—for the realm of "reenchantment" (a term used by Weber)—like those fostered by "urban

middle and upper-middle classes" who follow many of the new guru-centered movements (Babb 1986). As a devotee at one innovative temple described the founders, "they are intellectual people and educated people who tried to retain the old values and to a certain extent also cultivate them."

"Old values . . . cultivating them" can be a complex concept to understand. Anyone building a temple commits in some sense to tradition, but in a very tangible mode. The concern for old values increases as some Hindus in the diaspora try to demarcate their way of life from the surrounding and often seemingly overwhelming cultural ethos of Britain or the United States. The same need to maintain a space for "values" in the face of ultrarapid economic and social change in India likewise motivates the contemporary middle class in urban India. There is no doubt that phrases like "the eternal and universal life values based on Sanatan Dharma" (www.vhp.org) are part of a growing vocabulary of "Tradition," as it was in the beginning and always shall be. The VHP in America describes itself as "a society that is moving with the times, nay, verily pushing the envelope of time, ever radiating the timeless wisdom of the Rishis in every act, every achievement, every endeavor" (www.vhp -america.org). All seemingly new invention becomes a part of "Tradition."

Moreover, the VHP's vision of the temple as a space for the enactment of tradition in the modern urban world is widespread; they are in surprisingly good company. Milton Singer, especially his earlier work, fell under the spell, I think, of the master historian of religion at the time, whose office was just two or three blocks from that of Singer. "Religious man," for Mircea Eliade, built temples and other holy sites from "the desire to live in a pure and holy cosmos, as it was in the beginning, when it came fresh from the Creator's hands" (1957, 65). In his temples, "religious man" enacted his primordial myths of creation. The temple, for Singer, becomes the locus for a strikingly similar process that he calls "traditionalizing."

> While temples in Madras and in Madurai now perform some of their former functions along with secular and quasi-secular institutions such as art galleries, theaters, concert and dance halls, zoos, and political processions and celebration, they probably still continue to function as predominant centers for dramatizing in cultural performances the sacred myths of particular sects, and for traditionalizing the social and cultural innovations for which members of these sects are responsible. . . . The discussion of "symbolic traditionalization" in Madras and in Madurai would seem to suggest that a dominant value in India is a desire to assimilate innovative

changes in a city to some preexisting patterns or rules of a great tra-
dition. We might formulate this hypothesis as "all innovation is res-
toration." (Singer 1991, 92, 95)

But to say that the modern temple builders traditionalize their innovations, as
Singer did, is to deny them a consciousness of innovation, which many openly
acknowledged. To tell these modern temple donors, in the mode of the VHP,
that their task must be to promulgate and preach tradition is to deny them the
right of diversity. To suggest that the temple-building boom in Madras and in
the diaspora moves openly beyond "Tradition and Eternal Values," however, is
to court some sharp criticism. Indeed many of the trustees of new temples
invoked religious authorities and denied that the architecture of their temples
broke from the Agamas—the thirteenth-century textual authority for temple
design (see Davis 1991). But, there are different ways of working with tradition–
more subtle ways than rendering traditions into formulae. There is the art of
"cultivation." Listening to more voices and seeing some of the many new tem-
ples in Chennai might be a better guide to understanding the processes of
innovation in the context of the desire to "retain old values" among the rising
urban middle classes. In the process these temples reveal some of the religious
sensibilities shared by the devotees (the English term used for those who reg-
ularly worship at the temple, rather than the term *congregation*), donors (those
who give major contributions), and trustees (usually elected, sometimes ap-
pointed for life) that make these temples and the urban space that they occupy
both "modern" and in some sense "sacred."

First a word of warning: understanding middle-class religious *sensibilities*—
I use this term cautiously—in India requires a pragmatic method of listening
carefully and looking closely at the words, the actions, and the visual produc-
tions of those who identify themselves as middle class. Social categories in
India today are increasingly ambiguous—a matter of a person's shifting sense
of identity and changing status within various social contexts. Even caste, that
supposedly quintessential Indian social system, has anthropologists once again
puzzled. Some now mistrust old "objectivist illusions" and argue that "the
diversity, inconsistency and ambiguity" of caste in India today makes definition
difficult (Fuller 1997, 29). With economic reform on the nation's agenda,
everyone talks about the middle class. News magazines assume its predomi-
nance in political and religious life, popular books analyze "the great Indian
middle class" (Varma 1998), but few dare define it; a full discussion of the
historiography of caste and class must wait until chapter 3. In the academic
study of religion, discussions of "middle-class religion" in India—and else-
where—are just beginning to question, "whether and to what extent one can

successfully characterize major traits in middle-class religion in contemporary India as a whole."[8] The only "trait" commonly attributed to the middle classes is their very ambiguity, their "middleness," as historian Partha Chatterjee describes it (1993, 35–37). In a religious context, their situation becomes even more nebulous. Put simply: "class" has no formal legitimacy as a Hindu religious category. One term for "caste," varna, remains central to Hindu ideology and cosmology while the other, jati (*jāti*), at least has the imprimatur of the distant past.[9] The amorphous and unrecognized religious legitimacy of the "middle class" makes their encounter with "tradition" so important and so problematic. Educational accomplishments and economic importance give middle-class people an edge in political and cultural life but do not automatically confer religious authority the way, for example, that status as a Brahman priest would. Like their degrees and their income, their religious acumen must be learned, their religious commitment enacted, and their religious authority earned. By the deities they choose for worship, by the spaces they construct to house them, by the rituals they perform, and by the organizations they develop, we will know them.

In the pages that follow, I invite my readers on a worldwide tour of middle-class Hindu temples. We journey via a "multimedia scrapbook"—a history constructed from many taped interviews, photographs, pamphlets, formal invitations to rituals, and numerous books and articles that added other visions and other experiences. Such a scrapbook—like any album—cannot include all of the temples and all of many voices recorded in my initial explorations. My own itinerary combined a general survey of urban temples where most devotees and trustees were "middle class" and more intensive visits to certain temples whose devotees welcomed me and articulated especially rich visions of their religious experience both in words and in visual form. Reorganizing such a mass of sights and sounds from three continents can be daunting. Many of the temples are modern but not contemporary, with traces of donors and devotees from three centuries ago still written into their walls and into living memory. So I retrace a new itinerary for readers, which moves into the past and the present simultaneously. Walk with me into the neighborhoods of Chennai, especially Georgetown and Mylapore, to view old temples in their now seemingly incongruous urban environment. But keep in mind that in a former colonial trading city, this walk does not end at the city limits of Chennai. Original donors and their contemporary progeny maintain connections to villages and towns left decades, even centuries, ago.

Today the city's borders extend in new directions. Many of the cousins and brothers, literally and figuratively, of temple patrons and devotees in contemporary Chennai construct new divine houses in London and Washington, re-

making the religious panorama of the United States and the United Kingdom. My walk in the present extends into London, where I rove the streets of Tooting, climb upstairs in a former warehouse to see a goddess's temple constructed from plywood painted in trompe l'oeuil to create all of the features of a proper temple. In other London neighborhoods, I introduce the reader to the god Murugan in a temple immured within the stone shell of the former church, and another goddess whose temple is tucked inside a lovely white church on a quiet street. In Washington, a multiplicity of gods share a glorious white temple in an otherwise ordinary suburban neighborhood. Although these many different urban settings affect the character of these temples, I do not divide the chapters according to national borders. Rather I move my readers in the same manner as the donors and devotees navigate in and out of different urban settings, in and out of the past worlds of ancestral villages and old colonial trading networks, into a stream of worldwide resettlements of this or that god or goddess flowing from greater Chennai or even nearby Sri Lanka to the United States or United Kingdom, and often back again.

The chapters that follow are organized loosely into a chronological framework keyed to a broader context of world history. Our touchstone remains Madras/Chennai as a city formed at a key moment in history from an early "diaspora" of traders, artisans, and later bankers and bureaucrats who settled in this new city. As a crucial part of settling into their urban home, Hindus constructed new temples within a decade of the founding of Fort St. George, and these are still lively centers of worship. Chapter 1 recalls that period from 1638 to 1800 in the context of the current building boom in the new diaspora— the influx of professionals to Chennai and to London and cities throughout the United States. Chapter 2 turns to a single neighborhood within Madras city, where numerous temples recall another period of temple building when the area was an enclave par excellence of the rising middle classes (1800 to 1830), and where these now old temples are now undergoing "urban renewal." Chapter 3 follows the intense religious revival of long-standing temples in Mylapore to the recovery and gentrification of "ancient" sites to goddesses who were once associated with less educated villagers. Chapter 4 returns to the diaspora of some of the similar Goddess temples to London, but interestingly not yet to the United States. This chapter also traces a new network of temples to the Lord Murugan, as an icon of Tamil ethic identity, that appear simultaneously in London and Washington, and then circle back to the coast of Chennai. In all of these chapters, many other temples that we visited and the numerous people who voiced their experiences were never discarded; they remain in the background tempering my generalities with their harmonic hum.

Before following this crisscross itinerary, remember that a serious conversation with a set of interlocking theoretical issues will continue throughout the narration. How can we understand the meaning of middle class in India within a religious context? By extension, what can this discussion of middle-class religious sensibilities add to the meaning of class as lifestyle with religious overtones? What kind of public sphere/s do temples occupy within a modern "secular" metropolis? Do visible changes in the sculptures, the portraits of the gods, reveal an emerging vernacular—middle-class—theology? Before following a planned literary, I want to begin with an overview, some travelers' tips and pretravel preparations. The middle-class devotees and donors from over one hundred temples did not speak with a single voice, but certain themes emerged in their comments and in the visual statements embedded in the architecture of their temples. I ask readers to consider the following detailed descriptions the consecration of three new temples as an prelude to the pages that follow.

The Installation of a New Deity at the Madhya Kailas Temple

The Hindu announced: "Installation of Idol" in a small headline in its Madras city edition. The article continued in that special form of English that subsumes Indian language terms into a common lingua franca in this former British colonial port city, "Rs 1.25 lakh [125,000 rupees] panchaloka idol will be installed in an oval-shaped shrine . . . by Sri Bhuvaneshwari, Bhuvaneshwari Mandiram Triplicane." The shrine for the new deity, Sri Aadhyantha Prabha, would occupy a part of the Madhya Kailas Temple in the affluent neighborhood called Adyar within Madras city. Not only was the expense of this bronze panchaloka image (made of an alloy of five metals; see Parker 1992) of note but also the deity's novel form. Half of his body took the form of Ganesha, the elephant-headed god, and the other half the monkey body of Lord Hanuman. The oval shape of the sanctum continued the novelty. Typical shrines are square or rectangular. On the ritual side, *The Hindu* reported that in an interview the swami said "devotees would be allowed to pour holy water on the vimanam [also vimana, individual shrine] and also on the idol"—a privilege usually reserved for priests in south India. I had just come to Madras in search of new temples, especially those with innovations. This went beyond my expectations in my first month of work: the revelation of a new divine form, combined with architectural as well as ritual innovations.

Several devotees explained the new deity to me as we all stood near the new shrine looking in at the remarkable bronze image-body that it housed.

His name, Sri Aadhyantha, derived from "Aadhi" (T/*āti*), which means "beginning," and "Antha" (T-S/ *anta*) meaning the "end." An official provided more detail, using both Tamil and English terms. The beginning of life starts with sound, which is Ganesha's nonmaterial form. The end of life is the loss of breath, which belongs to Hanuman as the son of the ancient god of the wind. "When a child is born, he/she cries but at the end there is no breath. So both combined are the Beginning and the End called Ātiyantam. Moreover this is *pūrṇam*, complete life." Everyone saw the oval shape as innovative and possibly deriving from the form of an egg, subtly continuing the life-death theme. They pointed to the shrine, which they termed properly as the vimana or sannidhi.[10] Images of deities not usually seen together surrounded the top, the shikhara (cupola). Looking quickly around at this amazing oval cupola, I could observe a mélange of deities all carefully labeled in Tamil. Among them was a popular manifestation of the Goddess as the Wish-Fulfilling Cow, Kamadhenu, usually understood as the consort of Lord Shiva—but here to her right was a form of Vishnu in his incarnation as the cosmic fish (Matsyavatara), and to her left Shiva's youngest son Murugan. The architecture as well as the devotees spoke of fullness, totality, and inclusion—including their warm welcome of me.

Someone took me to meet the temple architect, the sthapati, who had designed the shape of the shrine as well as the new body of the deity. He explained that this oval was "the shape of the universe." He claimed a precedent for this form in Tanjore, the ancient city in the heart of the Tamil country, but the devotees continued to emphasize the themes of innovation and inclusion. I asked why this divine body was made of bronze rather than stone, more usual for a permanently installed image. "For this vigraha [image-body], panchaloka so that everyone—you yourself—can do abhisheka," answered one devotee, referring to the pouring of holy water over the image-body. Then speaking of the consecration of the temple, when holy water is poured over the temple as well as the image, a devotee emphasized, "Everywhere you can witness the kumbhabhishekam but here the kumbhabhishekam is done by yourself. This is a salient feature of this temple." While we were talking, I watched the faces of joyous devotees as they climbed the makeshift ladder to the top of the vimana to do the abhisheka themselves (figure I.3).

I began talking with a husband and wife whose children were at Penn State studying engineering. They told me how this form of God was revealed. The temple was dedicated to Ganesha. One day when a group of devotees were watching the priest doing arati, that is, waving lamps in front of the image of Ganesha while praising him, "suddenly they saw the idol of Hanuman also. In this temple! Not only the priest who was doing the arati but every one saw

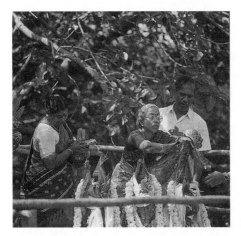

FIGURE I.3. A devotee reverently pours holy water from her kumbha onto the top of the new vimana for a novel deity housed below, Sri Aadhyantha Prabhu. The new sannidhi is on the grounds of the Madhya Kailas Temple in Adyar, Chennai.

it and they were amazed." They knew that "contained in our ancient texts" was a form of God that is half man and half woman. So they began research to find any such combination of Hanuman and Ganesha. "This is the only one of its kind in India," they said, but the devotees felt that the two deities have a lot of similarities in spite of Ganesha's status as a son of Shiva and Hanuman's identity as the powerful servant of Rama, a form of Vishnu. "Both are really bachelors and both in their natural form are really animals. They found so many similarities." Then this couple explained that this temple is not really Vaishnava or Shaiva, and intoned the virtual motto of this temple: "It's all together."

When describing this upscale neighborhood and its residents, conversations never turned to "caste" (usually politely called "community" in English) as a marker of identity. Rather, I was reminded that this neighborhood is adjacent to government land with the highly respected Indian Institute of Technology and other important institutes for research. "The executive committee—if you look at it—are all drawn from people belonging to some of these institutes." These are "intellectual people and educated people who tried to retain the old values and to a certain extent also cultivate them." The initial donor, as another women explained, was the philanthropist A.M.D. Chettiar, who founded this temples, because he and his wife did not have children they gave their wealth to charity. The long conversation ended with a theme I would hear frequently through out the year. Unlike the ancient temples, which "are so cramped," devotees praised the new temple for its spacious, open design and cleanliness.

My experience of this consecration and the conversations that followed revealed what I can only call the "religious sensibilities" of these urban devo-

tees. All acknowledged and even took pride in the uniqueness of their temple crowned now by this new shrine to the fulsome Lord of beginnings and endings, the first word and the last breath. They also valued "the priesthood of all believers," to use Protestant language. The devotees called on religious professionals to give form to their vision, but they initially experienced the revelation directly. As they told me, they saw it, "not just the priest." And this is where the Protestant analogy must end. In their eyes, the innovation was God's unique revelation to the devotees. Did they "traditionalize" innovation by saying this? To traditionalize is to neutralize time, to "abolish time," as Eliade would put it. But this deity, this vimana, this form of worship were new. Listening once again to their voices, I hear another and too often forgotten quality of Hindu theology (this *is* the right word)—the freedom of the gods to play (Sax 1997). Instances of ordinary people dreaming, seeing, hearing deities who demand a body could once be ignored because many of those stories were supposedly from the village (Ellmore [1915] 1984). In this case, those seeing the new form of God were from the classes of the rationally minded who obviously refuse to be religiously inert. In their struggle to uphold eternal dharma, Santana Dharma, the VHP—and Singer and Eliade—give the gods too little room to manifest, which Singer later admitted.[11] Or to put it more anthropologically, they give the devotees no space to celebrate the new, the novel. But such people do not wait for theory to give them permission to build. In Adyar, among all those technical and scientific institutes, the Madhya Kailas Temple embodies a new revelation in bronze. As my questioner from Duke asked many pages ago, why should this be such a surprise?

The revelation of a deity half-Ganesha and half-Hanuman also speaks of a trend in Chennai: the increasing popularity of these two deities with animal bodies. As the elephant-headed son of Lord Shiva and Parvati, Ganesha (also called Ganapathy) has long resided in numerous small street shrines in villages and in the city. In the important neighborhood of Mylapore, which we will visit in chapter 3, wealthy nineteenth-century devotees built small temples to him, usually tucked into tiny corner parcels of land. But in Adyar, within a mile of the Madhya Kailas Temple, the new large Varasiddhi Vinayakar (form of Ganesha as a healer/mystic) Temple attracts many worshipers. In the United States, Ganesha occupies the main sanctum in the Sri Ganesha Temple in the Flushing neighborhood of New York, the first "authentic" temple in this country (Eck 2001, 120–123). In the lovely Sri Ganapathy Temple in Nashville, the god presides over a major institution. His fellow animal-bodied deity, Hanuman, has also grown with the rise of the modern city. Hanuman until very recently appeared only as the faithful servant of the holy family: Lord Rama,

Sita (his wife), and Lakshmana (his brother). Texts declared that his image "should be only so high as reach the chest, the navel or hip of Rāma" (Gopinatha Rao [1914] 1993, 190). The exhaustive 1914 catalogue of Hindu iconography in south India records no major temples dedicated to him (Gopinatha Rao [1914] 1993), but there were exceptions, including a temple in Mylapore, which will appear later in the book. But now he has grown in size and popularity, with temples in India vying to produce the largest Hanuman (Lutgendorf 1994). In Nanganallur, the proud priests of the Adhivyadhihara Sri Bhaktanjaneya Swami Temple must use a stairway and a cleverly constructed lift to perform the daily rituals for their thirty-two-foot-high image.

Philip Lutgendorf has devoted the last decade to understanding the burgeoning devotion to this divine monkey. Among many reasons, he lists the monkey as a "hyper-signifier of inbetween-ness" (1997, 323), and then connects Hanuman's popularity to "India's growing middle class—a social group likewise in-between and rather amorphous in dimensions" (325). Paul Courtright ends his study of the elephant-headed Ganesha by emphasizing the deity's "meditorial roles." "Half animal/half deity, broken and joined together, half wild/half tamed son of the lord and lady of the universe, yet acquainted with demons, he is made up by joining that which at other times stands apart. He does not reconcile these opposites, he holds them together in dynamic tension" (1985, 250–251). I heard this same language of mediation used in another way by a perceptive devotee in one of those offhanded conversations with major significance. He told me that deities like Hanuman and Ganesha with animal bodies invite attention these days because they share with humanity a connection to the earth, a presence in the daily world. I would translate this concept into theological language as an *exalted imminence*. Perhaps the middle class does feel a special affinity for power emanating from tension of opposites, from uncertain status, from earthly beginnings. I heard some of this language at the Adhivyadhihara Sri Bhaktanjaneya Swami Temple in Nanganallur, where the trustees explained the magnificent size of their Hanuman: "In the Kali Yuga" Hanuman is "the creative authority." The Kali Yuga is our present age bound to darkness, to the earth, and to sensual life.[12]

The Consecration of a New Temple to Lord Hanuman

We documented the rapid progress of building this elegant temple in the far suburb of Nanganallur over several months, culminating in the consecration rituals, which this temple termed the "Mahasamprokshanam." Unlike older

temples, here a massive entryway opened into to a large multipillared mandapa (portico) with the huge image of Hanuman clearly visible. In the right corner of the compound, facing this structure, stood a much smaller shrine to Rama, his divine consort Sita, and his brother Lakshmana. Otherwise the temple has no other deities, not even in the decorative motifs. Instead flora, stylized vines, flowers, and tender shoots, run up and down the pillars and along friezes on the walls. The only fauna are two grand yalis in the entrance portico, half-lion half elephantine creatures who are symbols of royal power; a row of peacocks and two small camels on one wall; and a band of makaras; crocodile-like creatures, along another wall.[13] The sanctum for Hanuman would have giant wooden doors to shield the huge stone image-body from public view at certain times; workmen labored to finish these for the coming consecration (figure I.4). The complex gears of an open platform elevator were visible on the sidewalls of the temple, and a staircase appeared at the back of the grand image. We stood in front of this awesome—the only correct word—deity too overwhelmed to really see Him.

One of the trustees, who guided our first walk through the temple, pointed to Hanuman's folded hands and the rosary visible just inside the crevice where the two hands joined. He said that unlike any other deity, Lord Hanuman greets us even before we greet him. He constantly chants the name of his own Lord, Rama. Devotees can hear the constantly ringing bell inscribed in his tail—a low note that sounds like "rama-rama." The quality of Hanuman's utter devotion is celebrated in the full title of this deity, Sri Bhakta, the divine ultimate

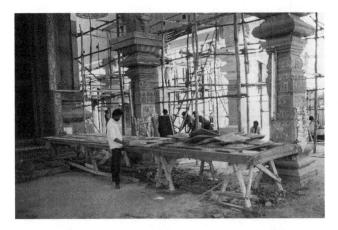

FIGURE I.4. A carpenter puts the final touches on the huge doors to the sanctum for Anjaneya (Hanuman) at the new Adhivyadhihara Sri Bhaktanjaneya Swami Temple in Nanganallur.

devotee. Here, as in much of south India, Hanuman takes the name Anjaneya so the full name of the temple is Sri Bhaktanjaneya Swami Temple. Later, another trustee spoke admiringly of the great detail in the fingernails of the giant sculpture and of Muthiah Sthapati, the architect and master craftsmen of the temple. Our guide told us that a priest who was well versed in the Agamas, the sacred texts that guide temple construction, had told them that this image-body was really svayambhu (*svayambhū*)—self-created and not really made by the craftsman—because Lord Hanuman had entered the rock long ago.[14] Completing our pradakshina, our sacred rounding of the main sanctum, I noticed again the austerity of the decorative elements. This main hall had an airy feel; lovely claret windows accentuated the light. To my eye this austere grandeur, this massive open hall, seemed an innovation, but the trustees assured me that they had nothing to do with the design, no choice. Muthiah knew "the old books" and worked according to the Agamas and told them "what was proper."

Several trustees of the temple recounted the history of the temple during a long interview, emphasizing their adherence to proper religious authority throughout their story. A schoolteacher, Mr. Ramani Iyer, began by doing pujas to Anjaneya in his house in Mylapore for many years. Eventually a group of men joined him. For over five years, they celebrated Anjaneya's birthday (Hanuman Jayanti) with special grandeur. They offered this worship to a man-sized wooden image of Hanuman painted black, which was kept in Mr. Iyer's house. This Anjaneya had begun life in a film studio, where he poured his blessing on the hero. After completing the film, the crew was going to dump the image into the sea, but these people asked for the image and began their pujas to it. Then the group of ardent devotees began to feel "that sanctity comes only in granite stone. Wood will perish." So the nine men formed a trust and began to plan for a temple and a stone image. None of them was rich; "we are all middle class and from different communities but are of like mind." Before embarking on the project, they consulted religious authorities in Tamilnadu, the Shankaracharya at Kanchipuram and the Shankaracharya at Sringeri, the two major voices of orthodoxy in Tamilnadu. Both said the same thing: "In the Kali Yuga, Anjaneya is Brahman, the creative authority. You must make him as big as possible." They explained to me that in earlier times, Hanuman was always pictured as very small next to his master, but now they had the sanction to make him as large as possible. I asked how they chose the site for the temple. They explained that in Nanganallur someone offered a parcel of land for half the usual price; the land had been intended for public use, a movie theater or such. They looked at the land and realized that it was perfect. The land was properly situated in an area called Rama Nagar, named for Anjaneya's own

lord. In addition, this tract faced a new worship center for Sri Raghavendra Swami, a great guru who had taken Anjaneya for his guru. Moreover, the Kanchipuram Shankaracharya discerned the area's innate sacrality by his own divinely gifted insight: six centuries ago sages had come to pray and meditate there. For the trustees, this rising new suburb of Nanganallur was already holy ground—a rediscovered sacred land

The voices of these trustees sound an important counterpoint to the devotees of the Madhya Kailas temple. The trustees of this grand temple to Hanuman did not claim "innovations" in their temple. Authorities sanctioned any seeming changes—Muthiah Sthapati from a distinguished lineage of temple architects, and the Shankaracharyas of the two major centers of Hindu orthodoxy. Even the land of Nanganallur was already sacred. And yet their invocation of authority in no way abolished time. They knew that the size and qualities of their Lord Hanuman especially suited the present age. The sacredness of Nanganallur happened sometime in the past, not in primordial time. When a trustee of another temple tried to explain how the Shankaracharya of Kanchipuram knew the location of the stone linga, the iconic presence of Shiva, that would grace the sanctum of his temple, he spoke of this same gift of "vision" to see past events. However, all trustees confirmed that the polity of their organization was new—their unity was not based on common caste origins but on being "like-minded."

This like-mindedness, however, was a trait they had in common with the middle-class devotees of Madhya Kailas. Both temples had the same openness, both social and spatial—clean architectural lines, open proportions, sunlight shining on polished floors, and no "Hindus only" signs outside the sanctum. I saw such design elements repeatedly in many of the new suburban temples. The Adhivyadhihara Sri Bhaktanjaneya Swami Temple trustees venerate old authorities, but their new temple conforms to another unwritten "code" of modern temples in Chennai—revere cleanliness (a prize is given for the best-maintained temple in the city), foster a serene atmosphere, and create openness in a broad space that welcomes a wider public, which sometimes extends beyond the middle class, as we will see in chapter 3. As the trustee expressed it, Hanuman greets us even before we greet him.

The Consecration of a New Temple Complex to Lord Jagannath

The as yet unfinished Sri Jagannath Spiritual Cultural Complex come into view as we drove along the coastal road to the popular Mahabalipuram (Mamallapuram), a tourist site of the famous shore temples (the Seven Pagodas) as well

as the Government College of Architecture and Sculpture. We noticed the complex and stopped to meet the supervising engineer, who allowed us to begin photographing the unusual set of buildings. At this point, only the innovative skeletal framework of a large two-storied central temple (figure I.5) and a small shrine to the right stood within a walled, partially landscaped compound. Under a pandal, a palm-frond and bamboo shed, traditional craftsmen continued carving the stones that would form the visible skin of the temple. Our host gave us a beautifully printed brochure in English that envisioned a "unique project to promote a healthy society over a strong foundation of spiritual and intellectual excellence." The complex would eventually house the central temple with a meditation hall beneath, a smaller shrine to Ganesha, a "spiritual audio-video library," a Vedic research institute, and a museum of handicrafts from all over India. The complex would be set among "lush green lawns and flower beds," and promised to cater to "people of all age groups irrespective of caste, creed, colour, language, nationality and religion." True to their ideals, a month later we received an invitation to attend the consecration of the first of these structures, appropriately the vimana to Ganesha, the Lord of Beginnings.

During the hectic rituals that consecrated Ganesha, the president of the association, which constructed the spiritual-cultural center, took time to speak with me. He explained that the Utkal Association of Madras, people who migrated from Orissa and settled in Madras, initiated the complex, with the main temple dedicated to the most famous deity of Orissa, Lord Jagannath. This tutelary god of the rajas of Puri, whose famous giant chariot came into English

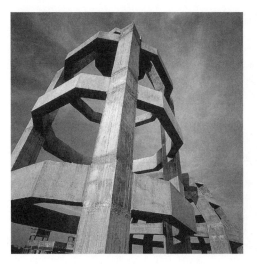

FIGURE I.5. The modern engineered inner framework for the shikhara awaits its traditionally carved stone facing at the new Sri Jagannath Spiritual Cultural Complex along the coast south of Chennai in Injambakkam.

as the pejorative "juggernaut," now has worldwide devotees in the Hari Krishna movement, the International Society of Krishna Consciousness (ISKCON). Although either Jagannath (as their founder's chosen form of Krishna) or images of Krishna and his consort Radha occupy the central shrine in all ISKCON temples, this complex is not associated with ISKCON but retains a widely inclusive flavor. Many of the donors did not migrate from Orissa but were local Tamil- and Telegu-speaking people, among them the director of successful Apollo Hospital. Indeed, those listed as "patrons" and "donors and well wishers" in the brochure included many names with the title "Dr." or "Prof.," nonresident Indians from Germany and the United States, as well as major charitable foundations and businesses such as the Birla Jute Industries and the AVM Film Agencies. The president also mentioned the Ori Society of America, made up of people who had immigrated from Orissa. I had seen a Jagannath image donated by this Orissan émigré community in the Sri Ganesha Temple of Nashville.

As we stood high on the completed walkway around the still-unfinished sanctum, we discussed the prayer hall that stood underneath as the ground floor of the temple (figure I.6). The president explained that the hall was designed by an engineer now in Delhi but once connected to the nearby Indian Institute of Technology. He complained to the engineer about a strange echo in the prayer hall that sounded like the mantra OM. The engineer came to check and found that it occurred only in one place—directly underneath the sanctum. This amazing phenomenon, which I later clearly heard, was taken as a sign of the special peace around this holy site. My kind guide went on to

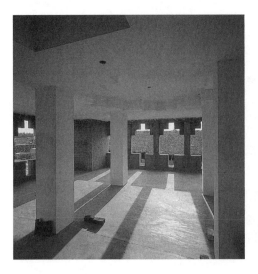

FIGURE I.6. The meditation hall just below the sanctum, which echoes with a mysterious sound, nears completion at the new Sri Jagannath Spiritual Cultural Complex.

explain that he modeled this prayer hall on the meditation area at the Vivek-
ananda Rock Memorial located on a small island at Kanyakumari (Cape Cor-
morin), the tip of India. "We will use this hall for congregation, prayer, medi-
tation. Those who do not want to go up into the temple sanctum, they can stay
here or sit in the garden. The only restriction is no alcohol, no nonvegetarian
food, no drugs, no noise." He then explained that just as the temple combines
Tamil and Orissan architectural forms, it also connects "the modern with the
unchanged, the conventional with the unconventional, and the conservative
with the progressive."

This highly educated scientist sees no conflict between science and reli-
gion. He shared some of his own personal philosophy as we stood looking out
on the gray-blue Indian Ocean. His father was a Sanskrit scholar, and "in my
childhood I came in contact with some highly spiritually evolved people." He
began to read the philosophy behind religious practices. "The more I liked it
and the more I read." For this active man science and religion "are comple-
mentary. Science explains the how of it but not the why." We spoke about the
narrow understanding of religion and what he considered a broader viewpoint.
"Whatever form It takes, whatever shape It takes, the expression of that unseen,
there is such a love, such a force. Like electricity, it doesn't have a shape." He
provided an analogy to of the relationship between that unseen force and the
concrete divine images like the image-body of Ganesha that priests were about
to consecrate in the shrine below. "You must see the world beyond the globe.
If you do not see the world through the globe, you will stick to the globe only.
Once you realize the world, you will still like the globe. See, the idol is a
manifestation of the unlimited infinite force." The he added that when anyone
realizes this wider vision of reality, "There is love everywhere: there is no con-
flict. You cannot hate anyone."

Sri Jagannath Spiritual Cultural Complex summarizes many of the seem-
ing incongruities that the middle classes somehow conjoin within the spaces
of their temples: "the modern with the unchanged, the conventional with the
unconventional, and the conservative with the progressive." Jack Hawley sug-
gests that "a terrain of interlocking religious themata" begins to characterize
urban middle-class religiosity throughout India and in the Indian diaspora.
Many of the themata he suggests speak to this capacity of the urban middle
class to bridge supposed contractions: "an oscillation between high-god stabil-
ity and middle-god creativity, a reframing of inherited rituals and theologies as
science, an effort to connect urban realities with a remembered hinterland, a
strong tendency to embrace the savory rationality of vegetarianism . . . and the
overarching mood of *bhakti*" (Hawley 2001, 224). To these I would add another
oscillation increasingly apparent among middle-class Hindus as well as "main-

stream" Americans: between idealized rationality (commitment to philosophy, readings, and all forms of "book learning") and openness to empirical experience with "enchantment"—direct visions of God/s, direct contact with "powers." The temple donors and devotees in contemporary Chennai live much of their religious lives fully conscious of global economics and what Wallerstein calls geoculture (1991). Many more of these "themata" will emerge out of the chapters that follow.

The context of all of this conservative creativity remains embedded within urban life. Philosophy may be the "software" of religion for the urban middle classes, as that member of that civic association put it, but temples remain the hardware. What separates the temple builders from members of the RSS or VHP—although some may belong to both (another of these conjoined incongruities?)—is their literal grounding in urban space and their creation of new communities within those multiple spaces. Recall that Max Weber, for all of his wrong-headedness about the "oriental city," defined the new urban city through its new "estate" (the middle classes); the tendency of this new group to form new communities outside and alongside of older social structures; and to count its wealth in buildings, not land. Among some middle-class devotees who will appear in the chapters that follow, temples become simultaneously new "property," public space, and the site for these new community formations. However, this new sense of sense of public life does not always become all-encompassing. Sometimes middle-class sensibilities even in religious life become so normalized in India, as in the United States, that the lower classes drop out of sight except as recipients of charity.

I

Hindu Temples in the New World System, 1640–1800

The proliferation of Hindu temples now spread over the North American religious landscape appear at first glance to be part of a very new process of globalization for Hinduism in an era of transnational religions. South India, long a bastion of temple culture, is simultaneously in the midst of a new boom in temple construction. North India's present resurgence of "Hinduism" remains steeped in ideology, so that ardent ideologists write in terms of the alleged destruction of thousands of temples by Muslim rulers and call for their reconstruction. "My gods are crying," writes one "angry" Hindu, "they are demanding restatement in all their original glory" (quoted in Bhattacharya 1991, 127). This postmodern era has experienced a surprising resurgence of religious communities, which Susanne Rudolph describes as "vigorous creators of an emergent transnational civil society" (1997, 1). But such religious regeneration should be contextualized. Without some historical perspective, the construction of Hindu temples may too easily seem to be only part of a very contemporary mix of religion, fundamentalism, and nationalism. Ours is not the first era of globalization that commingled massive economic and political changes with religious regeneration. A mapping of temples in the oldest English colonial port city in India, Madras, reveals a three-hundred-year process of the relocation of gods and goddesses that, in part, initiated the contemporary era of urbanized Hinduism. This chapter traces the expansion of temples in Madras city from 1640 to 1800 with an eye to describing pat-

terns of temple building in an earlier era of emerging global trade that Immanuel Wallerstein terms the first "world system."

I openly borrow the concept of world-systems analysis in the discussion of Hindu temples that follows. This theoretical framework requires a preface before turning to the case in point. Wallerstein's now two-decade-old theoretical approach emphasizes the centrality of the global economic network dominated by Europe as a key to constructing modern world history. His theory was recently described as "a synthesis of Braudelian historiography, Marxist historical materialism, and a dependency theory à la André Gunder Frank" (Sanderson 1995, 95). Critiques of Wallerstein, often aired in pages of the *Journal of World History*, have ranged from charges of "Eurocentrism," with his insistence on the notion of a core (Europe) and a periphery (Asia) with concomitant domination and subordination;[1] to his overemphasis on the economy rather than on "civilizations" or "cultures" as the unifying factor in the emergence of the modern world system—for Wallerstein the first capitalistic organization living within multiple political organizations.[2] His limited treatment of religions as themselves world systems, however, have not stopped a reformulation of his work to help define and refine Islam as a world entity (Voll 1994).[3] Gerald Larson, one of the few religionists to reattempt a broad-based approach to South Asia, judges Wallerstein's world-systems theory "still naively reductive in its treatment of religion as conventional Marxist analysis" (1995, 40).

These charges of reductionism are serious but are not automatic reasons to dismiss world-systems analysis from a study of religious institutions and communities in modern India. Much more careful modification of world-system theory is needed. Styles of world-system analysis that are more sensitive to culture, such as K. N. Chaudhuri's in *Asia before Europe* (1990) and more cognizant of Asia, such as André Gunder Frank's in *ReOrient* (1998) may prove far more useful. However, a consideration and awareness of the interplay between economic change and new cultural formations on a global scale ought to center studies of institutional forms of modern Hinduism—especially the temple. Unlike the textual studies that anchored the century-long process of defining Hinduism in the West, temples cannot be reduced to an intellectual proposition or bracketed from the economic world, as the lengthy work of Burton Stein and many others following him has shown.[4] Temples, unlike ethereal images of philosophers, are solidly a part of material culture, and expensive ones. They may well be barometers that denote moments of confident expansiveness for Hindus—periods of building new civic structures both physical and cultural.

Setting temples in the context of global economic movements opens some seemingly counterintuitive possibilities. Temples, usually associated in old history-of-religions circles with anchoring space and time, actually appear in modern times at periods of transition and movement. Temples, seemingly the least likely aspect of Hinduism to be portable, are the first indications, as this chapter will show, of resettlement in an urban environment—be it hundreds or thousands of miles from the homeland. Temples, most often associated with state authority and kingship, can flourish in a new world dominated by mercantile interests—a point opened by David Rudner (1994) and Mattison Mines (1994). And, the notion that temples as "sacred space" mark Hindu territory embedded and confined to the ancient soil of mother India becomes problematic if their appearance in modern times is because of and not in spite of global economic forces.[5] If world-systems analysis is taken moderately, with a pinch of salt and good south Indian pepper, it can as much reform as be reformed by religious studies and related disciplines. But such a proposition is far beyond the scope of this book. The case of temple construction in Madras in the early years of the East India Company is enough to open the debate.

Madras, at the time of its founding in the early 1640s, consisted only of Fort St. George, which provided defense and housed the offices and the go-downs for the East India Company. The British entered India as merchants and joined with India's established merchant communities from the first. The original grant of land for the Company was negotiated with the help of Beri Timmappa, who later took the title of the Company's "Chief Merchant." Almost immediately, the Company encouraged the resettlement of the artisans needed to create "calico" cloth in demand by Europeans. Weavers, dyers, and other artisans settled in Madras, joined by the old Chettiar communities of merchant-traders. Within ten years a thriving "Blacktown" grew adjacent to the fort. And, in this same time period, the new town built its central temple, with Beri Timmappa as the chief donor. In Blacktown, British merchants mingled with a mixed group of Telegu-speaking Vaishnavas (worshipers of Vishnu) who migrated from nearby Andhra, Tamil-speaking Shaivas (worshipers of Shiva) from farther south, and Gujaratis who moved from the north. Thus began the intimate relationship between temple building, resettlement, and the establishment of modern commerce as we know it. This same moment marked the beginning of Wallerstein's "modern world system," which he dates to the signing of the Treaty of Westphalia in 1648, ending the Thirty Years War in Europe. At the moment when, we have often been told, the "West" began to "rationalize" its religious practices, streamline rituals, and cease to build those cathedrals that marked the high Middle Ages, the mercantile period in India began

with a new round of temple building. As C. A. Bayly notes, "the formative rôle of Indian merchant communities in the growth of Madras was expressed through the building and endowment of temples" (1987, 69).

The Indian merchants continued the well-established practice of using their renewed "surfeit of wealth" for "ornamentation and symbolic display" that Janet Abu-Lughod contends was the common practice in the earlier world trading system of 1250–1350 (1989, 4). The great cathedrals in Europe and the Hindu temple complexes in south India alike became tangible signs of divine blessings generated, in fact, by a vigorous world trade. Temples in the modern world system, however, differed from those in this early period. In the new trading cities of India temples were not founded by kings or built in the name of royal houses; they were openly the product of merchant wealth and merchant control. In England, whether the new merchant classes were really so detached from similar material displays is already at issue in contemporary scholarship (Mukerji 1983, 15). Certainly in America, later industrial and mercantile barons marked the religious landscape with massive monuments like Duke Chapel and Rockefeller Chapel on campuses of their newly established universities.

Although the building of temples never stopped throughout the long development of Madras city, the largest proportion of temples were built at the very beginning and at the "end"—if Wallerstein is right (1991, 104–22)—of the present modernist world system. Merchants of all sorts dominated these moments of economic opportunity and congruent social change—then and now. In his more recent essays on the changing world system, Wallerstein argues, in a very Marxist mode, "Whereas, within the ongoing structural processes of an historical system, there is little role for voluntaristic 'speeding up' of the contradictions, at the moment of crisis of transformation, the role of politico-moral choice expands considerably. It is on these occasions that it can be truly said that 'man makes his own history' " (1991, 106). Eugene Irschick makes a similar point in his study of the "construction of south India" during the colonial period. In the early years of British settlement and Indian resettlement in the lands that would become Tamilnadu, Irschick argues that the "shakiness of British dominance enabled these regions to serve throughout the period as critical sites for productive epistemological projects" (1994, 9). Borrowing language from Mikhail Bakhtin, Irschick views these periods of "changed significations" as "the heteroglot and dialogic production of all members of any historic situation" (8). C. A. Bayly likewise sees this same period in south India, between 1680 and 1800, as a "commercial free-for-all" ([1990] 1987, 65), with an "easy symbiosis between Europeans and Indians" (69). The major moments of accelerated temple construction, then, have taken place in the context of two factors: untamed dialogue when distinct groups met and

merged, and high-speed economic activity. Material expressions of religious devotion appear most common in times when the economy dominates not only the flow of goods but also the currents of the mind.

The open confluence between the marketplace and sacred place, and a newly configured public idiom, are written into history in India—as in Europe.[6] Several famous temples in south India had grand pillared porticos added during seventeenth and early eighteenth centuries, through the patronage not of kings but of royal ministers. These served as open markets in towns with a growing mercantile wealth (Michell 1995, 102).[7] David Rudner's study of the Nakarattars, a trading caste of Tamilnadu also called the Nattukkottai Chettiars, traces the growth of the community to the "pilgrimage market town of Palani," with its famous temple to the ancient Tamil god Murugan. In Rudner's words, the earliest document from 1600 tells the tale of a Nakarattar salt trader, "his first contact with a Palani priest, his initial worship (puja) of the temple deity, the growth of his commercial activities in the temple market, and his endowment of the temple and subsequent installation as a trustee (dharmakarta) of the endowment" (1994, 135). This Nakarattar businessman then initiated festivals that generated an interlocking system of "ritual transactions between all of the notables of Palani," including his own community of traders, sectarian religious leaders, and the ruling rajas (137). Members of the later Nakarattar community continued this cycle of transactions, apportioning their wealth to increase business ventures and to support, and later construct, temples, especially in an area called Chettinad (189–212) between Pudukkottai and Sivagangai. In older market towns and in the countryside, then, a variety of mercantile groups, often with wealth generated indirectly from East India Company connections, entered the temple arena in a period that corresponds to the mercantile free-for-all in the very new urban center of Madras.

An important question remains: As the temple and the marketplace came to share the same space and in a broader sense the same public arena, what was the nature of this change for the temple? The famous old Sri Parthasarathy Temple in Madras gave Arjun Appadurai the example for his now much-quoted study of the effect of colonial rule on the south Indian temple. Appadurai notes two types of changes: first the growing control of merchant communities on the temple, followed by a new form of British bureaucratic control. He immediately lays his cards on the table: "Put baldly, what has changed is not the temple as a cultural entity but the principles that determine how to control or manage the temple" (1981, 19). For Appadurai temples retained their essential language written in terms of old royal rule. The deity remained a "paradigmatic sovereign" (21) reigning over his divine domain of God, as the king had once ruled over the royal domain.[8] But here world-systems theory allows us to think

of economic change as far more profound—the basis of life in a society in a broader sense.[9] New mercantile wealth, like the old royal wealth, flowed into temples.[10] Did the *cultural grammar* of the temple really remain unchanged? Does the study of a single royal temple later under merchant weal tell the whole story? Merchants built their own temples in a new urban environment that was fully part of a global interchange of goods and people. Considering Arjun Appadurai's most recent work on global flows and the transnational movement of various forms—he uses the terms "ethnoscape, financespace, technoscape, mediascape, ideoscape" (1996, 45)—he might well recontextualize the temple now in a different frame.

One thing is certain: during the centuries of the new mercantile era, Hindus continued to speak in terms of the "built form," in terms of architecture, at this moment of change. Much of their efforts still survive in various forms. These "new" temples constructed by the rising commercial groups continue to function in the city, and most thrive as living traces of this period. The architectural forms of these "new" temples are sandwiched now in the crowded streets of the Georgetown area. The British mapmakers painstakingly recorded all of the temples as well as churches and mosques in their growing city. The fortunate British penchant for collection has preserved most of these maps in the British Library and in the Tamilnadu Archives. Later maps of the survey office of Madras always included all temples except small roadside shrines until 1947, when all but the most famous tourist temples suddenly disappeared after the emergence of the new secular state of India. There is ample evidence in front of our eyes and in record offices in London and Chennai to take these urban temples very seriously. Their form and place within the early city remains an open book.

There is little question that scholars are paying attention to architecture and the cityscape as a form of semiotics, or at least as a crucial form of "language." Fredric Jameson sees our period of late capitalism as "dominated by categories of space rather than by categories of time, as in the previous period of modernism" (1991, 16). Milton Singer, whose early studies of entrepreneurs in Madras concentrated on articulated concepts within Hinduism, later wrote of the city in India as a "community of interpretation" best seen through architectural symbols (1991, 73–127). Susan Lewandowski, who pioneered work on space and colonialism in Madras, wrote that "Much can be learned about the enduring quality of Hinduism, and the nature of the modernization process in India, by examining the religious buildings and environments that exist in cities today, and comparing them with the built environment of the past" (1980, 147). The time is right to take her suggestion very seriously. Our own postmodern period in which image/space may indeed rule over time/ideas can

open our eyes to moments now and in the past when buildings are and were worth more than a thousand words.

After a full year of mapping the "new" temples in Madras, I see several types of temples that emerged at the initial moment of the present world system. After even more years watching the construction of Hindu temples in the United States, I notice that these same types are reappearing at what some consider the beginning of another new world system. The first type I would call *eclectic*, or perhaps the generic temple. The Town Temple in Madras was the first such all-community temple and began one phase of the long dialogic process. It was, I think, a celebration of the common mercantile nature of the entire Blacktown—and even included the seemingly "foreign" British. The second type, representing a radically different side of the dialogue between communities within the whole, is the "caste" temple, which I call the *community-only* temple. In his recent study of the Chettiar communities of Georgetown, Mattison Mines provides a vivid picture of the early days of the city and the fierce conflict between two rival groups that each coalesced around two major Chettiar communities, the right-handed castes were led by the Komati Chettiars (now called the Arya Vysya Chettiars) and the left-handed group headed by the Beeri Chettiars. Each group built its own temples, and their rivalry played out in terms of ritual precedent: rights to process the divine images along certain streets or to hoist certain flags at festivals (1994, 84–107). Mines concentrates on the Beeri Chettiars and their famous Kandaswami Temple. While in Madras in 1994–95, I spent some time with the once-rival group, the Arya Vysya Chettiars, and their own temple, the Kanyaka Parameswari Devasthanam in Kothawal Market. The third important type of temple constructed near Fort St. George was the *duplicated* temple—those shrines built not so much as copies but as a kind of "branch office" of older, more famous temples. The Chennai Ekambareswara Temple in Mint Street was constructed in the 1680s for the convenience of a devotee of the great temple in Kanchipuram. The Byragi Matam-Sri Venkatesa Perumal Temple, built, legend tells, by Muslim woman to honor the Lord of Tirupati, may be even older.

Each of these temple types that emerged as artisans and traders migrated to British urban centers now has counterparts in the latest wave of migration of highly skilled professionals to more distant shores. Although many years have passed since the rivalry between caste groups broke out in violent riots, the communities continue to maintain their distinctiveness and to write their identity into temples in contemporary India and in the diaspora. At the same time, the push toward distinctiveness is matched by the pull toward unity. The eclectic Town Temple has its almost perfect counterpart in the Sri Siva-Vishnu Temple in suburban Washington, D.C. The duplicated temple has its counter-

part in the chain of Venkateswara temples in the United States that stretch from Pittsburgh to Atlanta and to Malibu. Some community-based temples have appeared in the United States, such as the many temples to Swami Narayanan that are not formally announced as "caste" temples but are dominated by the Gujarati Hindu community. In the American context, these are more accurately termed "ethnic" institutions (Williams 1988, 152). Specific "caste" temples have not yet appeared, but the Arya Vysya community has installed the image of its patron goddess in separate shines within larger temples here. Among south Indians, the divide between Brahman and non-Brahman manifests in the Murugan temples that exist in metropolitan Washington and San Francisco near much larger temples, which many Sat-Shudras ("pure" caste non-Brahmans) perceive as merely reestablishing the generalized Sanskrit tradition that many fought so hard to overcome in India.

Interestingly, only a few of the approximately three hundred major temples built since the founding of the city of Madras house indigenous deities; the same is also true of new Hindu temples in the United States. In the Mylapore area of Madras, a local form of Kali remains the guardian Lady, nayaki, of the neighborhood. A major temple in Komaleeswaranpet houses a natural anionic form of Shiva, a svayambhu linga, that arose from the native soil. The image-body of Murugan in the famous Kandaswami Temple in Georgetown was miraculously found in the soil of the city and installed in the temple. Only one of the newest temples built in Chennai claims to house a "found" linga discovered near the coast. Within the present city limits are ancient temples once part of old cities now engulfed by the metropolitan areas. Their deities, who date to long before the founding of this city, are like islands of antiquity in a modern world. The many small Amman temples, as well as those to Ganesha that guard the street corners and the sidewalks of the city, might be considered native sons and daughters. In Madras, however, all of the larger temples built in this colonial port city house deities who "migrated" from somewhere else. In the United States, only in San Francisco's Golden Gate Park was an svayambhu linga discovered by a converted Hindu. This linga, once merely a discarded granite parking barrier, drew public worship until it was removed by the park service! In Hawaii, a temple will soon rise over another natural crystal linga, discovered in Arkansas by converts to Hinduism. All of the gods in the many other Hindu temples here, like their patrons, were engendered in India.

Yet in spite of the obvious evidence of the profusion of holy temples within modern urban space, "seeing" these temples remains very difficult. Part of the problem is already inherent in Appadurai's earlier argument that the cultural idiom of the Hindu temple remained unchanged during the colonial period. A closely related thought process in the last century may have consigned the

new Hindu temples and new patrons to the back pages of an emerging art and religious history. If new temples are created in the same idiom as the old, they reasoned, then these are simply a lesser version of a once grand model; if older royal temples come under the patronage of a new class, then their grandeur diminishes. Although the "new" temples of Madras have existed for 350 years, these urban shrines remained invisible to art historians and historians of religion for decades. Before looking closely at the urban temples, I need to deconstruct the walls of theory and of attitudes that have obscured them and their patrons for so long.

Erasing the Bourgeoisie from the Temples

By 1800, Blacktown was a checkerboard of sacred and secular space, a visual environment to see religion anew in modern commercial India. Temples stood at the center of or near busy markets. Business houses lined the mada streets— the four streets surrounding a temple, which were built to accommodate festivals. But this rich visual legacy of the new commercial elites was erased from the history of Hinduism in the nineteenth and twentieth centuries. Scholars in religious studies—both in India and abroad—gave major attention to the "reform" movements within Hinduism. Such movements turned to hypertextuality—to the restoration of ancient texts and the construction of a new written culture for "Hinduism." The new war of words that the masters of the "Hindu Renaissance" unleashed called for the purification of Hinduism from "superstition." Cast into the role of the enemy of progress, the temple priests were often pictured with bellies swollen from the profits of their traffic in superstition. European historians, following the logic of this "Renaissance," ignored or, more accurately, *refused to see* the construction of new temples and the rapid renovation of the ancient temples that accompanied the growth of commerce in a colonial port city like Madras. The successful modern Indian merchants were turning their wealth into bricks, mortar, and stone and recreating temples in the heart of commercial Madras. Yet their activities had no place in definition of the "Hindu Renaissance" during the colonial period. The words "new" and "temple" were an oxymoron—temples were the trope for atrophy.

The majority of early art historians and archaeologists, until recently the custodians of visual evidence, also refused to look for Indian art and architecture within the commercial hearts of the empire. The "real" India was always somewhere else. Moreover, they often considered the same bourgeois builders of new temples an all *too visible* obstacle to the pristine preservation of India's architectural past. In the case of art history, the project was not the reformation

of Hinduism through the ancient verbal texts but rather the restoration of ancient temples to the status of texts. In this context, the visual was extolled as the only repository of the past for this unhistorical people. A "numerous body of nobleman and gentlemen of England urging the necessity of preserving monuments in India" put their case to the secretary of state for India in 1873: "It is, in short, in its Buildings, and in them only, so far as regards long periods, that the History of India can be satisfactorily read; whilst from them at all periods, is derived a most vivid picture of her arts, her civilization, and her position relative to the rest of the world" (quoted in Cole 1881–1883, Preliminary Report February 9 to March 7, 1881, 13).

The new Indian bourgeoisie found a place in the footnotes that accompanied this emerging history of Indian art as obstructionists—those who whitewashed and painted over the purity of the past in their misguided attempts to preserve the ancient temples of Madras city and the Madras Presidency. A report from the records of the Archaeological Survey of India puts these new bourgeoisie in their place.

> Mr. Fergusson, who visited Srirangam many years ago writes, "One of the great charms of this temple [Jamukeswar] when I visited it was its purity; neither whitewashed nor red or yellow paint had sullied it, and the time stain on the warm colored granite was all that relieved its monotony; but it sufficed, and it was a relief to contemplate it thus after some of the vulgarities I had seen. Now all this is altered. Like the pagodas at Ramisseram [Rameswaram], and more those at Madura [Madurai], barbarous vulgarity has done its work, and the traveller is only too fully justified in the contempt with which he speaks of these works of great temples which have fallen into the hands of such unworthy successors." (Quoted in Cole 1881–1883, Preliminary Report February 9 to March 7, 1881, 13)

The attempts of these unworthy successors were to be erased as time passed, and the ideal of preservation meant removing accretions—erasing those dratted businessmen out of the ancient world of India that they dared to color with their own memory.

Not until the turn of the century did a few lone voices from the Arts and Crafts Movement (see Guha-Thakurta 1992, 151) openly support the work of wealthy Indians, especially the Nattukkottai Chettiars, who remain active in their own ongoing renovation work. The Chettiars tended to copy styles from old periods of Dravidian architecture that, in fact, did not erase but filled in and extended existing structures—often with such accuracy that their work has been mistaken for the original.[11] Even when temples were built new, the older

basic forms were repeated but with the innovations added. A book from the turn of the century, *Arts and Crafts in Southern India*, describes the process in interesting comparative terms.

> As with the cathedrals of Europe, so these temples have been started in a small way in many instances, and by additions at different periods have finally assumed the size and proportions we now see. The work still progresses in some places, especially where Nattukkottai Chetties are numerous, as in the country around Madurai. Here may still be seen important building operations being carried out in almost exactly the same way that great cathedral builders of Europe employed—that is, without previously drawn architectural plans, elevations, estimates, but with a master builder in charge of the work, developing it and elaborating as the building progresses: the only way in which a living architecture is possible. Just because the old hereditary systems are still constant and in practical daily use among Hindus, their buildings are still living vital things, instilled with life, and still in the vast process of evolution. (Hadaway 1914–1915, 106)

The book is interesting, however, for its omissions. In the section on "City of Madras and Its Environs," nothing is said about the newer temples in the city, except for a photograph of the ancient Mylapore area. The section on industries lists only British companies.

As late as 1991, a collection of essays on *The Concept of Space: Ancient and Modern*, published by Indira Gandhi Centre for the Arts, once again treats certain modern isms as anathema to the discussion of sacred space: consumerism, industrialism, scientism—all epitomized by urbanism. Raimundo Panikkar portrays urban space as the heart of darkness.

> Landscape not only forms, but also informs the human being. A person without a proper landscape becomes dehumanized. This is one of the causes of the erosion of humanness in the agglomerated and over-congested apartments and slums of many big cities. Dehumanization occurs when humans lack the vital Space, which constitutes part of their lives. . . . Many of the problems of immigrants have to do with the surroundings. The reason is deeper than lack of familiarity. It has to do with the "inscape" of each individual, which is linked, to landscape. This is also the case with modern urbanism. Modern technological megalopoles force people into straight jackets which change their very constitution. (Panikkar 1991, 21)

City life and urban people, it seems, are dehumanized and also bereft of spirituality. I wonder what Pannikkar imagines to be happening in the hundreds, even thousands of temples on India's urban streets.

The transgressions of the bourgeois continue. The temples that they built in Madras and that they are still building shine with red, yellow, magenta, and chartreuse. Now joined by a new middle class at this moment of the unleashing of full-scale consumer culture in urban India, they have initiated a new boom in temple building and temple renovation. It is as if the new middle classes are remodeling even the now older Madras temples, making slipcovers for the seats of divinity and upholstering the rustic frames where village deities still sit in the city. They are still despised by the classicists for daring to add their personal touches to the past—the neon sign above an ancient sanctum, the labeling of gods in clear letters with their logo—the sin of business in the divine house. They are now equally chided by intellectuals and by socialist bureaucrats for their nostalgic clinging to the past, their hasty patching of the decaying edifice of religion. But the incursion of the urban middle class into temple building and renovation will not abate. We cannot ignore the glaring evidence that tells us that the world of temples in India has long joined our world; it joined it at the moment that modern commercialism was born in Britain and India. The time is right to see the visual evidence in contemporary Chennai—to take seriously the relationship between Hindu temples and commercial towns and to see the history of the modern Hindu temples within urban space. What was their spatial relationship to the new colonial port city— the heart of the mercantile world?

Hindu Temples in a New Urban Space

Almost every book on the city begins with "Madras is a city of villages." This fact is so obvious and so fundamental that I can only repeat it once again. Milton Singer described the "preurban characteristics" that he still observed in the city in the decade from the mid-1950s to the 1960s while working on his monumental book, *When a Great Tradition Modernizes*. He describes "large tracts of unused land with palms growing on them, paddy fields and irrigation tanks, buffalo and washermen in the city's rivers and lagoons, fishermen's thatched huts and catamarans on the beach" (1972, 61). He foresaw the coming changes, but even now much of what Singer described is visible within the city. Madras in 1995 still had a village feel. But contemporary Chennai also has a metropolitan feel. Within its bounds are former villages swamped by the

city tide as well as ancient once-independent towns like Mylapore, Triplicane, Tiruvanmiyur, and nearby Tiruvottiyur.

The East India Company acquired control over the land that would become the city of Madras piecemeal over 150 years. Fort St. George and the old Blacktown-Muthialpet acquired in 1640 were expanded within thirty years to most of what is now Georgetown. The important town of Triplicane saw British control by the 1670s, and the old towns of Egmore, Chetput, Purasawalkam, and Kilpauk by the 1690s. The Company annexed Mylapore in 1749 (Kuriyan [1939] 1994, 301–315). By 1798, when the map "Limits of Madras as Fixed on 2 November 1789" was issued, Madras acquired its modern outline. The city stayed "fixed" for well over a century. The only additions came in 1923, when the zamindari of Mambalam was ceded to Madras, and in 1946 and 1981, when the borders of the city were extended. Although "Madraspatnam" emerged as a new political entity, some of the towns and villages encased by its limits had genealogies extending into the Greco-Roman period, and others had monuments to authenticate claims of Pallava (650–1100) and Chola (850–1350) rule (Raman 1957, 1–47). In all cases, the relatively recent rule of Muslim chiefs and the newly emerged Nawab of the Arcot (S. Bayly 1989, 164–175) left a late but indelible imprint of Islamic influence within the city. The Portuguese from their old fort city in Mylapore built the legend of San Thomé de Meliapor and a strong Roman Catholic presence into the city (Muthiah 1992, 178–182). Armenian merchants who came to this growing center of trade built one of the oldest extant Christian churches in the city and once had a strong presence there. At the turn of the eighteenth century, Madras spread into former agricultural land, but the city also added pockets filled with old memories wrapped in stone pillars and crumbing walls.

The last great expansion of the city occurred at an important moment in world history. In 1798, the East India Company had just embarked on a new mission. The Company moved from a trading corporation to a governmental organization, after military and diplomatic victories brought large tracts of inland territory into their hands (C. A. Bayly 1987, 76–78). In the Carnatic, the Company's forces with its allies were putting the finishing touches on their new political power with the defeat of the rebellious Poligars in the far south. The moment is important. If the "New World Order" began in Europe in 1648, the full extension of that order did not really begin in India until 1750s to 1800 (Wallerstein 1974, 137–89). Until that time there were overlapping systems of trade: one associated with emerging European colonialism, and an older system well described by K. N. Chaudhuri in *Asia before Europe* and Janet Abu-Lughod in *Before European Hegemony*. The point is important, because Madras

for its first century lived as an urban port city in a centuries-old configuration of trade. Understanding the complex relationship of its temples to urban space is intertwined with the city's transformation from a port city to a colonial city out of a conglomerate of villages and towns.

Viewing the City through Maps, 1710, 1755, 1798

The map, "Limits of Madras as Fixed on 2 November 1798" (figure 1.1), shows the first overall view of the city that was to become the capital of the Madras Presidency. The "view" says as much about the mapmaker as the city. Fort St. George stands at the center of the map, its ramparts drawn like a star radiating out to the surrounding city. A strikingly similar rendering of the fort area completed in 1791 ("Maps and Plans of Hindustan, no. 17") must have served as the stylistic model for R. Ross, who signed himself onto the 1798 map as "the chief engineer." Ross's birds'-eye view of the fort, colored in pink and green, shows nothing inside, and the starlike quality emerges at this range as much more like a lotus. The multiple ramparts of the fort extend from the center like lotus petals. This "fort" for Ross acts as an icon rather than a faithful rendering of the exact proportions of the structure. I do not think this is an over-reading of the *sign*, for this same visual configuration of the fort appears as late as 1946 in the last official map from the Survey Office under British rule. By this time the rendition appears with no real changes in the style but with the names of the buildings added in the center of the lotus-like star.

The shape of the "limits" of the new city seems to echo Ross's star/lotus fort, and the pattern is repeated in the area immediately surrounding the fort. Blacktown (figure 1.2), now walled and much expanded, no longer touches the fort, which stands in isolation. However, the river system now linked to the wall—drawn in this map with emphasized ramparts—creates extended rays/petals for the fort. Blocks of green paddy fields and clusters of pink houses dotted with blue irrigation tanks fill in the boundary line of the city. Ross has created a beautiful "map" of a harmonious city with bounded symmetry.

The checkerboard quality of the Ross map, however, defines the kind of harmony that he seeks to create. The large three-by-five-foot format gave Ross space to pick and choose features of the city to detail. The "pink" areas—the row houses in the oldest sections of the city—are literally reduced to featureless blocks, yet the garden houses in "Vipery," "Eggmore," and "Triplicane" are rendered in detail, with even the trees marked. The practice of marking and naming the country estates of well-known merchants dates to Conradi's earlier

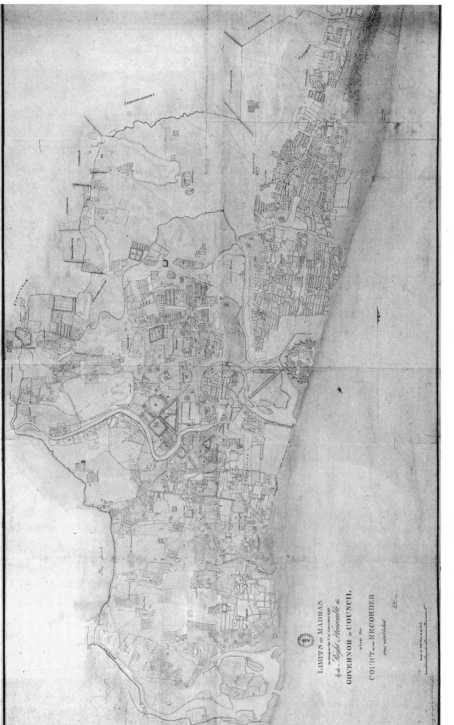

FIGURE 1.1. "Limits of Madras as Fixed on 2 November 1798" shows the extent of the city by the turn of the eighteenth century. Chief Engineer R. Ross gave out-of-proportion prominence to Fort St. George. Reproduced by permission of the British Library.

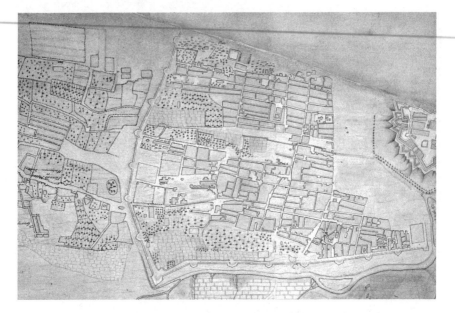

FIGURE 1.2. A detail of Ross's 1789 map shows Blacktown after authorities demolished the portion nearest Fort St. George for security reasons after the French had briefly occupied the fort. Reproduced by permission of the British Library.

map of 1755, which lists the greatest estates on the legend. This focus on the garden houses should not be dismissed as colonialist myopia.

Once the country houses of merchants who worked in the crowded fort, "garden houses" became the dominant style of urban domestic architecture until the 1970s in Madras. Many Indians readily discarded the previous style of row houses with inner courtyard and atrium that can still be seen in smaller towns in Tamilnadu and on remaining Brahman streets near the city's oldest temples. At first, garden houses filled the spaces between lands still in cultivation. Later, row houses built with the older Indian spatial sense filled in between the garden houses. Much later, as these great estates were subdivided after Independence, miniature garden houses filled in the spaces left by the grand houses in the urban centers. As the city grew, the plots of land around single-family houses were often reduced to a few feet, but the style remained— a house with windows looking *out* onto a garden immured by high brick walls. In the end, although many of Chennai's middle-class residents now live in "flats," the garden compound remains the ideal dwelling. The flats, four stories tall, still maintain an area surrounded by a brick wall with a tiny "landscaped" yard, often quickly turned into a parking lot. These are an odd degeneration

of an elegant ideal. For a society—both Indian and British—that supposedly valued social links, this architecture of splendid isolation remains a curious shared sense of space that Ross envisions in the very patterning of Madras—blocks next to blocks, layers of walls, a plaid of separate "colors," which, unlike the famous fabric named after the city, never "bled."

I mention "color" at this point. Although names like "Blacktown" and "Whitetown" make the checkerboard simile seem all the more apt for this city, colors in the seventeenth and eighteenth century did not always extend to "race," a concept not really invented until the mid-nineteenth century (see Kober 1998). The fort, although called "Whitetown," had areas owned by major Indian merchants, and the Company's Dubashes were also Indian—the function of the Dubash will emerge in chapter 3. At the same time that Ross created his map, all merchants were asked to relocate their businesses outside the fort area (Neild-Basu 1984, 25). The Dubashes followed the same living patterns as the wealthy Company officials that they "served," more often as partners than retainers. Rather than living too far from the city, they preferred, according to Susan Neild-Basu, "smaller gardens of only a few acres in the more adjacent villages favored by Europeans or in the older temple centers. Here they built mansions in imitation of their colonial patrons, often partly furnished according to western tastes, where they could lavishly entertain both Europeans and Indians" (1984, 25; see also Historicus 1951, 18–21). Detailed revenue maps of 1805 seem to bear out this living pattern, indicating that some of the garden houses may have been owned by Indians "(A Survey of Royaporam Village . . . 1805"; "Map of Madras, Egmore Division, August 1805"), which increasingly becomes the case by the turn of the nineteenth century ("Madras Town . . . 1908," section 22). These Dubashes, like their English "patrons," continued to keep houses in the heart of the city and lived in adjacent houses, as legal notices in *Madras Courier* from the period show.[12] An introduction for newcomers to the town written in 1750 as a dialogue advises a European man" as follows.

> In the first place you must take a house. J. Where about, sir, in white or black Town? C. To be sure in the white town, if not, you may stay in the black Town, so as you like it best. . . . J. How many houses are in the black Town? Ch. Sir, in the black Town are eight thousand and seven hundred houses. J. But how many houses are in the white Town? Ch. Sir, in the white Town are eighty five houses. . . . J. But sir, how many nations are in this Town? Ch. Sir in this town are all sorts of people in the world, for besides the English, there are Portugueses, Frenchmen, Spanards, Italians, Hollanders, Germans, Danes, Swedes, Moscovuites, Grecians, Arabians,

Persians, Turks, Armenians. Moreover, there are Bramanes, Marati-People, Gutzurati-Men Chine-Men, Malayos, Jews, Syrians, Malabares, Gentous, Cannari-People, Moors, Pathaniars and very like many more. (Shultze 1750, 1)

Race was not the criterion for separation at this point, but rather two types of space—the "garden house" and the "row house." The new gentry—English and Indian—owned both, while the poorer, or perhaps the less up-to-date, sections of society, including European folk—dwelt in these faceless pink blocks on Ross's map. Thus, space in this new city reflects the beginning of a class structure alongside caste.

Where do Hindu temples fit into this "new" urban space? Madras is not now nor ever has been a "temple city." Unlike Madurai or nearby Kanchipuram, its center, even now, remains Fort St. George, the old commercial headquarters of the East India Company—arguably the first of the modern global corporations. But Madras has over six hundred temples now, and had many in the past. The problem comes in delineating a pattern in the way temples are placed within the city, in relation to their location within the urban area and to each other. Although Ross tried to create a center for the city, neither his nor any earlier maps gives overt clues for the status of temples in the city plan. In "A Plan of Fort S. George and the Bounds of Madraspatnam" produced in 1755, F. L. Conradi carefully numbered all temples and named seven next to the list of major garden houses in his legend. Ross names none of the major temples, but carefully includes their tanks in bright blue. Since some of the garden houses also had tanks, guessing which tanks marked temples in his map is not always easy. In 1755, the garden houses and the temples shared similar features and continued to share these into the nineteenth century. Both had irrigation tanks and gardens within compound walls set amid agricultural fields. The only temple built inside an urban area was the Town Temple in the heart of Blacktown, and later the Chenna Kesava Perumal-Chenna Mallikeswara Temple that replaced it. Even the Kachaleeswara and Mallegeeswara temples that appear in Ross's map surrounded by the city are seen in Conradi's map in agricultural fields less than fifty years earlier (figure 1.3). As an even earlier map of 1710 shows, the Byragi Matam-Sri Venkatesa Perumal and the famous Chennai Ekambareswara Temple (figure 1.4) were constructed amid garden areas of the new city ("A Prospect of Fort S. George"). A flood of new houses sprouting up on former paddy fields gradually and sometimes rapidly inundated the garden house and the temple compound. In some disquieting sense, these two major institutions so seemingly disparate in purpose have something in common in their relationship to their urban environs.

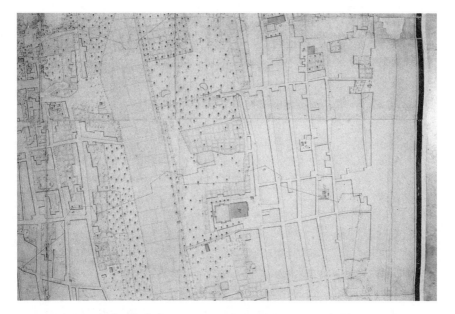

FIGURE I.3. The Kachaleeswara Temple remains surrounded by agricultural fields in this detail of "A Plan of Fort S. George and the Bounds of Madraspatnam" produced in 1755 by F.L. Conradi. Reproduced by permission of the British Library.

I am not suggesting that the temples were in any way modeled on the garden houses or vice versa, but that in the beginning they shared a certain kind of space within the city—a space of splendid isolation walled off from the street with a yard and a porch to escape from the sun. They each occupied and created their own world. The outlines of a new suburban neighborhood, Komaleeswaranpet, appear in Ross's map with the configuration of a temple amid residential property. Unlike the urban contour of the old Town Temple, however, Indians of various caste communities, but with common ties to their newfound wealth with the Company, built their own garden houses outside the Komaleeswara Temple, from which the neighborhood took its name (Historicus 1951, 17–19).

Temples in this period were built here and there only because the land was owned or controlled by the temple's patron. In this sense they were "unnatural"—a fact that is often cited as a sign of spiritual poverty of cities in essays like the one quoted earlier from *Concepts of Space* (Vatsyayan 1991). Such compounds were physically isolated from each other. Moreover, the features of urban temples in the seventeenth century in Madras were not confined to the British colonial cities. In the late Chola cities like Kumbakonam, temples

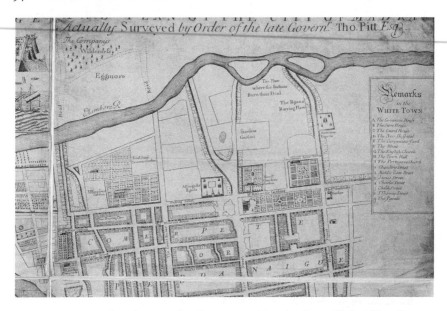

FIGURE 1.4. The Chennai Ekambareeswara Temple, then called "Allingall's Pagoda," is seen here at the beginning of the U-shaped extension of River Street. The Byragi Matam-Sri Venkatesa Perumal Temple, then named "Loraine's Pagoda," was a long block away. Note the large garden estates along the main road in this detail of the 1710 map, "A Prospect of Fort St. George." Reproduced by permission of the British Library.

were central to urban commercial life. In Kumbakonam, a city without a single central temple, a commercial corridor newly built in 1620—just prior to the founding of Fort St. George—linked two major temples, the Ramaswamy and the Chakrapani.[13] In Madurai, a flourishing market area surrounded the city's great central shrine, the Meenakshi Temple. In Ross's map, the link for all of the segmented areas of the city remained Fort St. George, the headquarters of the Company, which like Lakshmi, the goddess of wealth, sat in the middle of a lotus.

So this is how two early British mapmakers seem to picture the temples in Madras—as grand isolated houses. Perhaps these foreigners intuited the nature of urban temples in this colonial port city. The urban temples were not situated in consonance with the natural features of the land, mountains, or rivers. Like the noise-weary gentry, the divine occupants lived in worlds constructed behind compound walls. All such compounds were located on plots of land laid out by surveyors—the garden house or the temple had to accommodate itself to a predetermined urban grid. Although their divine residents

continue to be dressed and treated as kings, the urban temples after 1640 followed the spatial sense of the mercantile world. Such urban temples no longer have the feeling of sovereignty and centrality so obvious in the grandeur of the old royal temples.

The subtle harmony between garden houses and the temple compounds held for three centuries. Only recently have "flats" taken over as respectable middle-class housing. The destruction of the garden-house concept may well parallel the erasure of the colonial name of the city, Madras, in favor of Chennai. I wonder how much the new land-ceiling laws and high real-estate taxes that propels the wrecking ball deliberately hit on this hybrid colonial past. Oddly, the replacement architecture has no semblance of anything Indian—a hybrid past is traded for a cloned contemporary "anywhere" present. The sledgehammer readily smashes old domestic and public building. Dust to dust has come to be the unspoken epitaph for many an old brick building in the city (for a similar description of New Delhi, see Bhatia 1994, 18–22). I watched many lovely old bungalows literally bite the dust in one short year to make way for new high-rise apartment buildings. Even that famous Indo-Sacracenic landmark, Spencer's department store, whose beautiful façade had survived a fire, later crumbled before the wrecking ball to give way to a new air-conditioned multistoried shopping center with an escalator and a two-storied fountain. The new shopping plaza bears the name Mangalatirtham, which translates as "auspicious holy water," but also means an auspicious place of transformation! A transformation is indeed complete. The centrality of commercialism, only an inkling in the lotuslike fort of Ross's map of 1798, is now openly named in Spencer's new air-conditioned, multistoried emporium of delights.

A New Cultural Grammar for the Modern Hindu Temple

In addition to a shared sense of space within the new mercantile city of Madras, the urban temples in old Georgetown also developed a sense of temple *type*. These were not *styles* in the same sense that art historians often classify the architecture and sculpture of earlier periods. Until very recently, new temples borrowed their sculptural style from earlier models in what George Michell calls a "conscious archaism" (1995, 271). The temples of Georgetown follow, far less grandly, the same stylistic programs that were forged during the late Vijayanagar and Nayaka periods (Michell 1995, 73–120), the last years of Hindu royal rule in Tamilnadu. They often do this in a seemingly haphazard way. With mismatched pillars and borrowed granite blocks, often with scattered inscriptions, some temples appear to be constructed from stray pieces of sev-

eral giant erector sets.[14] I can understand why they fail to excite architectural historians. These temples nonetheless were innovative precisely because of their mismatched design. None was the product of a single great architect or great patron. Many came out of committee—negotiated either by caste groups or by the surrounding community. Such a process clearly did not make vivid architecture, but it did create vibrant temples.

The Eclectic Temple: Creating Inclusive Borders

The process of reestablishing the gods in the new city began as soon as the factory of the East India Company was established. Within ten years of the founding of Madras, the residents of the new community of "Blacktown," working together, established a proper stone temple with the help of the Company's chief merchant, Beri Timmappa, the same merchant who helped negotiate the treaty that allowed the Company to build Fort St. George (Muthiah 1992, 278–279). The first "Town Temple" was officially the "Chennakesava" (Ramachandra Dikshitar [1939] 1994, 361–362). Conradi used the more popular name "Perumal Pagoda" in his map of 1755, produced just three years prior to the temple's demolition to make way for military fortifications around Fort St. George. An earlier map from 1710, "A Prospect of Fort St. George," shows the temple in the very heart of Blacktown (figure 1.5) and confirms Susan Lewandowski's observation that the Town Temple in Madras followed the spatial patterning of the great mediaeval Meenakshi temple in Madurai, with the temple at the center of the native merchant's world laid out in grids according to caste and occupation (1980, 137). The temple appears in this early map with a large tank and a wall surrounding a spacious campus with separate shrines. The surrounding mada streets are wide enough to accommodate festival processions. A much-quoted description of "Maderas" by Dr. John Fryer from the 1670s mentions a grand procession, perhaps at the Town Temple, where "Their ceremonies were usher'd in with Tumult; in the middle of them were carried their Gods in State, garnished with all of the Riches of the Orient" (Fryer [1681] 1909, 118). He portrays the "one pagod" in the city as "contained in a square Stoned-wall; wherein are a number of Chappels . . . one for every Tribe; not under one roof but distinctly separate, through together they bear the name of the entire Pagoda" (108). What he means by "one for every tribe" is unclear, but the numerous chapels may be a precursor of the many temples in the United States where walled and roofed structures contain separate sannidhis (shrines), that often house a deity dear to one of the constituent communities.

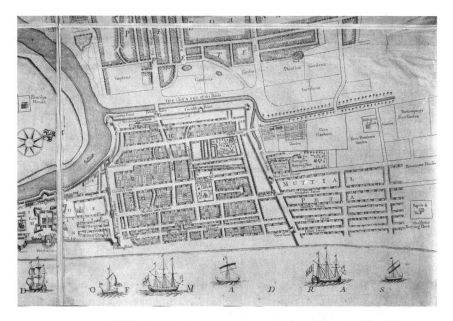

FIGURE 1.5. Old Blacktown stands contiguous with the fort, and the old Town Temple still centers the neighborhood in another detail of the 1710 map, "A Prospect of Fort St. George." Reproduced by permission of the British Library.

By 1755, there were four "chaultries" at the corners of the tank. A building of this kind seems to have served as the early courthouse as well as public meeting hall.[15] The mada streets appear narrower, and the temple appears to be a victim of urban squeeze with what could be shops or houses now abutting its south wall. The entire temple may also have been roofed, because the map no longer shows the outside wall or the separate vimana. In the intervening half century, the Town Temple became a central place of public business, both public and private. The great historian of Madras, C. H. Love, and others writing as late as 1938, conclude that "the Town Temple was the Company's Pagoda and most probably the management of the temple was at one time vested in the Company . . . a high percentage of the tolls collected in the city for the maintenance and upkeep of temples and choultries were devoted to the expenses of the Town Temple" (Ramachandra Dikshitar [1939] 1994, 361).

In 1757, the Company razed the temple and with it much of old Blacktown to create a buffer zone and stronger fortifications around Fort St. George, in an era when British power was continually challenged by the French. The Company, however, took great pains to offer new land as well as monetary

compensation, so that the local merchants could raise a new temple, which was constructed in 1766 and still stands. In 1994 the Hindu Religious and Charitable Endowments was in the midst of extensive renovations on this Madras landmark, and it was possible to get a very close look at the structure and to photograph it. The rebuilt Town Temple actually contains two temples side by side with a very modest door between them.

The Chenna Kesava Perumal Temple continues the name of the old Town Temple. Added to this on the same plot is the Chenna Mallikeswara Temple. Both the form of Vishnu as Kesava Perumal and Shiva as Mallikeswara are generic names of the gods. Kesava is the first of twenty-four forms of Vishnu, corresponding to the twenty-four names of God enjoined for daily prayers in a number of standard Vaishnava texts. These twenty-four forms are so generic that T. A. Gopinatha Rao describes them as "very alike . . . all standing figures, with no bends in the body, possessing four arms, and adorned with *kirīṭa* (crown) and other usual ornaments" ([1914] 1993, 1:227–234.) The only way to distinguish the forms is the order in which conch, lotus, wheel, and mace are distributed among the four hands. The district associated with the Kesava form is Karnataka, where a Chennakesava image stood in the great Hoysala temple in Belur.

Unlike the Kesava form of Vishnu, the Mallikeswara form of Shiva is not listed by Rao, but another temple in Georgetown bears the name, as does a recently renovated temple in the suburbs of Madras.[16] Now inside the police training academy quarters, this old temple has been renewed and adopted by the surrounding simple middle-class neighborhood. The priest during an interview claimed that it is five hundred years old, and the architecture in the sanctum might support his claim. The sanctum has an svayambhu linga in a silver five-headed cobra pitha (seat), which is associated with the name Mallikeswara. Again, this form of the linga seems to know no original "home" but remains generic.

The use of Chenna/i in both names normally derives from the Tamil name of the city, and now the official name for Madras. In the case of Chenna Kesava, the Chenna forms part of the generic name but very conveniently parallels the same Chennai used throughout the city so as to be as innocuous as possible, in order to avoid the kind of caste conflict that broke out in the city in some of the other temples that were constructed in the eighteenth century. The Company officials found themselves in the midst of these caste disputes over precedent, flags, and use of certain streets for processions, which began as early as 1652 (Mines 1994, 91–97).

The present Town Temple remains an impressive structure for its time (figure 1.6). The large wooden doors of the twin temples appear at the end of

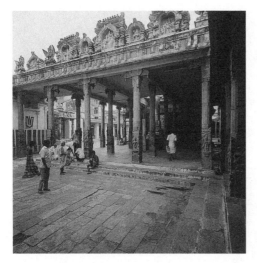

FIGURE 1.6. The present Chenna Kesava Perumal Temple, the Vaishnava half of the Town Temple, opens to a stone courtyard. The pillars of the mandapa are carved stone in a style copying that of the late Vijayanagar Empire, the last imperial Hindu rule in this area.

an enclosed commercial corridor, where vendors sell flowers, booklets, and other religious items so familiar in south Indian urban temples. The temples, both with carved stone pillars in a late Vijayanagar style, have all the essentials that make a south Indian temple "pukka," a commonly used word for "proper."[17] Entrance to the Shiva temple is through a small gopura (ornate gate) leading to an open courtyard. Next are steps up to the first mandapa (enclosed portico) with the dwajastamba (tall, ornate pillar used as a flagpole), the bali pitha (pedestal for the first offerings), and then a stone image of Nandi, Shiva's faithful bull who serves as his vahana (vehicle), facing the main sanctum (figure 1.7). The Vishnu temple repeats the same order, but with the bali pitha before the flagpole and the stone image of Garuda (an eagle, Vishnu's vahana) to the side of the sanctum, not in front of it.

Two pillars facing the sanctum in the Chenna Kesava Perumal Temple have black granite portraits in full relief standing on pedestals attached to them. A Tamil inscription provides the names of two hereditary dharmakartas (chief trustees) of the temple, Manali Krishnaswami Mudaliar and Shamasami Mudaliar. I suspect these images were added to the pillars in the early to mid nineteenth century, by the look of the "inscriptions," which are really labels, and by the neatly cut hair, mustaches, bare heads, and stiff formal attire.[18] A descendant of the initial major donor—Manali Muthukrishna Mudaliar, a Dubash of the East India Company—continues to serve as the hereditary trustee. In the back of the hall another pillar can be spotted with the image of a worshipful figure turbaned, as was the earlier style of headdress (figure 1.8). There is no label with a name, as was the earlier custom. Does this pillar portray a

FIGURE I.7. The Chenna Mallikeswara Temple, the Shaiva portion of the Town Temple, opens to a grand flagpole, but the pillars here are unadorned.

previous donor taken from the original Perumal temple, or is it Muthukrishna Mudaliar? Other mismatched pillars seen throughout the temple resemble the body parts of an earlier temple reused in this new incarnation. One of the temple officers thought that the pillars from the old temple were recycled in the new.

The impression that both temples create is one of utter propriety but not fine craft or great beauty—the stone pillars are there, but they are not all well carved and are often very simple. The entire campus paved with stone, the

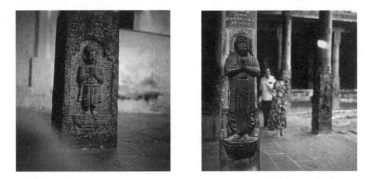

FIGURE I.8. Contrast the stone portrait on the pillar to the right with the more obscure portrait on the left. Both are in the Chenna Kesava Perumal Temple. The right-hand portrait-pillar is labeled "Manali Krishnaswami Mudaliar"; the other, which is hidden toward the back of the temple, has no identification.

golden flag poles—all betray an obvious concern that this temple should have everything, but in proportion that befits a merchant's—I am tempted to say a bourgeois—world.

Integrating the Non-Hindu into the Hindu World

This visual impression poses some serious questions: How were the "foreign" British integrated into this merchants' world? If they were simply ignored, then the argument might hold—funds for these temples in fact came from the new world trade, but such parentage was denied and left outside the temple door. There is nothing in the architecture to suggest a British presence in the present Town Temple, although there are a number of old bronze bells with the look of the Philadelphia Liberty Bell in other temples in Georgetown that officials maintain were gifts of the East India Company. The Company provided the land and a portion of the funds needed to construct the building. Muthukrishna Mudaliar put up 5,202 pagodas (currency) to the Company's 1,173, with the rest of the 15,652 raised by subscriptions from the community at large (Ramachandra Dikshitar [1939] 1994, 361). This made the Company a serious donor whose role in the temple was written not into the architecture but into persistent memory. In recounting the story of the Chenna Kesava-Chenna Mallikeswara temples in the commemorative volume for the tercentenary of the city, Ramachandra Dikshitar carefully mentions that in offering new land and compensation for the relocation of the Town Temple, "the government which was fully wedded to the support and patronage of Hindu institutions would not dare to desecrate the hollowed ground" (369).

Three hundred years after the fact, the Company appears to have filled a role as an important patron, but arguments over the nature of that role during the colonial period remain contentious. Mattison Mines refutes a model first posed by Nicholas Dicks and Arjun Appadurai which argues that temples proliferated during the early period of Company rule because the British could not fulfill their full obligations as "Hindu" rulers. This left a vacuum of religious authority that opened a space for Hindu merchants to step into the role of the temple patrons, each within their small sphere. Thus there were multiple temples with multiple kinglike authorities but no true overlord. Instead, Mines argues that the Company's newer policy to abolish the office of Chief Merchant and to distribute contracts and authority more widely through the various communities increased "the number of merchants and prominent individuals seeking to establish public reputations." Each of these would-be "Big Men" had the need for more temples to accommodate their patronage networks (1994, 98–

99). Mines sees the Company officials as joining and even imitating not the model of Indian kings but of the established Indian merchants. "Public giving of this sort marked the preeminent leadership roles the Company officers sought for themselves within the local Indian community . . . but in these activities, the British mimicked the many prominent Indians, whose model for displaying eminence they were following" (89). In this sense, the Company learned to speak the language of temples in a world of merchant-donors, not kings.

The question of the exact nature of the integration of the "foreign" into the temple culture of Madras remains important today as Indian temples here seek to find some ways to acknowledge the presence of "Americans" as they construct temples on American soil. I am not convinced that the British were physically integrated into Madras Hindu religious institutions either as fellow merchants or as reluctant kings. In spite of the very well-documented case of Lionel Place's conscious effort to "revive temple-centered Hinduism" as a part of British policy to recreate a civil religion (Irschick 1994, 80–86), I found a curious discrepancy between the legends of individual British officers' participation in the temples and any substantiating evidence of their actual concern. As an organization, there is no doubt that the Company supported temples, but legends go much further, to suggest that Company officers developed intense and genuine devotion. One such story comes from the now newly renovated Kali temple in Mylapore, the Kolavizhi Amman Temple. One version recounts the story of an Englishman who took a photograph of the fire walking in the temple and lost his eyesight. After fervent prayer to the Goddess, he regained his sight and thereafter each year "the Englishman used to take the festival deity of the Goddess to the Fort St. George and present Her with *Koorai*, a silk saree and a *Thali*, a gold jewel worn by married women" (Nambiar and Krishnamurthy 1965, 201). Another version of the legend has the Englishman losing his sight by looking through his binoculars at the fire walking.

Another very persistent legend involves a governor of Madras, Joseph Collet, who served from 1711 to 1720. This British governor is credited with building the Kalyana Varadaraja Perumal Temple in the area of Kaladipet, which is supposedly a Tamilized form of Collettepet. The governor presumably built the temple for the use of one of his assistants whose daily pilgrimages to pray at the temple of Varadaraja in Kanchipuram made him late for work every morning. When the religious-minded assistant was able to recount with precision exactly what the god was doing at the moment when the governor confronted him, Collet "had the temple . . . built to permit his devotee to pray in Madras. . . . He also endowed it lavishly—and regularly—from his export earnings" (Muthiah 1992, 245–246; also Ramachandra Dikshitar [1939] 1994, 363). This

tale almost exactly parallels another told about a British governor and his Du-bash Alangatha Pillai, who built the Ekambareswara Temple. Legend has it that the governor suggested that the Dubash construct the temple in Madras in the name of his beloved god in Kanchipuram to avoid the long, time-consuming daily journey to that holy city. In this case the governor is not credited with actually building the temple but rather with inspiring it (Nambiar and Krish-namurthy 1965, 178).

How can these stories be understood? Although none of the other English principals in these legends left any account of their experiences with Hindu temples, the letters of Joseph Collet to his family and friends survive in the India Office Collections of the British Library. In a letter to his brother dated December 13, 1716, Collet describes in detail his attempt to enter the open gate of a temple as he passed "with a design to see what sorts of Gods dwelt therein, but the priests were too quick and shut the Gate before I could enter." The governor then asked a Hindu who was standing by why he was shut out. "He told me they did not care to admit Christians and seemed to insinuate that the Priests thought that the presence of a Christian would defile their Temple." Collet then continues to describe an amazing conversation with this unnamed Hindu on the nature of idolatry. The governor was told, "We are not such fools as to think the images in our Pagodas are Gods, we know very well there is but One Supream God. . . . the Images in our Temples are no other than Sym-bols and representations of the Severall different perfections of the Supream Being. . . . There is no greater Difficulty with this, than in your Christian Re-ligion, for you say with us there is but one God and yet you say the Father, Son and Holy Ghost are each of them God." At this point the governor admits that he was "perfectly confounded" and then changed the subject to ask his inter-locutor "what representations these were pointing to two monstrous figures at a little distance." The rest of the letter describes his own shock at being unable to answer the stranger "to give a rational account of my own faith to a heathen and resolved to lay hold of the first opportunity to examine a Doctrine I had been taught to believe was a mistery and not to be pryd into" (Letter to Samuel Collet).

This letter reveals a different picture of the British in the Hindu temples from that in the stories still recounted in the city. Here stands a devoted Chris-tian shut out from the temple. His encounter with an obviously well-educated and wily "heathen" does not prompt his own devotion to the temple's gods but rather causes him to examine his own faith. Such a letter makes the story of his endowing a temple very unlikely. How could or would he patronize a temple behind the closed gates? And, those signs—"Only Hindus permitted beyond this point"—which are now only slowly disappearing in Hindu temples con-

tinue the tradition that the actual presence of a non-Hindu (usually interpreted in practice to mean a nonethnic Indian) remains highly problematic for priests and devotees alike. Why then do legends continue to portray the British as either personally devoted to the Hindu gods or willing to succor and even reward such devotion in their Hindu staff? I would call this distance between allowing the actual presence of foreigners and the keen desire to include them in the temples as *fictionalized participation*. These stories solve the dilemma of how to let the "spirit" of the British into the temples, to have the masters of the land adopt its gods, to bring these very gods and goddesses into the heart of the Company in Fort St. George, and yet leave the gods where no English body can physically pollute them. The issue remains today in some Hindu temples in India, and even in the United States. Although few if any temples here exclude non-Indians, there are multiple ways that they can be made to feel very unwelcome. At the same time and in the same breath, their presence is often desired as an important confirmation of the universality of the gods who now command devotees from all nations and all races. The topic needs much more discussion.

Exclusive Borders: The Temple as a Site for Recreating a "Caste" Community

Within one year of the founding of Fort St. George, the Beeri Chettiars, an important Tamil-speaking merchant caste, built the Kaalahasteeswara Temple in what was then a garden area (Mines 1994, 73). Thus the first new temple in the city was associated with a single caste community. The rival merchant caste, the Telegu-speaking Arya Vysya Chettiars, did not build their temple until the eighteenth century, sometime after they migrated into the city from Andhra. In the center of the old Kothawal market, the city's old vegetable wholesale outlet, stands the brightly painted gopura of the newly built Sri Kanyaka Parameswari Devasthanam (S.K.P.D.; figure 1.9). The bright new temple replaced the old shrine, which had stood since 1720, when an ancestor of the present dharmakarta, the hereditary chief trustee, of the S.K.P.D took up a collection as headman of the caste community and had the temple constructed on his land. The headman had been an interpreter for the East India Company. He had houses within the fort, which were taken when all merchants of any sort were ordered out. The Company allotted the land that now is Kothawal market in compensation. Mr. C. V. Cunniah Chetty, the recently deceased dharmakarta, described the original temple as "just like a house" with only a bronze image of the goddess for community worship. About three years prior

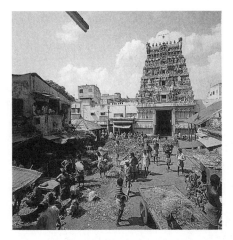

FIGURE 1.9. The new gopura of the Kanyaka Parameswari Devasthanam shines in the middle of a busy vegetable market. The government of Tamilnadu has recently moved the market, leaving the temple in a suddenly quiet vacuum after over two centuries of bustling trade.

to building the new temple, a group of Arya Vysyas met the Shankaracharya of Kanchipuram while he was in camp near Madras. They sought permission to install a granite image of the goddess Kanyaka Parameswari and then house it in a proper temple.[19] Later, the community constructed the innovative gopura portraying the story of the derivation of their caste (figure 1.10), the first of its kind in Tamilnadu to depict the origin of a caste. The Arya Vysyas trace their cohesion as a community to a kanyaka, a modest young virgin who sacrificed herself for the sake of her community—thus revealing herself as parameswari, a manifestation of the supreme Goddess. The young girl was an incarnation of Parvati. Yet in spite of the Shaiva connections of their patron goddess, the community remains staunchly Vaishnava. This is the story of Kanyaka Parameswari as adapted from a version told by the dharmakarta:

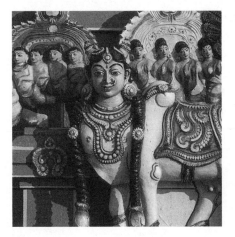

FIGURE 1.10. The Goddess as the Wish-Fulfilling Cow, Kamadhenu, glimmers on the colorful gopura of the Kanyaka Parameswari Devasthanam.

There was a Kshatriya [the warrior caste], a king, who made gestures
of love for the girl. So he sent somebody to appease the community.
Then the community had a meeting with him, then consulted
among themselves, but decided not to enter into any alliance with a
Kshatriya. Then the king insisted. The guru of the community fi-
nally said that it was not possible to give a girl to the other commu-
nity. Then, Kanyaka Parameswari thought, because I am a beauty,
the king wanted me, so because of me all of this is happening to the
community. She asked the priests to light a sacrificial fire for her
and she entered it along with 102 people who represented the gotras
that made up the community. But because she was a goddess and
because she showed such virtue, none were hurt by the fire. So after
that the community began to build temples or mandirs exclusively
for the goddess. Before that time members of the community would
worship a variety of gods but now there was only one kuladevi, [pa-
tron deity of an extended family or clan].

Rather than being a tale of inclusion, this narrative explains how a caste came
into a special relationship with a goddess who was born among them as a
daughter of the community. The decision to refuse her hand to the king was
the defining moment for the community, when the 102 heads of the gotras
(clans) preferred death to abandoning the principle of endogamy.[20] From that
time on, only those gotras whose ancestors entered the fire are properly known
as Arya Vysya Chettiars. Other Telegu Chettiars remain either Vaishnava or
Shaiva, according to their family traditions. And the goddess became a
model for this kind of strict adherence to what the dharmakarta described as
a "truth."

The community used to live together in the streets near the market, but
the caste's emphasis on higher education produced many middle-class profes-
sionals who left the crowded conditions and moved to the suburbs. They return
to the temple for the festivals and common community celebrations. The
S.K.P.D. trust at present runs a number of schools in the Telegu medium for
the education of Arya Vysya children, and a special students' home to enable
young members of the community from out of town to attend college in the
city. The home provides free room and board (S.K.P.D. 1967, 8–11). The De-
vasthanam also provides free marriages to twelve couples each year at the
temple, again emphasizing the importance of proper marriages for the com-
munity. These are fine affairs with clothes, simple dowry, and household gifts
for each couple, whose marriages are arranged by the community. The cere-
monies end with a community feast and the honoring of elders and donors.

When I attended one such function, the hall was full of enthusiastic members of this truly close-knit community.[21]

In the last three hundred years since their migration to Madras, the Arya Vysya have maintained their Telegu language. Their concern for endogamy continues even as members of the community have settled in the United States. There are marriage networks that ensure that marriages continue within the worldwide community. The Goddess now resides with the caste in the United States. Although she does not yet have an exclusive temple, I have seen the order for a granite image of the Goddess to join Meenakshi in the new Sri Meenakshi Temple in Houston.

The connections between the current patterns of migration that began in the colonial period with the relocation of gods from "home" poses many serious issues, as in the case of the Arya Vysyas. In the past, when new territory was claimed within India, gods were indeed taken (or reproductions made) from the old capital and reinstalled in the new, but fresh forms of gods were just as often discovered or revealed to the settlers/conquerors. Yet the soil of the new world of the colonial port city in India and the soil of North America— with one notable exception in the case of a linga discovered in San Francisco— has so far been barren, allowing only for transplanted divinity but no fresh revelations. The Arya Vysya caste waited over 250 years to build a permanent home for the Goddess and to install a mulavar (immovable stone image) in place of the utsava murti (mobile bronze image) that they had worshiped since 1720. The community clearly saw itself as sojourners in this colonial port city and chose to make its roots in the context of a diaspora—a community bound by a common deity, common marriage patterns, common language, and a shared home left long behind. Why the community decided to create a permanent shrine after so many years is unclear. But, the city of Chennai has become yet another abandoned home of the community as many of its young people have emigrated to the United States and elsewhere. The temple may now be the new place-left-behind for yet another "diaspora."

The "Duplicated" Temples: Sri Venkateswara as Universal Overlord

In the earliest map of Fort St. George and its environs in 1710, two temples are named in the garden area in the north and outside of the walled city, "Lorraine's Pagoda" and "Allingall's Pagoda." Both refer to the leading merchants whom the British supposed founded and owned them. The name of the famous Dubash Alangatha Pillai is easily deduced from the infamous Brit-

ish anglicizing of Tamil names. "Lorraine" presents more difficulties, but could be identified with Kitti Narayanan, a son of Beri Timmappa, as Muthiah suggests in *Madras Discovered* (1992, 281). I have already related the story of the building of Allingall's pagoda, now called by its correct name, the Chennai Ekambareswara temple. Lorraine's Pagoda now bears its correct full name as transliterated by the temple authorities: Byragi Matam Tiruvengadamudayan Sri Venkatesa Perumal Devasthanam. The name refers to both the math (monastery) for the Bairagis, a strict ascetic order, and to the Lord of nearby Tirupati, Sri Venkateswara, who presides over the adjoining temple. The temple complex remains in the control of a sect of Bairagis who continue to be trained in the north, in Lahore and since Independence in Allahabad. The present mahant (great one), who serves as head of the math and hereditary trustee of the temple, is the seventh since the founding of the complex. This temple to Sri Venkateswara is perhaps the first of many branch shrines of the great temple in Tirupati, the world's richest Hindu institution, located one hundred miles northwest of Chennai.

The temple-monastery, according to the story told by the ninety-one-year-old mahant, predates the founding of Fort St. George. The mahant adamantly denied that this complex was constructed by Kitti Narayanan, and asked me firmly to have Muthiah correct his description of the temple in *Madras Discovered*. In his native Hindi, Mahant Sri Damodar Das Ji Maharaj told me the tale of the temple's founding as he sat on his cot with his legs in perfect yogic posture and his body then in perfect health. His tale of the founding of the temple to Lord Venkateswara, who is a form of Vishnu, is rich enough to relate in full.

> The temple is five hundred years old. Our Mahatma Lal Das Ji Maharaj [the first mahant in this line] came from Lahore. Bagavan [God] Venkateswara came to him in a dream and said, "I am here [Lahore]. Take me and establish me there [Madras]." So they took the God Venkateswara and made a foundation here. The God Venkateswara has truth and a lot of power. He has brought the dead to life. . . . For example, one Muslim lady came here who had a pain in her stomach, which for fifteen years could not be cured. She asked Baba [the mahant] for medicine and he gave her a packet of poison and said, "If you eat this poison mixed with honey, you will be cured." And in the morning, he saw that she had taken the poison. According to the Muslim system [of medicine] if you give such poison, the lady would have died. And for this reason it was very painful. But God Venkateswara sustained her. When she came in the morning,

she said that fifteen years of pain had vanished. The Muslim lady then gave a bag of five hundred gold coins and with this money the first mahant bought the land and established the temple.[22]

Although Venkateswara appears prominently in this founding story, the mahant and an interpreter agreed that probably the math came first and then a temple was erected about one hundred years later. They speculated that Kitti Narayanan may have made additions to the temple and then claimed it as his own. The architecture of the math tells a similar story. The fluted archways with square columns in the math (figure 1.11) resemble palace architecture that appears in Vijayanagar and in places like Pudukkottai—a Nayaka style from the sixteenth to the seventeenth centuries (see Michell 1995, 121–154: Waghorne 1994, 135–152). The style of the temple proper has columns (figure 1.12) that also occur in the new Town Temple—what could be called the neo-Vijayanagar style of the eighteenth century.[23]

The math-temple complex could indeed date from the late Vijayanagar to the very early colonial period. The mahant's tale of the power of God Venkateswara to heal even a Muslim woman who came to him in faith fits the present rule of the great temple in Tirupati. Anyone can enter the sanctum to see the Lord by signing a statement that says, "By Faith I am a _____ but I have faith in Lord Venkateswara." The tale also fits the era of mid-eighteenth-century Tamil country, when an open-minded Muslim princely family, the Walahjah, ruled over the area, making donations to Hindu temples and mosques alike (S. Bayly 1989, 165). The story of a donation by a Muslim woman—her gender may be significant here—elevates Venkateswara to a overarching divine power. The divine lord of Tirupati became the major focus of royal patronage just as

FIGURE 1.11. Looking through a portal from the Venkateswara temple, the older architectural style of the math, which borrows freely from Islamic forms, appears in the Byragi Matam-Sri Venkatesa Perumal Temple.

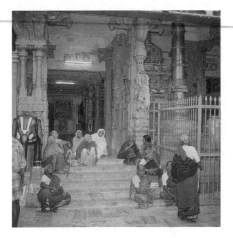

FIGURE 1.12. Early in the morning, older women wearing their saris tied in a north Indian style, sit with others in front of the ornate columned entrance waiting for a festival to begin at the Byragi Matam-Sri Venkatesa Perumal Temple in multiethic Georgetown.

the power of the Vijayanagar kings ebbed in the mid-sixteenth century (Stein 1989, 90). As the Vijayanagar Empire collapsed, Lord Venkateswara began his long rise from a local deity to a god with national and then global connections. Notice that in the mahant's tale, God "came" in a dream to the first mahant in Lahore and wanted to be brought to the area that would eventually become Madras! His connection with Tirupati does not figure in this story. And the agent chosen for his relocation headed a sect of Bairagis—a group that a *Digest of the Different Castes* in 1837 classifies as itinerant ascetics (Ramaswami 1837, 25).[24]

Mahant Damodar Das related a tale of crisscross migration. The god announced his new presence in Lahore, and then demanded a new home in the south. The Bairagis migrated to accommodate the divine command, and a Muslim woman in due time provided the money for the god's new home! The story of the divine migrant, however, continued with devotees in contemporary Chennai—many are Gujarati and Hindi-speaking Indians who, like their lord, migrated into Madras in the seventeenth, eighteenth, and nineteenth centuries from the north. An early group of Gujarati weavers, probably from the area near the East India Company factory in Surat, or earlier migrants to south India from the eleventh century (Muthiah 1992, 260) resettled in the new factory. They were voting with their feet, as weavers often did in India, seeking "relief from invaders and political extortion, as well as famines and similar natural calamities" (Chaudhuri 1978, 252). Gem merchants and moneylenders from Gujarat and elsewhere, both Jain and Hindu, eventually joined their compatriots, who now form a Hindi- and Gujarati-speaking community in an area within Georgetown called Sowcarpet. The area retains its identity as the home of sojourners from the north after three centuries. The Byragi Matam-

Venkatesa Perumal Temple lies within a city block of the northern edge of this community, and most of the devotees are from this neighborhood. During festivals, the mahant can be seen chatting in Hindi with devotees (figure 1.13). Some ladies who still tie their saris in the distinctive Gujarati fashion can still be spotted (see figure 1.12). In this neighborhood, the bronze image of Sri Venkateswara rides in procession on his great golden vahana of Garuda (the eagle) moving out of his grand gate past crowded rows of small shops, the popular Leena Snack Bar (figure 1.14), and a magnificent new marble temple of the Jain community. Thus the premier deity of south India lives as a northern migrant with his devotees from Gujarat and the Hindi heartland.

A mix of southern- and northern-style worship prevails here. Amid the overarching presence of the sadhus of the adjacent math, the priestly family that serves Lord Venkateswara traces its lineage to the Bhattars (Vaishnava temple priests) who attend the Lord in his grand temple in Andhra. They perform all rites in their temples as prescribed by the Tirupati Devasthanam, the governing body of the great temple, in the best south Indian Vaishnava tradition. This, however, is not the only temple in this complex. Earlier in this century a temple to Lord Hanuman as the patron of wrestling—an important discipline for the Bairagis—was erected in the north Indian style. Then, about forty years ago, the mahant had a dream in which God Shiva appeared and ordered a temple built next to Hanuman's shrine. Devotees worship both gods here in the north Indian style, with no officiating priests. For the benefit of

FIGURE 1.13. The vigorous, then ninety-year-old, mahant of the Byragi Matam chats with devotees during a festival at the attached Sri Venkatesa Perumal Temple. Royal umbrellas befitting his title of Maharaj shade him— he rules as lord over this devasthanam, domain of God.

FIGURE I.14. The grandly decorated bronze image of Lord Venkateswara riding atop his vahana Garuda moves through the crowded streets of Georgetown.

devotees, images of Rama and his holy family are kept visible to the street just in front of the entrance hall to the math. The residents of the math, as sadhus, use no priests. I spotted an image of the Goddess on the mahant's wall, a red form of Hanuman in the hallway, and tulsi plant (a type of basil) growing in a traditional urn in the courtyard of the math. The practice of yogic disciplines, however, still prevails. The math continues to feed and shelter sadhus on pilgrimage to the great temple at Rameswaram to the south and offers facilities for men to take a spiritual respite from family life for a few days.

This temple-math complex, then, enfolds rituals from the north and the south, deities from both the Vaishnava and Shaiva side of the theological spectrum, proper Brahman priests, and powerful-bodied ascetics. All are subsumed under the banner of a single overarching god and allowed to make their home here in a "new" urban environment. In an analog to many neighboring business establishments in this commercial center, the Byragi math/Venkateswara Temple creates amazing mergers of people and places through the power of a divine overlord—who works across borders and now across oceans.

Global Connections/Local Communities

What difference does it make to view Hindu temples in a global context? Viewed from a global context, what Arjun Appadurai once called the *cultural grammar* of urban Hindu temples does change. The nature of that change only

becomes apparent in what André Gunder Frank calls a "horizontally integrative macrohistory" (1998, 226–228).[25] This chapter began with an observation: major temple construction in the last centuries occurred during two periods, 1640 to 1800 and now the 1960s to 2003. Both have been times of rapid economic growth, but especially growth connected to flows of both people and products. As the urban port cities gain dominance, so do the cultural currents of the trading and professional classes—what are now the middle classes. The intense heterogeneity of the times does not always bring harmony but rather often outright violence. In this context, Hindu temples have grown up within a new urban environment, not at the center of the city but sharing urban space on an urban grid as a vital part of a world where commonality and difference are constructed along with new industries and new marketplaces.[26]

In this context, the three temple "types" that I have outlined here speak to multiple issues: How can seeming "foreigners" who help generate the common wealth of the world be accorded a place in "our" world? How can disparate elements sharing at least our common religious vocabulary be reconfigured into a common space? How can "we" construct our difference and still share in the commonweal? The eclectic temples and the community-only temples represent two poles in the long dialogue with the "West" and with each other that has absorbed Hindus for three and a half centuries in our common world system. The duplicated temples are a middle ground. One pole moves toward ultimate inclusion of all parties, even if only by a fictionalized presence in the temple conceived, as texts such as the Agamas claim, as a model of the universe. The community temples, however, are equally a part of the modern world, for these are carriers of traditions of movement and of the concept of a community built from displacement. The duplicated temples recognize displacement and universalism, but all under a kind of corporation that gives a new meaning to the old term devasthana, the domain of God—no longer a specific sacred place where God rules but rather the worldwide network of "offices" of a now universal Lord. The modern world of global trade demanded and still demands both a sense of universality (the whole world as our home) and at the same time its seeming contradiction (the particularity of each national and ethnic community and its gods). This is how Wallerstein describes the present world system, and certainly Hindu temples have managed to both express and accommodate these "contradictions" while remaining the visible *sign* of new beginnings and new turns in the economic history of the world (Wallerstein, 1991, 139–146).

Exactly how did the cultural grammar of the Hindu temples change in the early modern period? Inside the temple walls, deities often shared power; in the eclectic temples multiple gods reign together. In the duplicated temples,

the ruling god lives in tension with his own multiplicity—Venkateswara of Georgetown existed in the shadow of Lord Venkateswara of Tirupati. In the community-only temples, the deity is a kuladevi, a clan protector also named as a form of the supreme Goddess who is the queen of the universe. Her domain, however, remained situated with the community. Viewed within the spatial configuration of the city, none retained sovereignty; this privileged space in Madras belonged to the grand house of commerce, Fort St. George. There was no tutelary deity of the East India Company, no single divine guardian placed at the center of the commercial realm, much to the displeasure of the Anglican priests who had to build St. Mary's Church inside the fort with private donations (Muthiah 1992, 27–28). There was equally no Hindu deity at the center of this polytheistic and polyglot world. Where was the religious language of this commercial town generated? The answer cannot be found within the structure of any one temple, or even of the "Hindu temple." Temples should be understood as civil institutions, corporations in a very broad sense—constructed social bodies, physical manifestations, and sites to work out concrete answers in a concrete ways. But I think it would be a serious mistake to assume that by saying this, the gods who are yet the masters of these houses have been usurped from their rightful place and power by such theoretical moves. The divine masters of the temples remained vital to this new mercantile world. The very fact that temples existed then and continue now as the site of conversation, of business and of social life, makes this clear. If the problem with world-system analysis rests in its Eurocentric economics, that critique should also constructively extend to a discussion of a hidden Eurocentric theology, which assumes that no person can serve both Mammon and God.

2

Mylapore

The Recovery of "Ancient" Temples in an Inner-City Neighborhood

When an executive of the Ford Motor Company came to Madras on a site inspection for a possible plant in 1995, the very astute chairman of the board of trustees of the Kapaleeswara Temple in the old neighborhood of Mylapore arranged for the executive to visit the temple. The executive arrived with his wife and the U.S. consul general and his lady, clearly expecting a tourist experience. Instead the chief priest and other officials welcomed the entire party with a huge temple elephant in full regalia, with gifts of Banaras silk shawls, and with all the marks of regal respects as honored guests.[1] The whole party, which included my husband and me, formally processed around the massive temple compound, carefully walking in the footsteps of the elephant. While chatting, I discovered that the consul general had a serious interest in temple architecture. We ended our regal progress by sharing fine snacks around the great table in the executive offices, where all of us sang the praises of the city for the gentleman from Ford. Commercial concerns and sacred center once again coalesced in that moment at the great temple. The new Ford plant now operates just outside the city.

Just a week before and a few blocks away from this event at the grand Kapaleeswara, the trustees of the Virupaksheeswara Temple held their first annual celebration of the renovation of this very old temple compound, which almost fills a block in this otherwise crowded corner of Mylapore. Still worn and drab, much like an antique after the first cleaning, the outer walls of the shrine were cov-

ered with whitewash and new cupolas topped the sanctums for the goddess Visalakshi and the beautiful old granite linga of Shiva, here called Virupaksheeswara. That morning two young girls from the surrounding neighborhood polished the brass lamps to be used for puja (worship) that day. Another devotee mixed the fruit compote that would be part of the abhisheka (anointing) of the bronze festival images of the temple deities. Other volunteers walked in and out, greeting each other and us. Less than a decade previously, as a group of concerned neighbors they had united to work toward the restoration of several very old and neglected temples in the immediate area. In the process, they recreated a cluster of Shaiva temples now called "the Seven Lingas of Mylapore." They described themselves as "middle-income people," educated but working in salaried jobs. They explained that "rowdies" had encroached on temple lands and used temple compounds to "fly kites" and carouse. They had successfully cleaned and renovated the nearby Karaneeswara and Malleeswara temples and had begun to work here three years previously. A young woman majoring in English literature at college spoke of getting up early in the morning to pull thorn bushes out of the compound. She pointed to one still clinging to the banks of the temple tank, then still in disrepair. Devotees swept the yard, even whitewashed the walls with their own hands for six hard months. "We were tired but we enjoyed it." Even her brother and his friends now come regularly to help. Everyone had become friends during the project. Many spoke of the "peace" the temple now gave them. One devotee mentioned how the temple provided a little space for the many people who live here in small crowded flats. "People can come here and stay for an hour or so, relaxing, cooling themselves, forgetting their worries." The puja performed that morning, followed by a procession in the evening, felt like a large family celebration done in grand yet unpretentious style.

These vignettes occurred in Mylapore, now an inner-city neighborhood within Chennai most allied with two venerable temples, the Shaiva Kapaleeswara at the very center and the Vaishnava Parthasarathy, now in Triplicane, which under its antique name of Tiruvallikkeni was a suburb of this oncebustling ancient port city. Guide books for foreign tourists often recommend seeing these two temples, but as the *Lonely Planet Guide* puts it, "It's worth a visit if your time is limited and you won't be visiting the more famous temple cities of Tamilnadu" (Crowther, 1984, 696). I doubt, however, if the Ford executive was invited to the Kapaleeswara Temple only as a quick surrogate for the greater temple cities in the south. The Mylapore area functions for many Madrasis as the de facto sacred center in a business-oriented town. The actions of the chairman of the Kapaleeswara trustees, who owns a very famous silk emporium with budding international connections, reinforced that impres-

sion. Yet ironically by this same event, the Kapaleeswara was mapped back onto the global trading networks—a position it had held thrice before. A major temple by the same name graced the coastline of this once-independent port city of Mailarpu or in Greek, Mylarphon, as it was known in Graeco-Roman times (Krishnaswami Aiyangar [1939] 1991, 41), and again as a significant port for trade in the lands to the east during the great Pallava Dynasty some centuries later (Muthiah 1992, 172). Much later the temple was reconstructed slightly inland at the center of the town that once adjoined the prosperous Portuguese trading fort of San Thomé. Meanwhile, the trustees of the Virupaksheeswara struggled to create not a global network but a neighborhood safety net within the space of urban temples in a contested social environment. They count the regal Kapaleeswara shrine as a node on *their* temple web. Thus the would-be sacred center of Chennai and globally important temple is nonetheless drawn back as one among many *neighborhood* temples in the inner-city area of Mylapore. As both a global link and a neighborhood linchpin, this and other temples appear intimately connected with the contemporary urban character of this city and its often-noticed particular and even peculiar feature as "a fortuitous collection of villages separated from the surrounding county by an arbitrary boundary" (1908 Imperial Gazetteer's description quoted in S. N. Basu 1993, 231).

When we left Madras in the previous chapter as fully a part of the emerging new world system in 1800, this same homespun quality characterized this city, then quite large. That year was an endpoint for Madras as a global trading center. The city was transformed from "an emporium into an imperium" (Stein 1993, 216). At this the point, all of the small towns and villages were brought under the legal jurisdiction of "Madras," the political capital of the new ruling British authority in south India. "Defining Madras in the year 1800, was an act of perception; and perceptions are shaped by political considerations, cultural values, social contexts, aspirations, and habit," wrote Susan Neild-Basu as she pondered the complex meaning of that same key map of the previous chapter, "Limits of Madras as Fixed on 2 November 1798" designed by R. Ross. S. N. Basu reads this map as representing "the company's vision of a viable political center composed of many parts, co-existing in security and harmony under a benevolent administration" (1993, 227). For her, this "map" was an act of British wishful thinking, their attempt to define an enigmatic city to the many Europeans who traveled and worked there: "Its sections of dense population concentrations had a definite urban character, yet it did not have the structures, the institutions, or the appearance of an important city. There was no central focus, no clear boundaries between urban and rural localities, no qualitatively distinctive features in its cultural and social life that separated it

from its agrarian surroundings or allowed it to claim superiority or precedence.
. . . This was not the kind of city they had experienced in other parts of the
world" (238). Just as guidebooks for seekers of quaint culture dismiss the city
today as a convenient business stop, Europeans in 1800 apparently were un-
impressed with its lack of a monumental feel, centralized plan, or majestic
cityscape. It seemed only motley and a prosaic place to conduct business, in
spite of Chief Engineer Ross's attempt, quite literally, to piece the city together
into a patchwork of neat blocks of rose and pale green hues.

For Susan Neild-Basu as well as Burton Stein, this mercantile city emerged
for its "native" Hindu population as a definable organized urban locus through
its network of temples, those newly built in Blacktown and a series of ancient
temples that stretched along the coast near or within the city's new borders.
Stein concludes: "For those Indian groups, too, apart from the brisk business
of Chennai, it was their participation as worshipers in one (or more) of the
older temples of the place—the Śiva shrines in Tiruvottiyur and Mylapore or
the Viṣṇu temple in Triplicane—or the newer shrines built by the mercantile
patriciate that defined their place as citizens" (1993, 217). In the eyes of its
Indian public, Madras at the turn of the eighteenth century retained a conti-
nuity with its recent past as an important part of the three-centuries-old Cor-
omandel coastal trading network (Stein 1993, 215; Subrahmaniyam 1990). As
an Indian city, Madras retained more ancient connections as part of the region
of Tondaimandalam with four major temples of ancient repute in Tiruvotiyur,
Triplicane, Mylapore, and Tiruvanmiyur (Neild-Basu 1993, 235). In a volume
that marked the tercentenary of the founding of Madras as India moved toward
independence, a distinguished Brahman scholar noted that the foundations of
the city "marked the fulfillment of a desideratum which was felt by two sets of
people in two different ways." The British traced the foundation to their search
for a safe trading harbor, but "on the other side" he lists those same ancient
temples and confirms that "what we now call Madras is certainly no new foun-
dation" (Krishnaswami Aiyangar [1939] 1994, 41). Even more apparent today
with the expansion of the city, these temples of the Tamil region now mark the
center and the northern and southern borders of the city, respectively. In 1995,
the Tamilnadu government made a grand display of the renovation and recon-
secration of the long-neglected Shaiva temple in Tiruvanmiyur, as this once-
rural coastal area has now filled with apartments and many upper-middle-class
houses. Today the farmland obvious between the village settlements named on
the 1798 map has urbanized, turning villages into city neighborhoods without
erasing their character. Consumer banks now spread along Annai Salai, like
most of the streets in the city still called by its colonial name, Mount Road.
Major financial institutions remain in old Georgetown, while the government

continues to function out of Fort St. George, which never changed its name. Even now all of these elements appear to have grown together without ever creating a single-centered city, whether configured as a religious or secular landscape.

Stein or Neild-Basu may claim that the newly built temples of Georgetown and the ancient temples of places like Mylapore were knit into a seamless cultural framework for Hindus of eighteenth-century Madras, but there are important differences between the temples of Mylapore and those of Georgetown. In the last chapter, I made the point that none of the temples in Georgetown was understood as rooted to the soil in this town of migrants. The temples that the merchant communities created there in one way or another reflected the transient nature of this "factory" town. Although housed in stone, the deities had their roots elsewhere. The types of temples developed for the waves of migration are now echoed in the current temples in the United States, at yet another period of resurgent global trade. Mylapore was the home of two, and as we will see even more, temples that predate, or appear to predate, the emergence of the new world system—at least as delimited by Wallerstein. The Seven Lingas of Mylapore, like the quintessential iconic embodiment of Shiva, the linga, for which they are named, are rooted in the soil and understood as ancient. Yet this coastal area has a long history of trade with other towns along the coast of eastern India—with Rome, with Southeast Asia, and finally through the Portuguese with the emerging entrepôt of Europe.

The Kapaleeswara Temple as one of the Seven Lingas shares this rootedness, but the current temple takes only the name and not the actual structure of the ancient temple. In many ways the temple expresses this tension, or perhaps confluence, between a heart bound to ancient soil and a foot loose in world trade. The temple was rebuilt and maintained by a group of men of commerce, the core of which were from the landowning caste of the Poonamallee Mudaliars—a title taken by northern Vellalar subgroup associated with the foundations of both commerce and agriculture in the Tondaimandalam region (see Thurston [1909] 1972, 7:374). The power of these men rose for a brief time after 1771, when the Company abolished the official office of Merchant and shifted power to another class of Indian associates, the Dubash. Literally meaning "a man of two languages," these interpreters functioned as a "go-between or broker" (Neild-Basu 1984, 4). Unlike the Company's official Merchants, these Dubashes had a very different relationship with the area into which the new city was interposed. As temple donors and patrons of classical poetry and music, they mapped Madras as part of Tondaimandalam—a division of Tamil county that probably dates to the first Chola Dynasty in the second century c.e. (K. V. Raman 1957, 4). Their savvy within this larger agricultural

belt made them increasingly indispensable to the British as the Company slowly shifted from a merchant group to the new overseers and hence tax collectors for the countryside. As native sons of the area, or at least very ancient immigrants, the Dubashes straddled the line between the transit of commerce and the fixedness of the soil.[2] The temples of Mylapore speak of this tension between rootedness and portability in their complex nature. It would be a mistake, I will argue, to read them as part of a struggle between modern commerce and Hindu religion—once all too easy when Americans began in the late 1950s to run amok with economic development theory à la Max Weber. Mylapore, as an urban neighborhood and as a former trading center in its own right, contains the Seven Linga but also a very old temple to Hanuman, the son of the Lord of the Wind (Vayu), the very embodiment of movement. With a history of trade extending well over a millennium, unlike the recently established Blacktown, Mylapore poses another set of issues for understanding modern temples: the problem of continuity with the land, with the past, and with ancient authorities—all within the world of urban life.

This dual quality of Madras as a city of villages and a city of ancient cities, a place designed for commerce yet brimming with temples and a wide variety of "cultural performances," made it the centerpiece for Milton Singer's still very influential *When a Great Tradition Modernizes: An Anthropological Approach to Indian Civilization* (1972). The fact that the city's name does not appear in the title shows how closely Singer associated the character of this urban area with very generalizable issues in urbanization, modernization, and cultural continuity. For Singer, Madras became the gateway into "Indian Civilization" but also a spearhead into what was then a new approach to India. Singer presented this work as the bridge between the anthropological fieldwork study of the village, which "seemed to fit the social anthropologists image of a 'primitive isolate' . . . the hallmark of social anthropology" (1972, 258) and the culture usually associated with literate urban "civilization." He set his task "to chart an intellectual map of some of the researchable territory that lies between the culture of a village or small community and the culture of a total civilization" (67). That territory for Singer and his mentor and collaborator, Robert Redfield, lay within "the cultural role of cities," especially an early type of city, the *orthogenetic*, which "carry forward, develop, elaborate long-established local culture or civilization" (Singer and Redfield 1954, 57). Singer hypothesized "that because India has a 'primary' or 'indigenous' civilization which had been fashioned out of pre-existing folk or regional cultures, its Great Tradition was culturally continuous with its Little Traditions to be found in its diverse regions, villages, castes and tribes" (1972, 67). This concept allowed Singer to highlight the very complexity of Madras as village *and* city. Or, to put it another way, the

complexity of Madras fit especially well into Singer's own theoretical land-scape—perhaps by design or perhaps, as Mary Hancock suggests, because of his encounter with the highly articulate and, I would add, charismatic Sanskrit savant Dr. V. Raghavan (Hancock 1998, 357). So for Singer, Madras became the cipher for the continuity of the Great Tradition whose epicenter he iden-tified with Mylapore. For Singer, the Great Tradition appeared to radiate from this neighborhood. "Much of the action was centered in Madras city and par-ticularly in Mylapore, with its imposing Śiva temple, public halls, and concen-tration of Brahmans" (1972, 81).

As early as the 1960s, Singer directly attacked the "bizarre and paradoxical tone" of the then current discussions of the interrelationship of industrial de-velopment, modernization, and Hinduism, and folded this into his earlier stud-ies as the last section of *When a Great Tradition Modernizes*. Singer was reacting to the many self-styled experts in economic development who, fueled by the then-recent translations of Max Weber into English, pondered "beliefs" in Hin-duism and "the retardation of economic development" (Kapp 1963, 41–66), culminating in what I consider an egregious seminar on "Socio-Economic Change and the Religious Factor in India" (Loomis and Loomis, 1969). Singer turned the tables and introduced industrial leaders of Madras as an intriguing example of highly successful people who "do not experience any strong sense of conflict between the demands of their religion and their mode of life as industrial leaders" (1972, 316). He summarized the reaction of his distin-guished informants to what he later argued was a particular American con-struction of Max Weber's theory (Singer 1985, 28–30; Buss 1985, 4)—the (ri-diculous) notion that Hinduism retards economic development. As Singer reports, "When I tell orthodox Hindus about Weber's theory, they are aston-ished. 'If it is true,' they usually reply, 'how could we have lived and done so many things—built temples, ships, empires, fought wars and organized agri-culture, crafts, and trade?' " (1972, 275). In his long and sophisticated rebuttal of these Weberianisms, Singer never seemed to notice how his informants bundled the building of temples with all of their other productions. Nor did he ever connect the character of Madras as an urban village to these same rock-hard institutions, as Stein and Neild-Basu have done.

This once-burning issue of India's great Hindu legacy and the develop-ment of modern commerce is still smoking thirty years after *When a Great Tradition Modernizes*. Interestingly, all of the many businesses that border the mada streets surrounding the imposing Kapaleeswara Temple disappeared in Singer's description of Mylapore. When he turned to a discussion of industrial leaders in the last section of *When a Great Tradition Modernizes*, he decontex-tualized—more accurately despatialized—their places of business. Their ad-

dresses listed in his appendix reveal that most worked in the heart of Black-town/Georgetown or upper Mount Road, which runs into the main street of Georgetown. The many temples of Georgetown, which we viewed in the last chapter, also disappear in his text. Singer's thirty-year-old text could easily be dismissed as outdated. Yet *When a Great Tradition Modernizes* stands as a "gate-keeper of sorts" (Hancock 1998, 344) at the intersections of urbanization and village, of capitalism and commerce, and of Hindus and modernity. There are a number of issues that Singer bundled in this package of modernity and tradition, and many more that he ignored—not all of them directly intercon-nected but nonetheless coexisting. And from the beginnings of Madras as a city and now at this time of its full return to global networks, Hindus have responded at least in part with temples. Singer argues at the end of his famous text that a researcher may begin in India at any point and yet reach the whole (1972, 269). But to begin with temples in Mylapore, I will argue, shifts the very meaning of "tradition"—its keepers and re-creators. A focus on temples questions Singer's paradigm of Brahmans in their role as pandits and priests as the major custodians of a supposedly ever-enduring heritage.

In spite of its past as an ancient port city, Mylapore has an inner-city feel in contemporary Chennai, with a mix of working-class and slum dwellers living near schools for orthodox Brahman boys whose sing-song voices carry the sound of Sanskrit mantras into the urban streets. The area, like so many others in Chennai, has changed from an independent town to an urban neighbor-hood. Mylapore, however, remains a "temple city"—the neighborhood headed the list for the largest number in the last government survey of temples in the city (Nambiar and Krishnamurthy 1965, 153). Once the borders of Mylapore (as "Saint Thomé"—early British maps retained an Anglicization of its older Portuguese name) stretched west to Nungambakkam, south to the Adyar River, and east into Triplicane. This large area accommodated the gracious eighteenth-century garden-house estates of wealthy Dubashes and their En-glish "employers." By the nineteenth century, Mylapore, now diminished with-out Nungambakkam and Triplicane, housed prominent lawyers, mostly Brahmans, still in "garden" houses but on scanty plots near the Kapaleeswara Temples, the area became a center of nationalist activity. Soon even more Brah-mans, who left their traditional work as Sanskrit teachers or temple priests for various government positions and the professions, joined the others. These middle-class people maintained the ideal family home, but with diminutive gardens, which by the twentieth century became a few yards between the house and the surrounding wall. Writing on this late Indian "bungalow" style, archi-tectural historian Madhavi Desai argues that as an "accepted form of middle-class housing . . . [i]t became an expression of the freedom from collective

norms of a caste/community-oriented lifestyle" (Desai 112–115; see also A. King 1995). Yet these new bureaucrats and professionals crowded into Mylapore, anxious to live in the vicinity of proper temples that included several important Vaishnava as well as the grand Shaiva temple. The businesses that surrounded the Kapaleeswara Temple, however, remained in the hands of older, and once-dominant, non-Brahman landowning and merchant communities. When serious drought hit the area beginning in the 1970s, I have reports that many Brahmans with a high need for water for the religiously required daily bathing moved out to outlying places like Nanganallur if they could afford to do so. Thus this little city within a city has its own satellite neighborhood.

At the other end of the social and caste scale, the neighborhood always had fisher folk living in the nearby Marina area in thatched huts on the beach that looked like little villages. With the urban renewal policies of the early DMK governments in the 1970s, high-rise concrete tenements became home to these and other migrants, who all now come under the heading of "slum-dwellers" (Wiebe 1975, 1981), although many of the tenements now have a working-class population of motor-rickshaw drivers and the like. By the late 1960s, when I first came to Chennai, Mylapore still retained its reputation as a center of orthodox learning, and Milton Singer writing at the same time used the priests of Kapaleeswara Temple as living examples of "the social organization of Sanskritic Hinduism" (1972, 111), but the reality on the ground is more like a mix of street kids with wealthy women shopping for silk saris and gold jewelry. People who are engaged in urban renewal in this neighborhood speak of some areas of Mylapore as slums with problems of encroachment on temple properties and the pavements—indeed, on any public land. Mylapore is a religious center for the larger city, attracting wealthy shoppers but also inhabited by marginal people—poor slum-dwellers and, in many ways, the poorer Brahman temple priests, the gurukal, whose meager salary keeps them on the economic margins while living in their traditional agrahara-style (*agrahāra*) homes, which are now in prime real-estate areas near major temples.[3] The Kapaleeswara, along with all the other Seven Linga of Mylapore, lives in this urban mix.

Mylapore: The Ascetic Lord in a Middle-Class World

A visitor to Mylapore can enter this neighborhood by several roads; each entrance offers a different impression of the area. Buses and taxis usually bring tourists by Royapettah High Road, which runs past the imposing tank of the Kapaleeswara Temple (figure 2.1). Here begins the mada streets of the temple, the four roads that border the compound walls and tank forming the square

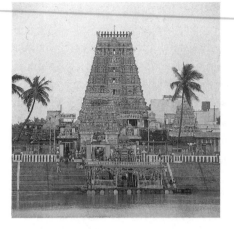

FIGURE 2.1. The grand tank of the Kapaleeswara Temple appears with the giant eastern gopura silhouetting the smaller western gate in front. A decorated float awaits the bronze divine image of Murugan for a major festival.

block obvious in any map of the area. This square, centered by the grand stone temple, appears much like the seventeenth-century Town Temple in old Black-town that we saw in chapter 1. These mada streets become sacred terrain when Lord Kapaleeswara and the divine family, bejeweled and mounted on their vahanas, their vehicles, process around their temple. Priests say that during these festivals, ideally no resident of these mada streets should leave the neighborhood (see Waghorne 1992). Around these streets, in some cases abutting the temple, are some of the best jewelry and cooking-vessel shops in Chennai. Near the magnificent multitiered temple gopuras stands the modern air-conditioned Radha Silk Emporium with its sumptuous Conjeevaram silk saris, which take their name from the old temple city of Kanchipuram, once the capital of the Pallava Dynasty less than fifty miles from here. Also on the mada streets are travel agents, an institute of technology, video stores, banks, medical clinics, textile goods, book stores, printing shops, small publishing houses, coffee roasters and coffee houses that long predate (and still surpass) Starbucks, as well as many old residences. The south mada street hosts a daily fresh produce market with vendors selling their bananas and ripe tomatoes out of thatched-roofed stalls that would look natural in any village. Visiting the house of God does not preclude a bit of shopping and running errands. Mylapore viewed from these streets looks crowded, not fashionable but prosperous, with shoppers and devotees well dressed.

Earlier publications of the temple give the present temple a royal lineage, crediting its reconstruction to the "times of the Nawabs and the Vijayanagar rulers." Tourist brochures continue to conflate the rebuilt temple with the original.[4] But even recent brochures disclose the fact that the ancient temple was destroyed and present temple "was rebuilt about 300 years ago," and this is

the usual time frame suggested by most officials. The reason for the demise of the ancient temple, often thought to be a shore temple much like the famous Durga temple down the coast in Mahabalipuram, varies according to the perspective on the period of Portuguese rule—a touchy subject for the many Roman Catholics. Their grand cathedral, the San Thome Basilica, seat of the cardinal, now stands on or near the assumed site of the early temple. Mylapore remains a center for Roman Catholics in south India, with the cathedral and other old churches, including the lovely old Portuguese Luz Church for Our Lady of Light, perhaps the oldest extant European architecture in India. Some sources demurely suggest that the temple was washed away by erosion or storms long before the Portuguese arrived (Kapaleeswara Temple 1978?). Others submit diplomatically that "Mylapore fell into the hands of the Portuguese when the temple suffered demolition" (Murugesa Mudaliar [1970] 1984), and a government temple survey puts the case most bluntly: the temple was probably razed by the Portuguese who "were very cruel and had iconoclastic tendencies" (Nambiar and Krishnamurthy 1965, 204). In an interview, the chairman of the board of trustees suggested that the Portuguese took permission to tear down the temple and extended compensation for its reconstruction. This would make the case of the Kapaleeswara analogous to the British destruction of the old Town Temple in Blacktown. If the temple were rebuilt during the Portuguese tenure in their fort and trading center at "Santomé de Meliapor," the present temple would date from the early-to mid-seventeen century. The Kapaleeswara stands as a very early case of new urban dwellers renovating, in this case recreating, older temples. The form and function of this "new" Kapaleeswara Temple carries traces of changes in the perception of the deities and of themselves among those classes who emerged as eighteenth-century bourgeoisie yet remained "native sons" of an ancient territory.

The Kapaleeswara, even in its ancient form, was an urban shrine. The most famous description comes in a poem by the beloved Tamil child-saint Tirugnana Sambandar who sang of the temple sometime in the seventh century c.e.[5] The poem preserved in the *Tevaram*, which Indira Peterson calls "the first Hindu sectarian scripture in a vernacular language (Peterson 1989, 4), remains intimately connected with the modern temple. In the song Sambandar, here beautifully translated by Indira Peterson, chides a beautiful girl for leaving without seeing the great temple in Mylapore. In a later elaboration of the saint's life, the powerfully exquisite poem resurrects the lovely girl Poombavai (Pūmpāvai) from death.

Pūmpāvai, O beautiful girl!
Would you go without having seen the feasts

in which our Lord who loves the temple
in beautiful Mayilai,
whose beach is lined with fragrant *puṇṇai* trees,
the Lord who dwells in Kapālīccaram shrine,
feeds his many devotees who love him? (Peterson 1989, 186–189)

Little clear description of the old city can be divined in this eleven-stanza poem except well-worn phases like "a town of beautiful women" or "town with wave-washed shores" or "fringed with coconut palms with broad fronds." The long poem continued to describe Mayilai town with streets "always busy with festive crowds" and the temple "surrounded by dark woods" or "set among fragrant groves." Whatever the factual case of this poetic description, officials of the reconstructed temple assure modern devotees, "Those who are capable of comparing the structure of the temple, the deities and the surroundings, with the contents of the verses of Tirugnanasambandar, will not be able to find any change unless it is told that the present temple buildings belong to a later date" (Kapaleeswara Temple 1978?, 3).[6] Indeed, within the current temple an old punnai tree still grows and is associated with the reigning goddess. Just inside the main gate stands a small shrine to Poombavai. During the still grandly celebrated ten-day Brahmotsavam festival, on the morning of the eighth day priests carry the bronze image of Sambandar in procession to a pavilion on the embankment of the tank and perform an elaborate abhisheka (anointing) of the saint in commemoration of this extraordinary poem. Later on that same evening occurs the grand procession of the sixty-three recognized Shaiva saints, the Nayanmar, the most renowned ritual event for this temple. Shiva in his grand silver palanquin with the setting sun on his face sits enthroned before all of the bronze images of his devoted servants in their brightly painted palanquins stretched along South Mada Street. The grandeur of this sight perfects the poetic praise of the young saint. At such a moment, this inner-city neighborhood manifests as a temple town created in the image of this holy poem.

This process of recreating this central temple of Mylapore may be an Indian case of a double "invention of tradition" well before the nineteenth century. The early-seventh-century poem of Sambandar was later given a new context in the twelfth century, when Sekkilar embedded all of the poems of the Shaiva saints into a continuous narrative, the *Periya Puranam*. This twelfth-century construction of "tradition" reads pūmpāvai (beautiful girl), as Poompavai, the name of the young daughter of pious rich merchant Sivanesa who hoped to entice the young saint into marrying his daughter (see Peterson 1989, 186 n.99). The girl died tragically of snakebite, but her ever-pious father put her ashes and bones in a pot to await the saint's holy song, which miraculously

resurrected her. In this context, the great faith of a pious merchant brings about a miracle that Sekkilar relates just at the beginning of another era of expanded global trade in twelfth-century south India spearheaded by a rising merchant class (Abu-Lughod 1989, 281–282).[7] The wealth from this expanded trade funded the construction of regal stone temples in south India—if Janet Abu-Lughod is correct (1989, 4). During this century, the grand royal temples meticulously carved in stone came to define the popular perception of a sacred centers of pilgrimage.

The earliest Shaiva saints in the late sixth to late seventh century, however, do not always describe the holy sites of Shiva's presence as temples; "many of the terms denote open, unstructured places . . . *kāṭu* (forest, uncultivated land), *turai* (port or refuge), *kulam* (tank of water), and *kalam* (field)" (Prentiss 1999, 52). As Karen Prentiss puts it, "built structures . . . are often a secondary development." She argues that Sekkilar nevertheless "presupposes an imperial temple culture" as he describes their pilgrimages in his *Periya Purana*—(52, 126). From this perspective, the "Kapālīccaram" temple "surrounded by dark woods" and "set among fragrant groves"[8] was not a grand royal temple but a simple shrine—like the probable Pallava-era temples among the Seven Lingas of Mylapore, to which I will return soon. Nonetheless, Sekkilar's image of the young saint Sambandar singing his potent verses in a grand imperial temple to save a pious merchant's daughter tenaciously inhabits the consciousness of devotees. The "invention of tradition" in Mylapore occurred once in the twelfth century and again in the eighteenth, and continues into the twenty-first.

An important clue to the close interconnection between the reconstruction of the grand Kapaleeswara and another commercial community appears in a ground plan of the temple drawn about 1800—again at that crucial moment that marked the end of Madras as a trading center and the beginning of its life as a bureaucratic headquarters.[9] The plan was bound inconspicuously into a folio marked "Mackenzie Drawings of Indian Sculptures" and identified in typical Anglicization of the period "Cabalesevara Pagodas" (figure 2.2). All of those who are credited with building or repairing this temple complex are titled "Moodr."—clearly an abbreviation for Mudaliar—which is pronounced to an English ear with a double "oo" like the eighteenth-century spelling *Hindoo*. This drawing, along with a recently published old poem about Muttiyappan Mudaliar's munificent patronage of the Kapaleeswara temple (M. K. Raman 1983) situates the temple within a world dominated by this new commercial community with strong ties to the land.

The Mackenzie diagram with its hand coloring, at once a survey and a picturesque drawing, delightfully depicts the separate shrines with their cupolas and the temple tank with deep blue water. Yet the drawing compares

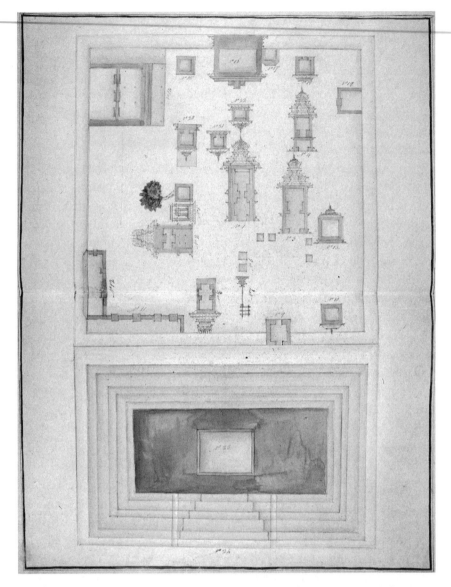

FIGURE 2.2. "Cabalesevara Pagodas" from the Mackenzie Drawings of Indian Sculpture provides a detailed diagram of the major shrines within the Kapaleeswara Temple as it was at the turn of the eighteenth century. Reproduced by permission of the British Library.

amazingly well to several sources: current diagrams of the temple complex (Kapaleeswara Temple 1978?), a detailed description of the temple that draws on a major Tamil source (Ishimatsu 1994, 104–110), and my own experience. Even if the rendering of names from the Tamil is frustrating, the artist-surveyor clearly spent time in the temple and probably was one of the many Brahmans employed by Mackenzie for the surveys he made of northern Tamil country at the turn of the eighteenth century (Dirks 1993, 294). The major shrines within the current complex occupy the same location as on the drawing. The sanctums of Kapaleeswara and Karpagambal rendered in the drawing as separate vimanas are now immured with a common multipillared portico. The present vimana for younger son of Shiva and Parvati, Subrahmanya (Murugan), was there in 1800, but the faded hand-written legends that identify each numbered element on the plan call it "a church of Soobramanya Sawmy or 6 Headed deity newly built by Verabadra Moodr." Curiously, behind this new shrine was another vimana for Subrahmanya identified as "an old church of the said . . . which was repaired by Moottyapah Moodr." The "old church" has disappeared in the contemporary temple. While the builders of the "Cabalesevara Pagoda," the shrine for Shiva, are named as "Bagavintorayer, Causy Mood and Coomy Valapa Mood.," the sanctuary for the goddess is called "an old church . . . which was repaired by Mootooapa Mood." Behind this vimana is a drawing of a tree next to a "new church to the said Goddess . . . built by Cavoor Subarog Mood." The sanctum, next to the still-living punnai tree, now houses a key image for the Mylapore area, Parvati in the form of a peacock worshiping a linga. The sanctity of Mylapore as well as its name derive from the legend associated with the fall of the goddess from her Lord's grace and her purification here at My-lapore by this pious worship of her estranged husband in his form as the linga. The new addition of this reference to Mylapore within the temple complex, along with anonymity of the builder of the Karpagambal's "old church," raises serious questions. In contrast with the clearly named builders of the new house for the reigning Lord, this anonymity for the builder of his consort's shrine is curious—an issue to which I will return. The specificity in naming the patrons of each shrine gives the impression that the mapmaker was working with living memory, which would date these major renovations to the latter half of the eighteenth century.

Such intriguing questions about the origin of this temple should not distract us immediately from more crucial information in this mesmerizing drawing: the names of those who built or repaired the shrines. With the exception of "Bagavintorayer," all of those named are Mudaliars, with "Moottyapah Moodr." appearing prominently. Under his Tamil name Muttiyappaṉ Mutali-yār, he is credited with rebuilding this temple in the *Tirumayilai Ula*, a pane-

gyric poem for the city of Mylapore composed in his praise (Ishimatsu 1994, 103–104; Muthiah 1992, 173; see also M. K. Raman 1983). In the key verses of this Tamil poem (quoted in Ishimatsu 1994, 104 n.20), the poet praises his patron in extravagant language for building a *poṇkōvil*, a golden or lustrous temple, a walled lotus pond, and a gopura, which he calls a "wonder of the four worlds," as well as mandapas (porticos), the wall surrounding "this holy abode," and a "pure golden, gem-studded tall chariot (*tēr*), the grandest vehicle for processions. "Lustrous" mada streets are "praised even by the celestials," and their beauty "humbles the assembly of the great." The verses end with the poet singing "Praise to Muttiyappaṇ, long may he live, seated majestically in the world."[10] The colonial drawing and the poem corroborate each other up to a point. In the detailed legend that follows the drawing, Muttiyappan's name appears frequently as each numbered shrine is identified. However, he is not credited with building either the main shrine or the two shrines for the goddess. "Moottyapah" said to have repaired the old shrine for Murugan and built several new smaller shrines. He built new gopura at the east and the old western entrances. The mapmaker also credits the pavilion in the middle of the tank and all of the walls and steps around the tank to this same donor. Muttiyappan may not have actually rebuilt the entirety of the temple, but the panegyric sets the munificence of this Mudaliar in words fit for a king.

Kapaleeswara and his new temple acquired a more royal tone during this period in the late eighteenth century. The newly built shines, which the old drawing attributed to Mudaliars, reveal much about the values of this prosperous group. The temple that welcomed devotees in 1800 would have seemed quite large and complex, if we take this drawing as basically accurate. Entering the eastern gate crowned by the new gopura built by Muttiyappan, devotees would be greeted by Vinayaka (Ganesha), the Lord of auspicious beginnings, standing in his new sanctum also constructed through the patronage of Muttiyappan. Following the prescribed clockwise direction, to the immediate left of the new gate would be "a room or place for making a kind of heathenish Sacrifice" no longer identifiable or extant, but possibly a version of a bali pitha, a place to make an offering in honor of the old spirits of the earth. Moving around, the devotee might stop for a moment at the now-missing shrine for Surya (the ancient sun god), newly built by Muttiyappan.[11] The worshipers would offer homage to the younger son of Shiva at the old shrine repaired by Muttiyappan for Subrahmanya who, assuming his ancient Tamil name of Murugan, would emerge in the early twentieth century as the quintessential Tamil god—at the moment when caste groups like the Mudaliars reclaimed their preeminence from the Brahmans who dominated the powerful colonial bureaucracy. Passing the new kitchen also built by Muttiyappan, devotees would

finally reach his new shrine for the now-missing and still mysterious "Poon-nungaleswarer."[12] The newly built abode of Subrahmanya would then have faced another nonextant shrine whose image appears to have joined other displaced stone images on the outer walls Kapaleeswara's sanctum. This abode was to the right of the new western gopura and housed "Virabadra Sawmy," a destructive form that Shiva assumed at the request of Parvati to defend the proper form of sacrifice. To aid her husband, the goddess assumed her terrible form as Badrakali (Gopinatha Rao [1914] 1993, 182–188). Her now-missing shrine once rested near the western gopura, another of Muttiyappan's dona-tions, which opened toward Subrahmanya. This little gate is now usually locked and appears to have yielded precedent to a new larger western gate, which faces the main Kapaleeswara sanctum. Once past the then-new flagstaff in front of the main sanctum and coming into the presiding Lord's presence, devotees would turn to the south, an area dominated by the goddess. Here was her main shrine standing separate from her husband's abode. Just next to the goddess another reminder of Mylapore's sanctity had been added. Under the ancient punnai tree, still alive and considered one of the oldest trees in Chennai, a new small sanctum housed an image of a peacock worshiping the linga—a refer-ence to the founding story for Mylapore, which will become very important below. The final two shrines, also donated by Muttiyappan, faced his new mul-tistoried eastern gate, Jagadeeswara, a form of Shiva as Lord of the World, and Sundareswara, the name of Shiva at the great temple of Madurai.

What alterations, beyond the structural, did the Mudaliars create in their rebuilt Kapaleeswara Temple? Even with the scant information about the orig-inal temple, a pattern emerges. The Mudaliars appear to have thoroughly do-mesticated their ascetic Lord. As Indira Peterson comments, "Shiva in the *Tēvāram* is rarely portrayed as the playful householder . . . the god's wife and his two children (Skanda/Murugan and Gaṇeśa) are no more than shadowy figures in his personal history" and the role of the goddess is "a relatively subdued one" (1989, 101). Indeed, Sambandar's song in the old *Tevaram* makes no mention of Shiva's consort Parvati or any of his children. The temple takes its name from Shiva as Kapaleeswara, the form he assumes at the dissolution of the cosmos, an ascetic holding a skull (kapala) as a begging bowl. Historians frequently relate the name to the Kapalika, a once-important sect of Shaivas who took their name from the skulls they used as begging bowls (for example see Ishimatsu 1994, 99; also Davis 1991, 14 n.22; Lorenzen 1972). Today this old association of Shiva with his radical ascetic roots is displayed on the evening of the ninth day of the Brahmotsavam festival, when a float emerges from the temple with Shiva as Bikshatana, the naked ascetic with a begging bowl who humbles a group of female ascetics who had refused to worship him as the

supreme Lord. As priests explained to me, the float shows these ascetic ladies in various states of undress, so overcome with passion for the handsome divine ascetic that they lose their mental chastity (see also Wendy Doniger [O'Flaherty] 1980, 139–140). Interestingly, this manifestation of Shiva occurs one night before his grand wedding to the goddess. In this grand festival, God's ascetic nature is thoroughly contextualized within his role as a husband and king, much like the familiar portion of an orthodox wedding ceremony when the groom, just before the marriage, threatens to go off to renounce the world and retire to Banaras. The grand Brahmotsavam festivals display Shiva as a king deeply devoted to his divine consort and his sons. Indeed, he is inseparable from them. Underneath the layer of clothes and jewels, the Lord Shiva appears in his most domestic bronze image as Shiva Somaskanda, eternally seated in "the mellowness of married life" with Uma (a form of Parvati) at his side and Skanda (Murugan/Subrahmanya) as a small child standing between them (Smith and Narsimhachary 1997, 38; also Waghorne 1992).

Parvati, here named Karpagambal, also appears to have her former independent powers now circumscribed by her role as wife and mother. Karpagambal, which means "She who grants all the wishes of her devotees, just like the celestial tree, Karpagam, which grants everything asked for in Heaven" (Kapaleeswara Temple [1994]). In the small shrine under the punnai tree, Parvati appears in the form of a peacock who worships Shiva by pouring water from her beak over the linga. According to a current retelling in an English-language brochure, "Lord Shiva was narrating in detail to Parvathi about the good effects of adorning the forehead with holy ashes and of chanting the panchakshara, etc. when she was distracted by the presence of a peacock with its spreading plumage, as a result of which, she was cursed to become a peacock by the Lord. The curse was freed after she came on earth and offered worship to the Lord of Mylapore in the form of a peacock" (Kapaleeswara Temple 1978?, 4). This image appears frequently in Mylapore, "the city of the peacock" (T/ *mayilappūr*). In the Radha Silk Emporium, the peacock adorns silk saris and wall hangings. In a nearby temple, an inventive flashing neon sculpture creates the illusion that the peacock's head is bowing to offer worship during festivals. The ubiquitous depiction of Parvati's atonement attests to Shiva's lordship, but a few unsettled issues are still in play between God and Goddess. Perhaps this tale simply sermonizes about a disobedient wife, but reading the much older Tamil story of the place, the sthalapurana, David Shulman suggests that the peacock's erotic association signals a fall from chastity. Shulman places this narrative in the context of many others dating from the sixteenth century onward in which a seductive local goddess entices the great Lord Shiva to take up residence in her abode.[13] Shulman translates the story as told in the *Tiru-*

mayilaittalapurānam, which follows the modern retelling but adds the detail that Shiva "promised the curse would end if she worshiped in Kapālinakaram (Mayilai = Mylapore). The goddess went there and made all the waters of the world enter the Kapālitīrtha [the temple tank]; she bathed there and worshiped the god. Śiva appeared on the bull and gave her back her divine form." [14]

Although many contemporary devotees may be uncomfortable with his proclivity for Freudian analysis, Shulman's insights reveal the goddess here in familiar context, as a powerful independent amman (village goddess) like the one found just down the road from this orthodox temple, Mundakakkanni Amman. Like Parvati, she resides under a tree, with strong associations to water. The shrine for Parvati's manifestation is called "punnai vanam," a term associated with groves of these fragrant trees that recall lines in Sambandar's great song. The Mudaliar builders probably relocated their Kapaleeswara Temple to land where a goddess dwelt under such a tree—a common location for an amman, whose shrines are scattered over many old neighborhoods within the city of Chennai. These goddesses will become prominent in the next chapter. Karpagambal now functions very much like a Tamil amman, an independent goddess deeply involved with her devotee's social, mental, but also material needs. In my conversations with nearby merchants, they considered her gracious munificence the supreme attraction in this temple. In the eyes of many devotees, Shiva's once-errant wife still rules their hearts, as she may have ruled this holy site long ago. Devotees remember that Parvati's fabulous power called forth by deep devotion ultimately lured her divine consort here to Mylapore. Thus under the protection of the Mudaliars, a domesticated Shiva with his now-penitent but powerful consort fulfilling all good desires and their two sons function as a divine royal family dispensing spiritual grace and caring for the worldly needs of their faithful devotees.

The rebuilt Kapaleeswara Temple in this Mackenzie drawing, like the map of 1798 from the same decade, marks a moment when Mudaliars—not the Brahmans whom Milton Singer later identifies with this temple—were numbered among the very elite Indians of this commercial city. The Ross map of 1798 shows "St. Thomé" thickly settled from the shoreline to the temple with nondescript blocks of houses filling the streets south of the temple and tank. To the west are still paddy fields and with groves of trees surrounded by unidentified fields. Visible also are several other tanks that indicate temples—which can be identified with some of the shrines now numbered among the Seven Lingas. The 1822 survey map of Madras created for the "Justices in Session" by civil engineer W. Ravenshaw (figure 2.3) shows the Kapaleeswara Temple and tank surrounded by houses, with the old fields virtually reduced to back yards. In a significant change, grand garden houses have appeared in

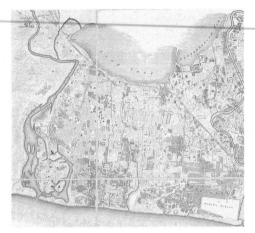

FIGURE 2.3. A detail of old "Saint Thomé" from the 1822 map of Madras created for the "Justices in Session" by civil engineer W. Ravenshaw shows houses already closely filling the area around the Kapaleeswara Temple. Note the old "Long Tank" and the Nungambakkam tank. Reproduced by permission of the British Library.

the field between old Mylapore and its former satellite city Triplicane. This was the Great Choultry Plain, which stretched from old Mount Road to Mylapore and north to the banks of the once-huge but now drained Long Tank. The filled area has become the still-fashionable Nungambakkam. The legend of this map, as of the 1755 maps of Conradi from the last chapter, list these great garden houses and their current owners. Among the elite English, Scottish, and old Portuguese names are a number of Chettiars and six Mudaliars. There is only one Brahman of this stature. At that time, many Mudaliars acted as Dubashes for the Company. Memories of the demise of the Moghul Empire were fresh then, and the Company made a great pretense of ruling in the old emperor's name throughout India. Here in the Carnatic, after a decade of war in the 1790s with the brief but brilliant Muslim dynasty in Mysore, the Company ruled in the name of the newly recognized nawab of the Arcot, who was busy building an image of legitimate Muslim sovereignty (S. Bayly [1989] 1992, 164–168). The age of mercantile power had arrived, but the model of royalty—albeit Muslim—still prevailed and has left its mark even today. During the Brahmotsavam festival, the Lord stills rides in procession dressed as a Moghul emperor, the last model for an Indian overlord.[15] Much as for the British bourgeoisie throughout the nineteenth-century, the model of fashion for the rising middle classes was still the prince—at least where gods were concerned. The Kapaleeswara Temple preserves not its ancient past but the memory of this

period of transition when Mudaliar money rebuilt a temple in an Indian royal idiom for the coming age of colonial bureaucracy.[16]

Other temples in Mylapore are also masked mementos of this key historical moment. One such temple on Royapettah High Road south of the Kapaleeswara was constructed by a dubash not of the East India Company but of its famous rival, Tipu Sultan, according to the current hereditary trustee. A large gopura now sandwiched between storefronts and billboards marks the temple for Sri Anjaneya Swami, usually known as Hanuman, the heroic servant of his Lord Rama. The trustee-manager of the temple, a descendent of the founder Cālivāhaṇavam told me this remarkable story.[17] His ancestor came originally from a non-Brahman family from Andhra county and settled in what is now the state of Karnataka; the family became known as the Shetty community and finally took the title of Chetti in Madras.[18] When Tipu Sultan became the ruler of Mysore and challenged the British, Cālivāhaṇavam served as his dubash. At the time, according the my kind informant, after closing all of the temples in the south and other places, "Tipu had become as a Hindu" under the tutelage of a guru at the great temple in Srirangam near Trichinopoly. Later this dubash resettled in Mylapore along with the Arcot nawab (probably in a similar capacity), and "under the instructions of the Arcot ruler ordered this Anjaneya here."[19] The manager guessed that this form of Anjaneya as Vira (heroic) Anjaneya fit Tipu and those warring times. A signboard in the temple lists all of the trustees beginning in 1800, and three photographs of ink drawings show the transformation of the temple from a simple flat-roofed shrine set amid trees and surrounded by a short compound wall, to a large gated structure, and finally in its current urban setting with the ornate gopura. Whatever historical accuracy of family tradition may be,[20] the temple marks the moment when the dubashes as a class moved between rulers and territories, before boundaries became fixed and bureaucracy ruled in the place of living and now legendary kings. Hanuman as the flying son of the Wind stilled in stone epitomizes the year 1800.

This brief period of dubash ascendancy in Madras lasted less than a half century but had major cultural impact. The problem, as we will see, is that this impact was discretely enfolded into the cultural consciousness of the rising new middle classes, some of whom were the descendants of the dubashes but many more who were the educated Brahmans that Singer associated so closely the Great Tradition. The story of the Brahmans in their roles as middle-class city dwellers must wait for the next chapter. At this point, the Dubashes—now appointed by the British—assumed the cultural role of kings—or at least a much-removed version of royal style and royal largesse. The Indian bourgeois at the turn of the eighteenth century in Madras occupied the middle ground

not only between the British and the populace but also between the masses and the old royal elites. By the nineteenth century, the remaining Tamil royal families, now confined to the rural hinterlands, continued to operate on older patterns of seemingly excessive royal largesse and a grandeur out of context with their actual financial and political power—at least that is how they appeared to the urban bourgeois of both the Indian and British variety. The bourgeoisie considered rajas such as the Tondaimans of Pudukkottai less truly educated and less refined than the new urban elites. The royal imagery in the temples that the new urbanites adopted recalled the times of the great Vijayanagar and Chola empires, not these upstart "kings."[21] Mudaliars openly acted in royal roles as temple patrons. As landowners as well as Company officials, this community ruled over very "little kingdoms" on their own estates, but their reign ended quickly. The Kapaleeswara Temple remains but one trace of their largesse. Their pretensions to royalty were brief but fortunately preserved in a old Sanskrit manuscript, the *Sarvadevavilasa*, discovered and later edited and published by none other than Milton Singer's guide, Dr. V. Raghavan (Raghavan 1958). The text stills that fleeting moment when learned Brahmans earned their livelihood by composing panegyric poems in Sanskrit for wealthy Mudaliars and other Dubashes, just before the Company bureaucracy would shatter Dubash power and scatter their many duties into new, often petty, civil offices. Ironically, such learned Brahmans would soon occupy these Company positions.

The *Sarvadevavilasa*, "a refraction of a brief period of Vellala/Dubash ascendancy . . . captures perfectly the 'urban' cultural discourses of a significant segment of the Indian elites of the city at a moment of transition," as Indira Peterson tells us (2001). In the lavish style of the poem, two Brahman interlocutors openly name four Dubashes—"Kalinga, Lord Ranga, Devanayaka, and King Vedacala"—as not only kings but also incarnate gods. These patrons support cultural activities, all with religious overtones—scholarly debates, the performance of dance, the composition of Sanskrit verse, and the composition of Carnatic music, which soon became the definitive south Indian classical style. They were temple trustees and lavish donors. In sum, these "kings" embodied "the traditional ideal of elite *dharma*" (Peterson 2001), at least in the eyes of their Brahman clients. What they were to other Madrasis remains a question, but as late as 1822 even the Ravenshaw map records their names along with British, Muslim, and old Portuguese gentry among the masters of grand garden houses in the then new "Town of Madras." In the area of "Saint Thome"—then extending west to the shores of Long Tank and "Nungumbaucum [Nungambakkam] Tank," south to the "Audiar [Adyar] River," north to "Triplicane," and east to the sea—the masters of two grand estates are the same patrons

that figure prominently in the *Sarvadevavilasa* as well as other British records of the time.[22] "Colingaroy Moodely," listed as the owner of a garden house marked on what is now Royapettah High Road within a mile from the Kapaleeswara Temple, assumes his proper name in this poem as Kalinga (Kalingaraya Mudaliar), one of the munificent patrons. Another much-praised patron, Vedachala (Vadachalam Mudaliar), appears in Ravenshaw's map as "T. Vadauchella Moodely," owner of a garden house in Nungambakkam located east of the Nungambakkam Tank. The garden house of another lauded patron, Deva Nayaka (officially Subba Deva Nayaka Mudaliar), does not appear in the 1822 map, but his name as well as those of Vadachalam and Kalingaraya appear in official British records (Neild-Basu 1984, 12 and 26). Deva Nayaka's descendants have recently renovated his great Agastheeswara Temple near his former estate, once on the banks of the grand tank at Nungambakkam. This now brightly painted temple adds renewed color to a once-faded memory.

Why is such a brief period of cultural production by these Dubashes so important? The early Indian Company merchants built more temples, held power far longer, and left a more visible impact on cityscape of Madras in the current contours of Georgetown. In contrast, the Dubashes appeared to renovate older temples and almost disappear from common consciousness in the process. Even as late the 1950s, most Mylapore resident considered the present Kapaleeswara an ancient temple and needed to be reminded of the seemly obvious facts that the temple did not follow the Pallava style of its supposed origins, nor were there any of the usual old inscriptions inside (K. V. Raman 1957, 32–36).[23] Subba Deva Nayaka's Agastheeswara Temple seems the exception but, as we will see, in good Mudaliar fashion the temple evokes antiquity. Even the literary sources that extolled the Dubashes lay unread in the Adyar Library until Raghavan began his research for early Indian sources for the tercentenary celebration of the city then at the verge of Independence (Raghavan [1939] 1994, and 1958). The importance of the Dubashes lies in their recreation, "invention," of the very idiom of a settled or rooted tradition. The Hindu temple becomes the palace of a divine Lord controlling a kingdom no longer obviously of this world. Ironically, when Milton Singer set out to find the "Great Tradition" in Madras with its assumed epicenter in Mylapore, he could see only Brahmans in their roles as pandits and priest as maintaining tradition within the modern world—once again evidence of the disappearing Dubashes.

The Dubashes spoke two languages in a complex sense. Not only did they act as go-betweens for the Company in Madras city but they, unlike the earlier Indian Merchants, mastered both an urban and a rural idiom. Historians of south India describe a complex network between the city and the hinterlands

near Madras during this era from 1750 to 1800. Until the 1780s, the Company controlled only the city of Madras and some of the surrounding areas. After uncertain decades of wars with the now-legendary Hyder Ali and son Tipu Sultan, final victory brought the rich agricultural area to the west, south, and north of Madras into Company hands, which they called the Jaghir.[24] During this same period, the Company in London forbade its civilian and military officers to engage in commerce—once a grand "supplement" to meager salaries. In addition, trade faltered during this period, leaving the recently acquired territories a new source of wealth for the ambitious, both Indians and British (Neild-Basu 1984, 9). The story of the struggles over land revenues is dizzying (see Irschick 1994), but the point remains: focus shifted from control of commodities to control of land revenues. With this economic change, Irschick argues, came a change in consciousness that he describes as cultural "restoration"—"an important shared project for local inhabitants and British administrators . . . key actors included Tamils concerned with explicating cultural identity for the region called Tondaimandalam" (67). This grand intellectual project matched a political project to fix ever-shifting boundaries and equally footloose people to the land. For the British administrators, this insured the flow of land revenue, which helped finance the ever-expanding bureaucratic regime. In these hinterlands, ever-active District Collector Lionel Place, whom we met in the last chapter, helped restore the ancient Varadaraja Temple in Kanchipuram and revive a temple-centered Hinduism (80). Most important, I would say, was his glorification of *ancient* temples, his mapping of these into the land and onto Tamil—and with it the European—sensibilities as emblems of fixedness. This rural project of the Collector was matched within the new borders of Madras by the activities of many key Mudaliars—most apparent in their reconstruction of the "ancient" Kapaleeswara Temple.[25] As supposed sons of the soil, the Poonamallee Mudaliars had a stake in fixing their associations with a stable place, as did many of their fellow landholders, which included Brahman as well as other Vellalar communities.

The construction of "tradition" for the Dubashes also meant patronage of Sanskrit pandits, poets, and musicians as well as temples. The twentieth-century reconstruction of Tamil culture with its sharp divide between indigenous Tamil and imported Sanskrit would have made little sense to these purveyors of a soon-to-be classical culture. The temple of the Dubash Subba Deva Nayaka Mudaliar well illustrates this. His massive Agastheeswara Temple, dedicated to Shiva, centers another old neighborhood, a vivid vestige of the Dubash era with an old village atmosphere just off the now trendy Nungambakkam High Road, which remains dotted with many smaller temples (see also Mines 1994, 118). This network of Shaiva and Vaishnava temples were all founded by

Subba Deva Nayaka Mudaliar, identified in my conversations with the executive officer as a Tavalai Tondaimandalam Vellalar and a Dubash for the East India Company. The executive officer emphasized that the founder was a staunch Vaishnava. When I asked why he founded such a large Shaiva temple, the officer replied, "He must have had a magnanimous mind." A gilt-framed portrait inside the temple offices shows this lordly Company's middleman dressed in traditional white with a dhoti under his Moghul-styled tunic; a white turban covers his head and Vaishnava markings imprint his forehead (figure 2.4). He

FIGURE 2.4. This garlanded portrait of Subba Deva Nayaka Mudaliar hangs in the offices of the grand temple that he founded in Nungambak-kam. My thanks to the officials of the temple for allowing the photograph-ing of this and other parts of the Agastheeswarar Temple.

sits majestically on a grand chair with the kind of scrolled gilt wooden arms that would later mark the nineteenth-century thrones of India's remaining native princes. Without doubting his magnanimity, his choice to dedicate the temple to Shiva as the Lord of the sage Agastya makes perfect sense in the context of a recreation of ancient Sanskrit culture. Agastya lived in the Tamil consciousness then, as he does now, as the Vedic sage reborn from a sacrificial fire pot by Shiva's grace.[26] He lowered the Vindhya Mountains, the gateway to the south, and carried Vedic/Sanskrit learning to Tamil country. By the nineteenth century he was called "the originator of Brahmanical colonization" as well as the ascribed author of "Ancient Tamil works in nearly every branch of science" (Oppert [1893] 1972; also Shulman 1980, 316). Agastya's lord and savior was Shiva, a connection no Vaishnava could deny. To honor the sage of the south, the linga had to grace the sanctum of this temple.

The Dubashes in the *Sarvadevavilasa* concentrate their religious activities around ancient temples throughout what would become the state of Tamil-nadu. Vadachalam serves as dharmakarta (trustee) for the famed temple to Shiva in Chidambaram (Peterson 2001). In this case, the fawning poet may have elided his identity with that of the far more famous Mudaliar patron of Chidambaram, Pachaiyappa Mudaliar, founder of Pachaiyappa's College in Georgetown, whose image stands near the east gate of the great ancient temple (Younger 1995, 147). Pachaiyappa, along with "Swamy Naik," another honored name on the Ravenshaw map, lived in Komaleeswaranpet, which became another temple neighborhood popular with late-eighteenth-century Indian gentry (Historicus 1951, 19–21)—another story of the construction of tradition yet to be fully told. By the late eighteenth century, the British along with their close partners the Indian Merchants, are written or rather sung out of the temples and out of serious dialogue with temple culture. The heterogeneous temples of Blacktown, which may actually be older than the recreated Kapaleeswara, disappear to be replaced by *ancient* temples, revived or remodeled or recreated. The point is pressing: an older tradition of heterogeneity fades into a newer tradition of antiquity.

This return to a reverence for antiquity was at the same time a construction of indigenousness within the now-defined borders of a city—albeit a collection of towns and villages not quite literally a megalopolis. Concomitant with this, the turn to ancient temples meant a return to royal imagery. Not only were the Dubashes portrayed as kings but the deities whom they patronized and worshiped as devoted servants were also set firmly into a regal world. Arjun Appadurai's description of the Parthasarathy Temple during this same period of transition, 1800–1820, confirms what he understood as the unbroken continuity of the image of God as king.[27] He set this in the context of the loss of

considerable power by temple trustees to the Board of Revenue, which technically now controlled the temple but in a very complex and ultimately negotiated sense (1981, 111–116). This loss of power looms in the much-debated issue, which I outlined in the last chapter, over the Company's reluctance to assume royal authority and the cultural vacuum created in the temple—a void that Appadurai sees as devolving on the "merchant-brokers" (1981, 109). Appadurai conflated what others have now identified with two distinct groups, the Merchants and the Dubashes. Certainly, the *Sarvadevavilasa* as well as the *Tirumayilai Ula*, that poem in praise of the (re)builder of the Kapaleeswara Temple, firmly set the Mudaliars on the throne, but what of their divine Lord? Appadurai, early in his now-classic book, poses the question of "what the deity rules." His answer, which now has almost canonical status: "The deity is a sovereign ruler not so much of a *domain* as of a *process*, a redistributive process" (22). But suppose the question were posed again in the context of the landed power brokers of this interim age. Over what does a revived divine sovereign rule? And why is divine sovereignty reconfirmed in an age when power vibrated between mastery of nearby land and mastery of what we might call human resources management? The tone produced was ultimately both discordant and harmonious.

The Dubashes came to brief power at a time when the British faced local complexities. Persons called dubashes also functioned as part of the older trading system, acting as interpreters and middlemen, but now their local savvy made them far more important than the former Company Merchants whose interests looked out toward the coast. The Dubashes controlled, it seems, knowledge (Irschick 1994, 73), people, and money—they had revenues from land and cash to lend (Neild-Basu 1984, 22). Put simply, the Dubashes dealt in transactions—they were not directly involved in the production or trade of commodities. The only tangible resource was their land, and even that amounted to managing a complex system of revenue sharing. The only thing they farmed was taxes. Like their divine Lord, they had no tangible domain aside from their grand garden houses. I can only suggest at this point that the "cultural model" that Appadurai draws of a "redistributive process" at the center of the temple fits remarkable well with the Dubashes' role in the polity of the Jaghir at the time. And the Parthasarathy Temple shows up in the *Sarvadevavilasa* as a favorite site for the kingly Dubashes who have no actual domain. Does the centrality of the redistributive process in the temple really continue a basic cultural structure? Or at this modern moment was this redistribution model (re)constructed *in imago Dubashi*?

For all of their attempts to melt into a world of ancientness, Dubashes were fully a part of the modern world. I view them as key players in the con-

struction of a coming middle-class mentality. According to Indira Peterson, the *Sarvadevavilasa*, although an admittedly mediocre literary work, was a signal of significant changes from the usual poetic genres of the time. The poem focuses not on social groups as a whole but on individuals. Although the Dubashi "divinities" use their status as local landholders, their glory depends on the wealth acquired by their own wily talents as servants, albeit powerful ones, of the new British-controlled regime. As Peterson puts it, "barely concealed beneath the metaphor of god-kings is the metaphor of entrepreneur/broker as king." An important aspect of their modernity: they acted as a *class* not a caste. They belonged to several different land-holding communities some of whom were Brahman (Neild-Basu 1984, 16). Their fame came as individuals—what Mines called the "big man" (Mines 1994). But perhaps the most modern aspect of the Dubashi mode was their creation and patronage of a *definition* of a tradition that hides its heterogeneity, and voids its most recent past for the sovereignty of God and the glory of supposed antiquity in the very face of modernity—all of those activities that Singer saw and grouped under "compartmentalization" and "traditionalization" (1972, 399) without realizing the historical precedent in the East India Company Dubashes and their fellow local landed elites.

There are many messages written in temples that do not appear as inscriptions. The Kapaleeswara had many such messages left within its smooth stone walls that hint at the transition from the Poonamallee Mudaliar religious sensibilities to those of the coming middle class—especially in the rise of what might be called "family values." Under their patronage, the acetic Lord Shiva came to live with his powerful consort and the two sons in a grand house, which soon became the focus of a surrounding neighborhood. The elite Mudaliars lost control of the area, but their cultural style embedded in the grand Shiva temple passed into new hands. An old revenue survey of Mylapore from 1855 still shows tree-lined streets surrounding the temple and its enormous tank ("Mylapore Division 1854–1855"). Closely built city houses and possibly shops appear on its east and north sides, and grand garden houses are spread out toward the west. This was the moment when Mylapore began to develop as an elegant residence for the city's rising Indian professionals and new bureaucratic class, the majority of whom were Brahmans. Brahmans dominated the bureaucracy and the courts by the turn of the next century. The publication in 1893 of the official sthalapurana of the Kapaleeswara Temple, edited and with commentary by Mudaliars, may reflect a challenge to this growing Brahman power. After a court battle at the turn of the century, members of the Mudaliar community secured their right to seats on the board of trustees for this grand temple (see Nambiar and Krishnamurthy 1965, 204) and frequently

had the right to sponsor various portions of festivals in the temple. In the 1950s, Singer rightly identified Brahman communities—especially the Smarta Brahmans—as the elite of the area. Ironically, he froze their supremacy into the American scholarly consciousness at another key moment when they were about to lose precedence and political power to a coalition of non-Brahman groups who comprised the soon-to-be ruling DMK party in Tamilnadu.

The public ethos of Kapaleeswara, however, continues to emphasize elegance in ritual and refinement in thought. The nearby Kuppuswami Sastri Research Institute emphasizes the study of the Agamas, the texts ordaining proper ritual, and Shaiva Siddhanta, a major philosophical-theological and ritual system closely associated with Tamilnadu. The well-known institute has hosted several foreign scholars whose work now adds so much to our understanding of the interplay of pragmatic ritual, Sanskrit texts, and philosophy (Davis 1991, Ishimatsu 1994, Prentiss 1999). One of the two head priests, Dr. Viswanatha Sivacharyar, served as a professor and head of the Department of Sanskrit at nearby Vivekananda College.[28] The Kapaleeswara Temple published an interesting set of lectures on "Siva Agamas and Their Relationship to Vedas" (A. S. Mudaliar 1972). The trustees celebrate the annual Brahmotsavam festival with unrivaled opulence in this wealthy city (see Waghorne 1992). Along with this refinement comes continued concern for ritual purity and a more conservative social environment. Propriety and general good taste seem to create an uncomfortable atmosphere for the poor and uneducated. In my many years of work in and around this temple, I have rarely seen local slum people within its precincts except children late at night. Although the temple officials and priest are gracious to visitors, the sign above the inner sanctum reads "Hindus only." But it would be a mistake to believe that the temple is exclusively Brahman-controlled. Rather, the predominance of Shaiva Siddhanta theology in the Mylapore area reflects an earlier era of social integration that evolved a new orthodoxy, with the Sanskrit Agamas considered equal to the Vedas. As the lectures published by the Kapaleeswara Temple put it, "While the Vedas are restricted to the three varnas, Agamas are open to all" (A. S. Mudaliar 1972, 14; see also Davis 1991, 41). In practical terms, this openness in the Agamas allowed learned and wealthy members of landowning and merchant communities, who were technically Shudras (thus excluded from the highest rituals in the Vedas), to qualify fully for the highest religious attainments, which centered in the temple and the maintenance of temple ritual. In Mylapore, this kind of high culture lives within the interrelationships of the Brahmans as temple priests and learned pandits and their merchant (Chettiar) and landholding (Mudaliar) patrons. I have often heard it said that the Chettiars/Mudaliars and the Brahmans have long formed a key alliance on which

temple culture depends. A look at the names of the board of trustees and the publications of the Kapaleeswara Temple illustrates the point.

This kind of seemingly lavish display—a continuation, I am arguing, from the old Dubashi style—is exactly what raises the ire of many current critics of the interlocking rise of "Hindu fundamentalism" and middle-class consumer mentality. For P. Varma in his *The Great Indian Middle Class*, a Hindu temple is not "an ethical center."

> Temples in India will have their coffers overflowing with personal donations from the religiously active, but few of the donors would see much spiritual merit in using the same money for the alleviating the misery of the thousands of visibly poor around them. The donation to the temple deity cements the pact that each one of them has at an individual level with his saviour. The question of using one's wherewithal for the benefit of the deprived may fall in the diffused category of meritorious work, but it is not as efficacious, in terms of spiritual or material benefit, as the private world of religious endeavour. (Varma 1998, 125)

Although not accurate as a summation of the complex world of Hindu social life, Varma's blunt statement reflects attitudes of certain educated urban middle-class people. Oddly, even as he criticizes the incipient "fascism" of the BJP, he bemoans the very aspects of current Hindu consciousness that such "fundamentalist" groups seeks to correct—the supposed lack of a strong fellow feeling and a strong national community spirit (see Hansen 1999, 77–80). The real issue here is the relationship of the "inner landscape" of a Hindu to the neighborhood community, as current urban theorists put it—"a feeling for the public identity of a people, a web of public respect and trust, and a resource in time of personal or public need" (Jacobs [1961] 2000, 16). Ironically, this public community is exactly what the "lavish" spending on temples seems to create, especially in the context of the Kapaleeswara Temple with its long legacy of bourgeois elegance constructed by eighteen-century patrons whose wealth derived from their ability to mediate and broker relationships in the colonial world. The Kapaleeswara, and the neighborhood it continues to anchor, was never about the private world of personal endeavor.

The Dubashes created a network of culture. The *Sarvadevavilasa* shows them moving from one temple to another as each patron lavishly celebrated a festival at *his* temple. Sometimes they traveled from garden house to garden house as each patronized a poetry or music recital. The Dubashes built loose networks on a framework of antiquity as a shared heritage—built with music,

with poetry and discourses, but most concretely with temples. The sense of Madras as an urban area knit together by temples needs some revision at this point. The period of the Dubashes, I am arguing, brought a second wave of temple (re)construction in the modern period. Eclecticism in the sense of contrasting deities sharing a common space and innovation in the open acknowledgment that the new temples were *new* gave way to a concern for antiquity and for specificity in traditions. Looking back on the last chapter, this change appears in the rebuilt Town Temple in Georgetown, if we look carefully again. Recall the date of that reconstruction, 1766, and the name of the new chief patron, Muthukrishna Mudaliar. He was the Dubash to Governor Pigot (1755–63 and 1775–77), but is also remembered as the last of the Chief Merchants (Ramachandra Dikshitar [1939] 1994, 361; Muthiah 1992, 279). His Town Temple can be read in two directions. Looking back to the passing period of Merchant power, this remains the town's temple created by subscription from a wide variety of donors but with its eclecticism highly modified. Looking forward to the new period of Dubash ascendancy, the Lords Shiva and Vishnu occupy the same site, but in two separate temples built side by side with the same Dubash credited for both (Nambiar and Krishnamurthy 1965, 190–191). Fryer's description of the old Town Temple quoted in the previous chapter tells of multiple "Chappels . . . one for every Tribe." The new Town Temple as the Chenna Kesava Perumal–Chenna Mallikeswara Temple creates borders symbolically and literally in the brick wall between the two temples, with an almost unnoticeable small door connecting them in the back. And this new Town Temple, after all, is a reconstruction of an admittedly not ancient but still older temple, the kind of reconstruction seemingly favored by the Mudaliars. With proper bali pitha, gold-covered flagpoles, and small pavilions for each deity's vahana, both are textbook examples of the new propriety in temple construction that came to define orthodoxy. An interesting little book by a French architectural historian in at the turn of twentieth century ironically legitimates this definition. In *Dravidian Architecture*, Jouveau-Dubreuil relied primarily on interviews with "master-masons" building the a new stone temple in Tiruppapuliyur to argue that there was "little difference" between ancient Pallava temples near Madras and the new temple under construction (Jouveau-Dubreuil [1916] 1987, 5).[29] Edited and translated by a Brahman scholar living in Mylapore in 1916, this book with temple plans drawn by Jouveau-Dubreuil's informants shows how firmly a certain model of the "continuity of tradition" became fixed—in the minds of the European scholar and his delighted Brahman editor and sculptors building yet another new antiquarian temple.

In modern Chennai, rival groups now appropriate the Dubashes' reconstruction of antiquity. A coalition of middle-class people, many Brahmans, have

joined to renovate a cluster of ancient Shaiva temples that stress orthodoxy—although a very contemporary version. A tight organization of non-Brahmans, often dominated by Mudaliars and Chettiars, orchestrated the rebuilding of a temple complex in Mylapore, and another templelike monument on the road to the cinema studios, for the fifth-century Tamil poet Tiruvalluvar. The presiding deity, "saint" Tiruvalluvar, functioned then and now, as we will see in a later chapter, as a new icon of a presumedly ancient but distinctly Tamil (read as non-Brahman) tradition. By the time Milton Singer wrote his tome on Madras in the late 1960s, the two sides had begun another round of my-tradition-is-more-ancient-than-yours.

A Neighborhood Network in a Less Affluent World

Most tourists never find the other less imposing Shaiva temples in Mylapore, although most do find the Radha Silk Emporium just beyond the grand eastern gate of the Kapaleeswara Temple. A series of old temples are nearby, just to the left and a few blocks down Mylapore Bazaar road—if a visitors can leave the delights of all of that silk. The neighborhood changes here and becomes more crowded. This area was a thickly settled neighborhood even in the 1798 Ross map. Just a few blocks from the coastal cathedral of San Thome, this section of Mylapore was probably the site of a much earlier Portuguese equivalent of Blacktown that stood just outside the large walled trading fort, with numerous churches—unlike Fort St. George—and rows of houses and barracks that functioned until the mid-seventeenth century ("A Plan of Santomé de Meliapor 1635," see figure 2.5). Midway down Mylapore Bazaar Road, the major thoroughfare here, a brightly painted squared gopura of the Karaneeswara Temple pushes out into the sidewalk. Neither large nor ornate, the gate features a well-framed cameo of a smiling Lord Shiva with his right arm around his grown son Ganesha and his left arm supporting his loving wife Parvati, who holds the baby Murugan on her lap (figure 2.6). Her pose seems to echo the Madonna and child found just further east at the San Thome Cathedral. This version of the mellow family image of the Shiva Somaskanda adds Ganesha, but as more mature than his younger brother Murugan. Clearly the artist intended to associate the Madonna-child motif with Parvati and Murugan, apparently drawing on a popular overlap in Mylapore (S. Bayly [1989] 1992, 265) and at the same time reinforcing the older domestication of Lord Shiva's ascetic identity in the nearby Kapaleeswara Temple.

Inside this gate, a lovely temple complex appears fashionably painted in coral pastel. The 1965 Temple Survey claims that this temple, like its grand

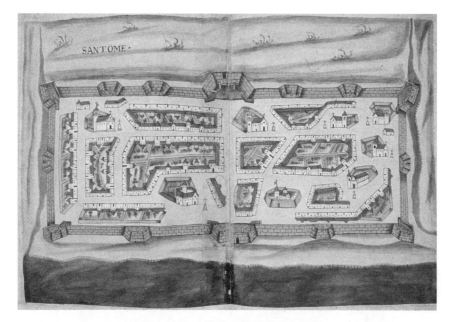

FIGURE 2.5. "A Plan of Santomé de Meliapor" drawn in 1635 shows the many churches that dotted the Portuguese fort in this Roman Catholic era of Mylapore. Reproduced by permission of the British Library.

neighbor the Kapaleeswara, "was built some 300 years back" (Nambiar and Krishnamurthy 1965, 201), but some very old bas-relief sculptures of dancers on the outside walls left me doubting this late date, as they did members of the Tamilnadu Department of Archaeology.[30] A remarkable feature of the complex is its multiple lingas, one in the main sanctum but others outside in covered shrines or, in one case, protruding from the stone walkway. I noticed this linga standing alone with wilting flowers from an earlier offering. Also remarkable was the shrine to Durga, which hugged the south side of the main sanctuary for Shiva. At each of my visits, I spotted the same crow sitting on the goddess's head like an iridescent black crown (figure 2.7). Crows, sculpted in cement, became a motif at the corners of another small shrine. Here an older devotee and later the priest listed this temple as one of the "Seven Lingas of Mylapore." On a later visit I met an old devotee with grown children settled in the United States. His son was then a software engineer in Michigan and his daughter-in-law taught computer science at the University of Michigan. Another son was a student in New Orleans. Again in this seemingly exotic place, I found yet another its-a-small-world encounter—signs of a global network—that marked my time in this city.

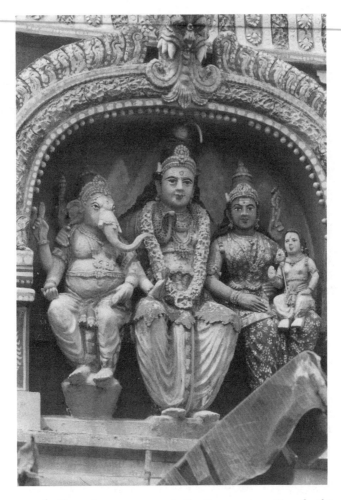

FIGURE 2.6. Above the entranceway to the Karaneeswara Temple, this cameo of the Shaiva Holy Family greets devotees.

This temple was the first that I encountered in my search for the "Seven Lingas of Mylapore," a phrase I had first heard a few weeks earlier. I also discovered the practice of neighborhood devotees making a round of visits, which I began to call a neighborhood pilgrimage, to temples located within a few blocks of each other. In one of the grand Vaishnava temples that also grace Mylapore, the Madhava Perumal, a middle-aged woman explained to me that she came there every morning but also went to the Kapaleeswara Temple with her husband in the evening, because "Vishnu is the day and Shiva is the night." She also said that she could make a round of temples, which were no more than a few blocks from her home, in one day. A helpful old priest at the nearby

FIGURE 2.7. Inside the lovely Karaneeswara Temple, two shiny black crows sit, as usual, forming a crown for this image of the goddess Durga standing against the south wall of the temple.

Veerabadhraswamy Temple carefully named the temples that made up the cluster of seven lingas in this order: "Kapaleeswara, Karaneeswara, Virupaksheeswara, Malleeswara, Valeeswara, Velleeswara, Teertha Paleeswara." He went on to rapidly list a whole series of other Mylapore temples in sevens: "seven Perumals, seven Ammans, seven Vinayakars [Ganesha]." At another temple, I even heard "seven churches and seven mosques" added to Mylapore's sacred sevens. With the old priest's list in hand, and leaving aside the other lucky sevens for the moment, I set out to find the Seven Lingas of Mylapore using a detailed map of the city from 1929 ("Madras Town: Topographical Map") that

meticulously marked all of the temples in the city (but without labels). The Karaneeswara was the first on his list that I could easily locate. The next was marked on my map as quite near.

The Malleswara appeared on the bazaar road down a short cul-de-sac. A fine recently painted gopura opened into this temple, which was clearly in the midst of repair. A bright new florescent sign hung over the entrance to the main shrine and a newly painted shikhara (cupola) topped the sanctum for the goddess, but newly dug holes gaped in the yard. A large new marriage pavilion, a kalyana mandapa, was in the process of construction on the south side of the temple and will take up most of that portion. Someone grumbled in Tamil that this was the work of the "aracu," the government, but then added in English, "all political." I did not question him about his discontent, but I did notice that a lot of encroachment had recently been removed. The renovation of this temple and many others that I would visit, no matter how commendable, were accompanied by disturbing displacements, both emotionally and physically. The temple was not very old, however; according to the Temple Survey, it was "built about 100 years ago by one Sri Chidambara Mudaliar" (Nambiar and Krishnamurthy 1965, 200). A miscellaneous collection of stone pillars made the outer portico; the two nearest the sanctum did not match but looked very old. The outer pillars were of very plain and simple cut stone. It looks as if some of these were haphazardly salvaged from elsewhere. The linga was directly visible from the main door of the sanctum, which had an apsidal-shaped roof—suspiciously unusual for the late nineteenth century. If actually built or perhaps renovated by a Mudaliar in the late nineteenth century, the temple spoke of a fall from grand wealth but not from a sense of ancestral duty.

Back and then down Karaneeswara Koil Street, which runs perpendicular to its namesake, a small side street dead-ended into a modest gopura. I asked a working-class woman nearby the name of this temple and she mumbled "Pillaiyar," referring to Ganesha and clearing making a wild guess. I found this was the south gate of the Virupaksheeswara Temple. A new marble plaque in Tamil announced that the reconsecration occurred July 15, 1994—just a few months previously, which explained the decorated pandal, a bamboo portico, still standing just outside this gate. Walking inside and down a short dirt path, I spotted the freshly washed clothes of the deity hanging just outside the main temple building. Inside several sanctums opened onto an enclosed central pillared hall. Facing the south entrance was a sanctum for the goddess Visalakshi, but oddly in front of the shrine were a bali pitha and a "rishabha" (the priest used this term meaning "bull" and not the name Nandi). A devotee explained that this devi did not have the "simha" (lion) because she was a calm goddess.

I wondered if this sanctum once held an icon of Shiva as a Bhairava, one of the few anthropomorphic forms that Shiva takes in stone—his name here, Virupaksheeswara, implies the association.[31] This image may have been removed to make way for a consort—giving this fierce form of Shiva the newer family-oriented character of the nearby Kapaleeswara. Also off this small pillared hall, facing south, were two rooms that housed lovely bronze utsava murtis, including a fine Shiva Nataraja (Shiva as the comic dancer), a beautiful standing Parvati, a seated Ganesha, and Murugan with separate images of this two wives. The Shiva Somaskanda here is formed from separated images of a seated Shiva, a seated Uma, and a small standing Murugan. The main sanctum facing east contained a beautiful linga. Moving out of this more commonly used south door, slightly offset from the main temple, appears a separate shrine for Murugan with his two wives. A grass-and-dirt path led around to another shrine for the Navagraha, the deities of the nine planets who control human destiny, dated 1935.

Outside, a large tank, now in disrepair with weeds growing from between its paving stones, marked this little temple as once of considerable importance. Facing this tank was the original doorway to the temple, now barred by a locked wrought-iron gate. A carved granite Nandi, Shiva's faithful bull, sat in a new little pavilion like some banished old retainer still patiently awaiting his master's favor (figure 2.8). Immediately inside the little-used "main" entrance on Mylapore Bazaar Road was a Ganesha shrine dated 1936, apparently added during that period in the 1930s when, I noticed, sculptural work was renewed or added to many temples in the city. A bronze bell hanging above the main building also had a stone plaque—with brush marks from a hasty whitewashing of the nearby walls—dating that gift to 1938. I could not recognize the temple from the photograph given in *Temples of Madras City* except for that "church" bell pictured on the south side (Raghaveshananda 1990, 67). Just four years previously, the temple had a simple flat roof with no protruding shikhara. That flat roof and the stone walls incised with very old inscriptions, now barely readable through the whitewash, and bas-relief of dancers in a style mirroring those of the nearby Karaneeswara Temple signaled an ancient past—or at least that many parts of the temple dated to a much earlier period. To my eyes, a genuinely ancient temple appeared to have been remodeled to conform to a sense of "tradition" and propriety in more recent years.

I never would have found the Valeeswara temple, supposedly quite near, but for a surprising coincidence, one of many that year. On her way home from her morning round of the local temples, the woman who had first told me about the neighborhood network of temples came smiling toward me. She lived on this street and guided me down a small throughway to a open red-

FIGURE 2.8. Nandi waits in his own pavilion facing his Lord Shiva in the newly restored Virupaksheeswara Temple in Mylapore.

iron gate attached to two cement pillars with whitewash now blackened from years of mildew. Above, a faded sign in Tamil identified this as the "Vālīśvara Tirukkōvil." Tin sheds encroached on both sides of the temple. Some people had set up shops at the north entrance that fronted Karaneeswara Koil Street as well as the south entrance that opened onto a parallel street; the 1929 map of Madras shows the temple surrounded by four mada streets with abutting buildings only on Karaneeswara Koil Street, as does the 1822 map. A large faded sign over what had been the north gate of the temple advertised in Tamil "bricks, cement, crushed stone, set tiles." Amid this earthy commerce, white

and red stripes on a simple rectangular building confirmed the presence of a temple. Just inside the entrance of the temple room, an image of a monkey saluted with folded hands. My guide told me this was Vali, the evil brother of Hanuman in the *Ramayana*, who found salvation in defeat, like his master the demon-king Ravana, at the feet of Shiva.[32] She said that a few devotees were trying to keep the temple going by giving small donations for the upkeep of the priest and performance of basic pujas. The linga inside the main sanctum was stunningly large and in the midst of such decay seemed all the more lustrous. On the northeastern side of the yard, a partially completed pavilion surrounded five lingas still standing in the open, much like the lone linga in the Karaneeswara Temple. The shrine for Ganesha had been recently renovated. Facing the east door stood an empty little pavilion. In a far corner I spotted the missing granite Nandi, mortally wounded with his front legs chiseled off (figure 2.9). The social atmosphere was fractured, as well. On a later visit, a gang of smirking men who looked like auto-rickshaw drivers tried to collect "donations" for the temple.

The prosperous Velleeswara—easily confused in name with the Valeeswara[33]—contrasts significantly with the other Seven Linga temples, although it abuts the south side of the Kapaleeswara compound wall. The temple has two entrances, with most of the temple under a stone ceiling. The main entrance has fine carved stone pillars that lead immediately to a Selva Vinayakar

FIGURE 2.9. A sad and broken Nandi can never occupy his place in front of the Valeeswara Temple. An image, once damaged, cannot be used for worship.

(a form of Ganesha bestowing prosperity) who faces south. Facing east, a stone shrine shelters the linga, which appeared to be a small svayambhu, but I was later told that the linga was added after the Vinayakar. My eye caught a small black cat curled up in an empty niche at the back of the vimana, perhaps one of the same that I had spotted enjoying the spilt milk during an abhisheka at the Kapaleeswara next door. In the office, I met the kind, courtly managing trustee for the temple. He told me that this temple is a community temple, what I called a community-only temple in the last chapter, governed by three trustees elected by members of the community. The temple was originally only a shrine for Selva Vinayakar but then was converted into a full-fledged temple. He estimated the temple is about two hundred years old and was always a "pure Saiva" temple. The community who controls the temple is the Sengunda Mulaliars, also known as the Kaikolan or weavers (see Thurston [1909] 1972, 3: 31–44). This community also manages six other temples within the state; two are within the city limits. The bronze utsava murtis of this temple were of such fine craftsmanship and age that they were registered by the Tamilnadu Department of Archaeology. The trustees had petitioned the department to declare the entire temple an historic place. I saw the bronze images beautifully displayed at a lavish Brahmotsavam procession, which I attended at the invitation of the managing trustee. The festival confirmed the legendary wealth of this caste, whose affluence and influence derived from their control of the manufacture and trade in textile in earlier centuries (see Mines 1984). But in spite of the contrasts in wealth and in the polity of the temple, the managing trustee and others once again mentioned the lingas of Mylapore and confirmed their temple as among the Seven.

The last of the Seven Lingas was far from the Mylapore cluster. Going to the Teertha Paleeswara requires a bus, a taxi, or a strong constitution. The temple is a mile or so north, up an extension of Mylapore Bazaar Road into what is now Krishnapet in Triplicane, near the famous Parthasarathy, which was the site of Arjun Appadurai's early work. A large mosque faces the temple from across Dr. Natesan Road, which existed in 1822 as Barber's Bridge Road. With a spacious compound surrounded by a high wall, the temple is obviously better endowed than its companions down the road. In the peaceful courtyard, a devotee, a labor manager for the telephone company, told me that he came often to enjoy the quiet serenity of the place. But to my eye, the temple seemed a refuge in an old heterogeneous but not harmonious inner-city area. Street kids besieged us when we visited the Parthasarathy Temple just down the road.

I had confirmation that the Seven Lingas existed as a neighborhood pilgrimage route later at a modest but heartfelt festival to mark the first annual celebration of the reconsecration of the Virupaksheeswara Temple in the heart

of old Mylapore. As priests bathed the beautiful bronze utsava murtis over and over with a variety of substances during a long morning ritual, I chatted with devotees who sat patiently watching this preparation of the deities for their evening procession. Most were middle-aged women joined by older retired men, the usual group who are free to attend daytime rituals here in this working city. An elderly woman devotee drew a map for me of the route she followed each day on her rounds of the temples in the order of their power, beginning with the Kapaleeswara as the most potent of the seven. Her order was the Kapaleeswara, Velleeswara, Karaneeswara, Malleeswara, Valeeswara, Virupaksheeswara, and the Teertha Paleeswara. She also marked the Mundakakkanni Amman Temple and the Madhava Perumal, not as part of her rounds but as a means of location. This apparent centrality of the Amman Temple will become important in the next chapter. For her and others, the Seven Lingas were linked through this kind of pilgrimage, but I never confirmed or witnessed the annual ritual that formally affiliated all seven temples: priests at other temples mentioned that on the full-moon day of the month of Masi (February-March) the bronze images of the presiding deities of all seven Shaiva temples were brought for a common dip in the ocean. I also never confirmed when this linkage first began. In my thirty years of sporadic visits to Mylapore, I never heard of this network until the mid-1990s.

Three of the nearby temples have a direct administrative connection, and their lovely lingas have a common set of benefactor-servants responsible for their new life. The executive officer from the Hindu Religious and Charitable Endowment (HRCE)—I will return to this government office in the next chapter—stationed at the Mundakakkanni Amman Temple also directs the affairs of the Karaneeswara, Malleeswara, and Virupaksheeswara temples, but with very limited resources. About eight years previously, a group of concerned neighbors began to talk in the evening about the deplorable state of these temples in their neighborhood. Over the next months, these devotees gradually told me the story of a renewed community spirit and their long hours of work reviving all three temples. The Virupaksheeswara was the newest project, so most of the group could be found there in the evenings. As one devotee at the Virupaksheeswara put it, "We did not even know what deity was in this temple." The doors were barred and no one even remembered the name. Everyone stressed that they were not rich but only "middle-income people." The renovations had "the support of the public." Technically only the HRCE could disperse money for renovations, so the group had the double task of finding a way to work within the HRCE rules and at the same time raise resources to begin needed repairs. One solution: they could accept in-kind donations like oil and rice for the pujas, or cement, stone, and brick for the repairs. They

began collecting small donations worth "five rupees, ten rupees, one hundred rupees" initially to open the sanctum and to supplement a salary for a Brahman priests to do the basic daily pujas. They did much of the maintenance work with their own hands and swept up the outside yard. I asked a trustee how they felt about doing such work that in the past many would consider degrading. "Now their mind has been developed, they have a devoted mind and are willing to work, even to whitewash." I also witnessed this roll-up-your-sleeves attitude during a crisis over the plague when young college men, determined that Madras would remain free of disease, began collecting trash all over the city. There was something new happening here, something that seemed to defy the years of outside as well as inside criticism of a supposed lack of a pubic spirit in urban areas. Temples, rather than fostering the inward world of private religiosity, recreated a neighborhood. Here feeding the gods, maintaining their divine life within the community, however, took precedence over feeding the poor. Social service has a different definition in this context.

Many of the devotees at the Virupaksheeswara, whether active in the renovations or simply supporters, felt that the temple "was a meeting place" and a safe haven from a busy and often crowed world. "The temple should be there in such a way that people come here and stay for an hour or so, relaxing, cooling themselves, forgetting their worries." One devotee told of special miracles performed by Virupaksheeswara for his personal peace. His estranged brother in Singapore kept visualizing the syllables that actually formed the god's name but did not know who or what this was. When his brother came to Mylapore and found this devotee involved with a temple with this same mysterious name, the brothers immediately reconciled. Ending his story, the grateful devotee said, "I do not do much here but when I am here I am happy." One devotee expressed concern over the changes that the last years have brought for Brahman families, with the necessity to take jobs outside of their traditional religiously based work. "We Brahmans are not supposed to be money people but we are now. Now every Brahman goes to a job from Tamilnadu to America. Those are the forces that are here." Even his father was an engineer. Another man, frustrated that the government did not use tax funds to support the temples, said, "We are not a minority in India, we are supposed to be the majority." He went on to explain that now, "In four hundred square feet ten people live today, so people become so tense. Office tension, house tension, buses. . . . Everybody is ready to get angry today, the way in which they live, nothing to reduce it. They come here for a half and hour and forget their worries." He saw the temples as fulfilling an important social role. They provided a "change from their day routine and their problems. . . . So it is better for the government to see to it." Clearly he saw this as a social function and hence a public service—

keeping citizens calm and giving them a place to relax and forget their worries. For him, the temple was *the* public space, and he argued for government support the way others might argue the benefits of a park.

At the same time, devotees enjoyed the personal, almost private, sense that participation in this small local temple gave them. "When I do something here I feel the result. In another temple you cannot see the results properly. You give but you do not know if it has been done. Here you buy oil, you give it, and the man will put it in the lamp or on the statue." But this sense of direct participation was contrasted to the personal satisfaction and prestige of building a new temple rather than renovating an old site. One devotee explained, "There is a reason, either I feel happy or I want others to know that I can do all these good things also. If there is not a reason then I am not a reasonable man. . . . Here whenever I feel that I do not know where to go or what to do, I come here." For him the reason for service to the temple was clear: it created his happiness. But he did tell me that redoing these old temples "is not counted," so that many people suppose, "Let me build my own temple. I can always say, see that temple, I built it." In earlier conversations, however, the antiquity of the Virupaksheeswara was a source of pride. Many devotees dated the temple to the seventh century and knew that the grand Kapaleeswara was actually a "second temple" and their temple was built "before the Kapaleeswara." The story given in the 1965 Temple Directory was repeated. This temple was founded by the Chettiar father of Poompavai—the maiden revived from death by Saint Sambandar (see Nambiar and Krishnamurthy 1965, 204). "*This* was her temple." Like those Mudaliars who rebuilt the Kapaleeswara, an association with antiquity would not guarantee these contemporary renovators their own name in history but it did offer another kind of continuity—an affinity with tradition.

With the reconstruction of the Virupaksheeswara, the active devotees now had a hand in a second round of the construction of tradition in Mylapore. In a sense, these renovators, many of them Brahman, bundled the reclamation of public space with a sense not of individual accomplishment but of a shared project and a shared connection with the presumed past. The two centuries that separated them from their unacknowledged Mudaliar forerunners brought these new renovators into the now fractured role of the once-wealthy Dubashes. These salaried employees could not act the role of the grandee, nor could they act alone. All royal pretenses are gone and—as in the United States version of democracy—only God can take the royal road as he moves in procession down the crowded streets of Mylapore. Unlike the first wave of temple building in Georgetown, there is less room here for bold eclecticism, less room for open innovation, and less room for an acknowledged heterogeneity.

When I speak of a lack of acknowledged heterogeneity, I do not imply that the dedicated renovators of the Seven Lingas of Mylapore did not share a global consciousness and openness to others. I was welcomed as part of this community, and my religious affiliations were never questioned. I stood in front of the sanctum with the other devotees and the priest made certain that I received all the blessed leavings, the prasada from the pujas. On the morning of the annual celebration of the reconsecration of the temple, my own birthstone-emerald ring was among the jewelry used to adorn the beautiful bronze Parvati (figure 2.10) during a phase of the long abhisheka called the

FIGURE 2.10. During a bathing ritual, the goddess Parvati thrills her devotees by wearing their jewelry. Her hand holds my own birthstone ring.

svaranabhisheka, the presentation of one's own jewels—which were then re-turned blessed. Perhaps I also felt so much a part of this renovation process because I have chosen to live in and restore old houses—some in terrible condition—in Boston, North Carolina, and now Syracuse, rather than buy new. In a real sense many of us assembled at that long morning abhisheka at the Virupaksheeswara Temple shared common cultural sensibilities—a common style of formal education, even in a common language; professional employ-ment in a state system; a shared sense of the value of antiquity; and a common concern for public propriety and orderliness—which the "rowdies" living just down the block did not. Expressions of divine intervention in their lives for the sake of wealth or even jobs were rare in our conversations. Rather professions of a generalized sense of "peace" in both a social and an individual sense came more readily. These sensibilities became a modus operandi—a working prin-ciple of orderliness, felt continuity with the past, localization—but all in the context of a world system. Just as the Dubashes had constructed their antiquity with the money derived from their connections with the British East India Company, their Mylapore middle-class successors continue this project within a web of rapid globalization.

The work of the Dubashes and their (re)construction of tradition included the patronage of music, poetry, and didactic discourses as well as the patronage of temples. The Kapaleeswara and other large temples in recent years have revived performances in the temple and continue the maintenance and (re)construction of traditional learning. But for many educated Hindus, espe-cially during the years of the secular and socialist Nehru family from 1947 to the 1980s, these functions split into a sense of religion as ritual/temple, culture as spirituality/art, and education as university/college. Music and dance are still primarily patronized by a network of music associations in Chennai called sabhas (assemblies), most located in Mylapore with no formal association to temples (see Allen 2000).[34] The intellectual side of the construction of tradition folded into the emerging university system until the coming of the DK in the 1920s and the electoral victory of the DMK in 1967, when the construction of history moved into the streets in parades, new public art, and especially the cinema (Irschick 1969, 330–350).[35] This new ruling party stressed the glory of Tamil culture as a highly rational system free of the ritualism, and with it the false social hierarchy, of the Brahmans. Tamil concern for ethics, for education, and for common human values became emblems of a new identity. The re-naissance of Tamil "rationality" became another side of the re-revival of "tra-dition." Interestingly, in Mylapore this once again took the form of revived temples.

Mylapore via Another Road: Enshrining "Rationality"
in a New Recovery of Tradition

To get a feel for the full religious and political complexity of Mylapore, I rec-
ommend entering the area not by the temple tank on Royapettah High Road
but through a small cross street that intersects with that major thoroughfare a
few block before the temple tank. Only a bicycle-rickshaw or auto-rickshaw can
fit past this intersection. Ride or walk over the Buckingham Canal, now vir-
tually a sewer trough with hutments on its banks, the homes of the city's
poorest residents. Within a few hundred yards, however, a high-rise building
houses the lower middle class. Turn to the left; at the far end of Amman Koil
Street is a Tamilnadu slum clearance housing project that looks successful.
Just down the street, moving south, a large gated temple complex appears
(figure 2.11). A new sign in Tamil above the entrance gate identifies this as
"Tiruvaḷḷuvar Tirukōyil" a temple to Tiruvalluvar, the fifth-century author of
the now-famous didactic poem, the *Tirukkural*, a homily on righteous living
for the householder. The major shrine, however, houses the guardian Lady of
the holy city of Kanchipuram—Kamakshi (see Smith and Narsimhachary
1997, 176–180)—and Shiva as Ekambareeswara. In Kanchipuram, Shiva as
Ekambareeswara resides in his own temple and is only loosely associated with
the Goddess, but here in Mylapore he is named as her consort and resides
with her.[36] On the right of Kamakshi's shrine stands a curious pavilion enclosed
with wrought-iron bars. At first I took the cement plinth to be a sepulchre but
later discovered that it protected the roots of the tree under which Tiruvalluvar
was born, as many believe. On the platform resides a now very familiar icon
of the bearded poet with his right hand raised in a familiar "teaching" mudra
(hand gesture) and his left hand holding a palm-leaf manuscript of his *Tiruk-
kural* (figure 2.12). In another small-world episode, I saw this same image in
bronze in the side yard of the School of Oriental and African Studies in London
covered in the blue paint which, I was told, the university authorities used to
dull its too-brilliant-for-the-British shine. In Mylapore, next to the statue is a
pair of feet carved in black granite. The painted inscription on a dry cistern
above says in Tamil, "feet of the eternal first preceptor"; the same words could
also read as "the base or root of the eternal god." Marble plaques date this
structure to former DMK Chief Minister Karunanidi's first term in 1973. A
sanctum to Tiruvalluvar and another for his wife Vasukiamma are toward the
back of the compound on the right. A very new temple to an amman with no
identifying marker overshadows Tiruvalluvar and Kamakshi and their consorts.
The shikhara, a large cupola over the sanctum, resembles a wedding cake—a

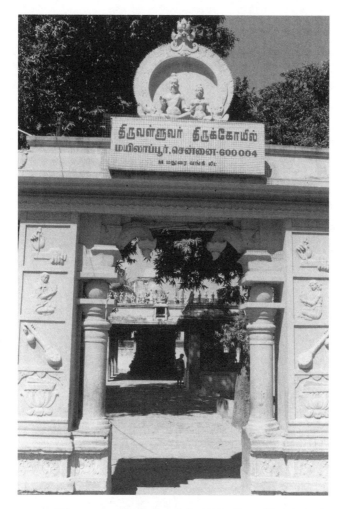

FIGURE 2.11. The very modern gate of the Tiruvalluvar Temple invites devotees. The musical instruments and books carved into the pillars emphasize traditional Tamil learning.

design that I had not encountered before. Next to the little temple, however, are the ever-present "village" marks of a south Indian goddess—tree, raised trishula (trident) and the nagakkal (carved stone slabs depicting holy snakes) (Smith and Narsimhachary 1997, 234–241). Another mark of contemporary times, a hand-lettered sign on the outer wall reads in English and then Tamil, "CLEAN AND GREEN YOUTH EXNORA, PLEASE HELP US TO KEEP THE STREET CLEAN."

Linger a while in this temple complex, because its history and design bear

FIGURE 2.12. An image of Tiruvalluvar, the divine didactic poet, sits beneath the tree where many say he was born. Visible in the back are the shikhara of his temple and that of his consort Vasukiamma.

the imprint of the rapid changes in religious fashions that have marked many neighborhoods in the city. The *Temple Directory of Madras City* reports the claim that the raja of Banaras constructed the temple (Nambiar and Krishnamurthy 1965, 203), and another survey from 1990 dates it to the sixteenth century (Raghaveshananda 1990, 62). A plaque on the entrance gate credits the building to two men, a Naicker and a Chettiar, and dates their work to, May 6, 1935. The Tiruvalluvar-tree monument came forty years later. Signs of its consecration marked the new Goddess temple—faded garlands on the cupola and expired coals in the sacred fire pit. Sorting all the pieces by date could take years of careful work, but I guessed at the time, judging by other similar architecture that I saw in Chennai, that the Kamakshi Temple came first, followed in 1935 by a renovation that added a new shikhara over the original Kamakshi shine and then put up the twin sanctums to the poet Tiruvalluvar and his wife, Vasukiamma. The other dates are obvious. Other evidence in Chennai points to a burst of temple renovation and construction in the late 1930s.[37] Ironically, at the same time the founder of the Dravidian movement, "Periyar" (E. V. Ramaswami Naicker), stepped up his attacks on religion, especially Hinduism, as he countered Gandhi's increasing coupling of religious rhetoric with the independence movement.[38]

Mary Hancock takes up the tale of this temple's recent renovation in *Womanhood in the Making* (1999), and solves some of the mystery. In this book, Hancock includes a long section on "Parvati," a Brahman woman who lived in the crowded neighborhood surrounding the temple (199–205). Parvati led

a group of determined women in the early 1980s in reopening the then-dilapidated Kamakshi Temple. Like the group of men a few blocks down on Karaneeswara Koil Street, these women went from door to door collecting money to begin regular pujas and renovate the shrine. They also negotiated with the executive officer at the Mundakakkanni Amman Temple, who likewise had jurisdiction of this site. The officer allowed them to keep all of the funds and eventually okayed additional funds to repair the other shrines at the site. Hancock reports that Parvati installed an image of Durga but does not mention a separate temple or what renovations were done on the "other shrines." When I saw the twin temples for Tiruvalluvar and Vasukiamma less than a decade later, they looked far too worn for a recent major repair. Their renewal probably ended with the usual whitewashing.

The Tiruvalluvar/Vasukiamma temples are a marvel of synthesis of two once-opposing trends: one toward temple renovation and the other toward cultural-educational renewal. Periyar's emphasis on rationality, science, and education appears in the innovative sculpture on the shikhara of these twin temples. At the corners of the temple tops, the guardian figures are engrossed in reading books (figure 2.13). The now ubiquitous icon of Tiruvalluvar shares the top tier with another amazing figure, a teacher with buttoned and collared shirt and plain dhoti instructing two pupils, also with books in hand. The

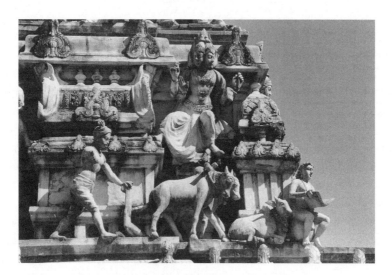

FIGURE 2.13. The studious guardian atop this shikhara shares space with an honest plowman. Both Mahatma Gandhi and Periyar E. V. Ramaswami shared the value of study in the context of honest work, although they disagreed on many other issues.

middle tier has images of generic gods and goddesses with no distinguishing features. The sculptures of the lowest tier depict highly idealized images of village life: a woman carrying a water pot, a farmer with this ox and plow. The sensibility here exudes the socialist reformism shared by Gandhi and Periyar—the educated in perfect accord with the peasants—but here mixed with devotionalism. Periyar's emphasis on female education seems to be reflected atop Vasukiamma's shrine in the images of Tiruvalluvar teaching his wife and another image of his consort herself in the pose of a preceptor. Here is a 1930s precursor of the movement for Tamil/Dravidian pride that would sweep the Congress out of power within three decades. The first didactic poet in Tamil, Tiruvalluvar, here becomes a god in a move toward "reenchantment" that would leave Max Weber grinning (Weber [1920] 1958b).[39] Note that Tiruvalluvar's faithful wife, here pictured as a model of Tamil womanhood, has her own sanctum. For all of its visual lessons on female education, however, Vasukiamma's temple advocates a rather orthodox view of women as ideal wives—a move in keeping with the version here of Kamakshi cohabiting with Shiva without her overt domination of him, as in Kanchipuram. The 1973 pavilion sets Tiruvalluvar in the seat of power as a guru with the footprints that often mark a samadhi (the final resting place) of a saint-preceptor.[40] I was told by the executive officer of the Mundakakkanni Amman Temple that all chief ministers since 1973 have come to pay respects at this spot with the exception of J. Jayalalitha, who could not come at that time because of security concerns.

The Tiruvalluvar Temple is not the only shrine to the poet in Chennai. A significant public memorial to the poet could not be located here in this old neighborhood, I was told, because of congestion, and instead the government constructed a massive monument on the road that leads to the famous cinema studios of Chennai. The Valluvar Kottam was built in the form of a huge granite chariot with a life-sized image of Tiruvalluvar in the seat of honor and scenes from each chapter of Tirukkural sculpted on the base. Kottam means a sacred place associated with pilgrimage but also a shrine. The verses of the didactic poem are set in marble along the perimeter (see Muthiah 1992, 336). The chariot is a stone replica of a wooden temple ratha or ter, which carries a god in procession. The designers of this monument have once again presented Tiruvalluvar as a deity—perhaps the only god fit for true Tamils. Next to the chariot stands a huge auditorium for dance and dramatic performances—making Tamil culture a synonym for religion? Interestingly in this new complex, the designers omitted Vasukiamma either as the poet's wife or his divine consort. Here the temple setting is evoked, but with an ironic message: The only

gods for Tamils are their poets; the only ritual is dance, drama—and the artful political speech.

The Valluvar Kottam is a digression set in stone from the religious evolution represented in the Tiruvalluvar Temple in Mylapore. The temple complex in this old neighborhood is highly gendered, but in a special sense. In the Kamakshi/Ekambareeswara shrine, the powerful Goddess of Kanchipuram appears all the more obviously as a respectable married woman. Tiruvalluvar extolled the married life in his great didactic poem, but here in Mylapore the builder went even further. Tiruvalluvar is given not simply a wife but a divine consort. All this emphasis on marriage may be why a kalyana mandapa, a marriage hall, is located next to the temple. But in 1973, Tiruvalluvar emerges as the eternal guru, with his wife a shadow of her former self. At this point the Valluvar Kottam takes the poet out Mylapore and into world of cinematic extravaganzas—a celluloid ideology shot in stone—but without a leading lady! There is something here that speaks to the changing place of ideology in contemporary religiosity. The DMK party had long before exchanged Periyar's primary medium of the printed and spoken word for the magic and message of the cinema. The party and its chief rival, the AIADMK, continue to emphasize ideology, though by using deities to make their point.

But here in Mylapore, people seem less interested in printed or even visual ideology for its own sake. They are interested in what deities actualize rather than idealize. The energetic Brahman woman Parvati infiltrated the Tiruvalluvar Temple and returned the pride of place to the Kamakshi shrine to such a degree that Mary Hancock overlooks the shrines to Tiruvalluvar and Vasukiamma in her description. The 1980s brought important changes in the religious sensibilities of local, often middle-class residents of this urban neighborhood. The innovative but deserted Tiruvalluvar Temple, in contrast to lively nearby Virupakcheeswara Temple or the thriving new goddess temples in his backyard, brings some key shifts in religious middle-class sensibilities into clearer relief. Perhaps more in line with the eighteenth-century Dubashes than the nineteenth-century bureaucrats and their early-twentieth-century descendants, the renewed religiosity of Mylapore turns away from a nineteenth-century mark of the middle class, the glorification of rationality packaged with the printed word—still confirmed in many American living rooms by the leather-bound volumes purchased to fill the obligatory but otherwise empty hardwood bookcases. The Seven Lingas of Mylapore were never reformed into an intellectual proposition, unlike their near neighbor, Tiruvalluvar, who became an all too blatantly manufactured deity whose only power remains to transform minds—an ideology concretized into a deity.

Conclusions

In the year 1800, a network of temples defined the blurry borders of the new city of Madras for its Indian inhabitants. Today in Chennai, that same process of tracing a neighborhood, creating locality, and defining urban space through a series of temples continues. I have only focused on a Shaiva route, but the lists of sevens included Goddess, Vaishnava, Muslim, and Christian networks. Many of these networks overlap for some devotees but not all—the story of the crosshatches stitched in this web of religious sites would be a project in itself. But if the focus zooms out from Mylapore or even from Chennai, another kind of spacemaking appears. The area of Tondaimandalam, if Irschick is correct, was also a reconstruction as were the temples that anchored this metropolitan area. Ross's "Limits of Madras" was matched by Hindus delimiting Chennai and its surrounding area as Tondaimandalam—both were acts not only of imagination, as Neild-Basu put it, but also of mapping, imagining in terms of space and place. Both mappings tacitly accepted the larger notion that the time had come for erecting borders and for fixing a set of "native" inhabitants within those confines. In other words, the European and Indians were both constructing a locality after a period of intense global trade. Whereas the British cartographer crafted his image on paper, the Dubashes imprinted the earth with temples through renovation and recreation. I am reminded of the grand Moghul emperor Akbar's palace at Fatehpur Sikri, with a giant chessboard etched onto the land. For the temple patrons, native status became a marker not of subjection but of ownership. Their "ancient" temples became more than place markers. I would argue that an historical coincidence—the turn to land revenues over trade—intertwined a set of processes conceived spatially: the emergence of soon-to be-bureaucratic class, the construction of tradition, the mapping of borders, the making of neighborhoods, and the defining of locality. In this context, temple and tradition both are imagined as immobile—which easily elides into a notion of unchanging. The earlier merchant-oriented sense of temples as portable, heterogeneous space with a complex notion of universality faded, at least in academic discourse if not in the elusive process of cultural consciousness. Nevertheless, both are modalities of the modern temple, and they shared a key feature: Hindu temples formed communities and formulated traditions primarily in terms of space and the powers resident within.

Mylapore continually transforms as a neighborhood—or overlapping neighborhoods—for its diverse population. Milton Singer chose well; this area might be an exemplar of the transformations of religious sensibilities at least

among south Indians, if not among Hindus more generally. Here Milton Singer anchored his own recreation of tradition, which he termed the "Great Tradition," formed by a class of literati, the Brahmans—particularly the Smartas. But in truth, Singer admits that never found a single Great Tradition. He worked as if one existed on the ground, playing with words like "commonality" and "common cultural consciousness" (1972, 67), and yet he never solved the problem of this on-the-ground multiplicity. He never really looked at the temple, as we are beginning to see, unified by shared space, not shared principles. Temples like the Tiruvalluvar that violate the primacy of space seem to falter. Perhaps the Dubashes, seeking an orthodoxy for a new age, opted for spatial not dogmatic unity—unlike the concept of a "church" (see Wach 1944, 141–144)—with an institution that was literally embedded in the world. Their "traditional" temples did not exist under the sign of culture as a thought pattern. Singer at that point in his career had not fully embraced semiotics (see Singer 1984) or the problem that occupied his last years, as I read him: finding a road between space, materiality, and concepts (Singer 1991).

The modern temple, then, emerged out of two larger models, which could be called the Merchant and the Dubashi. In the previous chapter I outlined a set of contemporary temple types that appear to echo those early temples in Blacktown: the eclectic and the duplicated. The other type, the caste-community temple, as yet has no parallel in Britain or America. Until last year I would have argued that the Dubashi mode of temple, which I could call the "reconstructed ancient temple," also has no parallel abroad, but this has changed. In North Carolina, the growing Hindu community now has two temples. The Hindu Bhavan remains a classic eclectic temple that unites not only a wide range of deities on its marble altar but also a heterogeneous group of devotees under its roof. The new Sri Venkateswara Temple of North Carolina at first appears to be another "duplicated" temple to the ever-expanding world of that "all-pervading Lord of the Universe," as the new Web site from Tirupati declares (http://www.balaji.net). But this notion of a duplicated temple may not tell the whole story. In a recent newsletter (July/August 2001), the chairman of the board of trustees called on devotees to buy the newly rezoned area around the new temple site. He writes, "This area should be called Venkateswara or Balaji Colony." The complex rezoning processes involved annexation of the area to the town of Cary and then rezoning from residential to commercial. The temple at this point consists of properly consecrated bronze images housed in a small ranch-style home and an orthodox priest brought from India. Plans for a grand temple remain on the drawing board, but the temple has already altered the landscape of the neighborhood and made a claim on the land itself. The current patrons want to recreate a temple on the most orthodox model

possible, including all of the concerns with purity.[41] At the installation of the bronze images, the published souvenir looked toward "An authentic Balaji [Venkateswara] temple that (i) has to comply with the Agama Sasthras and (ii) the flexibility to grow with time" (August 26–29, 1999). In this recreation of authentic antiquity inscribed onto our rapidly urbanizing area, I hear the faint echoes of the early work of the Dubashes as the new city of Madras took shape.

Today in Chennai there are other forces at work. While the middle-class men of Karaneeswara Koil Street continue to improve ancient temples and to revive new versions of tradition, other equally middle-class people just one block away are busy with the Goddess and with experiments in new hybrid traditions, which form other communities. Even in that epitome of revived antiquity, the Kapaleeswara, a community group raised enough money to build a new golden chariot for the Goddess. The neighborhood newspaper reported that earrings studded "with diamonds and other precious stones" were to be presented to the Goddess by "the Karpagam Suvasini Sangam in Mandaveli which is an association of 50 members who recite the Sri Lalitha Sahasrana-man [the holy names of Parvati] at the Kapaleeswara Temple every day" (*Mylapore Times*, April 8–14, 1995). "With donations from India and abroad," this same group bought a necklace with 1,008 gold coins in 1986, followed by a "Golden Parrot." There were no similar reports of such lavish donations, significantly by a community group headed by women, for Lord Shiva. Yet this enhanced devotion to the Goddess retains a sense of elite culture with a special Tamil tone at the same time that it enhances the status of women and the Goddess. Mandaveli borders Mylapore and remains a postwar neighborhood of small single-family houses, which are increasingly a luxury in Chennai. Only an economically prosperous group could afford such donations of expensive jewelry and processional vehicles—exquisite signs of devotion. When the devotees offer their own body, it is the form of words, chants, and prayers. A religious organization, now headed by women and defined as a neighborhood association, echoes the Dubashes in their lavish spending, while at the same time subverting their work. The Goddess at Kapaleeswara, after two hundred years, has perhaps reclaimed her space and her proper place once again.

3

The Gentrification
of the Goddess

At the corners of the freshly painted sanctum of the Kolavizhi Amman Temple in the Mylapore neighborhood of Chennai sit the brightly painted guardians of this newly renovated temple to Kali. These female guardians with fangs and spears but also with plump faces, peaches-and-cream complexions, and fashionable little halter tops covering their buxom breasts seem far more inviting than forbidding (figure 3.1). Yet they guard a very old shakti pitha (seat of divine female power), once the site, local legends says, of fire walking that so enthralled a British officer that he lost his sight as he stared at the ritual through his binoculars. Only his prayers to the Mylapore Kali restored his sight. Less than a decade ago, residents of this old neighborhood began the process of renovating the temple, whose grounds had suffered from encroachment. It had become, as one devotee put it, "a slum." Now the goddess is housed in a proper vimana (sanctum) with ornate shikhara (cupola), a fine mandapa (portico), and a grand gopura (gate). The trustees of the temple and the major donors for this renovation come from various caste communities. When asked who they are as a group, the answer is one that echoes throughout this neighborhood, "We are middle-class people."

The Kolavizhi Amman Temple, less than a block from the grand Kapaleeswara Temple, recently came under the jurisdiction of that temple's resident executive officer from the Government of Tamilnadu Hindu Religious and Charitable Endowment (HRCE) as well

FIGURE 3.1. A guardian lady sits atop the main sanctum of the Kolavizhi Amman Temple in Mylapore, Chennai.

as a newly appointed board of trustees. Hence this amman koil (also koyil; palace, temple) has a very proper place in the scheme of temple administration. When the consecration was performed in 1995, the goddess was resanctified with Vedic rites and served by new Brahman priests. The funds for the renovations and for the consecration ceremony, however, came not from the government but from a group of local residents and a few wealthy businessmen who donated their time and money. This complex project involved not only the physical renovation of the temple but also a controversial removal of people who had encroached on the temple grounds. One of those involved in the project was born in Mylapore but now makes his home near New York City. When his mother died in their family home, he wanted to work in the neighborhood in her memory. His articulate voice could be heard clearly over the sounds of the nadaswaram (a type of clarinet) playing on the day of the consecration. He told a story of the new Kapaleeswara administration that was attracting private donors to rebuild the facility and involving members of the surrounding community, telling his audience: "This is your community, you need to worship, you have to keep the place clean. It's a joint venture." He also spoke of the delicate negotiations involved in fighting the encroachment and of some lingering resentment, but hoped that the whole community would come together on this. I do not know how the former encroachers would tell the story, but the entire case sounded like what I heard in Boston during the gentrification of my Dorchester neighborhood in the 1970s. In his language, I could hear the voice of a New York City–dweller setting the story in the neighborhood of his birth in the context of the American city that he knew. The needs of the poor for some place to live are weighed against the preser-

vation of important historic properties, in this case temples and not houses. Involved here was not just historic architecture but the "sanctity" of this area of Mylapore, which he stressed. Very carefully my fellow American explained that some trespassers were Christians and Muslims who had lived on the grounds for some time, so great care was needed to avoid any religious problems. The practical needs for compensation and resettlement were paramount. The world seemed small to me at that moment as I sat there on a striped heavy canvas rug in what might have been an exotic scene amid smoking sacred fires and the sounds of chanting.

Mylapore, continuing the American analogy, is a "changing neighborhood," like so many of the well-defined older neighborhoods of Chennai. The 1950s brought an influx of rural folk into the city, many of whom settled here on "vacant" land in this once-spacious garden suburb of Brahman professionals, traditional Hindu merchant communities, older Christian families from the days of Portuguese control, and some Muslim families from the days when the nawab of the Arcot ruled the area. In an important sense Mylapore has long been a mixed middle-class neighborhood with groups living near each other, all in lucrative private practice of law or medicine, or in the upper administration in the bureaucracy, or owning their own businesses—an almost classic sense of the bourgeoisie in mid-nineteenth-century England. Now the streets are crowded with recent migrants from the rural areas, some still living in slums along a noisome canal or in better housing constructed by the state government slum clearance project. Kolavizhi Amman Temple's mahakumbhabhisheka (consecration ceremony) marked a key moment for this neighborhood: the articulation of a consciously multicaste activity openly called "middle-class" in English. This goddess temple further marks a new turn in the middle-class religious sensibilities in relation to newer lower castes, new working classes, and to shared rural roots. This temple and other goddess shrines like it throughout Chennai are giving shape architecturally and ritually to new *religious sensibilities* in India that are another vital part of what British historian Robert Stern calls the "bourgeois revolution . . . a momentous event not only in its own history but the world's" (1993, 6).[1]

In a year of mapping the new and renovated temples in and around Chennai, I witnessed the contemporary urban middle classes busy cleaning up and ordering all aspects of religious life in their neighborhoods and in the process also beginning to pay attention to other public spaces such as the streets. The contemporary process of renovation, which I witnessed in the oldest inner-city neighborhoods, included the Seven Lingas and other more ancient temples, as I have shown, but the goddesses received even more attention. Within the city, many old seats of feminine power attracted ardent new patrons among

the middle classes. These goddesses called Mother (amman) in Tamil always reign alone, without a male consort. Reports of this phenomenon appeared as early as 1980, when Margaret Trawick Egnor noticed that Mariyamman, the former village "smallpox goddess," was drawing new devotees in Chennai: "Although the bulk of those applying to the goddess for aid are poor people belonging to lower castes, her clientele spans all classes" (1984, 2). In the old section of Mylapore, the Kolavizhi Amman Temple was not the only old seat of a village goddess now immured by a new proper temple. Mundakakkanni Amman sat under a holy tree for at least two centuries in a simple stone body, but now she has a solid silver face covering her conical stone body. Her tree and thatched hut are incorporated into a brightly painted mandapa walled and marked by two ornate gopuras. In the new suburb of Chrompet, a shakti pitha, once a part of the older village, has attracted new middle-class devotees. Twenty years ago, they constructed a proper home for the goddess without disturbing her ancient tree. A similar village goddess pitha, the Muttumariyamman Temple in K. K. Nagar, has a new life in this rapidly growing suburban neighborhood. The village setting of this goddess remains as part of an upscale local shopping center with the ever-present outdoor vegetable vendors. Other caste communities in addition to Arya Vysya Chettiars (see Waghorne 1999c) continue to renovate the seats of their tutelary goddesses. Trustees of the Vishvakarman community[2] have poured funds into the total renovation of the Angalaparameswari Temple in Choolai. Outside of Chennai the now-famous Adhi Parashakthi Siddhar Peetam in Melmaruvathur has become a magnificent temple. Politicians, lawyers, and professionals from the city drive out to the temple in their cars. The urban poor and the rising middle class don the goddess's red color and catch a bus or walk to her site.

The activities of the middle classes as renovators and innovators of old seats of divine female power are not confined to Chennai. Much farther away in the small urban center of Pudukkottai, the goddess Mariyamman also has new middle-class devotees. The managers of the TVS motorcycle plant, along with other new businesses in town, have transformed the old Mariyamman festival, once patronized largely by the royal family here. The TVS float now carries a proper utsava murti (portable bronze image) of the goddess piled high with lotus buds. A bright red tractor pulls the elaborately lighted float trailed by its generator. Their float now joins those of other companies in the town, along with cycle rickshaws pulling more roughly made goddesses and small but heavily laden bullock carts filled with flowers. These middle-class managers with their faces in the glow of blue electric lights move with the rural poor on the same old royal road to an old Mariyamman temple in an ancient temple complex in Narttamalai.

Nearby, in the larger city of Tiruchirappalli, Mariyamman lives in her most successful temple. Recent studies of Samayapuram Mariyamman speak of the growing importance of the goddess to the urban dwellers, some of them middle class. As early as 1977, Paul Younger noticed that the "vast majority" of the devotees to the increasingly famous Mariyamman Temple in Samayapuram came from the nearby city (1980, 499). At that time the temple was already one of the wealthiest in Tamilnadu, far surpassing its more ancient and famous neighbor, the great Vaishnava temple in Sri Rangam. Younger situated the goddess's new position at the confluence of several contemporary movements: the weakening of castes and the increasing solidarity of urban non-Brahman lower castes, the then-rising antiorthodox ideology of the ruling DMK party, and the continuing identification of urban dwellers with village roots. Mariyamman, as Younger put it, "who once guaranteed the preservation of lineage and the fertility of the village lands, is now approached to care for those who suffer the uncertainties of rapid social change and to add sanctity and prosperity to the life of a busy city" (501). Younger wrote of Samayapuram Mariyamman as reinforcing "a composite sense of identity"—a generalized sense of non-Brahman caste solidarity among the once seemingly distinct categories of urbanites and villagers.

William Harman reports that temple officials have documented evidence that Samayapuram Mariyamman is the third-wealthiest temple in India, just behind Palani Murugan and Tirupati Sri Venkateswara (1998, 2). She increasingly draws devotees from outside Tamilnadu and outside the realm of Tamil non-Brahman caste consciousness. Harman sees signs of "Mariyamman's moving toward middle-class acceptability" and speaks also of the "move toward the gentrification of the goddess." Employing Brahman priests, forbidding animal sacrifices within the temple precincts, and disassociating the goddess with her questionable former role as a murderous wife and dangerous mother render her more acceptable to a wider public, surpassing her non-Brahman identity of the late 1970s (1998, 18). At another Mariyamman temple in Periyapalaiyam, Elaine Craddock reports that she recently found "much evidence of gentrification" in this popular temple just outside of Chennai.[3] Apparently the Mariyamman temples are now so wealthy and popular that their revenues support larger neighboring temples with old royal pedigrees.[4] And Mariyamman can boast a growing literary tradition.[5] Once studied only as a "village" goddess, Mariyamman's mercurial rise in popularity over the last decades and the growing wealth and importance of her temples speak of her popularity among urban people. She and other Tamil ammans are fomenting a new solidarity that *somehow* cuts across caste lines, crosses class distinctions, and bridges the urban-rural divide—all

under the banner of new middle-class respectability. The problem comes in understanding this elusive *somehow.*

Some governing factors in this case of the middle class and the goddesses are certain. This rise of the independent goddesses in Tamilnadu occurs in a period of rapid economic, political, and social change in the urban areas, especially Chennai. The change of name for the former colonial port city of Madras to its old Tamil appellation Chennai just a few years ago is emblematic of the new city that has emerged over the last thirty years. Some of these changes become starkly apparent when comparing contemporary Chennai to the Madras that Milton Singer so elegantly described in *When a Great Tradition Modernizes* three decades ago. That would indeed be a project in itself, but those of us who first knew the city in the late 1960s could rattle off a list of changes without a moment's hesitation. *India Today* now headlines a recent issue with the news of a new "Surging South" and photos of young professionals in jeans at a disco and in sleek shopping malls in "newly alive" Chennai (May 29, 2000). Neither the jeans nor the malls were even thinkable in 1968, when uniformed waiters still served tea to neatly dressed matrons recovering from the cumbersome maze of clerks and "chits" needed to shop in the only department store in town, the monumental Spencer's. Today Internet cafes dot a city where thirty years ago posting a letter to the United States took up a morning and much patience. Now Chennai is fast becoming both a major manufacturing center, with Ford and Hyundai cars rolling off the lines, and a major center for technology. There are opportunities here, as in other urban areas in India, for many "from a wide variety of social backgrounds" to share in the bourgeois revolution (Stern 1993, 213). This economic boom does not mean that the young professionals packing the discos are necessarily filling the goddess temples, but the patrons of the goddess benefit from this new super-charged economic environment. Their patronage, in part, depends on it.[6]

The political world has turned dramatically, as well. For the last thirty years, the DMK (Dravida Munnetra Kazhigam, "assembly for the advancement of Dravidian peoples") and the AIADMK (All-India Annadurai DMK)[7] parties have ruled the state by mobilizing non-Brahman castes and ending the hegemony of the Brahmans in civil administration and educational institutions as well as in religious affairs (see P. Caplan 1985, 23–24). Gone are the staid Congressmen like the last Brahman to serve as chief minister, C. Rajagolapachari (see Waghorne 1985, 53–83). This dhoti-clad lawyer in his white Gandhi cap contrasts sharply with his later successors, the flamboyant movie-star duo of Chief Minister M. G. Ramachandran and his even more audacious leading lady and successor, J. Jayalalitha. Both former film stars embody the populist style of this political revolution, which directly affects temples in the state. The

state government manages many of the temples through the Hindu Religious and Charitable Endowments Board, which places executive officers inside temple walls. Changes in hiring practices means that now non-Brahmans direct Brahman priests and follow an agenda largely set by government policy. The present parties extol the Tamil language and unique Tamil cultural forms. When the DMK or AIADMK retain old religiosity, they favor those deities perceived as indigenous to Tamil lands. The ammans, among others, benefit. And, most important, the politics of garnering public support permeates life on the street in this film capital. Most of the government high command, who got their start in the Tamil film industry, know how to turn political events into stage sets that, like their films, commingle the deities with all sorts of characters and mores (see Cutler 1984).

At this point, those of us who mark the rapid rise of the "village goddess" among urban-based people in Tamilnadu are groping for terms to describe this process of gentrification that involves the middle class within a larger nexus of relationships—economic, social, and political. When Elaine Craddock first encountered a thriving new temple named after the Mariyamman of Periyapalaiyam in an upscale neighborhood of Chennai, she described it as "a perfect example of how a village goddess is lifted from her rural milieu and becomes 'sophisticated' in order to survive among the complex population of the city" (1994, 46). She reported that this process appeared then to be associated with a new policy of the powerful Kanchipuram Shankaracharyas to "democratize" their bastion of Brahman orthodoxy by reaching out to many excluded communities. She suggested, however, that "this democratization is based on a middle class, high caste model" through which such goddess temples were "brahminized" (47 n.11). Democratized/gentrified/Brahmnized—discussions of the Tamil ammans appear to create a hybrid dialect out of terms that would have seemed an oxymoron three decades ago. Democratic processes from the political realm are now in the heart of contemporary temples to the goddesses. Brahmans as a group have lost political and even social hegemony, yet they seem to survive in the styles of worship now associated with a more sophisticated, upscale urban forms of a goddess who until recently was associated with poor, low-class and low-caste devotees. Evidence of an earlier sixteenth-century association of such goddesses with rising new local rulers, "little kings," also seems largely forgotten in this new style of gentrification (see Price 1996, 33–35; Waghorne 1994, 213–214).[8] Caste, once equated with hierarchy as the linchpin of Hinduism, now functions within some larger encompassing modus operandi associated with democracy and middle-class consciousness. At work are evolving religious sensibilities—not clearly defined, just emerging into definition, but nonetheless changing, even creating, possibilities for public life

and public worship in Chennai. I use the term "public" here in full view of the
current use of the term in "public culture" circles and in debates on the place
of religion as a component of "civil society" (Rudolph and Piscatori 1997,
246)—points that will emerge gradually as the many parts of this complex
issue of gentrification unfold.

Goddesses/Social Processes/Religious Processes

The nexus of caste, class, and religion is particularly knotted in Chennai be-
cause of the initial dominance of Brahman communities in the powerful co-
lonial and later national bureaucracies. In the urban context of south India,
the bureaucratizing of the British colonial state in the mid-nineteenth century
allowed space for a limited definition of the middle class: civil servants or
members of the closely allied legal and medical professions. The old merchant/
landowning communities—the Company's Merchants and Dubashes, who ap-
proximated the more classic eighteenth-century bourgeoisie of Europe, found
themselves on the sidelines. The eventual dominance of Brahmans in these
professions was continually contested; nevertheless, Brahmans continued to
top the economic strata of middle-class professionals and civil servants in the
two decades following Independence (Irschick 1969, 13–26; P. Caplan 1985,
23–26). Brahmans were even the most numerous caste group among the elite
industrial leaders that Milton Singer interviewed in 1964 for his now-famous
When a Great Tradition Modernizes (1972, 284). Singer, however, never seri-
ously faced the issue of "class" in his tome, despite a protracted argument with
both Marx and Weber over the growth of capitalism in India. He confined his
use of "class" to mention of "an entrepreneurial class" and the relationship of
new consumer goods to the "modern class" (395), a point that will become
significant later in my argument. When André Béteille published his influ-
ential *Caste, Class and Power: Changing Patterns of Stratification in a Tanjore
Village*, his was the lone voice in international social anthropology circles to
argue seriously that "class, caste, and power are closely interwoven" ([1965]
1996, 185).

In her recent study of Smarta Brahman women in Chennai, Mary Hancock
reads Milton Singer's famous work "against the grain" (1999, 14). Hancock
contends that Singer unwittingly furthered Brahman (especially the dominant
Smartas') hold on the very definition of "tradition," what she terms "Smarta
cultural brokerage" (64). Singer's admiration for the Smarta Brahmans as
prime exponents of the "Great Tradition" developed under the prodding of his
major guide in Madras, the distinguished Sanskrit scholar Dr. V. Raghavan.

Certain key aspects about these paragons of tradition were veiled in Singer's text: "the fact that, as civil servants and white-collar professionals, they were actively engaged in building the cultural and educational institutions through which they derived social and material privilege and from which they sought to exert influence" (Hancock 1999, 65). Although Brahmans continued to articulate openly the value of the old caste hierarchy in ever-newer forms, their actual wielding/welding of middle-*class* power, if I read Hancock correctly, depended on their continued control over the cultural articulation of "ancient" tradition *in* but never *of* the modern world. To take Hancock further, the mystique of this supposed continuity of ancient religious values in modern times depended on the fiction that Brahman prominence flowed from their learning in "Sanskritic Hinduism," not from their class status within contemporary society. My own experience with Dr. Raghavan in 1967 makes me hesitate to censure him for Singer's own romanticized image of Brahmans. This Sanskrit savant, afterall, first introduced me to the renewal of goddess worship.[9] Nonetheless, such a subterfuge of economic status, whether intentional or not, impinges on our own ability even to ask how *class*, especially *middle class*, operated in the formation of religious sensibilities.

Here I join a small chorus of voices working out of Chennai who have argued for the last decade that caste does not function as the only "indigenous" voice in urban areas, nor as the only openly assumed social identity. The earliest statistical research on class carried out in 1964–65 by sociologists Edwin and Aloo Driver revealed that "virtually everyone identifies the 'self' with social class" (1987, 22). Classes were identified with a set of traits: "ascription-achievement ranks of occupation, income, and wealth/property . . . educational attainment, various cognitive and behavioral orientations (e.g. intelligence, personal appearance, manners, self-esteem, sociability, honesty, subordination, and selfishness), and the psychological state called 'contentment' " (23). Their work seemed lost to much of anthropology, soon to be enraptured by the notion of caste and Hindu hierarchy à la Louis Dumont.[10] Lionel Caplan in a study of Protestant Christians in Chennai outlined the problem: "The long-standing reluctance to employ a class model stems from a wide-spread view which contends that analyses through indigenous (emic) categories provide a more authentic understandings of cultures than do those which utilize outsiders' (etic) categories" (1987, 8). Caplan found that his Tamil-speaking informants voiced an indigenous model of "their material and cultural inequities . . . generally presented as a trichotomous order, and the terms I encountered were the Tamil equivalents of 'rich' (*paṇakkārarkaḷ*), 'poor' (*ēḻaikar*), and 'middle quality people' (*naṭuttara makkaḷ*)—'middle class' when it is rendered into English" (11). In her study of women's volunteer associations in Chennai, Patricia Caplan

sidelines caste to ask how a class reproduces itself as a class "generation after generation" (1985, 18). She argues for a balance between economic and cultural factors in understanding class (19). Mary Hancock also maintains that "if class is to be dealt with, it should be treated as a cultural as well as an economic formation that encompasses competing meaning systems, modes of self-attribution, discourses of distinction, and forms of consumption" (1999, 46). All of these studies amend Béteille's early attempt to compare caste and class when he observed, echoing Weber, that "castes, as status groups, are defined in term of styles of life," whereas classes are "defined in terms of property, of ownership or nonownership of the means of production" ([1965] 1996, 188–190). Class status in Chennai then emerges as an indigenously perceived identity associated with both economic and cultural formations

The reproduction of class, to use Patricia Caplan's term, occurs in modern sites and through modern media closely associated with the new economic realm. The contemporary home, voluntary service associations and religious groups, lecture series in private homes or public halls, private temples in or near homes, and small associations within public temples—all of these sites emerged in the context of modern urban life, possibly as adaptations of missionary organization (see Hudson 1992) or the once-ubiquitous British clubs. In terms of media, Hancock looked to very "everyday" practices often centered in the home, whereas Patricia Caplan found "ideology" embedded in "souvenir" booklets and pamphlets produced by women's associations. Both remain attentive to consumer items: the refrigerators and furniture used as class markers in the home, and the style of dress and mode of transportation that signaled class on the streets.[11] Class, then, appears in recent studies to speak through *things* carrying cultural value (Appadurai 1986), in *ideas* mediated thorough transient popular literature, and in revisable *styles* of modern voluntary organizations. None of these sources have religious sanctions; none carry the weight of ancient history. Yet *class as class* speaks right under the noses, in the very families, of those industrialists that Singer found so wedded to religious tradition in the their homes and of those Smartas that he took to be exemplars of the Great Tradition.

Class-talk, then, remains both obvious and veiled. Unlike articulations of caste, class identity seems to emerge thorough ephemeral media such as magazinelike souvenirs meant to last only until the next commemorative issue. In addition, the traits that the Drivers present as common representations of class reflect the modern world of educational degrees, salaried employment, and personal appearance in terms familiar in the commercialized world of advertisements. All of these "traits" are likewise constantly subject to change.[12] Is it then possible to speak of emerging middle-class religious sensibilities that

coexist with life styles in the long-articulated realm of caste? Until recently, changes in economic status carried no religious imprimatur, that is no emic confirmation—at least that was the common "wisdom" in European-American academic circles after Dumont published *Homo Hierarchicus* (see Dumont 1970, 65–72). Dumont initiated the supposed indissoluble connection between caste, hierarchy, and religion in India: "So we shall define *hierarchy as the principle by which elements of the whole are ranked in relationship to the whole*, it is understood that it is religion which provides a view of the whole, and that ranking will thus be religious in nature" (66). More recently, Brian Smith confirmed the deep interconnection between this social hierarchy and the very order of the cosmos in the ancient Vedic world (B. Smith 1994). Yet increasingly in the 1950s in south India, older orthodox texts were interpreted in speeches and pamphlet literature to confirm a close association between the goddess and the alleviation of poverty—although not yet a rise in status. When the late charismatic Shankaracharya of the Kamakoti Peetam in nearby Kanchipuram called for a renewed devotion to "the Divine Mother—The Bestower of Prosperity," he cited Sanskrit verses of saints in his tradition that attested to her gracious power to relieve devotees of "poverty, suffering, and afflictions and sins" (Ramakrishna Aiyer [1960] 1995, 1:229–232). Of course the poor couple named in his example are dutiful Brahmans. A growing contemporary pamphlet literature intended for a middle-class public literate in Tamil, but also in English, reveals messages from goddesses denouncing both caste and class barriers in society. One such pamphlet from the famed Adhi Parashakthi Peetam in Melmaruvathur proclaims, "To 'Amma'—there are no barriers, high or low. There is no caste or creed, no colour, no race, no communal discrimination. She is the Mother of the entire humanity—Her blessed children."[13] Another booklet in English catalogues the loss and winning of fortunes and miracles of healing through Amma's grace (Moorthy 1986). When changes in class status and economic well-being become part of religious discourse, the goddess is always at the tip of everyone's tongue.

If class is implicated in the reproduction of culture, including religious culture, there lurks a potentially explosive implication. The association of the goddess with changing economic status may question what Dumont assumes so readily—that religion articulates an overarching "view of the whole"[14] and that this view is hierarchical in Hinduism. The new social cohesion that the goddess forms may create a different kind of "unity" based on different criteria. Such a set of newly accepted traits identifying a family as middle class in the newly independent nation emerged in earlier and sadly ignored reports of sociologists in India. André Béteille's early recognition of class as well as caste in his research reflects his own close association with Indian sociology and

social anthropology. A graduate of the University of Delhi, he continues as professor of sociology at the Delhi School of Economics.

In India as early as the 1950s, there was a small but growing discussion of the rising middle classes in urban centers throughout India. Well before the current work on class, these studies began to define the "middle class" by an emerging set of cultural values as they decried the overemphasis on caste in Indian sociology. B. N. Misra, working in India and in Britain, first published an historical account of the "Indian Middle Classes," arguing that the middle class "though heterogeneous and even mutually conflicting at times, exhibited in great measure an element of uniformity not only in their behavioral pattern and style of life, but also in their mode of thinking and social values" (1961, 12). Writing at the moment when Nehru first proposed his socialist agenda in India and when rising middle-class needs were giving way to the development of infrastructure for agriculture and heavy industry on the Soviet model, Indian sociologists began to plead for some attention to the neglected middle in contemporary India (Prasad 1968, 4; Chhibbar 1968, 130).[15] Just at the moment when the middle classes emerged as a conscious identity, Nehru's policies rendered them invisible as development turned again to the "masses" and the ever-ideal "village India." The argument could be made that scholars in America speaking to Indian-American granting agencies bent their work to this discourse.

Yet the force of the middle class, not so much as a fixed group but as a cultural style, grew in India. "Even the richer class does not want to be known as the aristocratic class and in common talks desires itself to be linked up with the middle class. . . . Again a group which can not strictly be called middle class and is much nearer the working group has a tendency to copy middle classes" (Prasad 1968, 7). By 1977, even the famous creator of the term "Sanskritization" suggested in a speech in Bangalore that India had a new cultural divide, not between high caste and low caste but rather between the urban middle class and the rural poor. M. N. Srinivas noticed old rural elites "are only too keenly aware that representation in the bureaucracy and the professions means influence if not power, and all rural folk are fascinated with the picture of officials sitting on comfortable chairs before large tables adorned by telephones and files while whirring fans make the weather bearable" (1977, 3). His essay ultimately critiques this entire picture through Gandhian principles. Srinivas's essay highlights the ironic reversal of Gandhi's project to set up the rural poor as icons of Indianness for so many of his then urban middle-class disciples during the independence movement. This same middle class who once sought to discover the *real* India of the village fast became, despite Nehru's

official policies, the new index behind what advertisements call "life-style choices" for both the old rural elites and the rural poor.

The middle class emerges not so much as a clearly refined group but rather as style—what we would interestingly call "classy." They speak though the visual impact of valued *things*. Theirs is a discourse that eschews abstraction formulations in favor of pragmatic formulae. The middle classes in Chennai prefer recipes over rationalizations—Weber not withstanding. Anthropologists must "read" through the many pamphlets, souvenirs, magazines produced by and for the middle classes to glean the "ideology" or discover the semantics operating here. They look to record the visual impact of homes and meeting halls and the myriad things chattering away in these middle-class spaces. A growing literature in cultural studies confirms the association of such "cultural capital" with class in late modernity as part of a worldwide phenomenon (Jameson 1991).[16] In the context of a volatile boom economy in Chennai, however, the procession of such "capital" can appear and disappear. Today's fashion is tomorrow's dowdy sign of lost status. Yet in India and certainly in Chennai, the middle classes are wedded to a volatile set of commodities that remain impermanent even in their intrinsic value. No horoscope can predict the permanency of this kind of union. Lest the line between caste and class be drawn too sharply, classifications of food, clothing, jewels as appropriate to the various castes are listed in many an ancient Sanskrit text (see B. Smith 1994, 67). Yet there are now things that mark caste and others that mark class. An old friend in Chennai saw herself as retaining her Brahman values by using a natural soap to wash her hair rather than the commercial shampoos her well-traveled upper-middle-class sister used.

The penchant for speaking with things may well have moved many in Chennai directly into the consumer world of late capitalism without the intervening period of supposed rationalizing—but such a tempting thesis is out of bounds here. Nonetheless, any mention of global processes of capitalism invites the Tamil ammans and their temples into another long-standing debate interwoven with the issues of the growth of institutions as a cultural formation in India. Here the argument turns on a different tack. The issue of caste and class concerned the social identities of individuals, their families, and larger kinship groups. In the delineation of middle-class identity in India, membership in voluntary organizations was often mentioned as one marker of middle-class identity. In Europe, the rise of the entrepôt has long been associated with the rise of new trading institutions and associations alongside both the state and the old extended family estate (Martindale 1958, 50–56). Max Weber in the early twentieth century left a legacy of comparisons between the "oriental" and

"occidental" city ([1921] 1958a, 80–89; [1920] 1958b, 318–328) and years of assumptions about the lack of civic organization in the East, particularly India (for example, Kapp 1963, 10). Recently, new discussions of the bourgeois and the growth of "civil society" in Europe carefully eschew comparisons between India and Europe, but the material presented opens a space for considering the Hindu temple in a new key. Some comparisons of the case of the middle-class devotees and the goddess in Chennai is a risky but important detour to seek out the nature of growth of the middle class, their increased patronage of Amman temples, and the development of public culture and civil society in contemporary Chennai.

Amman Temples/Bourgeoisification/Civil Society

In his retrospective article "Caste and Class in India: Nexus, Continuity and Change," K. L. Sharma warns that stark analytical separations between caste and class are artificial. But in a refutation of orthodox Marxist analysis he writes, "The proletarian is property-less, but he has also a chance of embourgeoisiement, and this is not stated by Marx" (Sharma 1994, 90). This term "embourgeoisiement" assumes that changes in class status are not only possible but also expected. The term has analogues in contemporary post-Marxist/postmodern discussions of the significance of the nineteenth-century project of "education"—now described as "enculturation" or, more acutely, as "programs of bourgeoisification" (Bennett 1995, 169). Tony Bennett's description of the force of this process at work in and though the "birth of the museum" in Britain and America may suggest a way also to view the interrelationships between the process of embourgeoisiement in India and the growth of religious institutions, particularly temples, during this same nineteenth- and twentieth-century period of "late capitalism."

For Bennett, the museum functioned as a new kind of public display—one that revealed power not simply for public awe but also for public education (1995, 23). Bennett shows that the museum reworked its visitors, recreated them into good middle-class citizens. The site and its sights re-formed the body of the visitor. In performance-theory terms, a visit to a museum became a transforming ritual. Bennett speaks of the "organized walking" regimes of museums—in Richard Schechner's terms, the process of kinetics, the ability of movement to transform (1986), or in the language of de Certeau, "a process of appropriation of the topographic system" (1984, 97).[17] Bennett, speaking in hybrid Habermas-Foucault dialect, never applies this discussion to religious institutions—the churches—which were obviously constant sources of those

quintessential Victorian calls for public moral reform. The full reason for this omission is an issue far beyond the scope of this book, but during this same period of the mid-nineteenth century, British residents constructed a grand museum in Madras; it never achieved wide popularity. Perhaps this is because Hindu temples as architectural spaces were long understood to be transforming—creating actors within a scene, not spectators. The traditional performance of pradakshina, the ritual walking around the temple, speaks to old kinetic practices as part of temple ritual. A Hindu temple was and is a site of organized movement through a visually instructive environment. During the mid-nineteenth century, throughout the Madras area, new Hindu temples continued to be constructed and ancient temples repaired through the patronage of old business classes (see Rudner 1994, 133–158) and some rising new devotees.

Jürgen Habermas prefaced his early study of the emergence of the bourgeois public sphere by insisting on the historical peculiarity of the event. "We conceive bourgeois public sphere as a category that is typical of an epoch. It can not be abstracted from the unique developmental history of that "civil society" (*bürgerliche Gesellschaft*) originating in the European High Middle Ages; nor can it be transferred, idealtypically generalized, to any number of historical situations that represent formally similar constellations ([1962] 1989, xvii)."[18] After the Reformation, Habermas claims that the Church lost its claim to publicness, the exclusive right to represent divine authority. Religion "became a private matter" (11). Then the expansion of new commercial relationships "the *traffic in commodities and news* created by early capitalist long-distance trade" brought an end to the paternalistic feudal estates (15). Thus the new "bourgeois sphere" opened to those very people who acted in and profited from this trade. The new space was for the first time "private" in the sense that persons here acted in their capacity as persons, as Habermas emphasizes, with a consciousness of their status as simply "human beings" (29). Emphasis shifted to the home, which was no longer an economic unit but rather provided the newfound space for "a process of self-clarification of private people focusing on the genuine experiences of their novel privateness" (29). From this emerged an active public voice to speak to and over the government—a voice between society and political authority. This new voice that claimed to speak for humanity consisted of a small educated, reading, and financially independent group. Habermas claims, however, that this very rhetoric of universal freedom led, by a long chain of events, to "a 'refeudalization' of society" and a welfare state created in part to extend the notion of open public access—a process Habermas dates to the 1870s (142–143). This is the period that Bennett describes, when new educational institutions like the museum developed to

extend bourgeois values beyond a small elite. Much of this remains highly controversial in its theoretical and historical aspects (Calhoun 1992), but Habermas provides one important clue to the nature of the bourgeoisie and its contemporary progeny, the middle class, which carries his basic description of the characteristics of the public sphere, in spite of his insistence to the contrary, well beyond Britain and northern Europe.

The fact remains that the British were resident in India first as traders in the East India Company and then as colonial masters during the entire period that Habermas proposes for the rise and development of the bourgeois consciousness—almost exactly (Waghorne 1999c). The port city of Madras founded in 1638 figured prominently in the far-reaching trading networks that Habermas credits with opening this new public space and public consciousness. Because the middle class and old bourgeois class never had an ascribed status, this group had to continually define itself through the creation of its own space and its own self-consciousness. Habermas sees this space created initially in verbal debate and print—in newspapers, coffee houses, and other public forums. By the turn of the eighteenth century, within twenty-five years of the time that newspapers widely appeared in London (Habermas [1962] 1989, 64–65), Madras had a lively public press. The *Madras Courier* (1791) and the more official weekly *Government Gazette* (1801) appeared in Madras, followed later by more polemical journals like the *Athenaeum* (1844). Although these appear to have catered to Anglo-Indian sensibilities, this English bourgeois world was not as far from the "colonial subjects," as much of current theoretical work on colonialism often portrays (for example Chatterjee 1993, 35–75). My own reading of archival records such as revenue maps paint a portrait of Indian-British relations different from the rhetoric found in newspapers and journals for the same years. Madras may be a special case, but revenue maps from as late as 1854 list Indians owning houses side by side with the British in Mylapore, whereas English-language newspapers seem to ignore their presence.[19] Early English newspapers in the 1790s, as I mentioned in chapter 1, carried notices of houses in the old "Blacktown" for sale that lists Tamil-surnamed owners as next-door neighbors to houses owned by British and other Europeans living in India. Much of this kind of argument depends on whether colonial port cities in India are initially viewed from the perspective of colonialism or from the perspective of the global trading network of which colonialism was only a part. Whatever the perspective, at least some Indians of Madras shared in the opening moments of the bourgeoisie public sphere and continued to share in the transformation of this sphere over the next two hundred years. The context of Madras certainly had its own configuration, but the world of capitalism by its very dependence on global trade and commodities

shaped the contours of a worldwide rise of the elusive group called the middle class.

These discussions of the rise of the bourgeois public sphere in eighteenth-century England and the processes of bourgeoisification in the nineteenth-century further the central question here in several key aspects. The identity formation of the middle class as distinct from the upper caste is not only a matter of changing criteria for marking status but also a difference in the very process of constructing and maintaining that status. The very terms "enculturation" and "bourgeoisification" denote active engagement in affirmation but also the expansion of middle-class sensibilities and middle-class status. The point Bennett makes could be translated into religious terminology: the middle classes are proselytizers—in the case of Chennai this may be the closest Hindus get to "converting" others. Unlike the fixed designations of Brahmanical thinking, to maintain borders and insure that people remain secure/secured in their life styles, the middle class "poses itself as an organism in continual movement, capable of absorbing the entire society, assimilating it to its own cultural and moral level" (Antonio Gamsci quoted in Bennett 1995, 98). In India that privilege of setting the code of hierarchy supposedly belonged to the Brahmans. Orthodox texts, however, suggest that Brahmans should be revered for their pure life-style but not that they should be copied. Perhaps only the in modern period could Srinivas speak of Sanskritization, the active adaptation of Brahman practices by lower-caste people to raise their own status in society. Already at this point Brahman practices are transformed into a style—a key measure of classy behavior. Larger notions of "volunteer" organizations envelop even the idea of caste. During a controversy, a member of a Brahman jati described the caste as working "in the nature of a club" (Conlon 1977, 162; see also Rudolph and Rudolph 1967, 88–103). Ironically, the definition of *religion* that Dumont so naturally assumes to be applicable to *caste,* namely, the power of religion to build an overarching worldview, may say more about Dumont's own bourgeois sensibilities than about supposed ancient Hindu religious consciousness.

Bennett also sees the reforming middle classes as using the museum to confirm their own corporate existence. Museums allowed "the bourgeois public to meet and, in rendering itself visually present to itself, acquire a degree of corporate self-consciousness (1995, 25). Bennett's discussion of the distinctions between the creation of public spectacle to display the sheer power of the state or of the sovereign and these far more subtle programs to re-make and re-form the viewer is especially interesting in the context of Hindu temples in south India, where the process is in many ways more complex. His insight that such public institutions not only reform others but also form the middle

class gives a clue to the goddess temples in Chennai as sites that may validate the middle class as a rising group. The case of the "bourgeoisification" of the goddess and her temples in Chennai will certainly not correspond exactly to the work of an earlier bourgeoisie—too much has changed in the intervening years and interrupted space between London and Chennai. However, that middle-class penchant for preaching and teaching was apparent in my conversation with devotees on that July morning when the newly renovated home of the guardian amman of Mylapore was consecrated amid Vedic mantras. Desire to create unity in some form, desire to draw in the lower classes, desire to confirm identity as reforming middle-class patrons—the heat of all of these desires hovered over the holy fire pits, mixing with the sun and smoke that morning.

The mechanism of that renovation of buildings and people, as much of the work reviewed here shows, functioned through visual rather than discursive modes. A Hindu temple, however, lives neither as museum nor as an educational institution. Sculptures on external surfaces mediate all sorts of messages, but the stone and bronze sculptures inhabiting the sanctum embody more than lessons—they are felt to have life as self-willed beings. Thus any analysis of the middle-class reworking of the goddess and her lower-class devotees must also exist side by side with an equally pervasive sense here that the goddess calls and transforms her devotees. The temple becomes the space for all that *work* both educational and transformative—interestingly, in Sanskrit the same term *karman* is used for works and for ritual. Confluence, differentiation, and interpenetration between middle-class modalities and Tamil religious sensibilities must be taken seriously.

The modern period for Hindu temples in south India begins with the British assumption of the administration of much of south India in the last days of the eighteenth century. As the new overlords, the British also inherited control of the temples once patronized by the local rajas. Yet during this same period, the officers of the East India Company followed a policy of noninterference in the religious lives of their new subjects, as befitted educated men of the Enlightenment. They were in many ways the quintessential bourgeois described by Habermas, but their own Reformation logic of religion as a "private" matter was never transported to India in full. Academic debate over the Company's complex problems with the Hindu temples in its charge has continued for the last two decades (Appadurai 1981; Presler 1987; Dirks 1987), but Eugene Irschick's perspective on the issue in *Dialogue and History* (1994) is especially helpful when set in the context of Habermas and the public sphere.[20] In India, "protecting" the temples was framed by nascent bureaucrats like Lionel Place as a duty inherited from Tamil kings when the Company assumed

the role of the Raj to protect the well-being of Indian communities (Irschick 1994, 82). Place argued and won government funds to repair the temples near Madras and to reestablish ritual in the period 1794–1799. Irschick offers an intriguing analysis that Lionel Place looked on his program for revival of the temples as a means to "create a new civil religion" and "simply another way to get the local population to be more productive" (81). He argues forcefully that the construction of a new civil religion and the creative resuscitation of Hindu temples were "not re-invented by the colonial state but were produced dialogically by the British and local individuals in the nineteenth and twentieth centuries as a way to redefine the sacred and disaggregate it to all individuals" (94). Evidence of the same emergence of public space out of the divorce of religion and "estate-based authorities" that Habermas describes in eighteenth-century Britain ([1962] 1989, 18) appear in Irschick's description of "disconnecting the political from the religious" (1994, 94). By this Irschick means that Lionel Place and other administrators, by removing the temples from the direct and unfettered control of powerful men acting as heads of large patrimonies and bringing them under bureaucratic supervision, began a process of what Habermas might ironically have to term "secularization." Add this to the concurrent "construction of a new kind of useful, productive religion" (94), and I am tempted to argue that this notion of a government directly intervening to insure wide pubic participation in government-fostered institutions anticipated the concept of the welfare state in Britain by at least seventy-five years! All of this reformation of Hindu temples and of what would become "Hinduism" occurred at the apex of the development of the new bourgeois public space (Habermas [1962] 1989, 89). The Hindu temple and with it the redefining of ritual and the reformulation of "religion" became the arena for the creation of a new civil space. The history remains complex, but in Tamilnadu there is now, and has been for some time, a space between the realm created and controlled by the state and a still nascent "bourgeois public sphere." No longer truly public in the premodern sense of an institution that displayed the largesse and power of the king and his councilors, the modern (post-1790) Hindu temple never became fully private except when any person or caste group could be identified as "owning" the temple and thereby making it private property.

Unlike the church in the United States or even the churches in England, many of the temples of Tamilnadu today are still controlled by the government, which acts not simply as a patron. The Hindu Religious and Charitable Endowment (HRCE), created in 1926, now micro-manages many temples in the state. After Independence, this control increased when an indigenous government was free of concerns that had racked the foreign rulers caught between

fear of antagonizing the religious sentiments of their subjects and dread of the charge of supporting "heathen" practices by an often-rancorous Christian public at home. The new Indian constitution created a secular government, yet the Supreme Court has upheld the legitimacy of the Tamilnadu HRCE board. The HRCE act creates this legitimacy on paper by restricting the board to financial and nonreligious matters. However, as Franklin Presler bluntly states, this policy of "noninterference" in temple religious matters "is a good slogan to legitimate the HRCE, but it is an inaccurate description of actual practice" (1987, 110). An executive officer from the HRCE maintains an office and is usually present on a daily basis in larger temples in the city. Today many Hindu temples in Chennai remain a civil space—but only the government's presence guarantees access to all Hindus, including the former "untouchables." The temples are all the more "public" through a newly active community of concerned citizens. Some older temples have continued to maintain their freedom from direct HRCE control as "denominational temples" or "private temples," but the Endowment often challenges this independence, especially when revenues from the temple rise. Thus the trustees of temples are either under the constant eye of the HRCE board or they see that eye always peeping around the corner.

Presler describes a tension between the cultural values of the officers of the HRCE and the temple devotees that he witnessed during 1973–74. "When the department sets out to improve the 'religious atmosphere' of temples, its definition of 'religious' is especially that of educated, upper-class Hindus who view temples as 'spiritual centers' of high culture; quite peaceful, apart from everyday life. This is in tension with actual temples, which are noisy, bustling centers of worship, social intercourse and commerce" (1987, 113). But in 1994–95, the difference between the attitudes of officials at the grand office of the Endowment—which resembles a temple—and the executive officers on site in the temple was striking. The executive officers of the temples that I encountered by 1995 appeared to work in tandem with the trustees in a mutual project to enhance and direct the growing interest in temple culture in the city. The concern for improvement was still there, but the "upper-class" attitudes were not. The social programs of thirty years of rule by the explicitly populist parties may have had its effect with the appointment of officers whose home values were closer to those of the temple trustees and devotees, while at the same time the trustees and devotees also changed their values. No officer or devotee that I met devalued ritual or tried to spiritualize worship. In all of my conversations with executive officers and trustees, I gratefully heard none of the these-are-not-really-idols-but-symbols talk that had been regularly foisted on me even a decade earlier. This does not mean that the HRCE officers did not hear the

distant trumpet of a state agenda for political and social reform, but that they also heard the loud cries of local community members actively pushing the HRCE to support their renovation projects.

In a real sense the officers and the local community of concerned devotees shared a new common ground, middle-class not upper-class religious sensibilities that are now just enough at the surface to see. The "educated" upper-class religious values that have faded are the very ones so alive for many Indians in American and Britain. The notion that religion is a private matter enacted in an atmosphere where the worshiper can "hear myself think" was inherited from the British bourgeois eighteenth-century ideology alive here and there in a once-common liberal university education. This educational system, which extended over the old empire, including much of the United States, was reformed in Tamilnadu after 1967—the year that many of the first new immigrants began to arrive in the United States from India. Tamil became the medium of instruction in most government colleges when the populist party, the DMK, swept into power. The new administration removed much of the old classic English literature from the curriculum and soon the language skills and interests of a new generation followed.[21] Those new middle-class sensibilities are most apparent in context of the amman temples. Open adherence to such forms of worship and such deities in south India once marked the religious divide between the "educated" and "uneducated." Places of quiet retreat from the world the amman koyils have never been. Vivid, noisy, pragmatic worship with daily life at the center is the world of the goddess. Yet in the 1990s, she appears to unify a new middle-class world. The former "village" shakti pithas flourish in neighborhoods where the middle classes have built their own homes. But in old city neighborhoods like Choolai and Vepery, deserted by the middle class that once inhabited them, old village goddess sites languish, their tin roofs leak, and dogs rest in the shade of their mandapas.[22] As they remodel, refurbish, and rework, the middle-class patrons are upholstering over the framework of village life in a city like Chennai with the padding of domestic comfort near their own new homes. The activities of the middle class now seem rather a kind of "vernacularization" on the one hand, and what I am forced to call a "*pukka*-zation" on the other. The new temples are dedicated to an amman, but they are "pukka" temples with all of the orthodox rites of consecration. They are molded in part by a conscious effort to create a multi-caste community that is integrated into a common ethos, which may indeed be "middle class." Inside the temple, I will argue, the architectural space and a new ritual process become a form of bourgeoisification but in a very contemporary key. This implicates middle-classness as a process performed within the temple as well as a process that formed the temple—an interlocking system

of relationships that may have been initiated in the late eighteenth century. Since the terms *bourgeois* and *bourgeoisification* are still highly charged terms intertwined with issues of Marxist analysis, I will return to the more neutral and architecturally defined term *gentrification*. Now, look once again with me at the "bourgeois" renovation of several temples to the Tamil ammans. Keep an eye toward some middle-class traits and modes that others have taught us to consider—their affinity for modern "public" institutions like schools and volunteer organizations; their emphasis on domesticity, their closeness to the language of contemporary commodities; their need to inform and re-form themselves and others; and the keenly felt instability of their own status. Let these notions percolate while I return to the very concrete events in Chennai to consider the rise of the amman temples there.

Mundakakkanni Amman and Kolavizhi Amman: New Architectural Forms

In his early study of Mariyamman in Samayapuram, Paul Younger alluded to the easy symbiosis between the ruling DMK's militant anti-Brahman ideology and the sense of social solidarity created among the urban poor within the goddess's temple and through her rituals. Much has changed in Samayapuram, and the middle class enter this mix along with the Brahman priests who now serve the goddess. A gradual change occurred in the last thirty years, from the early militant Dravidian ideology avowedly defying the alleged hegemony of the Brahman community and "their" Hindu religion, to an accommodation with the popular resurgence of temples in Tamilnadu. Recently the DMK has undergone a radical change and, in the ultimate irony, formed an alliance with the avowedly Hindu BJP but recanted in the last election. An executive officer of a temple in Chennai dated the initiation of this change to the first admin- istration of M. G. Ramachandran who, the officer felt, was so deeply concerned with temples that he took the portfolio that controlled the Hindu Religious and Charitable Endowment under his personal management. His successor, J. Jay- alalitha, gained support from many middle-class Brahmans and others because of her staunch support for the renovation and preservation of temples in the state. Indeed, the consecration ceremonies to mark the extensive repair of one famous old Chola temple became a state affair, with political luminaries out- numbering ordinary devotees who were left standing outside without the cov- eted formal invitation required by the police. Jayalalitha continued to be con- flated with the goddess Durga—an even the Virgin Mary—in numerous gigantic cut-out thirty-foot-high billboards that lined the major intersections of

Chennai. Much of Jayalalitha's reign in the mid-1990s reverted to the politics of spectacle, now in the cinema style. The overt appropriation of temples for political ideology failed to capture throngs of willing spectators—I heard jokes about these spectacles. The rise of the middle class as temple patrons relates to this distinction between overt political ideology too obviously and clumsily written onto temples by the upper echelon of politicians and the emergence of another far more subtle context for the temple—a matter of a quieter collaboration between state officers and the community. Keep in mind the important notion of "the bourgeois public sphere" (Bennett 1995, 25). This was not the space of the royal court or the state. Setting this in a Tamil context, this middle-class sphere competes with and even critiques the rather blatant attempts to return to royal acts of display by political figures. But this new public voice speaks from inside as much as from outside the temples. The case can be seen right on the streets of Chennai.

Both Mundakakkanni and Kolavizhi Amman are literally rooted in Mylapore, unlike many deities in Chennai who migrated with communities from elsewhere. The simple stone body of Mundakakkanni sprang from the soil where she still lives; Kolavizhi has a long history as the "village goddess of Mylapore" (Nambiar and Krishnamurthy 1965, 201). An old revenue survey of Mylapore from 1855 has a "pagoda" marked at the present location of the Mundakakkanni Amman temple (figure 3.2).[23] Usually the term "pagoda" meant a significant temple, while the little street temples were simply marked as "koil." If this is Mundakakkanni, then the site was indeed considered significant by the mid-nineteenth century. The unnamed pagoda rests at the edge of a large, now long-vanished, irrigation tank that recalls the close association of Mundakakkanni with water and lotuses. The HRCE has managed the Mundakakkanni Amman Temple since 1954. As a Tamil booklet issued by the temple at the time of that reconsecration ceremony in 1992 explains, the Endowment took control of this "ancient holy temple" by appointing a proper board of trustees or, as the booklet literally puts it, *araṅkāvalarkaḷ* (virtuous guardians).[24] To prevent further deterioration, the board quickly added a simple thatched cover over the stone and then enclosed the site with a wall. Priests were appointed and full worship services began by 1958. The booklet couches this narrative in terms of establishing propriety in worship and in administration in this "holy act" of fully restoring the temple, *tiruppaṇikaḷ pūrtti*. Interestingly, the tone in Tamil matches the English-language administrative reports of the HRCE Department from the 1950s and 1960s and may itself be a product of these reports, which repeatedly called for the publication of devotional literature, from the lyrics of "the various songs sung by great composers" to "booklets and pamphlets in respect of temples" (Tamilnadu 1962, 7–8). The reports

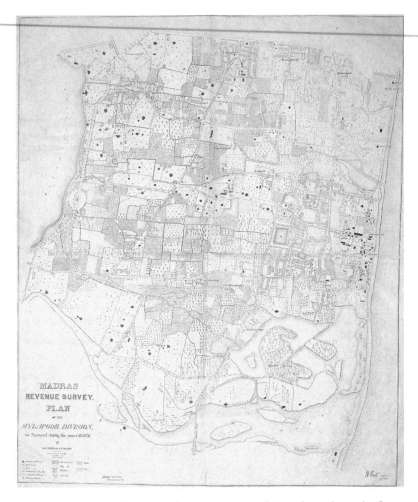

FIGURE 3.2. Note the now-defunct irrigation tank just above the tank of
the Kapaleeswara in this detailed revenue map of the "Plan of the Mylapoor
Division 1854–1855" surveyed by W. H. Walker. On the edge of this tank,
Walker marked a "pagoda" at approximately the location of the Mundakak-
kanni Amman Temple. Note also the garden estates marked here as black
crosses amid the numerous agricultural fields. Reproduced by permission of
the British Library.

also called for social programs, which would provide the prasada as lunches for school children (8). The concern that the temples be "neat and clean" is taken to the point of recommending specific pesticides and weed killers (Tamilnadu 1955, 12–13). The sensibilities in these reports continued to be reflected in my discussions with the executive officer. He mentioned the temple's social service in providing milk for poor children and a deep concern that proper religious authority guide the renovation of this and other temples. But the executive officer also added some interpretations of the power of this particular amman—the meaning of her renowned power to heal, which he understood to include also "the uplift of the poor and needy to cure also poverty, sickness and mental agony." His very pragmatic tone was also interwoven into the 1992 booklet, which combines intense devotionalism with a chapter on "Supreme Shakti and Reason," including sections on "life and enmity" and "the gift of divine knowledge," but in this context speaks of "the Mother's concern" and "the Mother's divine grace."

Inside and out, the Mundakakkanni Amman Temple still shines brightly from its renovation in 1992. The booklet in Tamil lists four sanctuaries (T/ *caṇṇitil*) of divine power in the temple: the Mother (here in formal Tamil, *aṇṇai*) Eḻantaruḷ Tēvi (the processional image manifesting the amman but considered a personage in her own right),[25] the nagas (holy snake), and the Seven Mothers (here the text uses both a transliteration of the Sanskrit term followed by the Tamil, *kaṇṇiyar*, divine sources of abundance). All of these divinities would be easily recognized in the village but they are not usually so central to large urban temples—the nagas and the Seven Mothers sometimes appear toward the back. Here all of these "village" forms are now set in a very proper temple context. From the street the first view of the temple is of the grand gate, the rajagopura. Passing through this massive structure, the main sanctum of the goddess appears on the south side facing east, the smaller sanctum of the processional devi is slightly behind and to the side of the south amman sanctum. The nagas are honored at the back of the main shrine. On the far north side is the shrine to the Seven Mothers. The temple offices are on the far south of the complex.

The most striking feature of the temple is the change in feeling as the visitor moves from front to back, that is, east to west. The façade of the major shrine shines with sculpture (figure 3.3). The pillars of the portico leading to the sanctum of the goddess appear to be carved stone painted blue, with pink lotuses at the center forming the cornices. The ceiling fans emerge from bright whirls of color suggesting feathers, clouds, or petals. Gandharvas, the heavenly musicians, borrow their form and faces from angels. They carry garlands in their chubby hands—a common motif on English Victorian greeting cards but

FIGURE 3.3. A devotee walks around the Mundakakkanni Amman Temple past the proper sanctum toward the old tree visible at the back. His pradakshina will take him into the village atmosphere and then back to the main hall complete with ceiling fans with an ornate swirl as the Gandharva flies just at the edge of our view.

also a popular form for painting and sculpture on Mylapore's temples. The Victorian style also appears in the painted drapery that circles the top of the portico—again a fashion of late-nineteenth-century wallpaper borders. The façade of the goddess's sanctum is flanked by two guardians goddesses carrying clubs but with soothing faces—not the usual fierce harridans that guard many other goddess shrines. Entering into the sanctum, the devotee can no longer see the simple conical stone body of the amman; she is covered with a silver mask and a pair of silver feet protruding from a sari draped to form a body. Topping the façade is a triangular form with bas-relief sculpture resting on an egg-and-dart lintel much like the entranceways to ancient Greek temples. Again, the Victorians borrowed this form for many public and domestic buildings. The effect of the bright colors—not at all a Victorian choice—on these familiar forms is to create a vibrant elegance with a very Indian accent. This elegant facing, however, quickly disappears from view as soon as a visitor begins to round the temple. At the back of the amman shrine, her sanctum suddenly becomes a thatched hut with a tree in front surrounded by a plinth for the stones with carved snakes representing the naga. Inside the thatched hut is the flip side of the sanctum with Amman's body as she once appeared. The scene shifts starkly to a rural world that continues throughout the back area and concludes with a shrine holding seven small stone images guarded by two important village guardian gods, Aiyanar and Munisvara. These are the

Seven Mothers, now covered with a cement canopy built to resemble the ornamental arch (tiruvacikai) that rises over images of major deities. The rural stage then stretches just out into the anterior of the compound. Another tree marked with red vermilion shades another set of naga stones on small plinth in front of the Elantarul Tēvi sanctum. In this temple the village setting has literally become the background for a façade that in many subtle senses writes over the simple conical stone that remains the body of Mundakakkanni Amman. The continuous renovations move toward propriety, but priests continue to be non-Brahman pandaram, as was long the custom with shakti pitha. I read this process as visual gentrification—everything is maintained but put into a comfortable—note the electric fans—and tidy environment.

An important clue to change in the last decades in what exactly constitutes gentrification appears in the sculpture on the grand entrance gate, the rajagopura, completed in 1979 (figure 3.4). While the 1992 renovations in the interior accentuate comfort in an elegant yet homelike environment, this grand gateway recalls an earlier and older model for refinement. The association of any local deity with regal qualities aggrandized their power and expanded their domain—in both a territorial and a qualitative sense—into cosmic proportions. Temples that were sites for royal imagery and indeed products of kingly patronage have claimed the lion's share of scholarly interest. And, the model of temple as palace long dominated ritual as well as architectural imagery even in a new colonial port city like Madras. The Mundakakkanni Amman rajagopura declares this goddess as a queen of a truly universal domain. This grand gateway actually has three doors, each topped with a sculptural program. The largest central gate, topped by a grand tower, suggests a master narrative with

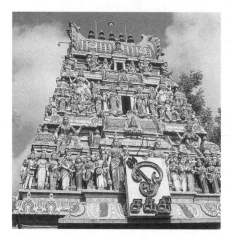

FIGURE 3.4. A neon sign in Tamil script flashes "Om Shakti" on the beautiful rajagopura of the Mundakakkanni Amman Temple.

Amman occupying the middle ground in the upper echelon of Hindu deities. The ornate top of the gateway has three tiers, each marked by a niche at its center. In larger gopuras, the niche would serve as a window for an internal staircase but here they remain decorative, each crowned with an image of Mundakakkanni Amman. Only her head and shoulders emerge from a pink lotus (figure 3.5). A five-headed cobra shelters her crown encircled with a halo of fire. Her thick hair hangs loose, unbraided, to her shoulders—the mark of a woman outside the confines of social conventions. Small fangs protrude from

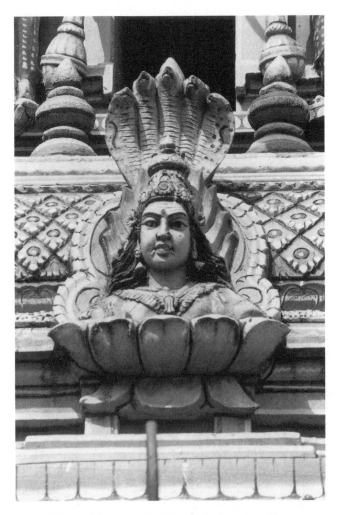

FIGURE 3.5. This striking portrait of Mundakakkanni Amman appears on all tiers of the gopura. Her head and shoulders spring from a lotus, her hair hangs loose around her regal face.

full smiling pink lips on her fair face. On the top tier, six guardians flank the niche. Closest are seated goddesslike attendants crowned and holding lotuses— a special flower for Mundakakkanni, who sprang from a lotus pond. These are followed by another set of standing goddesses-in-waiting. All have fair completions. At the right and left corners two slightly darker guardians with their heads bare and hair loose hold the tridents associated with ammans. The second tier has two important images flanked by multiple guardian goddesses. Facing the viewer on the right of the central niche sits Murugan, and on the left is Ganesha. Both sons of the goddess Parvati, they rest enthroned, each with their two wives. Mundakakkanni Amman's image looks north and south over all of these powerful sons and daughters-in-law. The bottom tier reminds the viewer of the marriage of the two major gods Shiva and Vishnu with their powerful consorts. On the left, the wedding of Meenakshi and Shiva shows Vishnu in attendance, as in the great Meenakshi Temple in Madurai two hundred miles south. At the other end Vishnu weds his two wives, with Shiva among his retinue. The gopura poses a question for the viewer. Mundakakkanni Amman here seems especially associated with the married goddesses. She seems to bless the married state but quite literally rises above it. Her face presides over the world of her gopura but "sits" above the niche of each tier much like a queen in durbar on her throne, with all of these gods and their consorts radiating from her left and her right. A related message can also be read from top to bottom. The married state may be the foundation, but crowning the entire program is Amman, whose bodiless head presides over and protects the embodied, married gods. The point is punctuated with a large neon sign, OM SHAKTI in Tamil script, now covering the bottom niche.

The two other doorways of the rajagopura directly associate Mundakakkanni with two forms of the goddess, each with ancient royal lineages. Atop the north and south gates are the two smaller sculptural forms. On each side, a goddess sits enthroned fanned by two ladies-in-waiting waving the royal flywhisk flanked by two fierce female guards. On the south, Kamakshi looks down from an unusual claw-footed throne, smiling gently. To add to this scene of benevolent power, two attendants on each side seated on pink lotuses play the vina. On the other side, blood pours from a fiend as a goddess spears this last dark remnant of the demons. Her lion, here her throne, stands on the decapitated body of her archenemy in a contemporary version of Durga as Mahishasuramardini—an image made famous in a stone sculpture at Mahabalipuram less than fifty miles to the south. The two sides of the goddess, power combined with benevolence and yet fierce justice, are made apparent. In each case, these forms speak from two powerful centers of old Tamil royal power: Mahabalipuram, an early capital of the Pallava dynasty, and Kanchipuram, a

center of Chola rule. Current politicians freely appropriate both dynasties as icons of Tamil identity.

The Mundakakkanni Amman Temple as it now stands incorporates visual imagery that carries a series of messages formed since this temple came under the control of the Endowment in 1954. The earliest renovations acted only to bring this "ancient site" under basic rules of propriety as defined in early years of the HRCE after Independence. By the late 1970s, after a decade of rule by the then anti-Brahman DMK, Amman reigns as a new queen over the gods and their consorts of orthodox south Indian Hinduism, but remains more powerful. She recalls the power of ancient Tamil rulers and mediates all sides of religious affiliations, Vaishnava and Shaiva. The appropriation of royal imagery constitutes one process of gentrification, which in the case of the Goddess is not really new. The Goddess figured prominently in the legitimation of the new local rajas that rose to fill the vacuum of power created by the declining Vijayanagar and Moghul empires beginning in the early sixteenth century. By this time, processes of urbanization and commerce were already in place, and "temples of the epoch fed this urbanizing process as the new stratum of local lords . . . sought to ingratiate their armed rule by raising local deities to new august statuses" (Stein 1989, 141). In the last surviving Hindu kingdom in Tamil country, the royal family first adopted a form of Shiva, Dakshinamurti, but then identified Brihadambal (the great goddess) as the tutelary deity of their little kingdom and instituted the great Navaratri festival in her honor (Waghorne 1994, 203–216). In nearby Ramnad, the rising ruling family similarly adopted the Navaratri and the shakti power of female divinity because "it connoted power and status as expressed in personal achievements of strength and skill, thus implying shifting political and social relations" (Price 1996, 34). Thus in the precolonial period of the late fifteenth and sixteenth centuries, the real beginning of the modern period in south India, the goddess already spoke for rising new classes of people, the self-made men of their era—but she spoke then in royal idiom. And clearly this idiom was still at work at the Mundakakkanni Amman Temple in the 1970s, when a new class of political rulers, the DMK, took an open stand against orthodox configurations of status and power.

By 1992, Mundakakkanni Amman transplants her rough village roots not so much into a palace as into a comfortable urban setting: she inhabits a grand contemporary house in a very Victorian sense. This change in imagery from palace to house marks the rising power of new middle-class sensibility in the temple. Katherine Grier in *Culture and Comfort* identifies the home and home-making as the central act of middle-class American consciousness—a process of identity formation. In her study of parlor design and middle-class identity,

she provides her own working definition of the middle class as "having that state of mind both compelled and repelled by consumption as a form of cultural rhetoric, seeking to balance between culture and comfort" ([1988] 1997, 221). Culture constituted a push toward that gentle world of cosmopolitan taste created through carefully selected and displayed items, which created "an expressive social façade." This was the touch of the old aristocratic world, but middle-class values demanded that culture be domesticated into "perfect serenity, and moderation in all things" (2). The home became a refuge from the corrupting world of commerce and industry. Yet at the same time, the mass production of consumer items at a reasonable price allowed a larger percentage of the American population to play in this game of hide-and-yet-seek with the rising commercial world in their new parlors—a term from the French *parler*, to talk. The parlor in Habermas's terms would be the space that fostered public sensibilities within the private homes. But in Victorian times the furniture and numerous decorative objects did most of the talking for the family (Grier [1988] 1997, 9–13).

The old British and American middle-class engrossment with domesticity is actually quite new in Chennai—or rather has now spread into the middle classes. The eighteenth- and nineteenth-century "bhadralok" (respectable people, middle classes) of Calcutta and the old merchant classes of Madras did furnish parlors in this European taste, but they were economically elite—entitled to their middle-class status by their mediation between the British and the rural "uneducated" population (see Chatterjee 1993; Neild-Basu 1984). But in the last decade, after years of state-controlled industry, the free market has generated consumer products that have suddenly appeared in new department stores. Magazines offer decorating suggestions, and more and more fancy shops open to cater to the creation of home decor—in openly Indian styles but with a global sense of comfort and the publicness of "private" spaces that await visitors. The "basics" now include refrigerators with a wide choice of colors, ceiling fans in every room, gas stoves, dining tables, and divans—ironically a word borrowed by the British from India—in the homes of solidly middle-class managers and professionals. In contemporary Chennai, the new layers of domestic imagery in the Mundakakkanni Amman Temple paper over the older royal idiom, while the trappings of middle-class comfort continue to excite urbanites. However, this sense of domesticity in the temple does not reflect actual homes of the local middle class but rather an image from the grand Victorian era of merchant wealth—a distinction between actual and imagined taste like the wistful sighs of middle-class readers of *Architectural Digest*. Thus the domestication of architecture in the Mundakakkanni Amman Temple re-

flects a pervasive, visual, but not yet discursive sense of middle-class values sited/cited within the temple—a sense with closer links to global patterns and global daydreams of consumerism.

A more radical form of emerging new middle-class sensibility appears in the innovative sculptural forms on the refurbished Kolavizhi Amman Temple. These more recent renovations date to 1995, when wealthy benefactors working with the executive officer of the prestigious Kapaleeswara Temple financed a new gopura, various mandapas, and shikharas. Individual vibrant images stand out on the surface of the temple complex and overwhelm the eye. On the main gate, some striking images stand on ornate lotuses or sit in miniature vimanas. Others, like the lovely guardian lady that introduced this chapter, sit at the corners on top of the pillared porticos. An image seated on the gopura appears to be the only rendition of Kolavizhi Amman as she appears carved in black granite in her sanctum. Devotees consider Kolavizhi Amman to be a form of Kali, but her six-armed image more accurately emulates the "village" goddess Bhadrakali (K. H. Sastri [1916] 1986, 197; Raghaveshananda 1990, 63). The divine dark image in the sanctum has a mysterious shadowy presence, while the bright Kali on the entranceway looks down with vibrant reddish face and flashing eyes on her devotees (figure 3.6). Her green-and-gold sarong accentuates the jewels in her golden crown. Her bodice barely covers her heaving breasts. Her weapon poised for battle, she radiates energy. But the real surprise comes in a nearby niche where Kali, wearing her emblematic necklace of skulls, comes riding on Durga's mount—a lion sporting the countenance of the British king of beasts (figure 3.7). This Kali wears the face of Narasimha and Mariyamman's cobra-hooded crown on her head. Here the visual reference to the lion-headed incarnation of Vishnu as Narasimha probably conflates

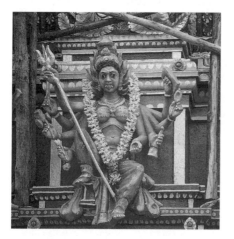

FIGURE 3.6. A bright image of Kali confronts devotees as they enter her temple in Mylapore. She radiates both succor and yet awesome power.

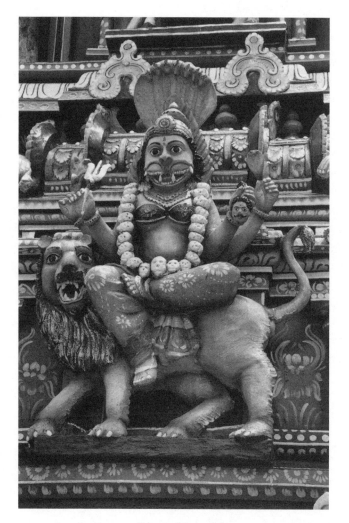

FIGURE 3.7. Another image of the goddess at the entrance of the Kolavizhi Amman Temple takes the form of Durga riding a very British lion— emblems of the last days of royal imagery here.

Kali's fearsome dance over her own husband's body with the bloody slaughter that Narasimha executes on the hateful father of a young devotee.[26] Mariyam-man likewise cannot be tamed by human social conventions—she gives and takes life as she wills. Just above this Narasimha-Mariyamman Kali, a five-headed figure of the goddess rides on Shiva's bull. She wears her hair on all five heads in a coiffure like Shiva's. The central face with a pink complexion wears the marks of Shiva and is repeated at far left and right. In between is a green face, which also bares the Shaiva emblems, but the blue face to the left

has the brand of Vishnu.[27] In all three of these images, Kolavizhi Amman resides in a various composite forms created from the emblems—the face, the hand gestures, vehicles, the weapons, crowns—of other deities.

I would describe these images of the goddess as visual henotheism, actively promoting "one God" by visually invoking the attributes of multiple deities—to borrow a term first employed by Max Müller. In the case of the goddess, however, this process was written into the theology and mythology from the time of the *Devi-Mahatmya* in the sixth century C.E. The text subsumes all names and forms of goddesses into the Goddess (see Coburn 1991, 18–21) and at the same time asserts that the various body parts of her body were constructed out of the powers of the male deities (verses 2.10–2.17; Coburn 1991, 40), and that each of gods ceded her his emblematic weapon (verses 2.19–2.2.30; Coburn 1991, 41). So the amazing forms on the gateway do have precedent, but their visual punch goes well beyond the texts. In these images the visual vocabulary is considerably expanded to include not only multiple images of gods but also multiple sources for these images. The sources include a long history of divine images in "God posters" and a freewheeling cinema industry, which continues to create god images on its sets. The usual wisdom was that such images, although very popular, did not appear in the more conservative sculpture on gopuras and vimanas in Tamilnadu. But this has changed. Most shikharas now are brick-and-plaster construction. The craftsmen (shilpis) who work in plaster seem less constrained by various shastras (traditional rules) than their counterparts who work in stone, although some officials insist that these sculptors should be bound by the same strict conventions. The sculptures on this temple were very photogenic, with saturated colors that played to our camera. Even the dress of these divine ladies seemed to imitate the cinema celebrities on movie posters—the halter top with sarong is a favorite for wiggly starlets.

But this borrowing does not make the images any less sacred. The use of very popular film and "poster" fashions marks a theological syncretism that may be emblematic of a new social synthesis as well. Posters of the gods are ubiquitous in contemporary India but until recently were ignored as popular kitsch. Their flamboyant colors and free appropriation of many popular genres from comics to stage seemed to disregard the supposed cannons of pious art. Now art historians and historians of religion acknowledge their popularity as an important democratizing process. As Dan Smith argues, "As a popular art genre, the poster gods have fostered a democratic revolution, a popular piety, of extraordinary proportions in the present age" (1995, 37). In 1981 an artist created a poster for Kolavizhi Amman, which was reproduced at the time of the reconsecration of the temple. The goddess appears as she would at the

crescendo of the puja, the alamkara (ornamentation), bejeweled and dressed, when her devotees see her resplendent with power. She glows and smiles in a way that only the loving devotees can see, but retains her formal black stone body. Interestingly, the feet and face of Shiva with forehead respectfully dotted with vermilion peeks out from beneath her right foot in a discreet reference to Kali's mad dance on her consort's prone body. Her image on the gopura over a decade later is even more alive—with the surreal life of the cinema. She is now closer to the assumed taste of the masses—a seeming effort to write the social program of this temple onto the entranceway like a marquee in plaster and paint, "Our Kali is all of the gods for all of the people."

A Ritual Process of Gentrification

Both important holy residences of Mylapore's indigenous ammans openly avow social integration and uplift in their art and architecture and in their public discourse. All of these visual public statements speak of a new kind of integration in Mylapore and elsewhere in the city, but rituals actualize and clarify the process. On May 14, 1995, the Mundakakkanni Amman Temple celebrated its annual festival for the goddess, the offering of 1,008 pots of milk to the Mother. In a striking synchronicity, that Sunday morning in the United States was Mother's Day. The reconsecration rituals for the Kolavizhi Amman Temple were celebrated on June 28–29, 1995. During that hot season, several other rituals and events closely associated with ammans provide interesting harmonics to the events in Mylapore. In late March, we witnessed the flower festival for Mariyamman in the town of Pudukkottai and later the festival at her famous temple in the now rural area of Narttamalai. Much later in an area far from Mylapore at another middle-class refurbished temple, Śrī Turkai Amman[28] (Sri Durga Amman) in Chrompet, we were invited to the dedication of new bronze processional images for Murugan and his consorts (July 7, 1995) donated by the father of our landlord. That same week, with welcome help from an ardent devotee, we had a personal interview with the remarkable founder of the famous Adhi Parashakthi Siddhar Peetam in Melmaruvathur (July 2, 1995), now the most influential center for the Goddess in and around Chennai.

Hundreds of shining brass pots covered the courtyard of the Mundakakkanni Amman Temple on that hot Sunday morning in May. Women officials of the temple began to cover each pot with bright yellow silk cloth. Each of these kumbhas (pots) would eventually bathe the body of the goddess in a cooling mixture of milk and fragrances. Devotees, mostly women but men as

well, donated fifty rupees for each pot, which they would bear on their heads in procession around the streets near the temple. Fifty rupees, while not a lot of money, would take a good percentage of a servant woman's monthly salary, so most of the bearers appeared to be middle class, but not all. Many women wore expensive silk saris fit for a grand wedding. Others had simpler polyester saris, not as expensive but worn with style.[29] The priests wore dhotis of the red-orange color of the goddess, as befits a non-Brahman pujari. Inside the temple, a woman with a determined, almost stoic, expression on her face held her teenage son's hand as they walked past the thatched hut and tree in the back of the temple (figure 3.8). She had tied her yellow and red cotton sari unfashionably above her ankles in the manner of working women, but she wore fine gold jewelry, and her son wore a proper green-bordered dhoti. Our camera caught the edge of a fine pink silk sari worn by a woman just ahead of her. Just visible behind the woman in yellow walked a young man dressed in very mixed metaphors. His checked shirt is a style favored by working-class teenagers, but his green-and-gold-bordered white dhoti would place him squarely in the middle class. In the very back of the temple, a thin young Brahman cook, his sacred thread obvious on his bare chest, fried vadai (south Indian donuts) in a huge black wok, while another gray-haired Brahman struggled with a huge paddle to stir pots of rice. The temple that morning was filled with such social ambiguity—years of honing my visual senses for signs of class and caste faltered. Even now, looking intensely at the photos of that special morning, I see mixture in more than just the ingredients in the cooking pots and the ritual vessels.

Next to the temple offices sat a well-built man with graying hair in a red

FIGURE 3.8. A very serious woman rounds the Mundakakkanni Amman Temple holding her son's hand as she passes the goddess's holy tree at the back of the temple. Another working-woman stops to make an offering.

dhoti and a very meditative mood. By his side were large leather anklets with hanging bells—the tools of a dancer. Inside I sat in front of the desk of the executive officer as he chatted on his white telephone. He had kept aside a VIP ribbon badge for me, which gave me easy access to most of the temple. A clerk offered me the opportunity to carry a pot—a temptation but not an easy task on a morning in May in Chennai. The procession would form in an hour. In preparation, the quiet man began a dramatic process of "dressing" to lead the cortege. No event signaled the serious change in middle-class religiosity for me so much as this ritual—it was the revelatory moment that led to this present chapter. With his family anxiously watching, temple officials began the process of attaching kavadis to his head and shoulders (figure 3.9). This is an ancient Tamil way to carry an offering, usually to the god Murugan but here for the goddess. A multitiered platform covered with peacock feathers soon immobilized his arms. Immediately above his head was the pot of milk that would lead all of the other bearers of holy kumbhas. Then one by one, his dressers inserted 108 silver spears into his chest. The anklets on his feet, he danced out of the temple to lead the procession, just behind blaring horns and in front of the elephant carrying the chief priest with the holiest pot. The most remarkable aspect of this process was the openness and pride taken in its accomplishment. No one tried to "explain" this to me. We were permitted to photo-

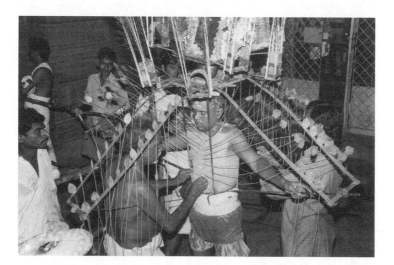

FIGURE 3.9. A breathtaking moment: a clerk at the temple is transformed into the dancer who will lead the procession carrying a kavadi. As temple officials begin the process of attaching the kavadi to his shoulders, family members and friends watch in awe.

graph this awesome act of discipline without any fear that we might later deride the ritual. I felt at this moment that finally the last remnants of the old colonial mentality were pierced by those silver spears. Several weeks later, I went to see the man who performed this feat—a mild-mannered English-speaking clerk in the temple. He was in his seat in the temple's outer office. He showed me his chest, which had only the faintest marks—no scars. Not a drop of blood had spilled and he experienced no pain during the ritual. I witnessed this.

On that Mother's Day, the dancer led hundreds (but not thousands) of devotees carrying the silk-covered brass pots toward the larger prestigious Kapaleeswara Temple and then around a large city block back to the temple. At the head of the procession, the chairman of the board of trustees in shimmering violet and orange silk carried her own kumbha with visible pride, as did many of her fellow trustees (figure 3.10). The day was hot but the route was not arduous when compared to the Mariyamman festival in Pudukkottai a month earlier, where men and women in bright yellow saris, some with shaven heads, trudged for miles carrying pots while whole families bore bundles of offerings on bamboo poles (figure 3.11). None of the women in Mylapore went into ecstatic trances, although some needed help from nearby relatives (figure 3.12); no one let her hair down—literally or figuratively. Ecstatic dancing,

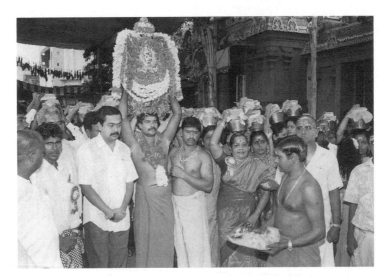

FIGURE 3.10. A priest carries the main kumbha, with the silver face of the goddess amid a profusion of flowers. Officials of the temple surround him as they prepare to lead the long procession of devotees carrying their own pots of holy milk, which will be poured over the stone body of the goddess in her sanctum.

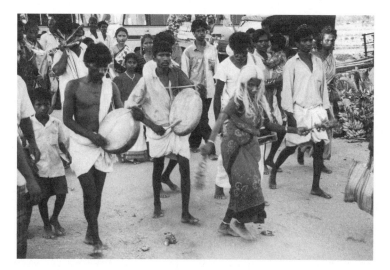

FIGURE 3.11. An ecstatic old woman, her hair loose, dances to the beat of the drummers as she leads country people for miles through rural villages to the more famous festival to Mariyamman in Narttamalai in Pudukkottai District to the south of Chennai.

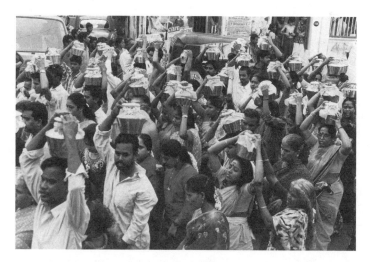

FIGURE 3.12. A woman almost loses consciousness, overwhelmed by her sense of the accumulating power (shakti) within the pot, which she bears on her head. She moves in procession through the urban streets of Mylapore with many others on a hot day in May.

prophesying, shaven heads, and wild free-flowing hair—a sign of breaking free of social constraints—among normally controlled women are common sights during the Mariyamman festival in Pudukkottai and elsewhere (Younger 1980; Harman 1998).[30] Here in one of the most respectable neighborhoods in the city, urban middle-class women put their bodies on the line *in public*—some wearing the same yellow cotton saris as their rural counterparts. Here was a melding of urban and rural styles, but in this case the urban women publicly spoke in a ritual idiom with a rural accent. But like their middle-class counterparts in Britain or America, they nonetheless maintained decorum as they walked out onto the streets. In the Śrī Turkai Amman in Chrompet, I witnessed a clear case of possession. A woman suddenly began to shake but she was immediately "cooled" by her husband. No divine words left her lips. Moments later she sat on the floor. Her husband's hand was on her forehead now, smeared with white ash. Public display among the middle-class women in Chennai retains inflections of urban sensibilities.

The integration of the goddess into urban middle-class life took a different turn in the reconsecration of the Kolavizhi Amman Temple a few weeks later. Here the urban middle class seemed less willing to share the ritual stage with their nonelite working-class neighbors. The rhetoric of a community public space voiced so elegantly as I spoke to the trustees and donors in the vignette that opened this chapter did not manifest in the ritual vocabulary of the mahakumbhabhisheka. Although the architecture openly presented a flamboyant Kali as the star of the neighborhood, the ritual intoned propriety and good taste. The rites here could be described as "Vedic vernacular." This seeming oxymoron was nonetheless a functioning reality. Brahman priests, wearing gleaming white dhotis and sacred threads, chanted all of the mantras prescribed by the Agamas into the fire pits—living artifacts of the Vedic sacrifices. At the end of the ritual, as in other contemporary Shiva temples, an otuvar (cantor) chanted Tamil hymns from the *Tevaram*—canonized hymns of the Tamil saints (see Peterson 1989, 55–75); many devotees who had passively watched the Vedic rites rushed toward the area to hear the hymns. At that point, the mahakumbhabhisheka closely followed so many other proper consecrations that I have witnessed. Presiding over the rites in saffron robes and matted hair was the head of an ascetic order, named in the program in honorific Tamil as Kuruji Cuntarrām Cuvāmikaḷ (Guruji Sundaram Swami).[31] The proceeding followed an increasingly common interpretation of propriety in ritual that privileges Vedic forms, adds Tamil canonical verses, and genuflects to the ascetic gurus. Yet the deities receiving such rites are no longer confined to the canonical forms of either Lord Shiva or Vishnu. In this sense, the rituals become vernacular.

The devotees at the morning rituals were visibly middle-class. I saw none of the mixed metaphors in dress styles that made class or caste identification so ambiguous at the Mundakakkanni Amman temple. The more usual array of older men in white dhotis and shirt, a few younger men dressed for the office, middle-aged and old women in silk saris, young girls, and some children attended that morning. The slum dwellers and working class were nowhere in sight. But the program included two major events: the morning consecration and an evening procession in the streets. For the latter the official program switched to using common Tamil and called the event literally a "holy street procession." By six o'clock the atmosphere had changed. A huge bright neon sculpture of the goddess was shown in front of the temple. Her bronze processional image had just rounded the streets on her lion mount. Inside the temple, I watched as poor women bowed to the goddess's tridents as they might in a rural village. Slum children played and yelled with no clear supervision. Some well-dressed children also played, sitting on the back of the plaster elephants but not joining the slum kids. The contrast of their fashionable clothes with the slum-dwellers' brown baggy pants and shirts spoke of a tacit separation of two worlds merely occupying the same space. In fact, only the children seemed willing to share this common space in the evening. The entire event spoke in images of day and night, the courtyard and the streets. Day belonged to the middle class who crowded the temple courtyard. In the night the working class and slum dwellers filled the streets and their children played in the temple. This was only the most tentative step toward integration, aimed at showing the slum dweller what constituted propriety in ritual behavior. In the rituals the middle class at this temple did not bend or blend, they demonstrated and dictated. The middle class had gentrified the rituals of Kolavizhi Amman Temple while at the same time they portrayed the goddess in the new public idiom of popular visual sensibilities.

Conclusion

The goddess temples in Chennai are changing their basic modus operandi to match the changing polity and the changing urban social realities. Royal models no longer dominate public space. While the former political masters of the Union government push images of Rama as lord and king of a coming Hindu nation, the middle classes in Chennai move toward another kind of public religious vernacular. Here the goddess temples articulate a variety of transformation not always complete or consistent. When I listened and watched, a tentative common public idiom emerged that challenges notions of elite and

popular, and lays waste to older doctrines of "great" and "little" traditions. But far more important, the new goddess temples force a serious look at a previously invisible issue in contemporary India: the rise of middle-class religious sensibilities. Because Habermas disassociates the rise of bourgeois consciousness in Europe with religion, we are left now with the threadbare notion of the "Protestant ethic" to cover the gaps between the rising bourgeois consciousness and religion in Europe. In India, this is not the case. The goddess temples provide the site for a rising middle class to become conscious of itself within the walls of a religious public space. The presence of the slum dweller and the working class seems to highlight the demise of royalty as a font of imagery and power. Ironically, the middle class seems now to draw on the power of the once-"village" goddesses and leaves the royal lord to sit alone in his grand ancient temples. Yet as willing as the middle classes are to appropriate the power of the goddess, they do this by cleaning her house and purifying or isolating her coarser elements, including her unrefined devotees.

4

Portable Stone

Murugan, Amman, and Globalized Localism

Lord of lost travelers,
find us. Hunt us
down.

—From a poem for Murugan by A. K. Ramanujan

The grounds of a small suburban plot facing the Indian Ocean were
covered with huge granite blocks, some carved and some still unfin-
ished. The sign at this site, with a large color picture of the old but
living senior Shankaracharya of Kanchipuram, read in Tamil Muru-
kaṉiṉ Āṟupaṭaivīṭu Tirukkōvilkaḷ, Murugan's six battle sites temples,
referring to the famous pilgrimage sites dedicated to Lord Murugan
and scattered over Tamilnadu. All six sites would come together
here, creating a single temple complex, rendered in English as the
Arupadai Veedu, in this upscale suburban neighborhood on the bor-
der between Besant Nagar and Tiruvanmiyur (see http://murugan
.org/temples/arupadai.htm). Carved granite temples such as this are
crafted in pieces and then assembled without mortar like a giant
erector set, making them paradoxically both the most permanent
and also the most portable temple forms (figure 4.1). Usually such
construction is too expensive for middle-class patrons in India, but I
saw a similar project in progress twenty miles to the south at the
busy Government College of Architecture and Sculpture in Mahaba-
lipuram. That seemingly immovable set of stones would soon be
shipped from Mahabalipuram to Singapore—another of the many

FIGURE 4.I. A skilled shilpi chisels a granite block in the shade of a
pandal. Workmen will soon assemble the completed granite blocks, visible
outside in the yard, into a vimana for Murugan at the grand Arupadai
Veedu Temple complex in Besant Nagar.

new Hindu temples in that multicultural city where many once-poor Indians
have made their fortune. Intrigued with this rare use of granite in contempo-
rary India, we returned several times to photograph the project. Finally I met
the chief donor at the concluding rituals that marked the consecration of the
first fully assembled temple, the recreated abode of Murugan at Swamimalai.
Dr. Alagappa Alagappan, "popularly known as the father of the Hindu temple
movement in America" (*Economic Times*, Madras, May 21, 1995), who initiated
the construction of the first authentic Hindu temple in the United States,
returned to build a monument in stone to the quintessential Tamil deity, Lord
Murugan.[1]

During the last five years, devotees in London and Washington, D.C.,
have repeated this seeming contradiction—the globalization of more localized
temple traditions. In suburban Washington, within minutes of the eclectic
Sri Siva-Vishnu Temple (http://www.ssvt.org), the mainly Tamil community
just consecrated a new temple dedicated to Sri Murugan (http://www
.murugantemple.org), even though his form occupies the central shrine of
their larger neighbor. In London, the manifold Tamil communities, mostly Sri
Lankans, dedicated their first temple to Murugan, now commonly called the
Highgate Hill Murugan Temple to distinguish it from a newer temple in pro-
gress in eastern London, the London Sri Murugan Temple of Manor Park in

East Ham. A publication for this newer temple, soliciting donations, names Tamils and other mostly south Indian ethnic groups from India, Sri Lanka, South Africa, Malaysia, and Singapore among its donors. The trustees of the East Ham temple have ordered a stone temple to be carved in Mahabalipuram under the direction of the new star in temple architecture, Muthiah Sthapati. Such temples to Murugan seem to follow the pattern of duplicated temples, like the virtual chain of Sri Venkateswara temples that now stretch from coast to coast in the United States or the many recreated temples in urban Chennai, such as the Chennai Ekambareswara Temple in Georgetown. Dr. Alagappan's Murugan complex has a precedent in a popular Murugan temple, Vadapalani (northern Palani) in the eastern suburbs of Chennai (see murugan.org/temples/vadapalani.htm). In the context of the diaspora, however, this turn to Murugan signals—I will argue—a new phase in the very character of the transnational Hindu temple and with it a new trajectory in the construction of Hinduism/s. The "original temples" for Lord Murugan are not famous national pilgrimage sites but rather regionally, even only locally, well-known temples, now transported with their wandering devotees into a global context. These temples foment a new kind of "transnational religion," perhaps part of the same process identified by Susanne Rudolph, who argues that "Self-generating, self-inventing forms of religiosity are proliferating, initiated and propagated by the local devout through informal, loosely coupled networks. These forms prevail as much as the religion of imams or bishops and the high orthodoxy of certified religious discourse" (Rudolph and Piscatori 1997, 248).

There is more evidence of what could be called "globalized localism." London, with a long history of Tamil migration, had no temples to the ammans or any of the independent goddesses until the late 1990s. Such goddesses are always "local" in the sense that they are associated with specific sites called shakti pithas in Tamilnadu and among Tamil-speaking peoples. Kali-amman, Durga-amman, Mariyamman, and the other independent goddesses remained a bit déclassé for middle-class British Tamil-speaking South Asians. As recently as 1997, I was told by an educated Tamil well settled in Britain that the less educated were, of course, continuing to build temples to Kali, Durga, and other such goddesses. He spoke with a tone of mild condescension. By 1999, however, the attitudes of this gentleman and many of the Tamil middle classes shifted in London. Mariyamman, long important for overseas Indians in Singapore and South Africa (Mikula, Kearney, and Harber 1982: 14–15),[2] finally came to the heart of the old empire in London's Tooting neighborhood in 1996, followed by a powerful form of Durga, Shri Kanaga Thurkkai Amman, in Ealing. The original temple called Sri Kanakadurga is situated in the midsize town of Vijayawada in Andhra Pradesh, an important pilgrimage site for a local or

regional constituency. The Mariyamman in Tooting called Muththumari Am-
man, takes her form from a local temple in Valvedditurai in northern Sri Lanka,
the hometown of her now dislocated devotees. A 1983 tourist guidebook—
from the days when tourism there was still possible—called Valvedditurai a
"conspicuously affluent" coastal fishing village (Keuneman 1983, 232). In Sto-
neleigh, a far southwest suburb of London, residents have constructed the Sri
Rajarajeswary Amman Temple.[3] In addition, the Goddess is on the rise as
devotees of independent forms of the goddesses have added images to other
temples, notably the Murugan and the Mahalakshmi temples in East Ham.
Within these last three years, new temples and new images to the independent
Goddess now surround the perimeter of London in the east, the west, and the
south. In contrast to the cases of Britain and the United States, Mariyamman
and Durga-amman have focused the religious life of the Hindu diaspora in
Singapore, Malaysia, the Caribbean, Guyana, and South Africa, where the so-
cial situation was the reverse of that in Britain and the United States. Migrants
from south India to these areas were indentured laborers, with a much smaller
business and professional community following later. In Singapore, a proper
temple now honors Mariyamman with a full-scale complex that strongly re-
sembles the Mundakakkanni Amman in Mylapore in sculptural and architec-
tural forms. In these later cases, the Goddess seems to have prospered and
moved up in standing, along with her faithful Tamil devotees.

In the United States this shift in middle-class consciousness has yet to
occur. Ammans have been conspicuously absent from the new temples con-
structed in the United States and Canada. In the United States, a veritable
epicenter of rising global middle-class Hindus, Tamils often took the lead in
the construction of new temples, yet the first temples dedicated to goddess
were consecrated in 1990 near Boston and in 1995 near Houston. Neither is
an amman temple. At the Sri Lakshmi Temple in Ashland, Massachusetts, the
goddess has her husband Vishnu, here as Sri Venkateswara, next to her, with
Shiva in his form as Nataraja also present. Although dedicated to the famous
goddess of Madurai in Tamilnadu, the main sanctum of the Texas temple has
the respectably married Meenakshi in the center with her consort to her right
and the ever-popular Sri Venkateswara to her left. The temple does include a
mix of deities with a new international scope, such as Hanuman and Ayyap-
pan,[4] placed at the corners of the in the outer rim of the temple—perhaps on
"the patio," Texas style.[5] The single concession to globalized local deities ap-
pears in the lovely marble image of the Arya Vysy Chettiars' Kanyaka Para-
meswari.

Durga was installed as the presiding deity in a new temple in the Virginian
suburbs of the nation's capital in March of 1999, under the strong leadership

of a north Indian physician. The Shree Sakti Mandir in suburban Atlanta also began with north Indian, mostly Gujarati, devotees. Near Rochester in central New York, the Sri Rajarajeswari Peetam attracts many new devotees.[6] The goddesses in all of these temples, however, are the highly spiritualized and universalized forms of the great Goddess of India (see http://www.srividya.org/; http://www.durgatemple.org). In Canada, the more recent Sri Lankan Tamil refugees in Toronto chose to support the Ganesha temple (Coward 2000, 157), and south Indians in Montreal have two Durga temples but so far no temples that honor Mariyamman or any of the ammans openly—but the situation may change.[7] The first tiptoeing toward a reaffirmed regionalism/localism among North American Tamil devotees seems confined to the Tamil Lord Murugan. Yet the process of reinvoking, and in some cases reinventing, local identities has begun.

In her commentary on new "self-inventing" forms of religiosity, Susanne Rudolph speaks from the cases that include Muslim and Christian movements, with a brief mention of Buddhism, all of which have "imams or bishops" and "certified religious discourse" (Rudolph and Piscatori 1997, 248). Hindus have never had a centralized doctrine, authority structure, or institutional base, although a loosely binding sense of orthodoxy/orthopraxy has always existed. This makes the discussion of local and orthodox forms of religions complicated and even ironic in a transnational context. The eclectic temples discussed in chapter 1 dominate the Hindu landscape in North America (Coward 2000) and Britain (Knott 1987). Laity and temple officials continue to construct theologies and philosophies to explain their choice of deities and the now-required "meaning" of the gods to their neighbors and their own children. Many now openly strive to create a common doctrine (Eck 2001, 233–236) often by reformulating the concepts of nineteenth-century "reformers" in India who lost no time in mitigating what was already viewed as a serious "lack" in Hinduism (Hansen 1999, 77). The first wave of temples in the United States attempted, consciously or unconsciously, to build at the very least solid institutions literally and figuratively set in concrete. Their accompanying philosophy or rationales, published as part of numerous fund-raising brochures and now Web pages, often haphazardly borrow from the sometimes competing ideologies of Gandhian neo-Hinduism and more strident Hindu nationalism of the growing "saffron wave." An outgrowth of older militant Hindu nationalist organizations, the VHP—the "V" stands for Vishwa (world)—now eyes the growing numbers of émigré Hindus. These Hindus are residing as a minority in the midst of the same organized religious systems that the nineteenth-and early twentieth-century reformers confronted in India as a subject majority. The VHP does not usually directly fund the construction of temples but rather works to build

a shared ideological framework for Hindus abroad. As Thomas Hansen recently put it,

> the primary targets of this strategy were no doubt the Indian immigrant communities, whose disengagement from the local religious complexities and politics in India made them receptive audiences and generous sources of funding for the VHP version of a syncretic, nationalized Hinduism. The same removal from localized complexities of rural and popular religious practices, and the embrace of a modernized "spiritual Hinduism" preaching personal development, success, and this-worldly ethics, applied in many ways to the growing middle class in India itself, which was a main target of the VHP's campaigns in the 1980s. (Hansen 1999, 156)

The earliest temples in the United States, like the Sri Siva-Vishnu, the Pittsburgh Venkatesvara, and paradoxically the Sri Ganesha Temple of Dr. Alagappan's Hindu Society of North America, at first attributed a decontextualized and spiritualized meaning to the very concrete deities they had installed—a point I will return to in detail. The newest wave of temples in the capitals of the English-speaking world are middle-class ventures that are not disengaged from their once-localized popular religion. Just as the groundswell of support for the once-rural forms of Mariyamman, Durga, and Kali ammans reaffirmed rural roots and popular religiosity in urban Chennai, Murugan and amman temples now go even farther, in many senses, as they seem to create globalized localisms. For contemporary Hinduism and for contemporary theory in cultural and religious studies, this is a small but very significant complex of events. Ironically the actual practice of Hinduism/s has finally caught up with the now almost dominant postcolonial-style injunction to shun "totalizing" and "essentialism," following the postmodern master's call for new critical apparatus that reveals "an autonomous, noncentralized kind of theoretical production, one that is to say whose validity is not dependent on the approval of established régimes of thought" (Michel Foucault in Kelly 1994, 20).

The small move toward localism has not stilled the growing voice of an "established regime of thought" for middle-class urban Hindus in India, and especially abroad. Increasingly the process appears coordinated from as close to a central religious bureaucracy as possible in Hindu circles. VHP ideology, like the Vedic Indra in his ethereal realm, waxes strongest in cyberspace, where many temple Web sites such as Hindunet (www.hindunet.org) offer links to its organizations. The full story of the VHP and even the more radical RSS in the United States has yet to be told, although several new works clarify its

genealogy and growth in contemporary India (Hansen 1999; Larson 1995; Basu et al. 1993). The soft hegemony of neo-Hinduism from the Gandhian era, however, remains dominant in temple publications. Long inscribed on the consciousness of educated classes in India as an almost natural way to "explain" God and the gods to real and imagined interlocutors from "the West," this same discourse now functions to explain Hindu ritual and the like to their often estranged youth. The same voice also speaks out of numerous brochures to the imaged mind-set of local neighbors and the larger American public— often still envisioned as that perennial conversation partner from the "West." Many of these aging émigrés are speaking to Britons and Americans now long dead, whose sometimes New Age progeny are more likely to be intrigued by the very goddesses and "magic" long eschewed for the once-certifying language of science.

Questions now abound. Many recent publications on globalization and transnationalism are fixated on the "fading" nation state or its "fragments" (Rudolph and Piscatori 1997; Chatterjee 1993), as Arjun Appadurai indicated a few years ago (Appadurai 1996, 188). Certainly a new kind of transnationalism means building identities that cross old borders, as the ongoing Internet work of the VHP within the diaspora temple complexes shows. But that is not my interest. Rather, like Appadurai, my concern here is with the "production of locality" in a global context and the place of certain temples in that process. A turn to what I have termed "localism" on the part of some diaspora communities often functions in the face of other kinds of transnationalism such as the ever-present neo-hinduisms and hindu-nationalisms (I eschew capitals here on purpose) that invade the very language available to "explain" the deities devotion and in a global context. In a discussion of "locality," Appadurai delineates a useful distinction between *locality* as a "phenomenological quality . . . a sense of social immediacy" and *neighborhood,* where locality is realized, actualized, either in geographic or in cyberspace (1997, 178–179). He sees a disjuncture in the construction of locality in the face of increasing inability to actualize neighborhoods. "The many displaced, deterritorialized, and transient populations that constitute today's ethnoscapes are engaged in the construction of locality, as a structure of feeling, often in the face of the erosion, dispersal, and implosion of neighborhoods as coherent social formations. This disjuncture between neighborhoods as social formations and locality as a property of social life is not without historical precedent, given that long-distance trade, forced migrations, and political exits are very widespread in the historical record" (Appadurai 1996, 199). But in matters of religion, Appadurai's useful distinction has some special complications, especially in the case of those "eth-

noscapes" formed by Tamils and former residents of the old Madras Presidency—a south India that includes much of the present Andhra Pradesh, Karnataka, and Kerala.

Transnationalism, globalization, locality, and neighborhood all have potential connotations within the religious world inherited from the years of comparative religion, missionary ideology, and more recent history of religions and world religions conversation. Much of this patrimony hides within pervasive academic sensibilities that subtly elide transnationalism into globalism and then into another process: universalization in religious matters. Globalization in its dictionary meaning, "to make global or worldwide in scope or application," in common usage is usually applied to the world of economics.[8] Transnational, a word given currency in the journal Public Culture, describes the spread of practices, deities, and devotees across national boundaries through migration. Studies of the spread of multiple Hindu practices into new spaces can too easily neglect the distinction between the processes of universalization and globalization. Globalization can continue to provide a space for locality, whereas universalization tends to blunt both locality and neighborhood in the religious dimension of worldwide migration.

What does local really invoke in the context of religion? In religious studies, such a term is often a cipher, especially in a south Indian context, for long-term assumptions about "village gods." Here the local perpetuates practices such as violent blood sacrifices, possession, fire walking, the entrance of god into the human body—a religiosity of instrumental, pragmatic, and interpersonal relationships with often capricious divine persons seen as devoid of any systematic reflection or ethical standards. As the influential missionary bishop Henry Whitehead put the issue long ago, "Śiva may be terrible and cruel, but at any rate there is something grand and majestic about him: he represents a world force; he is an interpretation of the universe and the embodiment of a philosophy. But the village deity is nothing more than a petty local spirit, tyrannizing over or protecting a small hamlet . . . she has no relation to the universe or even the world: she is the product of fear untouched by philosophical reflection" (Whitehead [1921] 1976, 153). In such a framework, a universalized religion must have a conscious discourse. Practice must have undergone what Max Weber termed "rationalization" to have legitimacy as something other than "superstition" or "magic." The good bishop managed to condone the massive blood sacrifices described in the Bible because "the Jewish sacrifices symbolized great moral and spiritual truths; the victims represented the worshipper, the killing of animals and the offering of blood expressed the consecration of the worshipper's life to God. . . . But in the sacrifices to the village deities in India at the present day there are no traces of those higher ideas in the minds

of the worshippers" (153). The contemporary return to the local, even a nostalgia for the locality in matters religious, openly returns—I will ague—to religious experience that can be loosely termed "magic" or, in the old Weberian term, "enchantment"—the sense that the concrete world becomes the site for divine powers to interact with human devotees, for curing pain in the body and agony in the mind, for financial success, for general mangalam (auspiciousness). Such a return to the "magic" in the local appears to have counterparts in the thriving cities of Taiwan. "As Taiwan has thrived in the new capitalist world it has simultaneously become more localizing and more universalizing, pushed market competition and charitable redistribution, celebrated individualism and constructed social values, wallowed in disorderly ghosts and crafted new kinds of order. It is both postmodern and modern, together and inseparable" (Weller 2000, 294).

This description of new religiosity in Taiwan, which I also witnessed in 1995, should remind us that in the case of globalization a tension always remains between religious tendencies toward universalization and concomitant drives to affirm locality. Contemporary globalization accommodates, perhaps even accentuates, this potentially creative tension, especially in the context of the Hindu temple. During the 1970s, when the notion of the "Great" and "Little" traditions held sway in American scholarship, the Sanskritic culture—as described by the famous Smarta Brahman V. Raghavan—supposedly subsumed local practices and created a refined homogeneous culture (Singer 1972, 80). The contemporary "saffron wave" appears to engage in a similar practice of blunting the local while constructing an idealized cultural whole. Ironically the VHP and BJP have used the construction of a temple to Rama as a rallying point for such a process. They have created a single locality dedicated to Lord Ram, "the personification of all our cultural values" (http://www.hintunet .org/vhp/d.Dimensions, 7) to define a religion ironically paralleling holy structures in Rome, Jerusalem, and Mecca. The universal Roman Catholic Church or Mecca allowed multiple sacred buildings, but turned all toward a universal center, be it Rome or the Ka'ba as the ordinal point.[9]

Hindu temples, on the other hand, live in an indeterminate space between locality and universality by their very nature. During the mahakumbhabhisheka, the consecration ceremony, this tension is articulated as the priests begin by invoking unmanifested and then partially manifested powers into the sacred fire altars—powers inhabiting sound, light, and finally their own breath. Priests then transfer these powers into a great kumbha (pot) now filled with power-infused waters, hence the name of the ritual, maha + kumbha. These power-full waters are then poured (abhisheka) over the image-body, turning stone into sacred tissue (see Waghorne 1999c, 236–240). The image-body exists precisely

at this point where spirit becomes matter or, put in other terms, the point where a universal deity is fixed in a locality—the Sanskrit term for this part of the ritual directly states this: prana + pratishtha, "fixing the breath." C. J. Fuller explains this tension: "the deity can neither be distinguished from the image nor identified with it, so the image itself is the 'bodily' form of the deity, made concrete and visible in mundane space and time" (Fuller 1992, 61). The same can be said for the temple itself. At the culminating point of the mahakum-bhabhisheka, priests ascend ladders to pour the holy waters over each vimana (individual shrine). V. Ganapathi Sthapati, the renowned architect who has designed many new Hindu temples in India and abroad, reminds his readers that the entire temple is the body of God (Ganapathi Sthapati 1988, 112–113), and thus always a concrete presence with transcendent qualities. None of the many commonly used words in Tamil or Sanskrit that translate as "temple" implies an idealized community (as does the term *church*), but always a con-cretized dwelling belonging—even legally—to a specific deity, the master/mis-tress of the house (alaya), mansion (mandir), or palace (koyil). Within the realm of religious sensibilities, at the moment a temple centers the religious life of a group, the locality or neighborhood—to borrow Appadurai's terms—comes into tension with the universal. The entire process may be played out in a global context, but this tension remains. As a local site of materialized powers, the temple houses holy beings operating beyond of the supposed laws of na-ture. As a site for universality, the temple also shelters old traditions of ration-alized power explicable as morality, philosophy, or a cultural way of life.

There is nothing new in processes of rationalization and universalization in Hinduism. They are as old as the Vedas, wherein the sacrificial altar and the great sacrificial rituals became analogous to the universe and finally to the processes of supreme consciousness. Ritual gave birth to philosophy in India. But in the contemporary world, this process of universalization is no longer intoned by priests or taught by pandits. As Richard Burghart pointed out more than a decade ago, "It would seem that authoritative statements from respect-able Hindu laymen about the universal dharma is a new departure for Hin-duism" (Burghart 1987, 232–233). Burghart was describing a process he wit-nessed in Britain where the newfound rhetoric of multiculturalism categorized Hinduism as one of the many "ethnic" religions in Britain. The National Coun-cil of Hindu Temples felt qualified to publish an "authoritative" statement on the "tenets" of Hinduism, "presented by those who know it best—not the scholars or the mystics, but the people who practice it as a daily way of life" (quoted in Burghart 1987, 232). In a paradoxical sense, this ethnic-centered Hinduism functioned as a new kind of "folk" religion—albeit middle-class

folk—because lay practitioners were encouraged to assume the voice of their religion.

This same logic of multiculturalism thrives in the United States as well, where the VHP, temple donors, and devotees alike assume that same voice of authority—sometimes seconded by quotes from a guru or two—often written onto inherited family and community status but usually sealed with a university degree. Middle-class credentials from the professional and business world translate without interruption into authority in the religious world. Witness the phenomenon of Deepak Chopra, whose qualifications as a physician plus a talent for writing provided the mantra to transform him into what an editorial reviewer at Amazon.com now breathlessly describes as "world-renowned author and spiritual leader." In his latest book, the good doctor is judged eminently qualified to teach his readers *How to Know God: The Soul's Journey into the Mystery of Mysteries*. The same reviewer explains: " 'The purpose of this ambitious book is to assure readers that anyone can engage in this process—it isn't a matter of faith, religious teaching, innate goodness, luck or some other mysterious factor,' Chopra explains. 'Our brains are hardwired to find God.' As he drifts through the cloudy realms of ESP, telepathy, clairvoyance, miracles, obedience, loyalty, evil, ego, addictions, and mentors, readers can trust that there is a competent pilot at the helm, deftly guiding this excellent book." Globalization with its strong overtones of economics gives the rising middle class—here even the "rich and elite" who remain culturally middle-class, their own fortunes having often been generated from acumen in business and/or the sciences—a new authority as they increasingly become the only group really capable of patronage. It is this group, the educated people, who are most likely to have imbibed notions of rationalism, moralism, and scientism as criteria of evaluating, explaining, and even engineering a religion. As lay people, however, they also live with family memories not far from the village, not far from healing via "spirit possession," not far from the local.

But the issue still remains: is there something about the new Murugan and amman temples that creates neighborhoods—I still prefer my own term, localisms, at this point—in a more emphatic way than temples housing other deities? We might envision a sliding scale of this urge toward reaffirmed locality: the VHP-style ideology of many temples as centers for moral discourse is the least concretized, the temples with generalized all-India deities are in the middle, while Tamil temples to Murugan or the ammans are at the other end, actualizing a sense of locality in the most "local" way. Why do Murugan and the ammans function as icons of locality even as they globalize? What aspects of the religious life of devotees does this return to localism activate? A

booklet sold at the famous Murugan temple at Palani offers its own explanation: "Devotees of Muruga are found the world over. . . . One possible reason is that temples for Muruga need not necessarily have Brahmin priests; the other is that the rituals are less elaborate; the approach to the deity is more direct. This explains the existence of a large number of Muruga shrines outnumbering Siva Shrines 40 to 1" (Somalay 1982, 9–10). Part of the answer lies in the deities' intimate relationship with devotees. In this chapter, voices of individuals dominate, which is befitting for Murugan and the ammans, who call personally to their devotees, the uneducated and educated alike, inveigling their sacred persons into the lives and even the very bodies of their servants. I heard new middle-class voices from Chennai to London as founders, presidents, and board members, usually lawyers, doctors, or businessmen, narrated their personal encounters with Murugan or a goddess. Many had thoughtfully formulated their own often-idiosyncratic visions of the nature of deity and the world. These were hardly "folk" philosophies, but then neither were they staid versions of Brahmanical texts. To keep this discussion of this process of concretization as concrete as possible, let's take London as the key site for a discussion of various south Indian groups and their ethnic cousins from Sri Lanka and other fragments of the old empire. Overtones from Washington, New York, and Chennai will add harmonics to this often-uneven global process.

Murugan and the Reaffirmation of a Place for "Enchantment" in Chennai

Commenting on the great popularity of Murugan that he witnessed in the early 1970s in Tamilnadu, Fred Clothey sounded a note of concern about Murugan's survival in the coming years. With the overthrow of Brahman political hegemony secured, the DMK cautiously disavowed the strident atheism of its near relation, the DK, headed by the then much-alive black-robed Periyar (E. V. Ramaswami). Clothey reports that the new chief minister, C. N. Annadurai, declared in Palani, the wealthiest temple within Tamilnadu, that Murugan was "the god of the DMK." In the five years after the DMK victory in 1967, "attendance at Murugan shrines and temple budgets had increased manifold" (Clothey 1978, 116). At that point, Clothey concluded, "It is clear that the cult of Murugan reflects, in significant measure, the mood of contemporary Tamil Nadu, even in the face of change and encroaching secularization. There are several reasons why this is so, not the least of which is that the god is riding the crest of Tamil self-consciousness" (2). In addition, the long-time inclusiveness of this deity fostered a sense that Murugan was "truly democratic and

attractive to a significant cross section of Tamil life" (3). Clothey's disquiet, however, concerned the new technological age that was just beginning to emerge in Tamilnadu. He wondered whether a god with Murugan's particular attributes could survive in the coming scientific and, he presumes, secular world. "It may be that he will survive the pending cultural upheaval and go on to a new levels of popularity. On the other hand, the history of religions is strewn with the remains of gods and symbols that have become otiose or have had their messages transferred into fresher symbols when historical change demanded it. Will Murugan have a similar fate?" (4). Paradoxically, Clothey's now three-decade-old warning about Murugan's fate was prophetic only in part. Murugan no longer holds exclusive sway over contemporary Tamils as the guarantor of democracy; the ammans now guard social integration. Murugan's gentle fall in popularity in Chennai, however, has little to do with any perceived lack of the "scientific" about him. Clothey could not have predicted the renewed interest in what once might have been called "magic" among many of Chennai's—indeed India's—technological and scientific elite (see Babb 1986).

Of the 108 new temples that I surveyed in Chennai, only three were dedicated to Murugan. Even the old Kandaswami Temple for Murugan in Georgetown was declining in importance and popularity for the Beeri Chettiar community and the general Georgetown neighborhood, as Matt Mines had found just a few years before (Mines 1994, 125–146). The Vadapalani Temple for Palani Murugan draws large crowds but not the reputation I remembered from two decades previously. In addition to the complex constructed by Dr. Alagappan, only two other new temples for Murugan had surfaced on the urban religious landscape. In the old close-knit neighborhood of Chintadripet, policemen constructed two lovely small vimanas surrounded by a low wall in front of their station. These shrines for Bala Ganesha and Bala Murugan, appropriately diminutive for the baby form of these powerful deities, might be mistaken for popular street shines except for their location off the road and proper Agama rites that consecrated them. Beaming uniformed policemen told me of the fund-raising in the office and the neighborhood that created this new miniature temple complex with shrines that were clearly designed for quick circumambulation before beginning a long day's work. At the center of the consecration rituals was an older woman wearing the saffron-colored sari of an ascetic, with her hair matted but also the gold thread and jewelry of a married women (figure 4.2). She had smeared her forehead with ash dotted with a huge red bindi. She rotated very slowly with her eyes shut in a near trance and her right hand in the mudra of abhaya hasta (do not fear), a classic pose for Lord Murugan (Smith and Narsimhachary 1997, 227; Gopinatha Rao [1914] 1933, 2:425). The presence of this women recalled one of the oldest

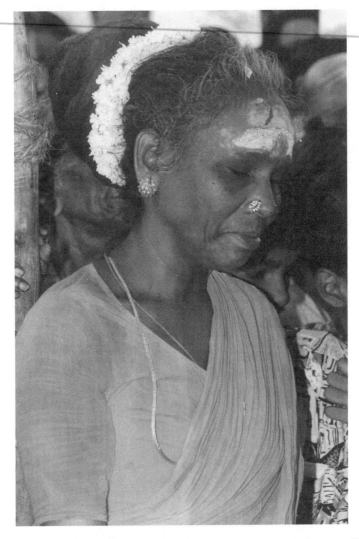

FIGURE 4.2. An ascetic woman presides at the consecration of two small vimanas for baby Murugan and baby Ganesha. With her eyes closed, she slowly turns to offer blessings to those present.

aspects of devotion to Murugan, his propensity to possess women as well as men; both genders have long served him as his voice and his priests in Tamil country (Clothey 1978, 26–28; Kailasapathy 1966; Ramanujan 1985, 215–217). Clearly she had a story to tell that I could not hear during my brief stay. The tale of another new temple to Murugan, however, I heard in full from a former businessman whose plans to build a shop in front of his new home were interrupted by Lord Murugan's inescapable demands.

My discovery of the Om Muruga Ashram and temple was by a fortuitous mischance when our car was blocked by a procession of red- and saffron-clothed devotees dancing as they carried kavadis over their shoulders (like the devotee to Mundakakkanni Amman in the last chapter), the traditional way to make an offering to Murugan. Several of the older men and young boys wore the sacred thread of Brahmans, which was not surprising in the solidly middle-class neighborhood of West Mambalam, thick with other small temples. The very fact of middle-class Brahmans dancing and singing while carrying kava-dis, however, was surprising (figure 4.3). Something special was happening here, and a bystander—a technical associate at the prestigious Indian Institute of Technology—kindly explained the event to me. The procession imitated an event at a famous Murugan temple in which devotees carry milk to the sanc-tum, where priests pour gallons over Murugan's image-body after the yearly reenactment of his victory over a horrible demon. Leading the procession was the chief trustee, his wife, and other officials of the nearby ashram-temple for Murugan; the men were wearing saffron dhotis and the women red-and-saffron saris. The trustee had been a successful married businessman who began to worship the Vel (spear), the heart-shaped spear that Murugan carries. This former businessman now functioned as the guru for his community. My informant related two miracles that occurred even in this small procession: the milk never spilled nor did it spoil in spite of the heat.

My guide then walked with us to the temple, which indeed had been built

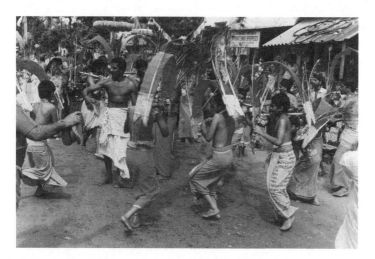

FIGURE 4.3. Young boys, some wearing the sacred thread of a Brahman, dance with kavadis on their shoulders through the streets of this upscale neighborhood of Chennai.

in the front yard of the small compound of a single-family house. The temple itself was actually a single vimana with a plain conical shikhara over a round sanctum. A large cobra formed a canopy for the divine stone image of Murugan, who resided here without his consorts. For this festival day, the face of the divine image was covered with sandal paste, a long white beard, and hair in the style of an ascetic. Our guide told us that this is the surreptitious form Murugan took to marry his second wife, Valli, the daughter of a hunter chieftain (see also Clothey 1978: 83–84). The reenactment of the holy wedding would be celebrated that night in the temple. Interestingly a back wall, which led to the sanctum and connected it to the house, was covered from top to bottom with all sorts of postcards and posters of a variety of saints and deities that devotees had taped there. Afterward we toured the once-private house that now functioned as an ashram. In the far back of a large kitchen, one very old woman prepared the food that would feed, we were told, over a thousand people.

A few days later, I interviewed the founder-guru, but only after yet another fortuitous mishap. We had returned to the temple on the evening of the procession to witness the marriage of Murugan with his wives. The founder-guru, dressed in a saffron dhoti covered with overprinted *Om Murukā* (Hail to Murugan!) in Tamil, lead prayers to Murugan in the courtyard of the temple-ashram. He wore large rudraksha beads around the bald crown of his long white hair and on his neck and around his arms. He looked the very image of a saint, but also seemed to mirror the white-haired ascetic form that the Murugan image had assumed for the festival. We asked permission to photograph, and after some hesitation were warned not to point the flash toward the sanctum. Unfortunately when the first light flashed, the trustee-guru stopped everything and was clearly angry—we did not wait to explain but quickly left. Feeling very disturbed by the presumed mistake, I decided to go back a few days later and speak with the guru, intending to apologize and ask him for the story of this temple. For some strange reason I have no notes of that important interview, but the sound of his words and the intensity of his face are still vivid after five years. I remember entering a very small hut attached to the temple and greeting the guru who sat facing us. He spoke elegant English. He said that he had been a businessman who bought this house, intending to build a business at the front facing the road. I vividly recall his face as he told me, "Murugan intervened then and set up shop here instead." He did mention that someone had flashed a camera and the sanctum was "blackened" the next day—I do not know if he knew that we were the ones! I also recall that he stressed that the temple and his ashram were open to anybody. He seemed to suggest quietly that he would accept us as devotees. I asked

about the temple. The founder-guru designed it himself without the help of a sthapati (architect), but when someone checked just prior to the consecration, the sanctum was out of square by several inches. Then the founder prayed, and when the vimana was again measured the next morning, its proportions were perfect. He told me that Murugan came to him in dream-vision. As ordered, he began digging and found an image of the god buried there, as he had seen in his vision. That is why the temple was on that spot.

These new temples and their enthusiastic patrons give little hint as to why Murugan has lost precedence in urban Chennai. For these enthusiasts, Murugan continues to manifest the qualities that mark his special relationship to his beloved devotees. He possesses. He comes in visions. He inhabits their world, their home and body. In turn, they can mirror the bodily form of the god by dressing in his saffron and red colors, making their hands form his gestures, wearing his imprinted name. Murugan willingly allows both men and women, rich and poor, to create themselves in his own image. Those who live in a world created by this relationship to Murugan live daily with what others might call miracles or magic. But today many of those same traits belong to the ammans—indeed to many other gods—as the earlier chapters showed. I will return to the nature of this close resemblance between Murugan and the ammans later. But still unique to Murugan is his special relationship to the Tamil country, and that may be both the source of his former precedence in Tamilnadu and a factor in his current decline. While Tamils in Sri Lanka continue their fight for a separate state, Tamilians within the Indian union move with each passing year toward a national consciousness. The series of alliances between the AIADMK, the DMK, and the BJP in Delhi brought once-rejected religious imagery back to the public arena. Celebration of the Ganesha Chaturthi (Ganesha's birthday) by a procession of huge paper-and-plaster images organized by the right-wing Hindu Munni met with public indifference and even deep concern in 1994; five years later, C. J. Fuller found the procession in full swing and an accepted part of public events in Chennai (2001). The need to assert a Tamil identity is an aging issue in Tamilnadu. I saw few young adult men or women at the Om Muruga Ashram or at the Bala Murugan Temple. Gray is the color of Murugan's true devotees' hair—at least for now in Tamilnadu.

Murugan, the eternally youthful god, has not aged for Tamils abroad. The vibrant face of Dr. Alagappan (Ph.D. New York University and an international civil servant) mirrored the new global context for this most Tamil of gods as he spoke with me one afternoon at his new stone temple complex to Murugan (figure 4.4). The planning and building of this temple complex moved—almost vibrated—back and forth between New York City and Chennai. He kindly

FIGURE 4.4. I sit talking intensely with Dr. Alagappan on lawn chairs during a lull in the consecration rituals for the first of the temples to Murugan at the Arupadai Veedu complex in Chennai.

shared with me not only this single story but also his vision of his place as the modern heir to a family and community heritage of deep involvement with temple culture. Unlike many of the founders of new temples in the United States, who admit freely to their own inexperience with the process, Alagappan's great-grandfather extended in granite the famous temple to Murugan at Swamimalai. As a scion of Nattukkottai Chettiars, he grew up with temple builders. On the streets of his hometown of Kanadukathan near my own beloved Pudukkottai, almost every family had significantly renovated or built a temple. Ironically, he sat in front of me as the living successor to all of those Chettiars whose supposedly gaudy renovation were reviled by nineteenth-century British architectural purists in the now fading records of the Archeological Survey of India described in an earlier chapter. History always has a living face in India. Dr. Alagappan's conversation with me wound back and forth between New York and India, between concrete ritual and philosophy. He has been living between the lines of national borders and between heritage and innovation. A metaphor for his life can be taken from his own narrative. He feels that the ancient sage Agastya continually guides his work across the continents through a process called Nadi reading: a trained medium receives messages through words that appear between the lines of the ancient *Nadi Shastras*, which are inscribed on palm leaves. The letters, as Dr. Alagappan

explained, keep appearing "like an electric line" on the text. And like electronic words, they can be gone in a flash. Dr. Alagappan's narration of thirty years of effort bringing the Hindu temple to the United States is rich enough to stop and listen to for some time.[10]

As the milk from the final abhisheka poured out from the sanctum of the newly consecrated temple on that March afternoon on the beach in Chennai, Dr. Alagappan sat with me on a lawn chair, answering questions for a over an hour. A decade earlier, he had had an idea to build a complex that would contain replicas of all of the six great pilgrimage sites for Murugan in one location. When he had an audience with the "senior Paramacharya" (the Shankara-charya of Kanchipuram) near Hyderabad, he said, "I posed the question 'Will it not be nice if all the six houses of Lord Skanda were in one place.' He looked at me up and down and said, 'I will give you the land.' I did not propose that I was going to do that. It came like an instruction." His Holiness saw to it that M. G. Ramachandran, then the ruling chief minister of Tamilnadu, gave over the land in Dr. Alagappan's name quickly. Dr. Alagappan was able to raise funds in the United States under a reciprocal aid program by American tem-ples, especially the Hindu Temple Society in New York City, which he had founded. The temple had received help from India, so in return they started a program to support projects in India. Then along with his wife and other generous donors, Dr. Alagappan donated the remainder of the funds needed to begin.[11] "Being in a population center, its is bound to grow in a big way."

Then the conversation turned to the first Hindu temple in the United States, with Ganesha as the main deity. Officially named the Hindu Temple Society of North America, devotees refer to the temple now as simply "the Flushing temple."[12] The founding committee was determined to find some central location in the city. When a less expensive building was available Dr. Alagappan said, "No, we have to build an authentic temple." He emphasized, "I am very conscious of being authentic. People succumb to the temptation to do it within their own life span so they rush to get things done because every-one wants to leave a mark on history so they want to do something quickly." Finally they found an old Orthodox church and bought it. For the architect, he chose M. Ganapathi Sthapati, the chief temple architect of the Government of Andhra Pradesh and the elder brother of the busy international temple archi-tect Muthiah Sthapati. Dr. Alagappan explained, "I came early on in the game." He avers that he is the person who proposed the establishment of the Lord Venkateswara Temple for Pittsburgh and Sri Meenakshi Temple for Houston. In the early days of the new Hindu temple movement in America, he acted initially as a go-between because he worked for the United Nations, could move

easily across national borders, and had contacts in India, especially with the Government of Andhra Pradesh.[13] Now he continues as a facilitator for finding suitable priests, traditional craftsmen (shilpis), and architects from India for service in American temples.

In describing his work, Dr. Alagappan emphasized the constant guidance he received from Lord Agastya through Nadi reading. His interest in the esoteric reading of texts extends to a deep reading of the meaning of this temple complex, as well. After we stopped for a few moments to hear a passionate devotional song to Lord Murugan and the power of his Vel, the founder drew a six-pointed star for me and explained how each of the six temples would be a point on this star, which reflected their location within Tamilnadu. He named the six (his spelling) as: Tirupparankundram, Tiruchendur, Palani, Swamimalai, Tiruttani, Palamudir Solai. Then he began to talk about the human pulse in relationship to these points, but I did not at that moment fully get the point.

Then he began to explain the significance of the stone Vel with a face outlined on the spearhead fixed in front of the vimana and towering over devotees who stood there watching the rituals. "Now the conception is that the Vel is not a weapon but a deity in its own right, a goddess called Jyothi." Devotees have installed images of Jyothi in her own sanctums in the temple in New York City, in Houston, and Los Angeles. "Now She says, 'I want to help the world at large.'" Jyothi is more than a goddess; she is an embodied ontology. Dr. Alagappan drew a chart for me outlining the system.

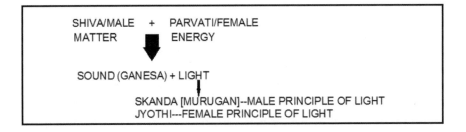

The way he explained it to me, "You have Light that becomes Shiva and Parvati, that is, the male and female principle. Shiva is matter and Parvati is spirit; when they meet, we get sound and light. Ganesha and Skanda [Murugan], they are called children, this is the meaning. Parvati gave Murugan the weapon which was born from a spark from her forehead. . . . Jyothi resides in between the two eyes." This chakra point is the border between the manifest and the unmanifested. "We have been doing Jyothi puja in the New York temple for about fifteen years every full-moon day." Then I mentioned Gayatri, another

new form of a goddess understood as the embodied sound of the great ancient Vedic mantra. He acknowledged that the movement had reached the New York temple. "Then someone was very keen to put the Gayatri figure into the temple but it did not create balance. Some devotees connect with it—I have seen it."

His conversation ended with serious reflections on his life. His inspirations have always comes from revelation, and he has no choice. "Now looking at it all, I find that this was my destiny to build temples in the North American continent. For that, all these things happened. Being born in my family, my education, and my position. I remember meeting my great-grandfather, who made an important contribution to the building and growth of the Swamimalai temple but actually died seven years before my birth. I remember exactly where I met him, talking with him in a hall in his house when I was about three or four." His home was in Kanadukathan, about eighteen miles from Pudukkottai. "I sometime think that maybe the sojourn on the planet is more short-lived than the life elsewhere. Another thing is that I feel that you participate in the decision on where you want to be born. So my impression is that I desired to be born for this purpose so I went and checked out this family in Kanadukathan."

Only now do I realize the significance of much of this long interview. Dr. Alagappan lives in what Max Weber (mistakenly) called an "enchanted" world. David Rudner's study of the Nattukkottai Chettiars brilliantly blunts such an assumption of stark separations between the utterly pragmatic character of this successful merchant community and their long-term temple construction and contributions to temple rituals. Rudner uses the phrase "the magic of capitalism" to refute Milton Singer's later-day revival of Weberian "logic" that "religion is, by definition, *other-worldly* and that it interferes with secular, *this-worldly* business concerns" (Rudner 1994, 134). The Arupadai Veedu complex in Chennai, funded by a global economy, planned by an international person, enables globalization that is at the same time localization. This model for a globalized localism circles around to the days of the dominance of the merchant communities in old Madras. During this early period described in chapter 1, Alagappan's ancestors were consolidating and restructuring their older role as banker-merchants which, as David Rudner argues, was interwoven with their building of temples and support of temple rituals in their "homeland" and abroad. The Nattukkottai Chettiars never permanently resided in Madras city but in "Chettinad," which appears on no modern map but is nonetheless a very concrete homeland about 150 miles south of Madras, overlapping with much of the old princely state of Pudukkottai. Driving through this seemingly

dry and rural area, suddenly a town like Arimalam appears, with a brightly painted massive Shaiva temple in the center surrounded by streets with some of the loveliest grand domestic architecture in the world. In the bazaar, a shop sells old bronze utensils and red-black lacquer with labels in Burmese betraying the source of such wealth. These streets—like those Alagappan knew—are home to descendants of the merchant-bankers who once "provided the financial wherewithal for many Southeast Asians to make a living and ultimately made possible the tea and coffee plantations in Ceylon, the rich rice frontier of lower Burma, and the tin and rubber industries of Malaya" (Rudner 1994, 5). The Nattukkottai Chettiars, who have roamed the world as traders and bankers, were a diasporic people long before the present wave of emigration. They long maintained their sense of place through their ancestral home to which they returned at retirement and through the construction and renovation of temples. It is not surprising that the father of the Hindu temple movement in the United States—as he put it—chose to be born in such a caste community.

The father of the Hindu temple in North America, with his clear-headed ability to organize the massive movements of people and material needed for the construction and control of temples across continents, can hardly be called otherworldly in the usual sense. And yet all of the practical affairs of his life are guided by the Nadi readings. His sense of life is measured both in the beats of the human pulse but also in the eons available for any really full life. This sense of an extended life was so clearly a natural phenomenon to Dr. Alagappan that he felt no need to camouflage his cosmos with me. All of this was tied together with nuances of the Tamil term nadi. On his diagram of the temple complex, which I have in front of me now in my notebook, points of the star marked the nadi, which he translated as "pulse," the literal dictionary meaning. The term also means an artery, vein, and even a lute string—anything tubular. It also refers to what the University of Madras *Tamil Lexicon* calls an "astrological treatise" as well as the word for "hours" (1936, 4: 2210). Before meeting Dr. Alagappan, I heard the word used to refer to a series of marks made on the stone murti (image-body) at the moment of the consecration. A string tied to a key point at the wrist carried the energy of long rituals, now consolidated in the fire pits, into the body of stone, thus infusing life. The nadis are about the circulation of energy throughout all aspects of the universe, of which the human body with its pulsing life is a microcosm. Thus the Murugan temples forming this star were at once spiritual maps of Tamilnadu and a mandala—in my terms—of the pulsating energy of Lord Murugan circulating in the cosmos and in each devotee's body. His Vel, now the goddess Jyothi, spreads this energy as she lights, as Alagappan says, the whole world. The ontological universe of Alagappan's chart moves back and forth, as he says, in

that space, that chakra, behind the human forehead; but I would add that this space contains the universe. Through this philosophical reading of his temple complex, Dr. Alagappan has embraced, I think, the liminal border-world that he has long inhabited—that creative space between national borders and between past and present. This space becomes in his narrative a concrete place in which to set up shop and make a locality into a neighborhood.

There are dimensions to Dr. Alagappan's project that complicate the scale of globalization and localization in an Indian context as well as create space for genuine innovation. In bringing together all of the sacred sites of Murugan in Tamilnadu, Arupadai Veedu temple complex creates a secondary localization, localization once removed. Each "original" temple to Murugan already fixed or concretized the deity into a particular site. By bringing these sites together, envisioning them as a star-shaped mandala, and then analogizing the whole to the human body, Alagappan implodes and then reconcretizes the locality of the deity and provides a model for a new portability. In the Mahalakshmi Temple in London, a miniaturization of this concept is already installed: a very interesting six-sided lotus-shaped structure carved out of wood that forms the platform for six bronze images of Murugan, each with a label in Tamil naming the form of Murugan that resides in his famous six sites in Tamilnadu. This inventive wooden vimana moves on ball bearings so that the priests can do abhisheka, pouring the holy substances on the bronze images as they turn the platform. The founder of the temple was well aware of the Besant Nagar temples. Alagappan's giant stone complex was miniaturized in wood and transported to London within five years of that moment when the first of the six temples took life in Chennai.

The Arupadai Veedu complex is complete now, with the recent mahakumbhabhisheka of the final three vimanas (figure 4.5) sanctified by the presence of the senior Shankaracharya of Kanchipuram (see http://murugan.org/temples/arupadai.htm). A proper mandapa encloses the Vel with the living presence of the goddess Jyothi, now called the Shakti Swaroopa Vel (S/ Śakti Svarūpa Vēl) (figure 4.6). Dr. Alagappan emphasized that this was "an innovation" and recently related the story to me.

> Lord Agastya and Nandi Deva [the holy vehicle of Shiva] believed
> that Jyothi should accord her dharshan [auspicious sight and bless-
> ings] not only to siddhas, yogis, and tapasvis [all renunciative saints],
> but also to all devotees. They believed that she should take form as
> Swaroopa "Vel." Since the Kali Age was advancing, such a form
> would give protection to devotees. They both approached Jyothi and
> presented their request. In 1970 the deity agreed to take form, and

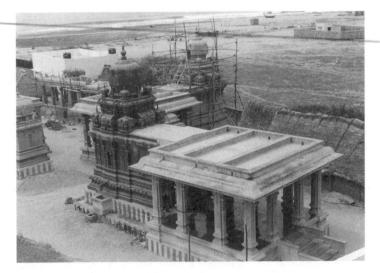

FIGURE 4.5. The Arupadai Veedu temple complex stands complete now. New granite shrines echoing the six famous temples for Murugan in Tamilnadu form a star on the once-empty sandy coastal plain of suburban Chennai. Photo kindly provided by Dr. Alagappan.

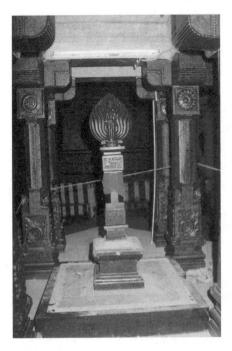

FIGURE 4.6. The Shakti Swaroopa Vel now stands in her own black granite mandapa facing the first of the new temples dedicated to Murugan, the Swamimalai vimana. Photo kindly provided by Dr. Alagappan.

the first Vel with her form etched in it has been consecrated on June
21, 2002, in the Arupadai Veedu complex by the Kanchipuram
Shankaracharya Jayendra Saraswathi. In addition, a Swaroopa Vel
temple all in stone is rising at Mayiladu Parai near Kundrakudi.
This form of Swaroopa "Vel" will spread throughout the world and
constitutes a major innovation in Hinduism.

Jyothi continues to manifest and to intervene in the world on a global scale.
Recall that Jyothi's first devotees offered her puja in Ganesha Temple in Flush-
ing. Her embodiment in stone occurred on the coast of Chennai. A new rev-
elation of divine power builds an international community of devotees for a
global age. Dr. Alagappan and many other contemporary Hindus understand
that divine power takes exactly the right form for precisely the need of the
times. In the Swaroopa Vel, Murugan's power reemerges as a newly embodied
goddess for the very hard days ahead.

At this point, my own narrative has followed as closely as possible the
religious sensitivities of this global temple builder, but his was not the only
voice that had a story to tell about this massive building project on the shore
of suburban Chennai. Through yet another odd chance, a few weeks previously
I had spotted an intriguing unfinished stone temple inside a still-secluded
ashram, officially the Pamban Swamigal Koil Gurukal, a temple and teaching
center in Tiruvanmiyur. The samadhi (burial palace) of this saint who passed
away in 1929 rested now near the center of the unfinished temple. The saint,
who was deeply devoted to Murugan, wrote over six thousands poems to his
Lord and was clearly an important part of the early twentieth-century revival
of devotion to Murugan in urban Tamilnadu (Clothey 1978, 113–116).[14] He
continues to have a following in Chennai and Madurai. In fact, one of his
devotees living near the new Murugan temple complex in Besant Nagar saw
us photographing the site and came over to tell me of the court case that
successfully stopped the construction of the six Murugan temples on the site
of this ashram. Devotees of Pamban Swamigal argued that the math should
remain a peaceful place of meditation. This court case was not in Dr. Alagap-
pan's narrative, but before that interview another devotee of the temple com-
plex had included the case in his own version of the recent history of the new
complex. The old Shankaracharya of Kanchipuram had wanted a Murugan
temple complex like this one just opposite the Pamban Swamigal math, but
this did not work. Then Dr. Alagappan was asked to take up the task. When
then Chief Minister M. G. Ramachandran went to Kanchipuram, the Shan-
karacharya asked for the land and the chief minister gave it, and all of the
papers were made out in Dr. Alagappan's name in a single day. The divergence

in these stories reflects, in part, a difference in the contexts of these narrations. Such tales do not belong at auspicious occasions such as a consecration, where seamless religious narratives of faith and destiny better fit the occasion. But in a much more recent communication, Dr. Alagappan told me that he was not aware of the efforts to build the complex on the site of the Pamban Swamigal Samadhi.[15] Nonetheless, temples exist in the world in more ways than simply as centers of spirituality. Such creations of new space seldom go uncontested, because one group's concretized locality can also be an unwanted presence in another's backyard. Such struggles to create a space for religious institutions within existing neighborhoods are part of the urban landscape in Chennai. But abroad, such scuffles over the religious dimension of a neighborhood end up under discussion in planning commissions in the United Kingdom or zoning boards in the United States.

Wrapped in the Shell of a Church: Murugan in North London

When I first attempted to find the Highgate Hill Murugan Temple some years ago, I almost walked past it. This was certainly the correct address, but there was no temple visible on Archway Road in Highgate, a solidly middle-class neighborhood in north London of single-family and duplex homes. People of Indian origin were entering an unimposing door of a church at street level, and a careful look up revealed a small OM in Tamil script in an upper window. This was the only public announcement of a Hindu presence in this large brick church structure. Seven years later, a clear street sign at the subway station pointed the way to the temple, and a large sign hung above its new formal entrance, facing the road (figure 4.7). A landmark visit by Queen Elizabeth brought the temple into the public eye and the public sphere in London—a point to which I will return. But the inside of the temple had not changed significantly from my first visit. Entering the ground floor, a typical church basement was upgraded but remained architecturally unchanged—reminiscent of the only remnant still unchanged of the old orthodox church that became the Sri Ganesha Temple in Flushing. Here in London, however, the entire shell of the church remained. When I first saw the ground floor, an unpacked crate with what appeared to be a new image about to be installed stood on the floor. Now the main door opens to a clean room. Climbing the stairs to the second floor and opening the door, another world suddenly materializes. Inside this former Baptist church that later served as a synagogue, a large proper south Indian–style vimana stands in the center of the room facing east, with its back to the main window of the former church (figure 4.8). Around the

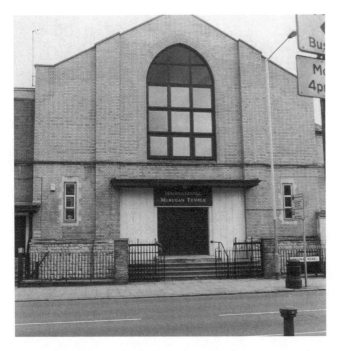

FIGURE 4.7. A board over the front entrance clearly announces the Highgate Hill Murugan Temple; seven years previously, the temple had been almost indistinguishable from the church it had once been.

perimeter are smaller shrines familiar in any Shaiva temple: Navagraha (deities of the nine planets), Bhairava (the guardian form of Shiva), goddess Durga, Nataraja (Shiva as the Lord of Dance), and a linga. On the west wall are Bala Murugan (baby Murugan) and Pillaiyar (Ganesha's form in Tamil as the "son" of Shiva). The only deviations from the Shaiva world are an image of Venkateswara near one corner and Krishna at the other corner.

The story of the founding of this temple, like Alagappan and the Flushing temple, revolves around the determined work of a well-educated middle-aged man. I heard his story retold by officials at the temple and by his own daughter, who was visiting the temple for the tenth anniversary celebrations in 1996. Douglas Taylor also recorded a version of the narrative a few years before, as one of the few British scholars who was paying attention to the various Tamil-speaking communities in London. Everyone agrees on the outline of the founder's early journey to London to take his law degree, his years as a civil servant, lawyer, and lecturer at the law college in Colombo, his retirement just as Tamils were being denied rights in Sri Lanka, and his final return to London with his wife and family in the mid-1960s. Mr. S. Sabapathipillai, as a Vellalar,

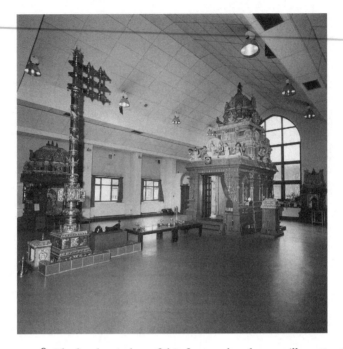

FIGURE 4.8. The lovely window of this former church now silhouettes the bright sanctum for Lord Murugan. A fine bronze dwajasthampa faces the deity at the Highgate Hill Murugan Temple.

belonged to the caste community that traditionally patronized temple renovation and construction in Ceylon. His portrait now greets visitors on the ground floor of his temple. His daughter adds that as a young man, he had been "religiously indifferent" but when he married, his father-in-law gave him a picture of Murugan. With his wife's encouragement, he began to worship. Later he took dishka, initiation, at the great Murugan temple of Palani. A souvenir published at the time of the mahakumbhabhisheka mentions the name of his guru in the Shaiva Siddhanta tradition there and specified that "he obtained the 'Triple Theedchais' enabling him to do Siva poojah."[16] This initiation also enabled him to act as a Shaiva priest performing not only puja but also life-cycle rituals such as weddings. Sabapathipillai, as the only qualified person in London at that time, performed all of these priestly services and used the money to start his project. At this point, when a trustee was narrating the story, another broke in to emphasize that even though people who performed funerals would never be "considered as big men in Ceylon, he did not care." Soon this former lawyer started the Hindu Association of Great Britain and began prayer meetings in his house. In 1973, the temple publication continues,

he traveled back to Kumbakonam in Tamilnadu, a center of traditional bronze casting, and had a panchaloka (five-metal) image of the Murugan in his form at Tiruchendur cast in bronze and then installed with all proper rites in a hall in Wimbledon. The following year, he legally formed the Britannia Hindu (Shiva) Temple Trust, with plans to build a proper temple. Sabapathipillai found and purchased the former church turned synagogue on Archway Road. In spite of efforts to gain "planning permission" to recreate the church structure in the style of a proper south Indian-style temple, the trust was forced to keep the shell of the church intact and build the vimana inside those walls.

The parallels with Alagappan's temple-building projects abound. Taylor interviewed Sabapathipillai while he still lived. This temple builder also had a sense that "he was especially called by Siva to establish Saivism in Britain and the West" (1994, 195).[17] The temple official with whom I spoke confirms this, and credits the founder with bringing the very idea for temples to the West.[18] Taylor more carefully qualifies this and credits Sabapathipillai with concretizing the vague desire in the largely Shaiva Sri Lankan community for some kind of religious regeneration into the determination to construct temples. "It would not be true to say that without him Sri Lankan Saivism would not have been planted in Britain at all. . . . The immigrants themselves were the bearers of their own religious traditions and it was they who wanted to bring these traditions to formal expression in Britain. But without this person, the form this expression took might have been different" (1991, 205). Like Alagappan, Sabapathipillai belonged to a caste community that regularly built temples in his home country and was no novice in religious matters when he emigrated. It could equally be said that both men channeled their diverse communities' shared desires for a reestablishment of religious expression into the idea to establish the temple as the major institutional structure for this process. The souvenir from the consecration of the Highgate Hill Murugan Temple credits Dr. Alagappan by name for his active interest in the Trust and for requesting a well-known priest in Chennai to "do poojah to a yantram [diagram for meditation] for the purpose of building the Temple in London." These pujas continued for twelve years "to keep the spiritual force" of the Sabapathipillai's bronze image of Murugan—the core of early temple devotion until the stone image in the sanctum was enlivened in 1986.

From the beginning, however, Sabapathipillai stayed focused on a vision of transplanting a very particular form of Shaivism and his own sense of orthodoxy, based on his training in Shaiva Siddhanta, to the temple. A split eventually developed, in part over the issue of his demands for a very particular image of Murugan to remain the absolute focus of worship and of faith (see Taylor 1987a). Those who left Highgate Hill eventually founded another temple

near the original site of the group in Wimbledon for the more broadly popular Ganesha, which was actually consecrated several years before the Highgate Hill temple. The picture of Sabapathipillai's Shaiva orthodoxy has softened, perhaps with time, perhaps with a broader view of the man. His daughter credits him with planning to install a large image of Ranganathaswamy, the form of Vishnu in the orthodox Vaishnava temple of Srirangam in Tamilnadu. But the image of Vishnu was strongly opposed, as another woman put it, "Some are allergic to Vishnu here."[19] A manager mentioned that the image would be on the ground floor. There are two small Vaishnava shrines in the main hall with Murugan, which again are credited to the founder's desire to honor the request of some devotees from Mauritius. This conflicting picture does not alter the general trajectory of Sabapathipillai's project to locate his temple within Shaiva ritual practice. Unlike the Flushing temple inaugurated a decade earlier, Highgate Hill began as an explicitly Tamil Shaiva temple. As the mahakumbhabhisheka souvenir declares, the mission of the original Hindu Association temple founded by Sabapathipillai was to unite "Saivites of Dravidian origin." "The main object of the Association was to foster the Saiva Siddhanta religion and its form of worship. The other aim was to generate a unifying force among the Dravidians from various parts of the world such as Fiji, Malaysia, Singapore, India, Ceylon (Sri Lanka), Mauritius, South Africa, so that children of these families may mix in a religious atmosphere so as to encourage them to follow their parents' religious faith and culture." All of these goals now center on the Highgate Hill temple located in a middle-class neighborhood where, as someone told me, "You cannot find even a dozen Indian families." Ironically the most consciously Shaiva, explicitly Dravidian, and the most concerned with orthopraxy in rituals, this Murugan temple exists outside of any of the several South Asian neighborhoods in London.

Middle-class patrons and devotees of the Highgate Hill Murugan Temple, like so many others that I interviewed, saw a serious distinction between the early émigrés like themselves from Sri Lanka and the later refugees. Coming to London as students, usually from urban centers such as Colombo or Jaffna twenty years earlier, these accomplished men were joined by their often well-educated wives from Ceylon and established their homes here as new restraints on Tamils were just beginning in Sri Lanka (Taylor 1991, 202–203). They were professionals leaving an increasingly inhospitable economic and social environment for a better future. Mr. Sabapathipillai epitomizes this early solidly middle-class community. A London-trained lawyer, he settled here with his "convent-educated" wife, as his daughter emphasized. The term "convent-educated" throughout South Asia signals a prestigious education in an English-medium school usually managed by a Roman Catholic order. The other Sri

Lankan Tamils came much later, often directly from villages or small towns, when conditions in Sri Lanka worsened into an outright war between Tamil separatists and Sri Lankan army troops. In the early 1980s, these immigrants were admitted to Britain as refugees. Many of the earlier settled émigrés bemoaned the lack of education, the inability to speak "even a word of English" of their country cousins. The temple's venue in Highgate Hill may well have forfeited a public declaration of Shaivism in exchange for a site in a good middle-class area. Until very recently, older professional Tamils kept their rituals literally under wraps in order to maintain a place in London's respectable middle-class neighborhoods. This fits the general tone of respectably maintained within these church walls, where the procession of the bronze image of Murugan never ventured—until now—into the streets and where the temple manager assured me that the temple tries very hard to keep the noise level down so as not to disturb their neighbors. This felt need for social propriety elided with a sense of propriety in ritual as well. Ritual practices such as possession, carrying kavadis, and noisy street processions are out of place in this venue. Taylor argues that this "omission of all forms of village Saivism" marks a key difference between practices in Britain and in Sri Lanka (1991, 206). Mention of the temple's adherence to a proper form of rituals as defined in the Agamas arose in my own conversations. The middle-class sensibilities that appear to link social propriety with ritual correctness in this north London temple parallel the heightened concern for "authenticity"—also called "agamization" (Clothey 1992, 129)—observed from Singapore (Clothey 1992) to that large city on the Hudson River (Lessinger 1995, 52). Here, like good middle-class neighbors, they keep quietly to their own affairs in their own home. As we will see later, the site of London's other Murugan temple in a largely working-class South Asian neighborhood in East Ham allows for a very visible temple, but traded for a location that one Tamil professional called "a place I would not want to walk around at night." This very complicated sense of locality and of neighborhood needs a wide-angle lens now to see the larger context within London of a set of new temples constructed by the diverse groups of those who share a sometimes remote but common past in south India.

London now has seven major temples that Tamilians or other south Indian peoples patronize. The popular names for these, in addition to the Highgate Hill Murugan, are: Ganapathy of Wimbledon, East Ham Murugan, Mahalakshmi, Mariyamman of Tooting, Rajarajeswari Amman of Stoneleigh, and Kanaga Thurkkai Amman of Ealing. Others add the London Sivan Koil. When asked about Hindu temples in general in London, many devotees and donors bemoaned what they perceived as willful obstructionism by borough (local) planning commissions and various safety inspectors in allowing Hindu tem-

ples a public face in this city. One founder of a temple called the attitude of many native Londoners "hypocritical" because, for all of the official talk about multiculturalism, when Hindus apply for planning approval for a new temple, they are frequently delayed or denied on the thinly disguised grounds of the architectural integrity of the neighborhood. Several Tamil devotees gave as an example the now much-lauded Sri Swaminarayan Mandir, whose 1995 opening in Neasden drew over 50,000 people and considerable media attention. Speaking of the prosperous Gujarati community, I was emphatically told, "with all of their wealth and power, it took them over seven years to secure planning approval." That temple has become the benchmark of unattainable financial success: "We Tamils are not rich but only middle class," or "We Tamils are not businessmen, we are mostly qualified educationally—we push our children to do well in school." In the finest example of the portability of stone, the tightly-knit mostly Gujarati community shipped the finest marble from Italy and limestone from Bulgaria to a port city in Gujarat to be carved and then shipped back to London, where the stones were assembled layer by layer on the site in Neasden.

That kind of public display of splendor eludes people of south Indian origin with their middle-class and, not-so-often-mentioned but very prevalent working-class incomes. A measure of pride, however, always accompanied the declaration of being *only* middle class. Implied in the tone of voice and the choice of words was a certain crassness on the part of the rich Gujarati businessmen—a lack of the kind of love of educational attainment that marked south Indian/Sri Lankan families. Here again were signs of ambivalence toward "going public" with their religious lives. The sense of locality, then, of Sabapathipillai's and other temples in middle-class areas of London is a complicated by a deeply felt assault on the very right of this community to build a proper temple, which in their former home would always occupy a public place. Yet at the same time, the middle-class members of the community remain committed to their own sense of propriety, including what I then clearly perceived as a hesitancy about public display—the very kind of display that their middle-class compatriots in Chennai are openly embracing as they carry kavadis and milk pots, and sing on the public streets. Yearning for locality among some diaspora south Indians that a temple actuates is not just for an institution but also a kind of neighborhood—one that paradoxically existed only within the bounds of its own walls.

When I returned to London recently, attitudes on all sides had changed. For her golden jubilee, Queen Elizabeth visited several religious sites of her non-Christian subjects. The Palace chose the Highgate Hill temple to acknowledge Britain's estimated 1.5 million Hindus. On June 6, 2002, the first reigning

monarch to enter a Hindu temple stepped inside the Murugan temple on Archway Road. *The Hindu* in Chennai reported the visit and noted that "a special 'pooja' was performed during the visit" (Online edition, Friday, June 7, 2002). In announcing the visits, Buckingham Palace explained, "Among the most significant changes to Britain over the past 50 years has been the growth of religious and cultural diversity. The Queen has reflected this in many ways over the years, including visits, her Christmas messages and the annual Commonwealth Observance. . . . The purpose of each of these visits is to indicate respect for the diversity of faiths, to support inter-faith dialogue and to show that non-Christian as well as Christian communities are central to contemporary Britain" (http://www.royal.gov.uk/output/Page1117.asp). One devotee who was present remarked on her graciousness and ease in talking with everyone there. Overstaying her scheduled time, she spent almost an hour. Whether this single act of royal legitimation will change attitudes of local planning boards remains unclear, but a sense of new security pervaded Highgate Hill and several of the other temples I revisited. As one official put it, "We are tolerated better now." The Highgate Hill temple now observes its annual Brahmotsavam with a chariot festival celebrated outside, in the public streets of their middle-class locale. In addition, the temple purchased property across the street for a senior center. Other temples in similar middle-class areas also bring their celebrations into the public square although not into what they as yet consider *their* neighborhood. With extensions across the street and a brief place on the public streets, Lord Murugan at Highgate Hill still presides over a tranquil domain bounded by the shell of a church. I have already discussed the suburban locality of many temples in the American landscape isolated from any Indian neighborhood except the one that their devotees and patrons create (Waghorne, 1999a and 1999b). So while new Hindu temples in places like Mylapore in Chennai center new multicaste and multiclass neighborhoods, a mark of the diaspora temple may be this very new function of becoming a neighborhood rather than anchoring one. This situation takes a very different turn for those temples constructed within a solidly South Asian locale.

Within a Diverse South Asian World: Murugan and Lakshmi in East London

The section of East Ham called Manor Park, I was told by a Sri Lankan gentleman kind enough to take an entire day to escort me, reeked from the fumes of a nearby factory, so the British people fled, creating a stock of inexpensive housing for the influx of South Asians who filled those jobs with "unsocial

hours and low pay" that British people were unwilling to fill during the years of rapid industrial redevelopment just after the Second World War (Visram 1987, 54; Vertovec 1995, 141). The area of East Ham, obviously poor and isolated, does not even rate mention as a quaint or trendy area for those seeking adventure in "ethnic London" (see McAuley 1993). Within Manor Park are two of the seven temples for people of south Indian origin. I soon discovered that the temples shared a common lineage as well as a common neighborhood. The Mahalakshmi, a refitted clothing outlet, has what one would call faux bas-relief pillars (figure 4.9). The old edges of this building were refaced as if they were the carved stone pillars of a temple. The doorway has an almost flat gopura at the entranceway with a good solid wooden door. Inside, the temple has a proper vimana for Lakshmi and Narayanan. Entering the compact temple, all of the markers of a proper south Indian temple are immediately visible (figure 4.10). A proper bali pitha stands just in front of a formal flagpole in brass, but only about six feet high. An image of Garuda, Vishnu's sacred mount, faces the sanctum. Along a side wall to the right of the main sanctum are a variety of small sanctums for bronze as well as stone vigrahas (body-images). Ganesha carved in stone has a permanent vimana. Here is the miniaturized rotating Arupadai Veedu. Hanuman also resides here carved in stone with a bronze utsava murti. A new image of stone Gayatri Devi has a sacred yantra (geomet-

FIGURE 4.9. The present Mahalakshmi Temple begins at the corner of a very typical street in this part of London. This innovative way to refit an older commercial building contrasts with the ubiquitous rows of brick houses.

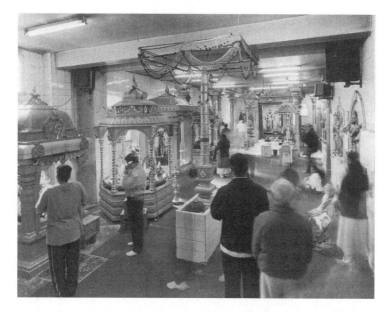

FIGURE 4.10. A surprise awaits visitors to the Mahalakshmi Temple. Once inside the doors, all of the elements of a proper temple greet the devotee. Notice the revolving golden vimana to the left of the flagpole. This wooden miniature echoes the Arupadai Veedu complex in Chennai.

rical diagram used for meditation) behind her. Near Sri Gayatri stands a small bronze Durga—a form with ten arms and sword at her side, her feet sideways and a crown of fire and small fangs; she seems a mix of Mariyamman and the famous form of Durga killing the demon buffalo. On the left side of main sanctum is a new linga on a round bronze pedestal with an umbrella forming the vimana. The ornate main sanctum has a proper path for circumambulating the main deity either before or after visiting the other deities. The only change I noticed since my previous visit in 1999 was that the English captions over the sannidhis (shrines) of the deities were gone.

On my first visit, as I was making my way around the temple, someone pointed out the founder, and I caught up with him as he too made his rounds of the deities. Thus began a long remarkable conversation that started in front of the Gayatri image and ended in his office upstairs. Once again, this was a rich narrative. At first he began to tell me that everything is really the sun's energy and that Hindus do not worship many gods. I did not listen carefully, thinking that this was yet another all-is-one cliché, until I realized that we were standing in front of Gayatri, the same goddess whom devotees now understand as the embodied total energy of the universe. He mentioned that this was the

only fully enlivened image of Gayatri outside of a temple in Nuwara Eliya in Sri Lanka founded by a popular guru. In yet another of those small-world coincidences, I knew of both the temple and the guru through a fervent devotee in North Carolina. I seemed to share with this erstwhile stranger several nodes of a "self-generating, self-inventing form" of a "loosely coupled network" that Susan Rudolph describes as a key part of transnational religions (Rudolph and Piscatori 1997, 248). We soon continued our conversation upstairs, which wound—both the conversation and the stairs—through philosophy, theology, and finally to the story of how this temple began.

Once in his office upstairs, this physician with a thriving local practice told me that medicine could not really give mental peace. This is what temples give, and Westerners who had no temple as part of daily life missed out on this. At birth all is already destined for the individual as karma, but the temple and gods help to deal with the suffering when predestined problems occur. I pointed out that many devotees believed that the gods could intervene, but he recognized this as possible but not the main point. I soon realized that this was his way of reconciling science and religion. As we spoke, the doctor used many examples from electronics as he talked. He seemed to have removed all instrumentality from the gods and viewed the temple as a special kind of therapy. Finally I directed him to *my* actual question, how this temple began. He brightened up when he realized that I wanted him to tell his own personal story. Conscious also of the presence of my kind guide, he began his tale, which he told in the context of an act of destiny in which those who had intended to do evil ended up bringing about his new temple.

In 1980 he came to London from Madras and set up a practice in this area, which he described then as "full of atheists," by which he meant overseas supporters of E. V. Ramaswami Naicker's DK Party—the most radical anti-Brahman and openly antireligious group in Tamilnadu. He was soon elected to a two-year term as president of the nearby Murugan temple, which was only in the planning stage. He found an empty truck garage and struggled to get the planning permission to convert it into a temple. Immediately he was opposed by the DK, who told him, "This is our territory and we do not want any temples." A problem with the site was that it was not properly facing east and he wanted more land, so he had to persuade the owner of the neighboring pub to sell. The owner was soon threatened by the DK with a boycott if he tried to relocate. The crusading doctor finally got the extra land and the planning permission, but just as he was to have the mahakumbhabhisheka he got threatening telephone calls form the same DK supporters. This time the issue was "How can a Telegu fellow know how to pray to a Tamil God?" They put up a

black banner with these words on the day of the mahakumbhabhisheka. He had called the police on the phone at midnight. The police promised protection. So on the next day when the banner went up he called the police, who locked up the demonstrators until the ritual was over. They continued to make a fuss, saying, "A Telegu fellow should not come to power. Better go back to Andhra and pray to Narayanan [a name of Vishnu]." At that point, he vowed that he would build a temple to Narayanan in London, and he told Lord Murugan that before he completed that new temple he would "come back and do a full abhisheka." Now he understands that these troubles were an act of destiny to push him to build a temple to Narayanan. He was God's instrument for this purpose. He still tells the new leaders at the Murugan temple that theirs is the mother temple. "Just like in the *Ramayana* or in the *Mahabharata*, the action that saved things came by an initial act of seeming evil. That is also how the *Bhagavad-Gita* was written."

This was not the end of his long narrative or his troubles with the DK. When he tried to get a large bank loan to refurbish this present location, the local DK once again tried to thwart him by offering a larger amount to the seller of the property. He managed to get the money first through a banker willing to help him out of this predicament. He felt that this was destiny—the DK once again provided the context in which a banker could not refuse the loan. Later he had the mortgage transferred to the Bank of Baroda, as his bank requested, and he pledged his house and surgery as collateral. They asked only for interest payments at first. He began to collect money in tin boxes from his patients. Then he had to get planning permission. Once again the DK circulated a petition among his Muslim neighbors, saying that they did not want the temple. His own petition was rejected. Finally he said to the Muslims who were his patients, "Why did you do that?" They said the DK fellow had asked them to sign and they did not even read it or know what it was about. When he reapplied, he told his patients not to sign again. He got the permission. In 1989 he went to Coimbatore to ask for help. He knew a wealthy businessman who was a great devotee of Lakshmi-Narayanan. This man donated the mulavar [immobile stone images resting inside the sanctum] of Hanuman, Ganesha, and Lakshmi, and the cost of the shilpis to make them. Before the consecration of his new temple, the doctor went to Murugan as promised and did the abhisheka. That is destiny, he said. Now he thinks that the DK may be trying to take over the Murugan temple and replace the image of Murugan with that of Tiruvalluvar.

He now has two Shaiva priests and one Vaishnava; 80 percent of the devotees are local. He had one more delightful story about his priests. He made a rule that all priests must serve all of the gods. But the Iyengar—usually the

most orthodox priests devoted to Vishnu—would not do puja for Ganesha and said "How can an Aiyer [a Shaiva priest] touch our Narayanan?" A new Vaishnava priest put a *nāmam* [a sign of Vishnu]—on the forehead of Ganesha and did the puja. The doctor was called at his surgery and told "Ganesha has a *nāmam*." When he asked the priest about this, the quick-witted man said, "Ganesha is an *ālvār* [Vaishnava saint] called Tumpikkai Ālvār [the saint with the elephant's trunk]."

I had no way at the time of confirming all of this narrative, but it can stand as a sonorous self-presentation. As a physician practicing in this neighborhood of less well-educated working-class people, this founder probably had the standing of a doctor in small-town America before the Second World War, as his ability to influence his Muslim patients illustrates. He was neither an ultra-sophisticated world traveler like Dr. Alagappan nor even a formally well-established lawyer like Mr. Sabapathipillai. Yet this was another echo in London of much of my conversation with Dr. Alagappan on the beach in Chennai. The founder of the Mahalakshmi temple is an educated professional from a community also with a history of supporting temples. His benefactor in Coimbatore was, accorded to my guide's supposition, a fellow Telegu of the Naidu caste. Like Dr. Alagappan, the doctor grounded his devotion within a philosophical—and I would say theological—perspective, which appeared to be still unfolding. The Gayatri movement is newly emerging out of Sri Lanka, which puts his temple at the threshold of a potentially powerful global movement. This echo has a curious counterpoint, however. This clearly Vaishnava "Telegu fellow" began by initiating a local temple to Murugan. He did concretize a specific sense of locality but technically not his own! He was not playing by the rules—either academic or streetwide—of supposed "ethnic identity formation." But he remained, in his own narrative, at the center of ethnic controversy in which he upheld religiosity against those who would either eliminate temples or at the least turn Murugan into nothing more than an ethnic icon. No wonder the DK was clearly bewildered. What was he doing as the defender of faith in a Tamil god? The trajectory of his current work shows that "this Telegu fellow" eschews ethnicity for broader sense of globalized localism.

A recent analysis of temples in Britain concludes, "Although a number of 'generalized Hindu' temples and associations exist, the great majority are characterized by regional, caste, and sectarian orientations" (Vertovec 1995, 145). At first glance, the Mahalakshmi Temple, dedicated to Lakshmi and Narayanan as the inseparable divine couple, could all too easily be counted as another sectarian temple. This neighborhood temple, on the contrary, balances Vaish-

nava and Shaiva divine forms and styles of worship—at the insistence of its founder. The board of trustees of the temple under the doctor's leadership is moving to even grander plans for the future. A beautiful color brochure now calls for donations to construct a "four storey-complete concrete building . . . with provisions of fully air-conditioned comforts, lifts, granite floors and all modern facilities." Sri Mahalakshmi-Narayanar will now share the ground floor with sannidhis for Meenakshi and her consort Sundareswarsar—the Lord and Lady of the grand temple in Madurai. The new Sri Mahalakshmi-Sri Meenakshi Sundareswarsar Temple will transcend the Vaishnava-Shaiva divide as well as the current state borders of south India. Smaller sannidhis for Durga, Gayatri, Ganesha, Hanuman, Murugan, and others will line the two sides of the ground-floor temple space. Echoing a model of many temples in the United States—the architect Muthiah Sthapati also designed many American temples—the basement will serve as a hall for classical dance classes. But befitting the truly urban character of the newly purchased large corner site, the second and third floors will serve other cultural functions. A kitchen and dining hall, and other small halls for "teaching vocal and instrumental music," will fill the second floor. The third floor will house an auditorium and wedding hall, a "hall for peaceful meditation" and yoga classes, and another hall dedicated to "moral discourses and community gatherings." The brochure succinctly summarizes their object: "to promote not only worship but also to maintain our traditional culture, and to promote morality, and educational activities." This new temple will truly become a neighborhood in itself where the gods and their devotees recreate a cultural tradition—but of south India in general.

In an ironic twist, the sectarians in the doctor's narrative were not a rival religious group but rather the "atheists" who openly viewed Murugan, the deity, only as an icon of Tamil identity who, given their preference, should be switched for another, Tiruvalluvar—the same icon of Tamil identity who reigns in his namesake temple in Mylapore. Tiruvalluvar can transcend any specific religious identity and comfortably accommodate secularists and a variety of religionists as an icon of a humane and thus superior Tamil lifestyle. Tamil "atheists," in the doctor's narrative, claimed East Ham and more specially Manor Park as their exclusive territory. He outwitted these forces and will finally build his own vision of a temple—an eclectic one that is broadly south Indian in orientation. Coming from Madras—a city that was once the capital of a broad colonial administrative unit, Madras Presidency, which included the present-day Andhra, Tamilnadu, and portions of Karnataka—the *localism* that he and the board of trustees have had in mind transcends the politics of Tamilnadu. His initial patron in Coimbatore, like him, was a Telegu settled in

current Tamil county. Had the doctor established within this temple a reunited south India that no longer existed in India? Is this new visible claim on public space within a South Asian locale a time capsule for a future as yet uncreated?

After my initial exciting conversation with the founder of the Mahalakshmi Temple, I walked with my kind guide to the London Sri Murugan Temple, which figured so centrally in the doctor's narrative, just a few blocks away. The president, Mr. S. Sampathkumar, and a few other trustees met us at the door, as the temple had just closed for the afternoon lunch break. The temple was then in the early stages of a major rebuilding project. The previous month the vigrahas were removed in a two-day ritual to a temporary home in the office area of the old garage. Plans called for the pub to be refurbished for use as a dining hall and the new vimanas placed on the land behind. The new officers proudly showed me photographs of their visit to Chennai to view the progress of this new granite structure. At first I thought that the entire temple would be granite, carved on the spot under the direction of M. Muthiah Sthapati, but later realized on looking at the ambitious plans in their fine color brochure that three vimanas would be shipped. The largest, for Murugan, will occupy the center and then to each side will stand the vimanas for Ganapathi and Puvaneswaran (a form of Shiva and a fairly common Tamil name). The temple will prominently occupy public space. Plans for a grand gopura and elaborate entranceway will mark a Hindu presence here. A sketch of the new ground plan calls for an attached dining hall and offices and considerable parking space—betraying a far-flung clientele, perhaps more so than the Mahalakshmi Temple. The officers added that Muthiah has built over sixty temples, including a new Murugan temple in Sydney and another in Washington. When I mentioned that theirs was the only granite temple outside of India, except for Malaysia and Singapore, the president was pleased and said to the others, "Yes, see that is what Muthiah told us!" When I asked, the president confirmed that they regularly take an utsava murti, a bronze image, of Murugan into the streets here, and about fifteen thousand people attend this chariot procession.

Although the plans are grand, the president of the temple at that time counted three hundred members as core devotees. The organization grew out of the joint celebation of holidays and monthly pujas, when a hall was hired—but then the group wanted a temple. The current president was a lawyer in India, from Madurai, who had come to Britain to take further bar exams, but the rules were changed. At age 40, he felt unable to go back to law school and took a position in the visa department of the Indian High Commission, where he worked from 1981 to 1993. He ran for the presidency when "Lord Murugan said for me to contest the election."[20] The president now devotes full time to the temple. The president, with some of his board members present, explained

that the entire Indian community except the Muslims uses the London Murugan temple, although it has only a relatively small group of members and donors. Sikhs come here to pray to Hanuman—they only approach his divine image and then go home. Many north Indians come to pray to Durga, who wore a necklace of lemons that day, as I have seen her in rural areas throughout India. The construction is financed with a loan from the Bank of Baroda to hire the craftsmen in India to carve the vimanas. The published capital campaign brochure given to me is mostly in English with some Tamil, Telegu, and Hindi—suggesting diverse educated middle-class patrons. The list of officers and major donors had recognizable names from Tamilnadu, Andhra, and Kerala, including a number of Naidus, the same caste community as the current head of the Mahalakshmi Temple. Clearly the DK Tamils did not wrest control from a larger south Indian constituency. Taylor records that of the Tamil people, "South African and South Indian Tamils attend the London Murugan Temple, East Ham" (Taylor 1994, 215).

Afterward I chatted with my kind guide and escort and asked him what makes a good temple. He felt that it was a matter of the general feeling, a good atmosphere, and a powerful deity—that is, the particular image-body of the deity; he also thought that the priests were important. He declared that he thinks the Murugan vigraha (image-body) in this temple is very powerful and the temple has a good atmosphere, and then contrasted it with another temple in a very different area—he was not referring to the Mahalakshmi—in which he felt that the manager was "a Hitler. He runs the temple efficiently but is too imposing—he does not treat the priest or even the devotees well." As we waited for the bus, I saw only South Asian faces, including many Muslims. In a few short blocks we passed a Sikh gurdwara (temple), and as we rounded the corner near the Mahalakshmi Temple, I spotted the "Tamul Madrasa"—a Muslim school for Tamils. The entire bus had a few Africans, but the rest were South Asian. I had the odd feeling that I was in India, as I was virtually the only non-Asian on the bus. One advantage for South Asians here appears to be that here the temples could occupy public space, with no objection that the "architectural integrity" of the neighborhood is in jeopardy.

When I returned to the London Sri Murugan Temple recently, English workers in hard hats were clearing the grounds and setting the concrete pillars that would form a roof over the three granite shrines from a distant land. The lovely vimanas now stood firm in the most quintessential London environment—the yard of a former pub (figure 4.11). The old pub continued to house Lord Murugan in his own sanctum, tableaux of lovely bronze images arranged around a corner section of the building, gracious priests, and a vibrant group of devotees (figure 4.12). At the end of the morning pujas, priests and temple

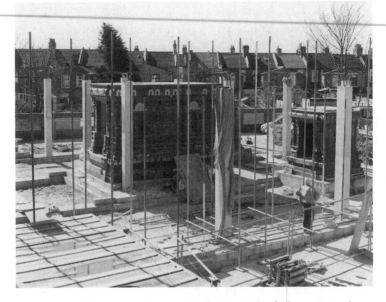

FIGURE 4.11. The granite vimana carved just south of Chennai stands assembled in the lot of this former pub. The cement pillars will support a roof to cover the complex in this colder clime.

officials presented us with beautiful dark red shawls—an unexpected honor. Beaming with the current success of the temple, Mr. Sampathkumar and other devotees again mentioned the queen's visit to the Murugan temple in Highgate. Since then, they felt that the "atmosphere improved" for Hindus in London. They also mentioned that the new temple would include both Shaiva and Vaishnava aspects, as more north Indians were coming regularly. So this once-Tamil enclave now accommodates the larger Hindu population and amiably welcomes a wondering scholar and photographer.

Both the Mahalakshmi and the London Murugan temples remain eclectic, allowing a range of deities to satisfy a diverse constituency. Whereas the Mahalakshmi caters mostly to nearby residents of this South Asian locale, the London Murugan has commuter-devotees who clearly plan to drive—there are sixty-six planned parking spaces—into this religiously diverse but nonetheless South Asian area. Steven Vertovec, attempting a broad overview of Hindus in Britain, argues that a "more complicated pattern is emerging" with regard to institutionalization. Summarizing and reformulating earlier work of several British scholars, he describes "phases" of the development of temples, beginning with the early days of often-contrived but important "All-India" celebrations. This unity broke down quickly into "numerous group-specific associa-

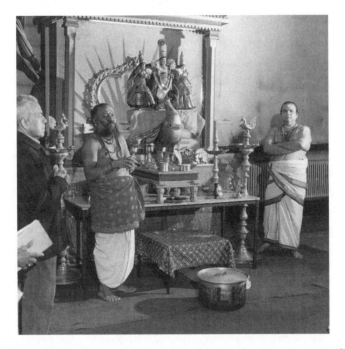

FIGURE 4.12. The distinguished priests of the London Murugan Temple
lead prayers in front of the bronze utsava murtis of Murugan and his two
consorts.

tions and institutions" once new families were established here (Vertovec
2000, 95–96). This same process coincided with changes in the British official
attitude toward the new immigrants, which began by emphasizing assimilation
and ended by defending multiculturalism. Vertovec's material suggests that in
Britain multiculturalism abetted the return to diverse ethnic configurations
that mirrored—sometimes darkly—the situation on the subcontinent. The
case of Murugan and Mahalakshmi in a poorer South Asian quarter of east
London complicates the picture of the recreation of an ethnic group in diaspora
here. The constituency of both temples appears to erase the new borders cre-
ated shortly after Independence and then again with the States Reorganization
Act in 1956, all of which dissected the Madras Presidency and a common
"south Indian" identity. Both temples remained broadly south Indian in spite
of opposition by a clearly formed "ethnic" group, the DK, which—according
to the doctor's narrative—recreated the politics in Tamilnadu. However, even
the DK lived in a time capsule. Their DK "atheism" has little support in con-
temporary Chennai. When contrasted with the initial sectarianism and ethnic
purism of the Murugan temple in the middle-class neighborhood of Highgate

Hill, these two temples in east London move well away from that kind of motivation. Interestingly I see a movement here toward a limited eclecticism, precisely because temples are in an "ethnic" neighborhood and in this sense cater, ironically, to a more diverse local constituency. The matter of the creation of a "generalized Hindu temple" is highly complex.

An ironic impetus to the reemergence of the generalized Hindu temple may evolve from the recent highly publicized activities of the royal family "to indicate respect for the diversity of faiths" (http://www.royal.gov.uk/output/Page1117.asp). The carefully planned visits of Queen Elizabeth and the much-quoted statement of Prince Charles that he does not intend to be the Defender of Faith but rather a defender of faiths may signal a coming change in British attitudes and policies. The once-official attempt to accommodate new immigrants by disentangling their private cultural-familial domain from a shared political sphere made little sense with institutions such as Hindu temples. Certainly in the case of south Indian/Sri Lankan temple builders, in the absence of an official "church" organization the group must negotiate their own polity, which easily elides into politics within the temple and the larger community. Moreover, to confine the deities within their temple thwarts a theological imperative much revived in contemporary India: as an act of grace, the gods reveal themselves to the public at large during the ritual cycle of the temple (Waghorne 2002, 31–34). The United Kingdom, paradoxically, never separated church and state, but in practice this link remained confined to the Church of England, when some attempts to adjust required teaching of religion to increasing numbers of non-Christians in Britain (see Kanitkar 1979, Jowett 1985).[21] In effect, the recent royal acts begin to legitimize temples in the public space and perhaps the public sphere in London, but as "Hindu" institutions. But, as Hindu temples both in South Asian neighborhoods and in multiethnic middle-class sections burst out of the shells of churches and openly enter broader public consciousness and the public domain, will Hindus move back toward a more generalized Hindu identity in a larger British public arena? As "Hindus" are accorded more space in royal public pronouncements—note that the Highgate Hill Murugan Temple functioned as an emblematic visit to all Hindu temples—then the label "Hindu" may once again blunt the carefully constructed localisms into a generalized version of what the trustees of the restructured Sri Mahalakshmi Temple are already calling "our traditional culture"—in the singular.

The tone of some of these temples nevertheless flows from a single strong founder with his own vision, a sense of destiny, and sometimes his god's clear commands. Such people must also figure in the broader attempt to classify—I think all too easily—the creation of Hindu temples as acts of identity forma-

tion. Some are also the acts of complex persons whose own self-presentations warm, sometimes heat up, an analysis that can too easily slip into newly forming academic clichés. These threads of personal narrative cannot be treated as loose ends. Such ends are pulled at the risk of raveling a rich story. We will meet one other such voice in the story of two new temples to venerable ammans.

The Mariyamman Upstairs/The Golden Goddess in a White Baptist Shell

Hindu temples in London continue to play hide-and-seek in the general landscape, moving in and out of church walls and even warehouses. The Goddess has taken residence in two ethnically mixed middle-class neighborhoods in London and, like Murugan in such environments, they are only beginning to appear in the eye of the general public. Mariyamman now resides in the upstairs of a large former warehouse-supermarket on a busy commercial street in the pleasant area around Tooting Broadway underground station. Kanaga Thurkkai Amman lives inside the shell of a former white Baptist church in another pleasant residential neighborhood in west London a short bus ride from the Ealing Broadway terminus of the underground. Neither is immediately recognizable as a temple even if a visitor has the address and is searching for it. At first their signs were inconspicuous to the point of obscurity.

To find the Sri Muththumari Amman Temple, I relied on a companion who had already located the temple with considerable trouble.[22] The entrance to a large, seemingly deserted, building was through a side door and up two flights of wooden stairs. Suddenly inside, we saw a large open room with all of the features of a proper temple ingeniously recreated. A bronze flag pole and the goddess's lion vahana stood in front of the central vimana with facsimile stone pillars with two alcoves toward the front for bronze images of Ganesha and Murugan with his two consorts. In the sanctum stood a lovely bronze image of Mariyamman in her form as Muttumariyamman (pearl-like Mariyamman). Smaller shrines containing bronze images edged the walls. On the left wall was a small stone Ganesha, then Rama with Sita and his brother, next to Ardhanarishvara (the form of Shiva as half man and half woman). Around the corner an image of Guruvayurappan (a form of Krishna popular in Kerala), then Shiva Nataraja next to the three popular goddesses Lakshmi, Saraswathi, and Durga (the three connote the blessings of wealth, learning, and empowerment). Then followed the Navagraha (small images of the deities representing the nine astrological planets) and Bhairava. The processional image of

Muttumariyamman faced the main sanctum. The entire effect was created by the trompe l'oeuil technique of very realistic painting on cutout plywood sheets! After a few moments, my eyes too were lulled and the space quickly felt like a temple.

I began a brief conversation with the founder, Mr. N. Seevaratnam, who also manages the temple. A formal interview followed in a few days. Mr. Seevaratnam was a chartered accountant who had once held an important position in a firm in Colombo that did work in Africa. When he fled Sri Lanka to settle in Britain, he had to begin as an entry-level accountant at a quarter of his former salary. He spoke of another man working as a cashier in a supermarket who once headed a large government department in Colombo, and of former doctors working as cashiers in railroad stations. Mr. Seevaratnam lamented the profound depression that many Sri Lankan Tamilians felt with their displacement. He had experienced severe depression himself, as had members of his family. This made him aware of the serious social despondency among others. He most worries now about the old, who are left alone all day when their children go out to work. They are essentially confined in their house because they speak only Tamil. The temple provides a place where they can meet and share their problems. Mr. Seevaratnam's narrative during a long formal interview revealed a man in close contact with the daily ritual life of a temple but not with formal theology.

He began by telling me that as a child he was raised near a goddess temple and thought of God as a loving mother. He choose this particular form of the divine Mother because many of the Sri Lankan devotees came from the same town in a northern part of the island which has a powerful goddess by this name. His upbringing was religious, and as a child he vividly remembers decorating small images of the deities available as toys in the bazaars. With his playmates, the children would dress and ornament these small images and then pretend to take them on procession around a temple. Even now the retired accountant takes great care with the clothing and ornamentation of the deities. All of Mariyamman's jewels in his temple are genuine gems and gold, and the saris are the finest south Indian silk, mostly from the famous weaving center in Kanchipuram, termed Conjeevaram silk. He has personally purchased much of the goddess's jewelry and hopes someday to have gems that match each of her saris. The priests in the temple who expertly dress and decorate the goddess received high praise from this manager. Mr. Seevaratnam did not want his goddess to be less well dressed than his own wife. Yet in spite of his intense emotional perception of the deities and his pragmatic understanding of ritual, he feels that his own knowledge of Hinduism is limited because, like many of

the middle-class people in old Ceylon, he studied in Roman Catholic schools. He never received a formal religious education. Unlike Dr. Alagappan or the founder of the Mahalakshmi temple, Mr. Seevaratnam did not theologize or philosophize aspects of his devotion.

A skilled craftsman from Swamimalai, a major center for bronze casting in south India, fashioned the icons. All of the images in his temple are in portable panchaloka except the small stone Ganesha, because this site is only leased. His understanding of the divine forms is catholic; he had ordered different deities at the request of local devotees. The Gujarati community requested the holy family of Rama, so he ordered the images from Swamimalai. A Gujarati lady who had had visions of the gods especially requested a Lakshmi, but he decided to order all three of the now popular trio of the goddesses of wealth, knowledge, and power. A wealthy restaurant owner from Kerala covered the cost of their Guruvayurappan, which literally means "the father of Guruvayur," the town where his famous temple resides. Mr. Seevaratnam thought that many understood this form of Krishna as the male form of Shakti. Another gentleman whom Seevaratnam considered the most important man in the Tamil community had attempted to convince a number of other temples to have an icon of Bhairava, who is the fierce form of Shiva, a guardian who is usually given the keys of the temple each night. In Jaffna, a lot of village people worship him. In all larger temples in Sri Lanka his presence is usually acknowledged as a bronze trident only. Mr. Seevaratnam willingly accommodated his request and ordered the Bhairava from Swamimalai. He then turned to me and said, "I would not object to an image of Mary, if any devotees requested it."

The manager took great pride in the quality of the ritual services of his priests and the cleanliness of his temple. He carefully selected the five priests "on merit only," three from south India and two from Sri Lanka. When we discussed what makes a good priest, Seevaratnam outlined three areas of accomplishment: *mantra* (the ability to pronounce clearly and accurately), *kirikai* (good "body language"), and *bhāva* (good expression of emotions).

The founder-manager estimated that of devotees who come regularly about 60 to 65 percent are middle class. The other 35 percent are upper class, like the knighted physician who comes; there are also some from lower classes. At the moment the majority are Sri Lankan Tamils "who are never business people" but engineers, doctors, accountants, and white-collar employees, but who now have taken to business in these strained circumstances. I asked his opinion on why temples to the goddess were so slow in coming to London and are still very rare in the United States. He returned to the issues of educated devotees. Normally people who went to the United States, as he understands it, hold high positions now but probably, just as here in Britain, they had come

as students who struggled with odd jobs while they were studying. Once they passed their exams, they still had no time "to think about these things." Again, many in Britain, like him, may have attended Roman Catholic school and have little idea about the nature of the deities or even have thought much about God. Life is so fast, and such people would like to have either Shiva or Murugan or Ganapathi, the most well-known and basic forms of God. He then returned to talking about the devotees who came empty handed as refugees. They are often educated but can never set aside any money because all of them still have family at home who need money. He explained that there are too many mouths to feed, so they can never catch up. So great is the need that the constitution of this temple stipulates that any income above expenses be sent back to Sri Lanka for aid to projects. He must take care that too much money is not given to any one group because as soon as the various guerrilla bands find out that there are a lot of resources, they will simply confiscate the money.

This long narrative evoked vivid images of displacement. Unlike the three other voices of temple founders—the doctor, the lawyer, and the United Nations administrator—this certified public accountant left his home as a refugee. In the ultimate sign of displacement, Mr. Seevaratnam created his temple to be packed up and moved any time his lease lapsed. All the deities were embodied in their traveling form as bronze processional images with a proper lineage. These divine bodies emanated from a respected craftsman in a recognized center of bronze casting. The images, like the founder and the devotees, took birth in a Dravidian world. The priests too are authentic imports. The surprising element in all of this is that these deities lived in a trompe l'oeuil creation yet no one, not even at other temples, criticized this seemingly ephemeral temple as inauthentic, and everyone listed it along with all of the others as one of the community south Indian–Sri Lankan shrines. Thus the transparency of the temple to my eye and to the graduate of the School of Oriental and African Studies with me seemed opaque to priests, devotees, and the founder. This temporary temple lives perpetually in the space of the festival, when the temples of the gods are recreated on the streets in vehicles like the chariot which are moving temples, or when the deities are set up in often grand but temporary spaces created within the home. Perhaps Mr. Seevaratnam's mention of his own boyhood memories playing procession with small toy deities prefigured the very temple in which we sat. His love of the goddess's clothing, his desire to see her beautifully ornamented, framed his consciousness. Mr. Seevaratnam's concerns did not extend to creating a "permanent" temple for Mariyamman, nor did he view that as a goal for his refugee community. This Muttumariyamman temple lives in an ethereal public space somewhere be-

tween Sri Lanka and London, created within the eye of the beholder and the memory of the founder.

In a pleasant middle-class area near Ealing Broadway station, the brightly colored sanctums of a new temple to a golden goddess are hidden inside the white wall of another former Baptist church with a plaque dated 1865 (figure 4.13). The church-temple is tucked between houses on a very quiet residential street in a nice ethnically mixed middle-class neighborhood with all shopping available. Some South Asians and East Europeans could be spotted living nearby. Shri Kanaga Thurkkai Amman Temple, as it was spelled in English, now has a proper vimana inside designed by a sthapati from India and completed by several shilpis. The present chairman of the board of trustees took time in the busy day before the mahakumbhabhisheka to talk about the temple as we walked on the still dusty floor and watched the shilpis put finishing touches on a beautiful central vimana. As we looked up at the finial on the top, the chairman proudly told me new bronze kalasha (pot-shaped finial) forged in south India would be gilded here in the United Kingdom with real 22-karat gold. The jewelry painted on the images of the goddess on the sides of the vimana was also real 22-karat gold leaf. The gold was especially appropriate for

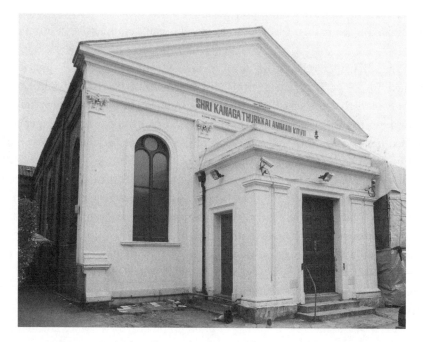

FIGURE 4.13. A signboard over the former white Baptist church clearly identifies the Shri Kanaga Thurkkai Amman Koyil.

the goddess to be installed here; Kanaga means the "golden one." I noticed that the crews working on the inside of the sanctum doing the tile work were local people but not all English; there were accents from Eastern Europe. I asked about the church, and once again the chairman told me that getting fresh permission from the local planning commission was impossible, but he spoke with enthusiasm on how well this old church fit the temple. The sun in the claret window in the east shone directly into the sanctum in the early morning. The rafter that seemed to block the sight of the kalasha on top, they later they discovered, was perfectly placed—one should never see the radiant finial directly but rather more obliquely so even this massive beam fit the scheme of the temple. He said that 65 percent of the funds for this construction had come from the "public," with the trustees donating the remaining 35 percent. The board of trustees, however, would only oversee the trust that controlled the temple. The daily working of the temple remained in the hands of an executive committee elected by the general body. I asked him the professions of the trustees; he worked for the railroad and others were mostly white collar, with a few businessmen—all middle-class people whose professions depended on education. He admitted that Ealing was not really an Indian neighborhood but that local Indian people, who were not Tamil, also used the temple. This neighborhood, although the chairman did not mention it, lies about four miles east of the long-established South Asian area of Southall dominated by Punjabis. In London, four miles can be a massive cultural distance.

The chairman related the story of how the great goddess Durga (also spelled Turgai or Thurkkai in the Tamil style), immediately after killing the demon Mahishasura was fiery with the passion of battle. The other deities "asked her to please cool down." Finally she did gain control of her anger and shifted her trident from her right land to the left. She formed the "fear-not" gesture with her right hand, putting the gods at ease. She was then in her "soft form"—not her fearsome black but the radiant golden form—hence her name Kanaka (or Kanaga, Golden) Durga. It is in this form that she resides in a temple in Vijayawada, which he said was somewhere in "north India." Later the wife of one of the trustees clarified the location as just north of Madras. I finally located Vijayawada as a small city in Andhra about 200 miles north of Chennai. India apparently was not very familiar to devotees or to the chairman from Sri Lanka, who was a large, warm man willing to talk in the dusty construction zone.

A few years later, we returned to photograph the thriving temple, which remains much as I first saw it during the long the mahakumbhabhisheka rituals. The main sanctum for Durga dominates the center of the now-gutted interior of the church (figure 4.14). In front of her ornate vimana stand a proper

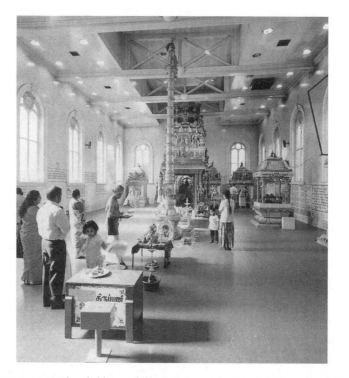

FIGURE 4.14. The shikhara of the main sanctum juts into the rafters of this former church, which provides the necessary shield to protect devotees from a too-sudden encounter with the bright golden finial at the very top at the Shri Kanaga Thurkkai Amman Temple.

bali pitha and an image of her lion mount, her vahana. Very close to the side of the main sanctum sits a small image inside a vimana. I had never seen this deity, which priests identify as Chandeswari—a seated female who is the feminine form of the ever-present guardian of any Shaiva temple, Chandeswara. The main foyer for the church, now at the back of the main sanctum, has the door barred and has become an area for two small sannidhis (shrines): Krishna on the left and Hanuman on the right. In front of these, on the wall once facing the altar of the church, are four more small sannidhis, beginning with Ganesha on the left then a full image of Parvati joined by her consort Shiva in the form of a stone linga. On the right side came a sanctum of Lakshmi-Narayanan and finally Murugan with his two consorts. On the right hand wall, a golden vimana holds a bronze image of Shiva Nataraja. Farther along toward the middle, to give room for the obligatory circumambulation, stood the Navagraha, black stone images of the nine planets that control human destiny. A beautiful wooden pavilion, which holds the bronze processional images of the main

deities, stands to the right of the new entrance to the temple. On the right side of the door stands Bhairava, the fierce form of Shiva who guards the welfare of temple in south India and Sri Lanka. The form of this temple has the look and feel of a very traditional temple in south India—by far the most "authentic" I had seen up to that point outside of India, not so much in detail as in the arrangement of so many key elements. The inclusion of Vaishnava deities, as I soon discovered, was mirrored in the form of the goddess.

During the mahakumbhabhisheka, I had the rare opportunity to have an intimate experience of each of the image-bodies of the gods. This was the day of the thaila-apiyangam, the applying of the oil, a ritual I had never seen among the many consecration rituals that I have witnessed in the last decade. All devotees who wished—including me—could apply oil to the as yet unsanctified stone vigraha with their own hands! A priest later told me that this ritual is not done in India but is always part of the ritual of consecration for new temples in Sri Lanka. I followed a line of many others along a prescribed route to the many stone images that ended in the main sanctum of the temple with the goddess herself—a very tender experience of deep intimacy with the deities. Quietly, rows of pensive devotees moved respectfully from deity to deity. All this happened as a group of priests chanted in front of burning fire pits in an adjoining room—patiently bringing universal energies here to transform these stone sculptures into divine bodies of God. Speaking of the priests, the chairman mentioned they would continually bring priests from Sri Lanka on a rotating basis every two years—he said they did not want the priests to become too involved and possibly start factions within the temple or try to break away. "All these poor fellows should have a chance."

The next day was at first disappointing. When I arrived at 10 A.M., the temple was hopelessly crowded and I could not enter the small church that was bursting with excited, well-dressed patrons. Guessing from the number of parked cars on the sidewalk, many of these devotees had come from other sections of London. Bobbies were on guard, walking patiently and respectfully outside the temple to insure order. Waiting outside, I and my husband could hear the live nadaswaram (large clarinet) and drums inside. I cannot guess the number of people, but at least five hundred had wedged into the former church. Finally, when the moment of the consecration was over and people moved out of the temples, I went in, meeting the same kind man who had taken me to East Ham just a week before. I encountered a group of priests standing next to the chief sthapati for the temple and began a discussion of the various forms of the deities here. All agreed that this form of Durga was actually close to Lakshmi, "Lakshmi-Saraswathi-Durga all the same." Her golden color made her much like Lakshmi. The sthapati then detailed her form: her right hand

has the abhaya hasta (fear-not) mudra and she made the "be at peace" sign with her lowered right hand. In her two upraised hands were the discus for the sun and the conch. A priest added that these were light and sound. I interrupted, "But these are the marks of Vishnu!" Everyone agreed. This form of Durga is Vaishnava; some even call her the goddess Vaishnavi. At the time no one could explain why this Durga, who bears Vishnu's emblem and whose only other temple is in a small city in Andhra, now presides over a temple listed among the U.K. Federation of Shaiva Temples, whose priests are all from Sri Lanka, as are most of the patrons.

A chatty elder gentleman sitting with the priest began to give his own answer when I posed the question to him. He said that Ealing has Tamils and Punjabis. This Durga is from Andhra, but cautioned that I must think of the south as in the days of the British Madras Presidency before the current linguistic states were created—a position I have taken seriously throughout this chapter. He added "But here in U.K., we cannot be so exclusive."[23] He said that this form of Durga is for wealth and well-being. After all, what is the temple for—so that people can ask God for benefits. His blunt explanation that this goddess conferred wealth and well-being was echoed in a more elegant and nuanced version in one of the few English essays in the well-printed color souvenir titled, in Tamil only, *Kumpāpiśēka Malar* (literally, the opening/blossoming of the consecration). Describing the great goddess, the secretary of the board of trustees explains, "Shakthi is the prime force on whose infinite mercy the entire Universe and the Souls that populate it, survive and thrive. . . . In this Kaliyuga [age of degeneracy] it is only through the Divine benevolence of mother Thurkka [Durga] can we hope to achieve salvation . . . Thurkkai Amman's other manifestations of Luxmi [Lakshmi] and Saraswathi bestow wealth and educational excellence on devotees." The temple so emphasizes education that the compilers devoted seven full-color pages to reproduce delightful drawings of the goddess as well as essays in Tamil and English by the children of this community. One of the young authors proudly showed me her essay as I sat talking with patrons and devotees. The temple began its school on Hinduism, meeting each Sunday, well before the temple was consecrated. In East Ham, the founder of the Mahalakshmi Temple had bemoaned the lack of religious education in his area and said that the temple at that point had no educational program—a lack clearly corrected in the plans for the new temple. However, Kanaga Durga's middle-class congregation—in this context the term is appropriate—put education at the fore, perhaps even in the selection the very form of the deity—a loving mother to her children and a form of both the goddesses of wealth and learning. And the chairman of this temple told me that Tamils always made their livelihood on the basis of their educational qual-

ification, not business. In other words, education was wealth for these Sri Lankan Tamils.

Yet another source to explain this golden goddess in Ealing comes from an oblique reference in the consecration souvenir crediting the inauguration of weekly pujas to this goddess in 1991 by "Chief Dr. Priest Sambamoorthy Sivachariyar of the Kalikambal [Kaligambal] temple." This charismatic old priest with gray hair the color of platinum keeps a hectic schedule, leading many of the teams of priests assembled for consecration ceremonies now happening on every continent. His home temple, which dates to the seventeenth century, abuts the crowded streets of old Georgetown in Chennai on Thambu Chetty Street. When I last visited it, the chief priest was out of the country again. The only time I met him was at the Siva-Vishnu Temple in Washington, D.C., as he lead a consecration there—a most photogenic priest who gave personal blessings to devotees, switching without hesitation to flawless English as he came to us offering "health and well-being." He would indeed be familiar with the growing popularity of this Andhra goddess who is the subject of a small English-language book published in Tirupati by a graduate of Madras University (Moorthy 1992). The author mentions recent renovations to the temple "in view of the ever increasing influx of tourists and theists" which added "guest rooms, canteen, queue cabins, [waiting rooms to see the deity] bookstall" (38).[24] All of these are marks of increasing numbers of middle-class pilgrims. The author, a professor of English, describes the "swambhu-self manifested" image (meaning that it had no human sculptor): "Her round enchanting visage wreathed in smiles looks aglow with golden hues mesmerizes the viewers" (30). His description of the form of the divine figure varies from the image in Ealing, but this is the same goddess. In Vijayawada, she stands on the buffalo head of the demon, as she does in Ealing, but with her eight hands carrying weapons and her trident in the act of piercing the fiend. There is no mention of Vishnu's conch and discus. The story of her name and her settling in Vijayawada also differs. In Andhra, she remains closely associated with Shiva. During her battle with the buffalo-headed demon, she rejects his suit, according to Moorthy, telling the demon that she is already married to Shiva. After her final victorious slaughter of the demon, the sage in this area of Andhra begged her to stay. Prof. Moorthy closes the story: "She then made this sacred hill as her permanent abode and lived thenceforward raining compassion in unending torrents and protecting their lives. . . . It was at this moment that she rained gold for enviable living on those who lived in this region. So she was adored as Kanakadurga then appropriately" (28). The sthapati probably softened her image for this Ealing temple, connecting her now with Vishnu. The connection makes sense, as the professor's description harmonizes with

many popular poster-art images of Lakshmi that depict the beautiful goddess with her hand raining gold coins. Interesting, all of the priests acknowledged the new form and the new story, and none seemed to realize that a change had occurred.[25]

The hands of the devotees of this temple now pour their success into charitable works in their old homelands in Sri Lanka. When I returned to the temple, the secretary of the now-thriving institution stressed their growing involvement with healing the scars of the long—hopefully ending—war in the one-time island paradise. The former meeting hall of the church now displays not only the new vahana that carries the goddess into the streets of Ealing but also a collage of photos taken in Sri Lanka, centered by a snapshot of a group of children under a banner in English, "London Shri Kanaga Thurkkai Amman Orphanage." A percentage of the donations beyond expenses are returned to this kind of charitable work in the motherland. One devotee added that formerly her family did not donate to temples, preferring to give directly to charity. Now she can participate in a temple and be certain that her donation will also support the needy. Multiple circles now return money from the goddess's great popularity in London to Sri Lanka and at the same time return middle-class sensibilities that equate religiosity with charity to participation in the ritual life of a temple. This very particular goddess from Andhra who blesses her Sri Lankan Tamil devotees also extends her grace beyond any borders. While we were photographing the temple, the secretary asked us please to take a picture of Kanaga Durga inside her sanctum; such photos are rarely permitted (figure 4.15). Her reason: "Sri Durga willingly reveals herself to everyone, after all she *is* the Mother."

Conclusion: Voices from Middle Earth

Listening to these many voices in London and Chennai with those echoes from New York, Colombo, and Jaffna, I can hear a constructed universalized Hinduism cracking at the very moment that the process of definition begins. The tone of all of these voices, of both VHP and the goddess-Murugan devotees, are solidly middle class—the new voice of the layman. What distinguishes these temple patrons from the VHP universalizers? These devotees hear the still small voice of the gods directing their actions; such language is ironically and conspicuously missing from RSS and VHP manifestos, at least in the English-language cyber material whose voice shouts over the continents. The VHP Web site out of Delhi speaks of "eternal and universal values," "ethical and spiritual life," "preaching principles and teaching practices of Hindu

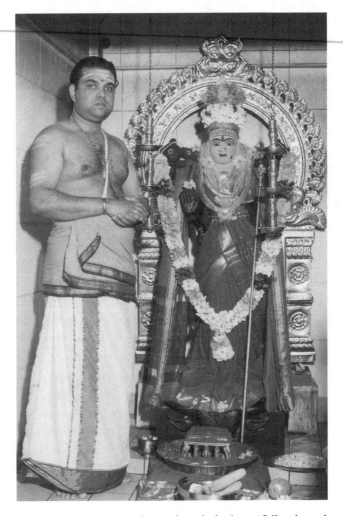

FIGURE 4.15. A priest reverently stands with the beautifully adorned goddess, the Golden Durga, inside her holy sanctum.

Dharma" but not a word in their Aims and Objectives that mentions the call of any divine voice (http://www.vhp.org/englishsite/b-objectives/aim_object .htm). God is amazingly silent in militant Hindu organizations. The Maharaja of Mysore in a speech inaugurating the third meeting of the VHP executive council, which was held in the summer palace near Mysore, worries that "many sectarian beliefs and superstitions, which crept into Hinduism, hide the string of unity running through it." The speech then enumerates the many threads: "the law of Karma and Rebirth," "the common texts that govern Hinduism," "the belief in common gods," and "all Hindus believe in a Trinity." In another

essay that surpasses even Max Müller's ideas of a grand universalism, an un-named essayist announces the "Hindu Concept of Universal Oneness." He then declares, "Impersonal Religion—Alone can be Universal Religion." The entire Web site muffles the voice of particularity ("unity is knowledge, diversity is ignorance"), and usurps the right of gods to dare break these "laws" of Hinduism, to take the bodies of devotees, to invade their dreams. Such "su-perstitions" are not real Hinduism. Of course, such a "tolerant" religion would never punish this ignorance.[26] In tension with this "totalizing discourse"—a term that ironically fits the VHP as readily as British colonial ideology—are the calls of Murugan to the Chennai businessman who built a temple in his front yard, or to the president of the East Ham Murugan temple who was told to contest the elections, or to Dr. Alagappan who eagerly awaited messages from the ancient sage Agastya flashing across the pages of the Nadi texts. The gleaming eyes of Mr. Seevaratnam as he describes his Mariyamman aglow with real jewels or the delighted chairman showing the real 22-karat gilt on the shining temple of his Golden Mother—all of these faces turn toward the gods as a living presence in their lives. This is a religious sense of locality, the embodiment of divinity here and now.

Murugan and the goddess share this direct intrusion into the lives of de-votees—the cleavage of the normal and the ordinary, and even of the wholeness of things. Dr. Alagappan's complex chart of the universe speaks not in terms of principles or laws but of powers. His goddess and Murugan are vibrant Light. They are not impersonal but rather living energy, the vibration of the universe and the pulse of each devotee. The VHP exists at the far end of the sliding scale between an urge toward reaffirmed localism and an equally pres-ent desire to build a systematic framework for Hinduism. Hinduism system-ized would become a Religion encircling and thus surpassing other religions with its true universality. The middle classes are caught in the midst of con-flicting desires. Their education and professions all depend on a world of sys-temization, managerial or legal or scientific. They may yearn for order and yet turn toward Murugan or the goddesses, craving a lost world of "magic"—tapping powers or feeling powers. These Hindus share this tension between seeking a staid Order—however denatured—and seeking a more inscrutable dynamism with many other contemporary middle-class professionals who chant mantras and light incense to rediscovered gods in their New Age spiri-tuality. I now walk past a giant Shiva Nataraja in the window of the successful Seven Rays bookstore, complete with incense and newly revived gods from a once-lost European past. For many contemporary people, Hindus and non-Hindus alike, "spirituality" is the preferred term. "Religion" is rejected. In my conversation with many undergraduates, "religion" is equated with rules, reg-

ulations, and too many doctrines. They associate religion with bounded particularity and "spirituality" with the world of suprareason and power, but also with an unbounded universality. The difference for Hindus in a global urban context is that this same realm of spirit and magic clings to localism, to particularity. The universal religion in the contemporary world of the VHP lives in ideology and in a denatured set of principles. In his discussion of the saffron turn toward ideology, geographer Thomas Hansen puts the work of the VHP another way: "This sliding, or reconfiguration, of the signification of ritual practices away from the sacred and onto a larger field of objectified, national culture was a crucial innovation in the politicization of Hindu symbols" (Hansen 1999, 177).

The environment in which diaspora Hindus function and the milieu of a founder's own life experiences, however, further complicate localism. In the current British rhetorical environment of multiculturalism, we are told, Hindus happily take up the banner of ethnicity and remain in their ethnic enclaves. Until very recently, their temples reflected this isolation from the British public space. Reflecting on the meaning and nature of being Hindu in Britain Steven Vertovec wrote that, "due to a particularly dominant discourse surrounding multiculturalism and certain concomitant attempts to exclude minority groups from the public space, such processes are largely confined to a localized—private or community—space" (1995, 151). Thus the process of ethnicization, which increasingly has parallels in America's own versions of multiculturalism, may create a sense of locality without the religious sensibilities of locality in India—that "village" tradition of possession, of divine instrumentality. This happened clearly in the case of the DK and the doctor. Murugan for the DK became a "symbol"—without any of the nuances of the term in religious studies—for a Tamil identity. Thus the much-discussed identity politics often adheres to a locality but remains in the realm of ideology—intent on "atheism," as the founder of the Mahalakshmi Temple bluntly put it. In a sense, the Tamil nationalists wanted to construct a Murugan without his Vel, his instrument of divine power. In describing the situation in Britain, Steven Vertovec borrows the term "symbolic disarticulation" to describe this process of subtle desacralization. He quotes from Bruce Kapferer, who works among Sri Lanka's ethnic groups: symbolic disarticulation "removes ideas embedded in the fabric of social practices and symbolically idealizes them" (Vertovec 1995, 149). Culture—including the gods—then becomes an object for ethnic unity and utility. And yet, in the Tamil temples of London, the articulation of ethnic commonality oscillated between deities viewed as icons of Dravidian reunification and at the same time as mighty purveyors of power. All of these conflicting desires, all of these diverse functions of a temple, when seen through the narratives of

individuals, reveal complex personalities with multiple goals and multiple mo-
tives—often playing out such conflicts within themselves. Most of the founders
view their lives as instruments of god/goddess, almost at the same moment
that they create the framework for new ethnic conglomerates—all of this within
the realm of very particular temples. If they more toward universalism, they
never flavor their speculations with distilled ideology. In this sense, they retain
locality.

The localisms that do retain divine instrumentality and a measure of
magic, however, are not without their own kinds of problems and controversies.
The ideological enterprises of the VHP and others of saffron hue have endured
sharp academic critique in India and abroad. The founders of Murugan and
goddess temples shared a basic style and potentially divisive common cultural
image of Tamil leadership. In English, Tamils often use the term Periyar in its
literal translation, a Big Man (see Mines 1994, 149–153). Mattison Mines ar-
gues that Tamil leaders attain a "civic individuality," self-importance derived
from their status and their service within a group. Temples have long provided
the arena within which a Big Man can establish his claim to the title (see also
Rudner 1994, 138–158)—a claim that can be and often is challenged. The polity
of the London temples shifted between this model of the single founder-
manager who controlled the temple, often with careful consideration of his
constituencies and sharing some measure of power, and a model of a managing
board, a larger group of donors with elected officials. I know that some consider
Mr. Seevaratnam's management style as heavy-handed. Dr. Alagappan admit-
ted that some called him a dictator in his Flushing temple because he kept a
tight reign on factionalism in the temple. He was careful to appoint a repre-
sentative of all groups, but he had not encouraged elections. The physician-
founder of the Mahalakshmi Temple made his struggles to secure authority
central to his narrative. I mention this because the very concept of a Big Man
is local in scope, attached, as Mines says, to a particular social community. The
continued functioning of the Big Man in the new global networks of temples
comes with a certain edginess. When power built on money and position won
abroad comes home to Chennai, has a new kind of colonizer arrived? Lingering
in the voices of those who had opposed the construction of the temple complex
for Murugan was just this kind of frustration. It was one thing for the old
Chettiars to return home from Burma to build magnificent temples within
their own Chettinad, but to build temples in major Indian cities may be another
issue, especially if perceived as coming from "the outside."

In the end, what does it mean to have the voice of religious authority
divested to this new middle class—even in the context of a reaffirmation of
locality? In Dr. Alagappan's narrative, the idea for the Murugan complex was

his—the Shankaracharya gave his important consent and turned the idea into a formal "instruction." This is a dilemma of those who work to reaffirm locality—their authority always derives from a deity whose instrumental power they strongly affirm. Yet if the members of the VHP stand accused of usurping the voice of the traditional Sanskrit pandits, do those who reconstruct locality also supercede the oldvillage priestesses and visionaries? Of course, the village visionary must yield, or perhaps bend, her power to the new middle-class devotees. The businessman in West Mambalam who turned his home into an ashram and himself into a guru, albeit by Murugan's command, joins a twentieth-century movement of many other middle-class persons who encountered God and gave up their professions. The narratives of their lives, however, never fail to mention their educational accomplishments as a subtle part of the religious dossier that lends to their greatness. For those middle-class devotees who hear the voice of God, the inflection of their years in the professions continues as they, and their circle, tell of their lives.

Conclusion/s

Making Space for God/s in an Urban World

At the climatic moment in the mahakumbhabhisheka, as the stone image of Lord Murugan took life, one of the founders of the Sri Siva-Vishnu Temple near Washington, D.C., suddenly collapsed in front of the sanctum. His doctor announced over the microphone system to worried viewers that this well-known medical specialist was only overcome with excitement. Some devotees simply took the statement at face value, but not everyone. With devotees of Murugan, as we have seen, the line between exhaustion and ecstasy is thin. I was very close to the event and sensed that, for many, Murugan truly manifested both in his image and within his leading devotee. With this important moment in mind, I reflect now and consider a question I once saw posed in a brochure, "Why temples?" What difference does building a temple, making a new space, have for those who want to preserve and develop religious life in a new city within India or abroad?

Contemporary urban middle-class Hindus live in the midst of two models for the escalating institutionalization of religious activities—the temple and the ideologically driven organization. Ironically, as the home increasingly becomes the spatial image for the temple, as I suggested in chapter 3, religious activities move out of the domestic sphere and into public organizations. The process spans at least three continents in an English-Tamil-speaking world, and probably beyond this. The most prevalent story of the origin of a new temple begins with a group of "like-minded" people, often

neighbors, meeting in each other's homes for prayers or discussions and then collectively deciding to build a temple. I heard this story in Chennai, in London, and in Washington. The official Web site for the Sri Siva-Vishnu Temples describes the history of this now massive temple complex.

> The seed for the idea that a Hindu temple should be built in the nation's capital was planted in 1976 among a few friends. By 1980, that idea had been nurtured and shared with others, and the Sri Siva Vishnu Temple Trust was formed. Its goals seemed fitting for immigrants thousands of miles from their ancestral home: to unite Hindus in America, individuals diverse in their customs but unified in their devotion and values, and to offer a place where Hindu culture could thrive among immigrants, their children and their children's children. (http://www.ssvt.org)

The conjoined themes of preserving culture and developing devotion in the midst of modern life ran through my discussion with devotees and officials in Chennai as well as in London and Washington. Recall from the introduction those well-chosen words of the middle-class couple at the Madhya Kailas Temple in upscale Adyar. They described the temple's executive committee as "intellectual people and educated people who tried to retain the old values and to a certain extent also cultivate them." The mission of the RSS also includes the "spread of Hindu culture" (http://www.rss.orgNew_RSS/Mission_Vision). So, in the end, what distinguishes a temple and its devotees from organizations such as the Rashtriya Swayamsevak Sangh and the Vishwa Hindu Parishad—keeping in mind that individuals may participate in both? I think the difference returns to the temple as architecture, as space, as a form of materialized divinity—a central theme throughout this book.

In chapter 1 I quoted Fredric Jameson's much-discussed theory that "categories of space rather than categories of time" now dominate our period of late capitalism, in contrast to the "previous period of modernism" (1991, 16). In the entrepôt of India, Madras as the case in point, categories of space dominated as much at the beginning of the modern world system as now. The tension, however, for the Hindu inhabitants of this city was not between space and time as the dominant motif but between the resacralizing of space and the articulation of values. Hindus, by the late seventeenth century, reestablished places for God/s within the new urban space of a global trading network. Unlike today, no published brochures explain the whys of this building program nor are there newspaper interviews available with the donors. Yet amid the crowded streets the old city within Chennai, sometimes sandwiched between shops, gates open into sacred houses created by that almost alchemical

process that turned the wealth of merchants into the abodes of God/s. Such temples preceded the period of colonialism and the new world of rhetoric that would accompany the coming of bureaucracy, English education, and the nineteenth century's reverence for rationalism.

Just at that moment when the entrepôt of Madras was about to become a bureaucratic center, a new round of temple building and renovation accompanied the change in power from the Merchants to the Dubashes, as chapter 2 described. At that moment these new rising bourgeois articulated "tradition" and the "traditional"—not yet termed "Hindu"—in this multicultural city. They built their grand houses as spaces to intone the now classical Carnatic musical tradition and the almost forgotten poetry that their wealth patronized. They built a cultural system of which the temples were, I think, spaces of visualized values. For all of its holiness, the Kapaleeswara Temple, which introduced me to the Hindu temple, nonetheless carries the memory of an old process of bourgeoisification. I realize now why this temple has always felt so comfortable—the Lord here lives in a world of middle-class sensibilities, his ascetic self now in harmony with his powerful consort, his children sharing his house. I do not think the tensions between ascetic power and social propriety or between powerful passion and righteous laws are resolved in the Kapaleeswara, but they are comfortably muted for the ordinary devotee. In his grand home, the Lord has put aside his skull-bowl to share in the middle-class world of his devotees in Mylapore. In this sense temples as abodes of divine presence already begin to lose some precedence to temples as spaces for "culture" understood as "values." These temples exist on the edge between principles and holy matter—where dwell the religious sensibilities of many modern Hindus or perhaps many modern religious people in general.

I have said little about the intervening period between the temple-building Dubashes and the temple-building new middle classes of modern Madras, but I implied much about the rising middle-class sensibilities in chapter 3. Beginning in the mid-nineteenth century, interest in temples gives way to concerns over educational and employment opportunity. The English petitions to officials and various permutations of the Government of the Madras Presidency and the British Parliament from the Madras Native Association and later the Madras Mahajana Sabha could be part of another essay on the changing consciousness of the rising middle classes in the south. In the 1850s, the association remained concerned with dual problems of the preservation of culture and at the same time the right to enter into the highest ranks of the civil service (Madras Native Association 1852 and 1859). The growing strength of missionaries in public life forced them to defend their religion but in terms of the tenuous position of temple property, which at that point "continues, without

protection of the law . . . a heavy blow against our social and religious exis-
tence" (Madras Native Association 1859, 2). By 1885, concerns switch exclu-
sively to the issue of elected "native" representation in the government (Madras
Mahajana Sabha 1885). This is the doldrums for constructing temples; from
the mid-nineteenth to mid-twentieth centuries the middle classes—at least
from all of the documents readily available—seemed caught up in the expres-
sion and experience of Hinduism in the public sphere as philosophy, mythol-
ogy, and grand literature. The reformist temperament began to dominate in
public rhetoric among university-educated Hindus who abjured gods as idols
and lavish temple rituals as a waste of resources. The sense of tradition that
they reconstructed—along with many British Orientalists—became the Great
Tradition that dominates Milton Singer's view of Madras and most of the text-
book presentations of Hinduism until recently. With the first provincial elec-
tions in the 1930s (recall the Tiruvalluvar Temple) and finally independence
from British command of country and consciousness, temples begin to per-
vade public space and the public consciousness of the Hindu middle class.

Delineating any distinctiveness of the contemporary period in urban
Hindu temples becomes only more complex as researchers unearth ancient
material culture, carefully read medieval temple inscriptions, or reread preco-
lonial documents. There is nothing new about temples occupying urban space;
this possibly occurred as early as the Indus Valley cities of Mohenjodaro and
Harappa. Contemporary temple builders may feel a democratic pride in usur-
pation of the role of kings as donors, but there are precedents for merchants,
local leaders, or women assuming the honored role of temple donors (Orr
2000). The power of merchant communities and local leaders—the nattars—
becomes more obvious in premodern south India (Karashima 1997; Sivaku-
mar and Sivakumar 1993), exposing any narrative of a sudden shift in power
from kings to the general populace as simplistic. Yet entwined in our collage
of modern urban temples are visible changes in the ambiance of the architec-
ture, the configuration of the polity, and even the hue of the theology. Audible
as well are more recent changes in the inflection of religious experience within
the temples, the tone of ritual life, and the emerging ideologies that sometimes
murmur from the ground-floor meeting rooms of modern temples, or shout
from very different spaces. Yet naming these changes has not been easy. News-
papers such as *The Hindu* and *Hinduism Today* report the construction and
consecration of new temples almost weekly, and the increasing presence of
even smaller temples in Chennai on the World Wide Web provides an infor-
mation overload that often complicates rather than clarifies larger trends. Of
course this very interest in details, this recording of the acts of relatively or-

dinary people, this creation of a public sphere, constitutes the very milieu of a modern world.

Beginning first within the city of Chennai but then in another recent wave of diaspora, Hindus have chosen to transfer a portion of their wealth from business and now technological and scientific know-how into the renovation, construction, and maintenance of temples. In what do three centuries of this modern work culminate? I am never comfortable with lists or generalizations, but I do see certain new inflections of style and sensibilities in this consecration of space to God/s—sometimes working in tandem, sometimes in tension. Many of these changes have important implications for the general history of religions.

First, a new sense of the sacred sphere, of temple space, emerges within an urban environment dominated, as Max Weber suggested, by the ownership of houses and not land. The detachment of temples from their association with the sacrality of the land which they occupy is not complete. In some cases, such as the Adhivyadhihara Sri Bhaktanjaneya Swami Temple for Hanuman in Nanganallur, the temple rests on ground hallowed by the acts of holy men. But missing are the features of nature—the mountains, the confluence of rivers, forest groves—that marked ground as intrinsically suited for a sacred structure. Missing also is the later-fifteenth- to seventeenth-century sense that temples center a city and command crossroads of all other activities. This may explain the increasingly elaborate consecration rituals now, which sacralize both the temple and its land. Emphasis falls on the work of devotees to make a place, to build a home, to locate deity in a space that conforms to their own lifestyle. Temple founders stressed the needs for a place to worship close to work and to homes. This trope began as early as the Dubash of the British governor who built the Chennai Ekambareeswara Temple, at his lordship's suggestion, to circumvent the long trip to the sacred city of Kanchipuram. The Arupadai Veedu complex in Besant Nagar now offers devotees a convenient microcosm of all six holy sites to Murugan near their homes on a lovely coastal site without any intrinsic sacrality.

As I reread Mircea Eliade's monumental *Patterns in Comparative Religion* in the context of these modern sacred spaces, such temples look denatured. Those who construct modern urban temples seem unaffected by the contemplation of awesome elements of nature such as the sky, "which directly reveals a transcendence, a power and a holiness" (Eliade [1958] 1996, 38). Do they even fit into the language of "morphology"—the attempt to see sacrality as a natural phenomenon? Devotees construct a modern Hindu temple; they work to bring deity there to inhabit their world. When devotees "transplant" gods—a

perhaps inappropriate metaphor commonly used by academics and devotees—into the milieu of a heterogeneous urban community, they construct a new kind of bounded space for the gods that is ironically more global and less universally natural. In their new urban temples, the gods rule over their own domain sometimes shared with other deities—one that can stretch worldwide like Sri Venkatesvara's, but ironically they do not rule over the cities or even the neighborhoods where they are situated. How can we make room for this kind of sacrality?

The second change is that even the architecture both of the space and the polity of new temples reflects democratic models of civic organizations, which leads to new space for meetings, lectures, and education. In the United States, Hindu temples participate in civic organizations such as various interfaith councils or community adopt-a-highway programs. In Chennai, temple administrations increasingly make or reuse space for offering services such as free medical clinics, like the Ratnagiriswara Temple, or offering milk for the poor, like the Mundakakkanni Temple in Mylapore. A research project on temples in the United States and India as philanthropic institutions is under way.[1] Recall the devotee at the Shri Kanaga Thurkkai Temple in London, who regarded the temple's charities as the major inducement for her to join. A collage of photographs of the temple's service branches in Sri Lanka covers an entire wall of the entrance hall to that temple. Indeed, ancient temples also rendered service to the community, but without the nineteenth-century emphasis on religion defined as a social gospel or as "moral muscle" (van der Veer 2001, 94–101). In Indian terms, this very middle-class propensity to equate religion, culture, and ethics reemerges in modern temples as a legacy of Gandhi and the independence movement, but also of the founding fathers of the RSS (Hansen 1999, 79–80).

Particularly in the American and British contexts, the very space of the temple often resembles a meeting hall rather than a mansion for the gods. The brick Hindu Bhavan near Raleigh, North Carolina, for many years had a large multipurpose room with a fine chandelier, a stage for cultural performances to the left, a large hall in the middle, and three marble platforms enshrining the deities at the back.[2] Temple Web sites and mailings urge potential devotees to "join," in part because of requirements for nonprofit tax status but also because of a changing sense of polity. Even in India, where the legal status is even more complex, devotees still "join" as they subscribe to a building fund and the right to a voice in elections. Also I often heard that temples in Chennai now compete for prestige and hence membership by sponsoring the very best festivals with nightly performances by famous classical musicians. Most new temples include a hall for performances, lectures, and other public meetings.

"Membership" in a temple becomes one association among many other organizations as well as other temples. For some members, the temple functions primarily for "social" purposes—as many other devotees almost everywhere frequently complain.

The architecture of many contemporary temples reflects a divided consciousness between the temple as a civic organization and as the abode of divine presence. At the Sri Siva-Vishnu Temple in metropolitan Washington, the meeting rooms in the basement accommodate talk and argument while the gods, alive in their stone bodies, grace the upper floor (Waghorne 1999a). I recall speaking once in the general meeting room of the Sri Siva-Vishnu temple about the importance of rituals and divine presence. As we could hear the last ringing bells of the nightly puja upstairs, a man rose to firmly disagree, arguing against rituals in this room literally underneath the gods. The Jagannath Spiritual Complex in Injambakkam also has a separate lower floor, again right under the main sanctum, which will accommodate not only meetings but also those who prefer contemplation to ritual. The plan for the new Mahalakshmi Temple in London calls for an entire floor devoted to meeting and teaching rooms. The sacrality of certain spaces within temples does not seem diminished by the concept of devotee-members, but the much-debated sacred/profane, sacred/secular divide now partitions space *within* modern temples.

A third change is in the complex middle-class religious sensibilities that emerge within the temples but that also affect the style and polity of the temple—often reflexively. Religious authority shifts from the hereditary priests and pandits to the educated laymen whose accomplishments in the sciences or whose acumen in business legitimate their voice not only in administration but also in a growing visual (and verbal) lexicon of popular theology articulated and practiced in the temple. The goddess temples in Madras openly display this vernacular-visual theology with special verve, but the visual style borrowed from cinema or poster art appears throughout Chennai.[3] Written on the walls of these temples and onto the gopuras and vimanas, these theologies present gods and goddess as moving out of their world, climbing down from their heavenly abodes, and entering the lives of their devotees. When I look at the remaining sculpture, especially on the gopura, from the periods prior to the "modern," the gods condescend to offer the devotee a glimpse into their divine world. Now Kolavizhi Amman appears almost to clutch any who pass through the gates of her temple. The gods now seem to desire popularity and actively seek devotees. They do not single out just a few special persons—as in the past—but call to everyone. I cannot establish a one-to-one relationship between this almost media-centered divine presence with the rise of educated laymen, but this vernacular theology fits their democratic rhetoric and parallels their

own modus operandi as self-made men and women who must build a résumé, seek clients, and make a name.

C. J. Fuller reports that priests are recovering status and assuming a new professionalism in Tamilnadu (Fuller 2003). At the same time, however, the more potent voices of swamis and gurus—often former businessmen or college-educated professionals like the guru-founder of the OM Murugan Temple in Chennai or the now-famous "Amma" of the Adhi Parashakthi Siddhar Peetam—not only dominate the discourse on religion but frequently found new temples within larges campuses that include colleges and health services. The massive Adhi Parashakthi complex combines technical schooling with a potent site for the goddess. The learned pandits, like those I saw working at the Oriental Manuscripts Library at the University of Madras or helping many a scholar translate difficult texts over the years, look worn and underpaid. The celebrity status of popular culture now adheres and possibly motivates the photogenic and media-savvy saints. Middle-class devotees appear to have little patience with the exhaustive—and exhausting—philological arguments of the old pandits, at the same time that meeting rooms of contemporary temples welcome discourses that often glorify ancient Sanskrit minus any nuanced philosophy or seemingly tedious textual commentary.

At the same time, the legitimacy and propriety of temple architecture takes on a new importance. Sthapatis steep their discussions—often printed in kumbhabhisheka souvenirs—in the language of Agama Shastras, even the Vastu Shastra, the science of space now coming into mainstream decorator magazines and Web sites as the Indian feng shui (www.vastu-decorators.com/vastu-feng-shui.html). The Shankaracharyas of both Kanchipuram and Sringeri maths enter public life as never before. In the case of the Sringeri Shankaracharya, his organization has begun to construct meeting halls with an attached temple in upscale neighborhoods within Chennai.[4] When they preside over consecration rituals, their Holinesses lend a particular prestige to that temple. Many temple founders spoke of "seeking permission" of the Shankaracharya to build a new temple, or as in the case of the Kanaka Parameswari Devasthanam, asking permission to install a stone image in place of bronze. However, I could not always discover if the role of the Shankaracharyas was to legitimate the decisions that the lay boards of trustees had already taken or to actually give new directions. At the Ratnagiriswara Temple in Besant Nagar, the president credited the now-famous late senior Shankaracharya of Kanchipuram with directing them to the location of the stone lingam that would grace their sanctum. Residents had already decided, however, to build a temple; they sought permission and help. Dr. Alagappan suggested the idea for the Arupadai

Veedu temple complex; the Shankaracharya sanctioned and lent his good offices to the project.

But as the Shankaracharyas are increasingly sought to legitimate a temple-building project, the number of "traditional" craftsmen and craft styles as well as religious functionaries seems to shrink. Dr. Alagappan, with many connections, reaches out to many more traditional siddhas (healers) and mediums, but for most temple builders, who sometimes openly called themselves amateurs, they look to the few famous names. The face of the charismatic head priest of the Kaligambal Temple in Georgetown frequently appears in our photographs of consecration rituals worldwide. This is also true of sthapatis with the proper lineage. I rarely talked to a building committee in the United States or in Britain who hired anyone but Muthiah Sthapati, V. Ganapathy Sthapati of Chennai, or M. Ganapathi Sthapati of Andhra Pradesh—each with his modest but jet-set shilpis. These temples do reflect the landscape of their location, but the styles of each master architect becomes readily recognizable. Common decorative motifs, common building materials and techniques, and similar spatial design appear in temples from Hawaii to London to Chennai. The much-bemoaned middle-class predilection for tract housing and for brand names seems to cross over to sacred spaces and holy persons. On the surface, new temple spaces appear repetitive and denatured, but it would be a mistake to read the discussions of Vastu Shastra or Agama Shastras as just window dressing. Those voices from chapter 4 and the "exhaustion" of the trustee at the Sri Siva-Vishnu Temples reminds us that new temple spaces have other dimensions.

The RSS, a potent organizational structure in modern India and in the Hindu diaspora, also speaks from a sense of space but abjures any mysteries about its methods or its ideology. The official Web site explains the simplicity of its scheme in very interesting terms.

> The Sangh's method of working is of the simple kind, and there is hardly anything esoteric about it. . . . The daily Shakha is undoubtedly the most visible symbol of the Rashtriya Swayamsevak Sangh. The Shakha is as simple in its structure as it is grand in conception. . . . What is the Shakha? A saffron flag (called the Bhagawa Dhwaj) flutters in the midst of an open playground. Youths and boys of all ages engage in varieties of indigenous games. . . . All activities are totally disciplined. . . . Also forming part of the routine is exposition and discussion of national events and problems. The day's activity culminates in the participants' assembling in orderly rows in front

of the flag at a single whistle of the group leader, and reverentially reciting the prayer "Namaste Sada Vatsale Matrubhoome" (My salutation to you, loving Motherland). . . . The prayer concludes with a heart-felt utterance of the inspiring incantation "Bharatmata Ki Jai." (http://www.rss.org/New_RSS/Mission_Vision/Why_Shakha.jsp)

Notice the venue here. Spatial imagery prevails: a simple field, a flag, and a group of young boys. However, the disciplined body of the young sevaks standing at attention, not the yard, primarily exemplifies the Sangh, which would provide any follower of Foucault with a field day. This notion of a "simple field," however, has Vedic overtones. The potent Sanskrit word *kshetra* means both field and the abode of the soul, that is, the body. The term *kshetra* appears in the *Bhagavad-Gita* as the inner battlefield between desire and equipoise and the outer battlefield demanding sacred duty. Emphasis in the RSS remains on the person, the group of persons, and an embodied ideology. The "Matrubhoome," the Motherland, is the only valorized space—but is it a place, a locality, or a solidified abstraction, especially for Hindus in the diaspora?

When a group decides to construct a temple, I have argued, space predominates over ideology—with a turn not just to spatial terminology but also to a certain kind of space. In my discussions with temple administrators and builders, they seem very aware that all members—and very often many of the devotees' gods—should be "accommodated." This model is as old as the original Town Temple in Blacktown, Madras, described in 1670, with "a number of Chappels . . . one for every Tribe." The Hindu Bhavan in North Carolina selected the deities to install on their long altar in a free election; the president showed me the ballots with a smile—where else has democracy penetrated religion so thoroughly? The deities clearly reflected the regional preferences of the temple's diverse Hindu constituency. I am tempted to play with the differences in English between "accommodated" and "tolerated." Accommodated is a thoroughly spatial term associated with *modus*, and literally means to conform to the right measure. Newer temples, especially in the diaspora, include meeting halls, which also can accommodate service groups or ideologically oriented organizations as well—again more like a church or modern synagogue complex. When a group closely associated with a deity from "home" is accommodated, they also have room within the walls of the temple—sharing the same space with civic organizations. Gods, who once ruled over their own domains, now live together, in their own vimanas but under the same roof. When the RSS and the VHP praise Hinduism as a "tolerant" religion, they have—I think—left the realm of space. The term "tolerant" carries an edginess left from the English Reformation, and means to forebear (Latin, *tolerāre*, to bear),

endure, or in the old English usage "to suffer" difference without legal prohibition. This is not shared space of accommodation.

As V. Ganapathi Sthapati so articulately reminds devotees during consecration rituals, the temple building, not simply the god, becomes divine at the moment of the mahakumbhabhisheka. Priests carry the holiest kumbha to the top of the vimana and pour these life-infused waters over the finials. At the same time, the vigrahas also receive the life-giving waters. The entire structure is the body of God pulsating with energy which, as I have heard this famous sthapati say, will vibrate in the lives of the devotees and outward to the surrounding community—even if they do not realize this. The temple thankfully always makes room for the capacity of gods to remain capricious. These are the miracles that often accompany those stories about the beginnings of new temples—the stone images from India that arrive in the nick of time, the amazing ease of moving a stone deity weighing many tons, the vimana that corrected its own proportions, the perfect stone image located in a fisherman's hut. That interplay between Murugan and his devotees continues to have a place in the temple—the scientist overcome in front of his sanctum in the Sri Siva-Vishnu Temples near Washington. I have heard persons speak of the goddess demanding an end to caste distinctions. When I hesitated to take a leading part in a ritual, worrying about my foreign hands touching the altar, the priestess told me, "If I discriminate, Devi will discriminate against me." The space of a temple is God and in that sense is always more than a concept or a set of values—it is matter with a living will, and that is the difference, I think, that will matter in the future for urban middle-class Hindus worldwide. I am left wondering what kind of sacrality will accrue to the temples in cyberspace with their virtual pujas. And how will this living space of the temple matter for historians of religions whose much-criticized propensity to "authorize, normalize . . . highly contestable 'experiences' of the world in which we live" (McCutchen 2001, 8) has made us far too cautious? Will we make room for this kind of public and in many ways empirical sacrality? But those are issues for the future.

Notes

INTRODUCTION: NEW HOUSES FOR THE GODS IN
AN URBAN WORLD

1. In temples in India and even in the United States, signs in English frequently call the divine image *idol*, which carries too many negative connotations in the Euro-American context to use here. Throughout the text, I will use *image-body* or simply *divine image*. *Murti* more literally means body, while *vigraha* means "separation," that is, an individual form or shape manifested from undifferentiated divine wholeness.

2. The Prasanna Venkatesa Perumal Temple.

3. The Kusa-Lavapurishvarar (also called the Kurungalishvarar) and Vaikunta Varasa Perumal temples.

4. I borrow the phrase from the title of the 2002–2003 Religion and Society Speaker Series at Syracuse University.

5. In the 1980s, as part of an general reevaluation and deconstruction of Weber, major edited volumes, books, and articles appeared on his discussion of Asia, particularly Hinduism in India, which fostered a brief but intense reevaluation of the "spirit of capitalism" in Indian religious context (i.e., Kantowsky 1980, 1982, 1986; Buss 1985). The debate also moved to Germany; see Schluchter 1984. Andreas Buss argues that Weber's own revised essays on the sociology of religion in a comparative context, which he published in a massive three-volume work, the "Collected Essays in the Sociology of Religion," were never translated into English as a whole. "Instead, separated translations, which leave the reader unaware of the interrelations, have been published out of the various parts." Buss points to the "new and misleading titles" that presented the cannibalized work as *The Religion of India* and *The Religion of China*. He also points to "poor and misleading translations" by Hans Gerth and Don Martindale (1985, 1–3). Buss (1985) and

Kantowsky (1980) actually try to free Weber from the taint of his misuse in the later economic "development" projects. Although much of this debate does not quite succeed in de-Orientalizing Weber, the argument that Weber never intended to glorify either Protestantism or modern European civilization remains important.

6. Weber refers to Totemism, silently nodding to Durkheim, and then moves on with his own perspective. Durkheim argued that sacrality derived from effervesence of the community itself.

7. Information from discussion at "(Un)common Ground: Rethinking American Sacred Space," a symposium sponsored by the Department of Architectural History, University of Virginia, Charlotte, October 31–November 2, 2002. Gretchen Bugglen of the Winterthur Program in Early American Culture, University of Delaware, has work in progress on the meetinghouses of early New England.

8. A panel at the annual meeting of the Association for Asian Studies in 2000 was devoted to "Reinventing Traditions: Contemporary Trends in Religious Practice in India." Revised papers of that panel just appeared together in the *International Journal for Hindu Studies* with a perceptive introduction by Jack Hawley, whose draft manuscript I quote here. Earlier, at the annual meeting of the American Academy of Religion in 1996, I organized a panel on "From Baboos, Bohras and Banyas to Bureaucrats and Businessmen: The Middle Classes and the Building of Modern Religion(s) in South Asia."

9. See Stern 1993, 54–71, for a good general discussion of the meaning and practice of "caste" as a social system: the complex difference between the ideology of varna and the daily practices of jatis.

10. The term *vimana* is primarily architectural and refers to the structure. *Sannidhi* mean "presence," and is used in a more devotion context. Devotees may comment on the lovely vimana but speak of a Durga sannidhi in a certain temple that they visit. In English we tend to subsume both concepts in the word *shrine*, which does not convey an accurate sense of either term.

11. Singer critiques his earlier analysis (1972) of the Krishna Bhajan movement, "The initial observations were accurate enough, but they were confined to what I could see and hear and left out the invisible, the imaged—especially Krishna" (1984, 166).

12. The term for darkness (*kālī*), also the goddess Kali, the Black One, who is closely associated with the cycle of birth and death and the passing of time.

13. The makaras are part of a very common motif found at the very top of temples, in which a makara spews multiple beings, usually human babies, from his mouth.

14. I then said that some artisans feel that they are simply chipping away at the stone to reveal the hidden god inside, and he heartily agreed that this was the case for this Hanuman.

I. HINDU TEMPLES IN THE NEW WORLD SYSTEM, 1640–1800

1. His thesis has been challenged by multiple scholars arguing for an Asian-centered look at the early trading world of the seventeenth and eighteenth centuries.

The most prolific and challenging for the region of the Indian Ocean is Chaudhuri 1978, 1985, 1990. For a revisionist look at the centrality of the Chinese in the Asian trade, see Mazumdar 1998. For an overview of new historiography in the Indian Ocean with an eye to world systems, see Arasaratnam 1990. The latest and most strident critic of Wallerstein on this point is André Gunder Frank in his new book (1998). See also Blaut 1993 and Hodgson 1993.

2. The conflict and possible rapprochement between world history as defined by "civilizations" or by "world systems" is the topic of an excellent volume. See Sanderson 1995. There are some world-systems theorists who debate Wallerstein's dating and would like to push the theory back. See Abu-Lughod 1989; Frank and Gillis 1993 and Chase-Dunn and Hall 1997.

3. My own students, graduate and undergraduate, first at University of North Carolina at Chapel Hill and now at Syracuse University, wonder how "religion" can fit into such a seemingly narrow economic framework, and much of this chapter grows out of my attempts to answer to their concerns.

4. The list of Stein's publications is long; his best-known early affiliates are Arjun Appadurai and Carol Breckenridge. Important examples of his work include Stein 1960 and 1978.

5. This idea of embeddedness in ancient soil, so fundamental to notions of sacred space, still retains its force. "Space can have a sacred aspect in an even more elemental, territorial sense by virtue of intensity and strategicness of the social boundaries its signifies, e.g. . . . 'the motherland'." *The HarperCollins Dictionary of Religion* (San Francisco: Harper, 1995), 945.

6. Interestingly, this same relationship existed between religious festivals, pilgrimage sites, church monastery yards, and early shifting European markets and trading fairs. These European markets, like their Indian counterparts, created new social relationships and—perhaps—a new kind of sacred language. Irschick openly takes his theory of "heterglossia" from Mikhail Bakhtin's essays on the controversial sixteenth-century humorist Rabelais—a reference that fits into the context of world-systems analysis in striking ways. Bakhtin emphasizes the reemergence of popular, "vulgar" speech in the busy market towns of France—a speech that Rabelais returns to literature. Bakhtin speaks of the "language of the marketplace," where trade was conducted in the midst of a carnival atmosphere. Here a space opened for languages of "freedom, frankness and familiarity"—free from the more formal constraints of church and court proprieties ([1968] 1984, 153). Abu-Lughod shows that the late-medieval and early-modern "fairs" of France, drawing traders from many parts of Europe who were buying and selling merchandise for a worldwide market, were tied to the cycle of "religious (and movable) feast days" (1989, 60). These were seemingly associated, which she does not add, with the saint's day of different towns and their churches. The language of the marketplace for Bakhtin is about older folk understanding of fecundity—bawdy and bodily words that unite sign and matter in fruitful ways. Such notions of the fecund language of the marketplace provide a tantalizing hint at the root of the connections between a mercantile free-for-all and the nearness of such markets to churches and in India to temples, which blessed fruitfulness.

7. In 1620, when Govinda Dikshitar, divan-administrator for the Nayaks, constructed the Ramaswami Temple in Kumbakonam, he added a commercial corridor between his new temple and the older Chakrapani Temple. (See George Michell, "The Temple Architecture of Kumbakonam," and Vivek Nanda, "Urbanism and the Cosmic Geography of Kumbakonam," papers delivered at "Kumbakonam, Sacred and Royal City of South India," a conference organized by the Educational Service of the British Museum 4–6 June 1996. Michell and Nanda are involved in an ongoing project to map the city of Kumbakonam.

8. Appadurai goes on to explicate the nature of this divine rule and argues that the deity was the sovereign ruler "not so much of a *domain* but of a *process*, a redistributive process" (1981, 22).

9. This deeper cultural connection between economic and other modes of living is more fully developed in the work of K. N. Chaudhuri. See especially his discussion of earlier work and his own emerging theories (1990, 24–41).

10. Pamela Price describes the changing position of the Nattukkottai Chettiars vis-à-vis the royal houses of Sivagangai and Ramnad in detail, from an initial sense of service to the sacred or dharmic duty of the king to eventual court battles with these same royal houses at end the nineteenth century (1996, 102–105). Speaking of the impact of these changes on the temples in these domains, Price notes "the possibilities for tension between the human and divine court: a devout servant of Lord Shiva, for example, could decide that his duties to the divine lord were more important than those to his human lord" (107). When the image of God as king is used to challenge the hegemony of human kings, that change is profound.

11. Anna Dallapiccola has pointed out this out in a paper, "The Temple Painting and Sculpture of Kumbakonam," delivered at "Kumbakonam, Sacred and Royal City of South India" a conference organized by the Educational Service of the British Museum, June 4–6, 1996.

12. It is easy to trace who lived where from the notices of sale and of estate sales in the *Madras Courier* from 1781 to 1794. Houses in Blacktown are advertised and obviously open for purchase by Europeans. For example, a notice appeared on 23 February 1792 (on the ad pages):

Notice for a public sale of a house

Thomas Unpherson vers. Cottrell Barrett . . . two houses and grounds situated in Peddo Naiks Pettah: Viz. . . . a house and ground in Stringer street adjoining to the house of the late Mr. Robert Pierson, measuring. . . . and . . . the other house and ground in John Pariera's Garden Street, between the houses of Davana Mootue and Coosseneycaurah Anthony . . . being the property of the above named defendant.

13. This information was part of two papers presented at the conference "Kumbakonam: Sacred and Royal City of South India" held at the British Museum June 4–6, 1996.

14. Stone temples are built to this day like erector sets, with the pieces held to-

gether by the weight of the granite. Such temples can be disassembled and parts moved, which appears to have happened all over the city. Parts of the present temples in Mylapore area certainly came from older temples.

15. Also spelled "choultries" and defined by Yule's *Hobson-Jobson* ([1902] 1984) as "Peculiar to S. India. . . . A hall, a shed or a simple loggia, used by travellers as a resting place, and also intended for the transaction of public business. In the old Madras Archives there is frequent mention of the Justices of the Choultry."

16. The form here can be confusing; *mallikā/mallikai* appears to be the name for a form of cultivated jasmine, so the translation would be the Lord of the Jasmine. The Temple Directory of Madras City lists this temple as the Chenna Malleeswara (Nambiar and Krishnamurthy 1965, 190), which probably is incorrect but a logical error, since *malli* also means jasmine, but the wild variety. There is a temple in Mylapore called the Malleeswara. Transliterating these names is a nightmare because they are often a hybrid of Tamil and Sanskrit and appeared in various English forms for centuries in official documents. Most are known by their common Anglicized spelling in the temples' literature, which is often still printed in English.

17. In the United States someone corrected my use of pukka and insisted this was slang. I heard the word frequently among educated people. The term occurs in most English dictionaries.

18. I saw this same style of portraiture on pillars from temples dated in the early nineteenth century. I also saw a very similar style on the Sri Vedanta Desika Perumal Temple in Mylapore, which probably dates from the early nineteenth century. In the back of this temple are pillars with stone portraits of the donor—one with a buttoned-down long outer coat in a English-modified Mogul design and a dhoti, his feet splayed out to the side of his body!

19. Sri Coolah Venkata Cunniah Chetty kindly granted me an interview at his house in Kanchipuram on March 22, 1995.

20. Marriage within a jati like this one is vigorously recommended, but one may *not* marry within a gotra, since the gotra is considered a family.

21. My husband and I were guests at the 22nd mass marriage, 4 December 1994.

22. The tape of this conversation from 17 January 1995 was kindly translated by Afroz Taj and John Caldwell, my colleagues in the Triangle South Asia Consortium, while I was at the University of North Carolina at Chapel Hill.

23. George Michell outlines the art of Vijayanagar and later Hindu and Muslim states in south India but stops short of looking at early-colonial-period temples in Madras. I saw many temples that looked like Vijayanagar work but were somehow too "new," and some without doubt dated from the eighteenth century. I call this style neo-Vijayanagar because it eschews any borrowing from Islamic models and seems to look back at the last seemingly clear "Hindu" temple architecture.

24. I thank Kelli Kober for providing this reference. She discusses Kavali Venkata Ramaswami and his more famous older brother, Venkata Lutchmiah, in her perceptive dissertation (1998, 73–77). Both brothers worked for Colin Mackenzie on his now-famous project collecting texts, manuscripts, and tales of south Indian history.

25. He acknowledges borrowing the term from Joseph Fletcher's earlier work (see references given on the same pages).

26. Recall that at the beginning of the early modern period, at the very moment when Asia and Europe began to reconfigure our present world system, Hindu temples in south India began to share the same space as the new market centers. In old "temple cities" like Kumbakonam, Palani, and Madurai, markets surrounded and often connected the temples. Especially in Madurai and Palani, one major temple dominated the cultural and economic landscapes; Kumbakonam may mark an important departure from this pattern. The issue remains: are these patterns new or simply renewals of those in earlier periods of world trade?

2. MYLAPORE: THE RECOVERY OF "ANCIENT" TEMPLES IN AN INNER-CITY NEIGHBORHOOD

1. I have traveled with members of the Pudukkottai royal family to temples, and this kind of greeting strongly resembles the old temple honors given to the family. Since the party in this case were not Hindus, the honors at the sanctum were omitted, of course, but the food served at the temple could be regarded as prasada (food first offered to the deity), although I do not know if the food was cooked at the temple.

2. Old documents in the Mackenzie collection now housed in the Oriental Research Library of the University of Madras tell the story of the settlement of the area by a low-born son of the Chola king called Atoṇṭai, who brought these Vellalar with him to establish agriculture. See Waghorne 1994, 186; also Thurston [1909] 1972, 6: 369.

3. The term agrahara technically refers to the tax-free land grants given to Brahmans in south India, but within a city it refers to the enclaves of Brahmans still living in traditional single-story tile-roofed houses near the major temples.

4. Two examples are important here. The Lonely Planet series on India refers to this as "an ancient Shiva temple" (Crowther 1984, 697), and a Tamilnadu tourist group's publication also calls it "ancient" and recommends it as "a delightful introduction to Dravidian architecture" (Muthiah 1985, 22).

5. Tiruñāṉa is a title referring to the gift of "holy knowledge" received by the child-saint from the goddess Parvati. The full story of the child-saint is retold in a condensed English version of the twelfth-century *Periya Purāṇam* by Cēkkiḷār. See Vanmikanathan 1985, 145–271.

6. See the *Sri Kapaleeswara Temple*, which has no date, but I purchased the English-language pamphlet in 1979. The dates of the Vijayanagar Dynasty even in its ebb could include the temple's building. Conversations with the former director of the Archaeological Department of Tamilnadu confirm that the temple could not be more than three hundred years old.

7. The temple brochure retells the story following local legends, and names the father as Sivanesa Chettiyar—a member of the major trading caste in south India (Kapaleeswara Temple 1978?, 4).

8. A grove (T/ *kā*) is an in-between area where nature and culture meet, which could be the site for a royal temple since it mirrors the nature of some kings in south

India (see Waghorne 1994), but also could be the site for a royal takeover, as described by Paul Younger (1982, 252–253).

9. The exact date of this plan is uncertain, but judging from other drawing included in the folio, I have guessed 1799–1806. Mackenzie's work is not usually within the city limits, so this is unusual.

10. The translations here are mine.

11. The stone image may well be the same as one on outer walls of Kapaleeswara's sanctum. See the detailed description of the stone images now kept there in Ishimatsu 1994, 108–109.

12. Possibly *ponnankal* + *īsvarār*, Lord of the Golden Ones?

13. Shulman, translating from the Tamil sthalapurana for the temple, tells the story differently; here the Goddess is distracted by a peahen with eyes in its tail, thus making this an image of the Goddess's own subdued eroticism. Shulman includes this story in his section on "The Lustful Bride." See Shulman 1980, 168.

14. The text Shulman used was by Amurtalinkattampirān with commentary by Kāñcipuram Capāpati Mutaliyār, edited by P. A. Capāpati Mutaliyār, 1893.

15. For a fine discussion of Islamic court dress among Hindu kings, see Wagoner 1996.

16. This same pattern of new merchant control but continued hegemony of royal imagery has been well documented for the truly ancient Parthasarathy Temple in nearby Triplicane (Appadurai 1981).

17. A signboard in the temple in Tamil gives the name of the founder as Cālivāhanavam Cattinar and the date simply as the eighteenth century.

18. Chetti, as Thurston explains, is a title that means trader, is much like Mudaliar, which means the foremost (i.e., landowner), not really a caste name. I do not know the exact name of the caste involved (Thurston [1909] 1972, 2: 91–92).

19. The current trustee told me that he was the seventh generation from the founder, that the date of the original temple was 1721, and that his great-grandfather, under the orders of Tipu Sultan, accompanied the nawab of the Arcot to Madras. He may be referring to the first phase of the Walahjah rule, when the nawabs of the Arcot began to support the holy places near their new capital, especially around Trichinopoly, which apparently included Hindu as well as Muslim holy sites. In this sense these Muslim rulers could be seen as "Hindu" by those patronized (S. Bayly [1989] 1992, 165). I would guess that his ancestor eventually served as a dubash for the Nawabs.

20. The trustee told me that he had old records to confirm his claims, but unfortunately I did not have the time to see these—which is one major problem with any broad survey.

21. These kings also continued the Vijayanagar style in the additions they made for state temples, but in their own chapels the style, especially the painting, was more innovative. See my discussion of the Dakshinamurti Temple in Pudukkottai (Waghorne 1994, 207–216).

22. Lord Ranga or Srirangam is more difficult to place at this point. In her article on the Dubashes, Neild-Basu 1984 does not mention his name in the record that she surveyed.

23. K. V. Raman seems to be one of the first to suggest that the temple was not ancient. He feels that he must prove that something is odd about this "ancient temple" with poorly carved pillars in no definable style and no old inscriptions,

24. The term Jaghir refers to a grant of land by an overlord to his vassal. In using this term, the Company continued the fiction of ruling in the name of a local overlord, which was technically still correct.

25. The date given to Muttiyappaṇ Mutaliyār's (re)construction of Lord Kapāliśvara's abode is apparently in the late seventeenth century (Ishimatsu 1994), on the basis of the Tamil panegyric poem, but certainly all of the names associated with the project and the easy rendering of them into common abbreviations in the Mackenzie drawing of the temple lead me to suggest a date closer to the ascendancy of the Mudaliars as Dubashes. More historical sleuthing might find these names among colonial records.

26. A manuscript that recounts the tale of his coming to the south is part of the Mackenzie Tamil manuscripts housed in the Oriental Manuscripts Library at the University of Madras. This collect dates from oral stories given to Mackenzie's scribes about 1800.

27. In one of the Sanskrit works offered by Raghavan in the *Madras Tercentenary Commemorative Volume* as early as the late seventeenth century, this model of patronage of ancient temples appears already part of the cultural consciousness. The Parthasarathy Temple and its surrounding community in Triplicane becomes emblematic of the piety, learning, and honor of the Indian community there in contrast to the "Town," filled with "objectionable inhabitants, chiefly white people (Huna) intent on destroying the good" (Raghavan [1939] 1994, 107–108). This poem that Raghavan summarizes does eventually praise the British, but for their secure administration and their mechanical inventiveness, never for their patronage of temples, which at that time did occur, as shown in the last chapter.

28. The temple has two chief priests, who alternate in the position.

29. Many of the classical "Orientalist" works were readily reprinted in India. The timing of the reprint can be revealing, and I do not regard the reprint of this volume in the late 1980s as a coincidence. This is the period when many new "traditional" temples were constructed in the diaspora, especially in the United States.

30. I met an epigraphist at the Tamilnadu Department of Archaeology, R. Vasantha Kalyani, who was working on the inscriptions of the Karaneeswara and others of the Seven Linga, and who expressed the same doubts.

31. Interestingly, the nearby Veerabadhraswamy Temple openly contains two sanctums for Shiva: one holds the linga but in the other stands a fully carved embodiment of Shiva as Veerabadhra—a form of Shiva closely related to Virupaksheeswara. They are both listed as among the sixty-four Bhairavas, the fierce demon-destroying forms (Gopinatha Rao [1914] 1993, 2:180–182).

32. In a popular Tamil version of the story, Ravana was a great devotee of Shiva, a learned albeit flawed king. Here Hanuman's brother is set in a similar story.

33. Even the Temple Directory mixes these. See Nambiar and Krishnamurthy 1965, 205, where the Valeeswara supposedly is located on South Mada street, where the Velleeswara stands.

34. Matthew Allen has been studying the history of these music societies. Sometimes they function for their members and patrons as a more genteel connection with spirituality than the seemingly outdated ritualism of the temples. This same division between spirituality and problematic ritualism often informs the founding of new music societies in the diaspora.

35. I mean this quite literally. I was in Madras for the first time in 1967, and watched the floats depicting Tamil history go by in a parade for the International Tamil Studies Conference, and almost daily saw the raising of the many new gilt images to Tamil heroes and heroines that now line the beach road and Mount Road, soon to be renamed Anna Salai. Many other streets were renamed at this time.

36. In Kanchipuram, Shiva lives with Kamakshi in her sanctum as her consort as Ardhanarishvara, his half-man, half-female form. The Ekambareeswara temple is a very old and a quite separate entity.

37. I saw many shrines and renewed gopuras and shikharas dated between 1935 and 1938, which coincides with the brief term as premier of Madras State of C. Rajagolapachari, a Congress stalwart, an Iyengar Brahman, and a fierce opponent to E. V. Ramaswami and his DK. I wonder if the premier redirected the HRCE to undertake this work?

38. The dates of Periyar's major speeches, collected in a very useful volume called *Religion and Society*, all come from the late 1920s and 1930s. Periyar left Congress in 1925/26. See Ramaswami Naicker 1994. For a succinct history of EVR (as he was known), see Barnett 1976, 32–55.

39. The controversy as to whether Weber decried this kind of religiosity or bemoaned its loss remains complex. See Andreas Buss's contention that Weber has been mistranslated and therefore misunderstood, and Milton Singer's quasi rebuttal (Buss 1985, 1–7; Singer 1985, 28–43). For the notion of reenchantment in India, see Weber's discussion of gurus ([1920] 1958b, 318–328).

40. In classical Sanskrit, the term *samadhi* means ultimate peacefulness, but here the term is used for the resting place, the gravesite of a saint. In south India, whereas ordinary people are usually cremated, such saints are buried.

41. There was a debate whether the temple should have a basement, including toilets. The original request for funds mentioned a two-storied building, but the current plans appear to reject that idea.

3. THE GENTRIFICATION OF THE GODDESS

1. I have used the term *religious sensibilities* here. Such a term coincides with other terms like *habitus* used by Mary Hancock and other anthropologists. My field is religious studies, and my concerns are constantly written within another lineage. Rather than looking at the evolving nature of Indian society and the part Hinduism may play in it, I consider the evolving nature of Hinduism and the part that social life plays in it.

2. The officers told me that this was a goldsmith community, a subgroup of the larger craftsmen jati.

3. In August of 1998, I inquired about recent work on Mariyamman on the list

serve for the Religion in South Asia/American Academy of Religion (RISA) forum. Elaine Craddock responded on August 12, 1998.

4. Samayapuram is administered by the same local administration of the Hindu Religious and Charitable Endowment as the ancient temple of Sri Rangam, the Sri Ranganathaswamy, and brings far more into the local coffers. Revenues from the Mariyamman temple in Tanjore are said to maintain the great Brihadeswara Temple, as reported by Jayabarathi in an e-mail response to my inquiry on RISA from Malaysia dated August 11, 1998.

5. The executive officer for the Mundakakkanni Amman reports that the temple's prototype lies much further south, in the city of Nagarcoil, and a set of printed devotional poems—a set of *tālāṭṭu*, lullabies, in the Library of Congress listed as published in Nagarcoil—confirm the importance of that Mariyamman temple (LC Control Number 80901572). In addition, an e-mail message from Jayabarathi in Malaysia (note 4 above) reported that the famous Carnatic composer Mutthuswami Dikshitar dedicated a piece to the Mariyamman. There are now several printed versions of old poems to her in Tamil; the most accessible is Ā. Tacaratan̲, *Māriyamman̲ kataippāṭal* (Chen̲n̲ai: Tami_l Ōlaiccuvaṭikal̲ Pātukāppu Maiyam, 1995).

6. I did not survey all of the patrons of the Amman temples to find the source of their own wealth, but I do have anecdotal evidence. Increasingly temples are supported by moderate donations from many patrons whose names are inscribed on slabs of marble or granite that line the walls of new or renovated temples. This indicates that many more people in Chennai can afford the 2,000 to 10,000 rupees that put them on these rolls of honor. In older temples, often only a single donor or a family could gain such permanent recognition. The major donors now were owners of smaller local businesses with new international sales and trading connections.

7. This is a splinter party that takes its name from the first DMK chief minister, C. N. Annadurai. Currently the office of Chief Minister swings back and forth from DMK to AIADMK control. The once-supreme Congress Party never polls more a small percentage of the popular vote.

8. In this chapter, I have avoided discussing the myths that surround many village goddesses. The ammans often gain power out of their own social transgression. Mariyamman in particular has the head of a Brahman but the body of an untouchable. For this kind of analysis, see Craddock 1994, who reviews much of this literature.

9. In the fall of 1967, Dr. Raghavan took me to a wonderfully loud Durga Puja on the outskirts of the city in an old Pallava-era Durga temple that he and a group were trying to put back into active worship. Obviously the goddess meant a great deal to this seemingly staid Brahman, yet curiously he never introduced Singer to this side of his own religiosity.

10. The Drivers did not begin to publish their findings until the early 1980s. The 1970s were so controlled by Louis Dumont's model of hierarchy that I wonder if they hesitated to release such contradictory data, which might have seemed very out of fashion.

11. Hancock's mentor Arjun Appadurai connected trade in commodities to culture in what he called "anthropology of things" a decade earlier (1986, 3–63).

12. This does not mean that caste, by contrast, remains a primordial constant but only that it is perceived that way.

13. The pamphlet in both English and Hindu is simply called "Adhi Parashakthi Peetam" and has no date or pagination, as is typical for this kind of pamphlet for devotees visiting well-known temples. The temple also printed another English book-let, *The Magnificent Miracles of Bangaru Adigalar: The Amma*. This guru, born Ban-garu Naicker, considered the embodiment of the goddess, is called Amma, mother. Feminine pronouns "she," and "her" are always used by devotees to speak of him. Such pamphlets are often sold near large temples to the goddesses. William Harman has told me that he has a large collection of these from Samayapuram. Babb used this same kind of pamphlet literature in his study of new religious groups in Delhi, none of which are centered in the goddess although the Brahma Kumaris focus on women's spirituality (1986, 139–155).

14. This remains one of the few working definitions of religion still widely held in religious studies (Smart 2000, 2; Larson 1995, 170).

15. Well before Nehru's policies took real effect there were a few voices in American scholarship that hailed the Indian trading communities' help in achieving Indepen-dence and in the same breath spoke of the Brahman view of life, understood as antitheti-cal to merchants and trade, as "losing ground in modern India" (Lamb 1959, 33).

16. The journal *Public Culture* frequently publishes articles on cultural capital in a global context.

17. Portions of this section from de Certeau are also quoted by Hancock (1999, 197).

18. Habermas's ideas in this book influenced English and American scholars only after a two-decade-long time lag between the German original (1962) and the English translation (1989). A flurry of new work in English on the public sphere came out after the translation, beginning with Craig Calhoun's edited volume of es-says from a conference held to mark the translation (Calhoun 1992). Bennett's work followed in 1995.

19. "Plan of the Town of Madras and its limits, as surveyed in 1822 for the use of the Justices in Sessions by W. Ravenshaw." The map numbers all the garden houses in the city and then lists the owners' names on the legend.

20. Irschick derives his theoretical perspective from Bakhtin's concept of dia-logic activities, especially heteroglot processes. He relies extensively on Bakhtin's works *The Dialogic Imagination* and *Rabelais and His World*.

21. I was teaching English at Ethiraj College the year that Tamil medium was introduced. At the time I applauded any move that would remove Dickens from the list of prescribed texts to teach "contemporary" English idioms! I had to surrepti-tiously tell my classes that few people in the United States or even the United King-dom spoke like Dickens.

22. These deserted temples are tantalizing clues that the phenomenon of the Goddess and the middle class may have antecedents in the early years of the city.

23. "Plan of the Mylapoor Division as surveyed during the years 1854–1855 by Revenue Surveyor W. H. Walker." The 1822 map shows the tank and some sort of dwelling in the same spot, but it is not marked as a temple.

24. The title of this booklet is *Nalantarum Nāyiki Aṇṇai Muṇḍakka Kaṇṇi* (Beneficent and Protecting Mother, Mundakakkanni) published by the temple.

25. Her name is the Tamil term for the Sanskrit utsava murti, the festival image taken in procession. The pamphlet moves between Tamil and transliterated Sanskrit terms and sometimes uses both.

26. Another sculpture on the same gate has an image of a divine dancer; her right hand holds Shiva's drum and one left hand takes the same pose that Shiva assumes in his famous Nataraja image, but her second right hand is in a mudra (hand gesture) associated with Parvati (see figure reproduced in Dehejia 1990, 37). Narasimha is very much a Telegu deity, and may also be here as a sign of inclusion for many migrants from Andhra who settled here and in other parts of Chennai.

27. A similar composite figure called Dattatreya appears with three heads standing next to a similarly styled bull in the new temple to Shirdi Sai Baba in Injambakkam. A publication of this temple says that deity was formed from the bodies of the "Brahma, Vishnu and Shiva, the Hindu Trinity [the Trimurti]" through the virtue of a sage's wife and the power of the gods' consorts, "Saraswathi, Lakshmi and Parvati" Parvati," respectively. The magazine, called *Sai Chetana*, described this deity in the October 1994 issue. If this is a case of visual intertextuality, then at the Kolavizhi Amman the goddess's five heads could symbolize the three female consorts of the Trimurti—Saraswathi (Brahma), Lakshmi (Vishnu), Parvati (Shiva)—plus the heads of Shiva and Vishnu.

28. I keep this in Tamil transliteration because this small temple uses only Tamil.

29. In contemporary urban Chennai, women wear signs of their social and economic status, their class, on their bodies as surely as their grandmothers revealed their caste with jewelry and saris. Asking about caste is no longer a polite casual question here, much like demanding to know religious affiliation in Britain or the United States. But social class is obvious in the jewelry, the choice of cloth and colors, and the style of tying the sari. My visual sense developed after years of comments and conversations with women in Madras, beginning in 1967–68, when I taught in a women's college. Men wore white shirts with dhotis, formal dress for a man. Others had on brighter shirts and pants.

30. As witnessed on March 26–27 and April 7–10, 1995. All events were photographed by Dick Waghorne, and we have extensive visual documentation.

31. All of the announcements, the official program, and newspaper reports were written in highly Sankritized Tamil using the Grantha script, four key letters added to the Tamil alphabet to transliterate Sanskrit terms into Tamil. This marks a change from the earlier policy of both the DMK and AIADMK parties to use "pure" Tamil terms and script.

4. PORTABLE STONE: MURUGAN, AMMAN, AND GLOBALIZED LOCALISM

1. Dr. Alagappan explained his "double-barrel" name to me. As is the custom in south India as the eldest son of Alagappan he takes his father's name as the equivalent of his surname, which in Tamilnadu always precedes the given name.

2. The importance of the ammans is apparent throughout the Singapore. The *Singapore Hindu* is a publication of the Hindu Endowments Board of Singapore. The ninety-year-old Sri Mariyamman Temple has continued fire-walking rituals in this urbane city. See *Singapore Hindu* 1.3 (1990): 16.

3. This goddess is usually understood as a form of Parvati, the consort of Shiva, in her aspect as ruler and creatrix of the universe (Smith and Narsimhachary 1997, 49). However, the addition of Amman emphasizes her independence. I did not visit this temple.

4. Sri Ayyappan has rapidly gained devotees in the last decade, beginning in Kerala where his home temple thrives at the renowned Sabrimalai. He was born when Vishnu took the female form of Mohini, who seduced a willing Shiva (see Smith and Narsimhachary 1997, 218–225).

5. My thanks go to Jack Hawley for pointing out the importance of the patio in Texas and thus of the location of these deities.

6. Corinne Dempsey, who has extensively researched this temple, emphasized the "miraculous worldview" of the devotees in a lecture at Syracuse University in October of 2002, but then told me that the goddess nonetheless was highly spiritualized. Her new work will deal with this.

7. Paul Younger reported to me that these Durgas strongly resemble Mariyamman in all but name. I wonder if these deities are really the Tamil goddess Durga Amman, who is fully an amman.

8. See *The American Heritage Dictionary of the English Language,* 3rd ed. (New York: Houghton Mifflin, 1992). Electronic version licensed from InfoSoft International.

9. Vestiges of the local remain, however, as in the practice of interring relics, earthly remains of a local saint, in the altar of a Roman Catholic church.

10. Dr. Alagappan kindly went through my draft of this narrative. Its present form reflects his corrections and clarifications. The final form, however, is mine.

11. Dr. Alagappan mentioned several other donors in a recent letter to me, including Mr. Goenka and Mr. Viswanatha Iyer. Later major donors for the other temples included Dr. V. Venkatachalam and Mrs. Alagammai Venkatachalam; Mrs. Parvati Nachiappan, Mr. Arun Alagappan (his son); and Dr. Chitti Ramakrishna Murthy. Mr. Rajagopal of Saravana Bhavan Hotels will build the massive rajagopura. Mrs. Visalakshi Ramaswamy will put up the office buildings and kitchens.

12. For more details on this temple as well as other sacred sites in this multiethnic neighborhood, see Hanson 2002.

13. Dr. Alagappan noted that "the line of chief ministers and senior officials have been supportive of the movement of temples in the U.S.A. especially at New York City and Pittsburgh."

14. The various centers for the swami still publish his poems. I was kindly given several collections in Tamil along with stories of the saint's life at the ashram in Tiruvanmiyur. Basic information on his life in English and Tamil was published in a souvenir volume in 1989 for a new temple to the saint and his Lord in a housing section of Madurai named for Pamban Swamigal.

15. He added that he had heard it said "that Pamban Swami had foreseen the

establishment of the present Arupadai Veedu complex and had said the Lord was coming close to him to give continuous dharshan in all his forms. The present Six Houses in stone indeed have far surpassed the wildest dreams of devotees."

16. Information on "Progress of Brittannia Hindu (Shiva) Temple Trust" is in the Mahakumbhabhishekam Consecration Ceremony souvenir dated July 9–13, 1986.

17. Taylor uses the term Mr. X to protect his living informant's identity. Since the temple publishes his name and many were anxious that his memory be connected to the temple, I have named him here. His work is now a part of the public record and the public life of modern London.

18. But there is no mention of the funeral rites, mentioned by the temple trustee, in Taylor's dissertation account. Taylor emphasizes the founder's concern with purity. So this may well have been a way to align the founder with a more liberal view.

19. Another woman felt that the whole controversy was more about who brought the image than which deity it was.

20. This may have been the same election that the Telegu doctor lost before he left to begin his own new temple.

21. The Education Act of 1944 required both instruction in religion and daily acts of worship in the classroom. By the 1980s the rising numbers of non-Christian children from immigrant families forced the government to consider ways to accommodate teaching religion to Muslims, Hindus, and others. The resulting Swann Report was debated in the progressive journal *New Community* over two decades.

22. Jennifer Howes introduced me to the temple and was a welcome guide. She is the author of a recent book on religious/political architecture, *Courts of Pre-Colonial South India: Material Culture and Kingship*, Royal Asiatic Society Books (London: Routledge-Curzon, 2002).

23. He went on to tell me his version of the Tamils' arrival in Sri Lanka. He said the Chola kings come to the Jaffna area in search of trade, especially in pearls. They found only aboriginals who did not put up any fight; this was not really a conquest. "We have been in Sri Lanka for all of these years. Now the Singhalese tell us to leave, and they are really only abos [aboriginals]!"

24. I owe this reference and the booklet to Devesh Soneji, a doctoral candidate in Faculty of Religious Studies, McGill University, who kindly sent it to me. I had not heard of this goddess.

25. There are still many questions about how changes occur in such a transcontinental migration of a goddess that will have to wait for a detailed study of this temple, which is not possible in a survey essay.

26. The VHP Web site frequently updates material. The address of Jaya Chamaraj Wadiyar, Maharaja of Mysore (the title is no longer officially recognized by the state), which the site entitled "Grass-roots of Hinduism," along with the anonymous essay, "Hindu Concepts," appear here as accessed on October 4, 2000 at http://www.vhp.org/d.Dimensions.

CONCLUSION: MAKING SPACE FOR GOD/S IN AN URBAN WORLD

1. Priya Anand, a researcher with Murray Culshaw Advisory Services, a Bangalore-based organization that provides services to the voluntary sector in the areas of public communications and fundraising, is studying U.S. temples and religious philanthropy.

2. The temple has recently added a separate cultural center so that the old temple could function more like a mandir—with that always-valued "quiet" for devotion and worship.

3. I should mention here that the grand eastern gopura of the staid Kapaleeswara Temple, may be the earliest example of the "intervisuality" between popular poster art and temple sculpture. Built in 1906, the sculptor rendered several of the print images of Ravi Varma, the father of "calendar art," into three dimensions. The style of all of the sculpture echoes Ravi Varma's work.

4. Sringeri Sarada Peetham Mutts, Sringeri Jagadguru Shankar Mutt, and Vinayagar, Saradambal, and Adi Sankara shrines in T. Nagar; Sringeri Jagaguru Sanatana Dharma Vidya Samithi-Sri Vinayagar Sri Saradambal and Sri Adi Sankara Temple in Raja Annamalaipuram; Sarada Temple and Meenakshi College in Kodambakkam; Sarada Temple in West Mambalam.

Glossary

Terms appear here in the most common English form with the transliteration and diacritics from Tamil (indicated with T/) from Sanskrit (indicated S/) or a composite of Sanskrit and Tamil (indicated T-S/).

abhaya hasta (S/ *abhaya hasta*) hand gesture of a divine image (*see* mudra) meaning do-not-fear

abhisheka (S/ *abhiṣeka*) pouring water and other substances over an image body for purification and sanctification

acharya (S/ *ācārya*) learned teacher, usually in a particular tradition

Agama, Agamas (S/ Āgama) texts ordaining the proper form of ritual and often giving the meaning

agrahara (S/ *agrahāra*) settlements reserved for Brahman priests or Brahman scholars given as a charity by a king or wealthy landowner

alamkara (S/ *alaṃkāra or alaṅkāra*) ornamentation of the divine images during rituals in order to prepare them for viewing (*see* darshan) either in the temple or for processions

alaya (S/ *ālaya*) "house or mansion"; common name for "temple"

Alvar (S/ Ālvār) name given to saint-devotees of Vishnu comparable to the Nayanmar of Shiva, who composed hymns considered sacred by Vaishnavas

amman (T/ *ammaṉ*) name meaning "mother" used for goddesses in south India who rule alone in a temple, usually without a male consort

annai (T/ *aṉṉai*) formal name for mother, usually used for goddesses

antha (T-S/ *anta*) "end," usually as ananta meaning endless

arati (S/ *āratī*) waving lights, usually camphor flames, in front of the divine images as the last part of a ritual

bali pitha (S/ *bali pīṭha*) a rounded pedestal at the entrance of a temple to make an offering in honor of the old spirits of the earth

bhakta (S/ *bhakta*) devotee, one who loves the deity

bhakti (S/ *bhakti*) deep devotion to a deity

Brahmotsavam (T-S/ Brahmā + *utsava*) grand festival for the major deity of a temple, usually ten days long; celebrates the presiding deity as the creator (acting like the god Brahmā) and ruler of the universe

darshan (S/ *darśana*) the act of viewing a deity, and being seen by that deity

devasthana (S/ *devasthāna*) domain of God, term applied to a temple or a temple organization

dharmakarta (S/ *dharmakartā*) a trustee; major trustee of a temple

diksha (S/ *dīkṣa*) initiation by a spiritual master into a community of learning or a tradition of ritual knowledge

dwajastamba (S/ *dhvajastambha*) tall ornate pillar used as a flagpole at the entrance of a temple

gandharva (S/ *gāndharva*) heavenly musicians that resemble angels in contemporary depictions

gopura (S/ *gōpura*) ornate multistoried gates in the walls surrounding a south Indian temple complex, usually opening at each cardinal direction

gotra (S/ *gotra*) subdivisions of caste communities, originally of Brahmans, reckoned by descent from celebrated teachers; members are considered to be of the same larger family

guru (S/ *guru*) venerable one, teacher, often the leader of a religious organization

gurukal (T/ *kurukkaḷ*) priest, usually Brahman, who perform rituals for devotees in the temple

jati (S/ *jāti*) common term for caste, usually in the sense of smaller communities within a region

jayanti (S/ *jayanti*) birthday of a deity or a great person, often celebrated as a general holiday

kalasha (S/ *kalaśa*) a brass pot used in rituals; also the pot-shaped finial that tops a temple spire

Kali Yuga (S/ Kālī + *yuga*) present "dark" age; a period of confusion where rules are broken and uncertain

kalyana mandapa (T-S/ *kalyāṇa-maṇḍapa*) hall for marriage rituals of human couples or a pavilion for the marriage of the god and goddess in temples

kanyaka (S/ *kanyā*) a modest young virgin

kapala (S/ *kapāla*) scull used as a begging bowl

kavadi (T/ *kāvaṭi*) platform, sometimes multitiered, strapped to a devotee's shoulders to carry offerings to a temple, usually for Murugan or a goddess in south India

kottam (T/ *kottiram*) sacred place associated with pilgrimage, but also a shrine

koyil or koil (T/ *kōyil*) palace, a common term for temple in Tamilnadu

kshetra (S/ *kṣetra*) field, especially a battlefield; also the abode of the soul, that is, the body

kuladevi (T-S/ *kuladevī*) patron goddess of an extended family or clan

kumbha (S/ *kumbha*) pot, especially when used to hold holy waters used for rituals

kumbhabhesheka/m (S/ *kumbhābhiṣeka*) pouring holy waters from a sacred pot over a divine image or a temple spire as part of the reconsecration rituals for a renovated temple

linga (S/ *liṅga*) principle divine image of Shiva, a conical-shaped stone

mada streets (T/ *māṭavīti*) four streets encircling a temple used for processions during festivals

mahakumbhabhisheka (S/ *mahākumbhābhiṣeka*) grand rituals consecrating a new temple

mahant (S/ *mahānt*) great one, the head of a monastery

mahasamprokshanam (S-T/ *māhāsamprōkshaṇa*) another term for the great rituals consecrating a temple

makara (T/ *makara*) crocodile-like creatures used as decorative motifs in temples, seen especially atop the gopura with the world spurting from their mouths

mandapa (S/ *maṇḍapa*) portico, usually a multipillared hall in front of the sanctum of a temple

mandir (S/ *mandira*) mansion, common term for a temple in north India, sometimes also used in the south

mangalam (T/ *maṅkalam*) auspiciousness, power to bestow wealth and well-being

math (S/ *maṭha*) monastery housing Hindu renunciants

Mudaliar (Mutaliyār) surname taken by member of the Vellalar caste, major temple donors and landowners near Madras

mudra (*mudrā*) hand gestures in sculptures of deities indicating aspects of divine grace and powers; also hand gestures used in dance

mulavar (T/ *mūlavar*) primary form of a deity, usually in stone within the sanctum of a temple

murti (S/ *mūrti*) the divine image-body of a deity, the stone or bronze sculpture after consecration (*see* vigraha)

nadaswaram (S-T/ *nādasvara*) large clarinet-like instrument used for sacred music within a temple or during processions

nadi (T/ *nāṭi*) reading by a trained medium through words appearing between the lines inscribed on palm leaves

naga (T/ *nāka*, S/ *nāga*) snake, refers to the holy snake worshiped within Shaiva and goddess temples

nagakkal (T/ *nākakkal*) carved stone slabs depicting holy snakes that are worshiped underneath the sacred tree in temples for Shiva or goddesses

nattar (T/ *naṭṭār*) leaders of a local area

nayaki (S/ *nāyakī*) goddess of a neighborhood or royal domain

Nayanmar (T/ Nāyaṉmār) sixty-four great devotees of Shiva recognized as saints who share in his divinity

otuvar (T/ *ōtuvār*) a cantor of hymns in Tamil temples

panchaloka (T/ pāñcaloha, S/ pāñcalōka) alloy of five metals used to make the bronze image of a deity, but usually with gold added

pandal (T/ *pantal*) shed constructed of bamboo and palm fronds, often used as site for rituals

pandaram (T/ *paṇṭāram*) non-Brahman priests who serve in temples, usually for goddesses or village deities

parameswari (S/ *parameśvarī*) a manifestation of the supreme goddess

Periya Puranam (T/ Periya Purāṇam) hagiography, holy story of the sixty-four Shaiva saints (*see* Nayanmar) composed in the twelfth to thirteenth centuries

pitha (S/ *pīṭha*) seat, the site of a god, goddess, or holy person

pradakshina (S/ *pradakṣiṇā*) the walkway around a temple to allow for the ritual act of walking around the perimeter of a temple, with right shoulder facing shines

pranapratishtha (S/ *prāṇa + pratiṣṭhā*) "fixing the breath," ritual that infuses life into the sculptural form of a deity

prasada (S/ *prasāda*) sacred leaving, the offerings returned to the worshiper after presentation to the deity in a temple; usually blessed food

puja (S/ *pūjā*) ritual worship of a deity within a temple; in south India, most commonly by presenting offerings of coconut, bananas, flowers, and camphor

pujari (T/ *pūcāri* S/ *pūjāri*) priest, usually Brahman, who makes offers to deities in a temple on behalf of devotees

punnai (T/ *puṉṉai*) tree considered sacred, often within a temple

punnai vanam (T/ *vaṉam*) grove of punnai trees; in the Kapaleeswara temple, the site beneath a tree where the goddess Parvati manifested as a peacock to worship Shiva

rajagopura (S/ *rāja + gōpura*) eastern gate of a temple in south India considered fit for a king; the tallest and most ornate gate

ratha (S/ *ratha*) large wooden chariot carrying the divine images, pulled in procession during festival, also called the ter

rishabha (S/ *ṛṣabha*) bull, sacred to Shiva, used as his mount (*see* vahana)

rudraksha (S/ *rudrākṣa*) seeds usually associated with Shiva; considered holy, strung as a necklace or rosary

sabha (S/ *sabhā*) "assembly," usually a voluntary association formed to promote art or religious activities

sadhu (S/ *sādhu*) ascetic who renounces both home and social position

samadhi (S/ *samādhi*) burial place of a saint or holy person, usually a site of worship

sannidhi (T/ *caṉṉiti*; S/ *saṃnidhi*) place of divine presence, the term for the individual shrines to various deities within a temple complex; refers to the presence rather than the architectural form (*see* vimana)

Sarvadevavilasa (S/ *Sarvadevavilāsa*) Sanskrit story of the city of Madras from the eighteenth century

Shaiva, Shaivas (S/ *Śaiva*) relating to Shiva; term for his worshipers

shakti (S/ *śakti*) power usually associated with female energy; term for goddesses

shakti pitha (S/ *śakti pīṭha*) seat of divine female power, the term for a goddess site in a natural setting or a formal temple in south India

Shankaracharya (S/ *Śaṅkarācārya*) title of the influential heads of the major monasteries in India associated with the sage Shankara, founder of a major tradition of philosophy-theology

Shastras (S/ *Śāstra*) traditional texts giving rules for the proper practice, usually of religious rituals or moral precepts

shikhara (S/ śikhara) cupola, ornate upper portions of a shrine (*see* vimana), often shaped like a dome or cone

shilpi (S/ śilpin) craftsmen who carve sculptural details on a temple

siddhi (S/ siddhi, T/ citti) special powers obtained by devotion, usually used for healing; one who processes these powers

simha (S/ siṁha) lion, mount (*see* vahana) of the goddess Durga

sthalapurana (S/ sthalapurāṇa) sacred story of the origins of a religious site, usually a temple

sthapati (S/ sthapati) traditional architect, who designs temples with all decorative forms as well as divine images

svaranabhisheka (S/ svāranābhiseka) presentation of one's own jewelry for the ornamentation of a deity (*see* alamkara), returned blessed after the ritual

svayambhu (S/ svayambhū) self-manifested; natural appearance of a divine image, usually a stone understood as the linga or the presence of a goddess

swami (S/ svāmi) master, title of a renunciative teacher

ter (T/ tēr) Tamil designation for the wooden chariot used to pull the gods during festivals (*see* ratha)

Tevaram **(T/ Tēvāram)** collection of hymns to Shiva composed by his major saint-devotees (*see* Nayanmar), dating from the eleventh to the thirteenth centuries; canonical text for Shaivas in Tamilnadu

thaila-apiyangam (T/ tailāppiyaṅkam) ritual act applying oil by hand to unconsecrated images prior to consecration rituals of a new temple (*see* mahakumbhabhisheka), done by devotees

Tirukkovil (T/ tirukkōvil) term used for "Temple" in formal names of temples

Tirukkural **(Tirukkuṟal)** ancient Tamil treatise on ethics

tiruvacikai (T/ tiruvācikai) ornamental arch, often in stone or bronze, covering a divine image as part of the sculpture

trishula (S/ triśūla) trident; within a temple indicates the presence of a fierce deity, usually a goddess or a form of Shiva, often held by the deities in sculptural forms

tulsi (S/ tulasī) small-leaf basil considered sacred to Vishnu, planted within the courtyards of Vaishnava houses or monasteries

utsava murti (S/ utsava mūrti) the mobile bronze image in a temple

vadai (T/ vaṭai) doughnut-shaped snack made from ground rice and lentils, fried, often offered to the deities in temple (*see* prasada)

vahana (S/ vāhana) vehicle, animal mount of a deity, often depicted in wooden form to carry the utsava murti during processions

Vaishnava, Vaishnavas (S/ Vaiṣṇava) relating to Vishnu; his worshipers

varna (S/ varṇa) four divisions of society enjoined by ancient Hindu scriptures, term often equated with caste

vel (T/ vēl) heart-shaped spear carried by Murugan; indicates his power (*shakti*) when standing alone.

Vellalar (T/ Vellālar) name of a major landowning caste in south India, considered pure non-Brahmans

vigraha (S/ vigraha) individual body, preferred term for divine images

vimana/m (S/ *vimāna*) architectural term for the individual shrine for a deity within a temple complex

vira (S/ *vīra*) heroic; term often applied to Hanuman or other warrior deities

viswa (S/ *viśva*) world, universe

yali (T/ *yāḷi*) composite fabled animal, part lion and part elephant, associated with kings and the ruling power of a deity in south India; often used as a decorative motif on columns in temples

yantra (S/ *yantra*) geometric diagram for meditation, sometimes inscribed on copper plates and placed under the base of a divine image before consecration

References

MAPS

"Cabalesevara Pagodas." Mackenzie Drawings of Indian Sculpture. British Library, London.

"Limits of Madras as Fixed on 2 November 1798. R. Ross, Chief Engineer." British Library, London. Oriental and India Office Collection X/2408/1.

"Madras Town Topographical Map." Government of India Survey Office, Madras 1906.

"Madras Town: Topographical Map." Drawn and printed by the Government of India Survey Office, Madras. 1929. Adyar Research Library, Theosophical Society, Madras.

"Map of Madras and Its Suburbs, Embodying an Area of Twenty Seven Square Miles and containing all additions and improvements to the year 1869. Compiled by J. W. Jackson." Published by Gantz Brothers, 175 Mount Road, Madras. British Library, London. Oriental and India Office Collection 54570(6).

"Map of Madras, Egmore Division, August 1805." Tamilnadu Archives in Chennai. List of Maps and Plans Transferred from the Survey Office. Supplementary Catalogue, Districts Records for Chingleput and Madras, Map 61.

"Maps and Plans of Hindustan. No. 17. Ft. St. George in 1791." British Library, London. Department of Manuscripts 19820, folio page 14.

"A Plan of Fort S. George and the Bounds of Madraspatnam." Surveyed and drawn by F. L Conradi, 1755. Original manuscript in the Map Library, British Library, London, K.115.76.2.TAB.

"Plan of the Town of Madras with its limits surveyed in 1822 for use of the Justices in Session by W. Ravenshaw." British Library, London. Oriental

and India Office Collection. Maps (in three parts) X/2412/1/1–3, X/2412/3/1–3, X/2412/3/1–3.

"Plan of the Mylapoor Division as surveyed during the years 1854–1855 by Revenue Surveyor W. H. Walker." Madras Town Maps. British Library, London. Oriental and India Office Collection, Map X/2424/7.

"A Plan or View of Santome de Meliapor drawn by a Portuguese artist about 1635." The British Library. European Manuscripts Maps and Plans. Sloane Collection, 197, folio 324.

"A Prospect of Fort S. George." Survey by order of Gov. T. Pitt, 1710. Reproduced in London from the original in the Bodleian Library, Oxford. British Library, London. Oriental and India Office Collection X/9775.

"A Survey of Royaporam Village with Tamonjette [Thambu Chetty] Tunda Pettah [Tandiarpet] and Tripato [Trivatore] Roads by Lieuts O'Donnoghue and Chavasse, August 1805." Tamilnadu Archives in Chennai, List of Maps and Plans Transferred from the Survey Office. Supplementary Catalogue, Districts Records for Chingleput and Madras, Map 60.

ARCHIVAL RECORDS

Cole, H. H. "Preservation of National Monuments. Preliminary Reports of H. H. Cole, 1881–83." Official Publications: Indian Administrative Series V/21/32. British Library, London. Oriental and India Office Collections.

Collet, Joseph. "Three Letter Books of Joseph Collet dated 1711–1719 (1673–1725). Governor of Madras 1717–1720." British Library, London. Oriental and India Office Collections. European manuscripts MSS Eur D1153.

BOOKS AND ARTICLES

Abu-Lughod, Janet L. 1989. *Before European Hegemony: The World System A.D. 1250–1350*. New York: Oxford University Press.

Allen, Matthew. 2000. "Systematize, Standardize, Classicize, Nationalize: The Word of the Expert's Committee of the Music Academy of Madras, 1930–1950." Paper presented at the 29th Annual Conference on South Asia. Madison, Wisconsin, October 12–15, 2000.

Appadurai, Arjun. 1981. *Worship and Conflict under Colonial Rule: A South Indian Case*. Cambridge: Cambridge University.

———, ed. 1986. *The Social Life of Things: Commodities in Cultural Perspective*. Cambridge: Cambridge University Press.

———. 1996. *Modernity at Large: Cultural Dimensions of Globalization*. Minneapolis: University of Minnesota Press.

———. 2000. "Grassroots Globalization and Research Imagination." *Public Culture* 30:1–19.

Arasaratnam, Sinnappah. 1986. *Merchants, Companies and Commerce on the Coromandel Coast, 1650–1740*. New Delhi; New York: Oxford University Press.

———. 1990. "Recent Trends in the Historiography of the Indian Ocean, 1500–1800." *Journal of World History* 1.2:225–247.

Babb, Lawrence A. 1986. *Redemptive Encounters: Three Modern Styles in the Hindu Tradition.* Berkeley: University of California Press.

Bakhtin, Mikhail. [1968] 1984. *Rabelais and His World.* Translated by Hélène Iswolsky. Bloomington: Indiana University Press.

Barnett, Margarite Ross. 1976. *The Politics of Cultural Nationalism in South India.* Princeton: Princeton University Press.

Basu, Tapan, et al., eds. 1993. *Khaki Shorts and Saffron Flags: A Critique of the Hindu Right.* New Delhi: Orient Longman.

Bayly, C. A. [1990] 1987. *Indian Society and the Making of the British Empire.* Vol. 2.1 of the *New Cambridge History of India.* Cambridge: Cambridge University Press. Indian edition published by Orient Longman, Madras: 1990.

Bayly, Susan. [1989] 1992. *Saints, Goddesses and Kings: Muslims and Christians in South Indian Society, 1700–1900.* Cambridge: Cambridge University Press. Indian edition 1992.

Bellah, Robert N. 2001. "The Religious Response to Modernity." In *Religion in a Secular City: Essays in Honor of Harvey Cox,* edited by Arvind Sharma. Harrisburg: Trinity International Press.

Bennett, Tony. 1995. *The Birth of the Museum.* London: Routledge.

Béteille, André. [1965] 1996. *Caste, Class and Power: Changing Patterns of Stratification in a Tanjore Village.* 2d ed. Delhi: Oxford University Press.

Bhatia, Gautam. 1994. *Silent Spaces, and Other Stories of Architecture.* New Delhi: Penguin.

Bhattacharya, Neelandri. 1991. "Myth, History and the Politics of the Ramjanmabhumi." In *Anatomy of a Confrontation: Ayodhya and the Rise of Communal Politics in India,* edited by Sarvepalli Gopal. London: Zed Books.

Blaut, James M. 1993. *The Colonizer's Model of the World: Geographic Diffusionism and Eurocentric History.* New York: Guilford.

Burghart, Richard. 1987. "Conclusion." In *Hinduism in Great Britain: The Perpetuation of Religion in an Alien Cultural Milieu,* edited by Richard Burghart. London: Tavistock.

Buss, Andreas, ed. 1985. *Max Weber in Asian Studies.* International Studies in Sociology and Anthropology 62. Leiden: E. J. Brill.

Calhoun, Craig, ed. 1992. *Habermas and the Public Sphere.* Cambridge: MIT Press.

Campakalakshmi, R. 1986. "Urbanism in Medieval Tamilnadu." In *Situating Indian History,* edited by Sabyasachi Bhattacharya and Romila Thapar. New Delhi: Oxford University Press.

Caplan, Lionel. 1987. *Classes and Culture in Urban India: Fundamentalism in a Christian Community.* Oxford: Clarendon Press.

Caplan, Patricia. 1985. *Class and Gender in India: Women and Their Organizations in a South Indian City.* London: Travistock.

Cenkner, William. 1986. *A Tradition of Teachers: Sankara and the Jagadgurus Today.* New Delhi: Motilal Banarsidass.

———. 1992. "The Sankaracarya of Kanchi and the Kamaksi Temple as Ritual Center." In *A Sacred Thread: Modern Transmission of Hindu Traditions in India and*

Abroad, edited by Raymond Brady Williams. New York: Columbia University Press.

Chase-Dunn, Christopher K., and Thomas D. Hall. 1997. *Rise and Demise: Comparing World-Systems.* Boulder, Col.: Westview.

Chatterjee, Partha. 1993. *The Nation and Its Fragments: Colonial and Postcolonial Histories.* Princeton: Princeton University Press.

Chaudhuri, K. N. 1978. *The Trading World of the English East India Company, 1600–1760.* Cambridge: Cambridge University Press.

———. 1985. *Trade and Civilization in the Indian Ocean: An Economic History from the Rise of Islam to 1750.* Cambridge: Cambridge University Press.

———. 1990. *Asia before Europe: Economy and Civilization of the Indian Ocean from the Rise of Islam to 1750.* Cambridge: Cambridge University Press.

Chhibbar, Y. P. 1968. *From Caste to Class: A Study of the Indian Middle Classes.* New Delhi: Associated Publishing House.

Clothey, Fred W. 1978. *The Many Faces of Murugan: The History and Meaning of a South Indian God.* The Hague: Mouton.

———. 1992. "Ritual and Reinterpretation: South Indians in Southeast Asia." In *A Sacred Thread: Modern Transmission of Hindu Traditions in India and Abroad,* edited by Raymond Brady Williams. New York: Columbia University Press.

Coburn, Thomas B. 1991. *Encountering the Goddess: A Translation of the Devī Māhātmya and a Study of Its Interpretation.* Albany: State University of New York Press.

Conlon, Frank F. 1977. *A Caste in a Changing World: The Citrapur Saraswat Brahmans, 1700–1935.* Berkeley: University of California Press.

Converse, Hyla S. 1988. "Hinduism." In *The Religious World: Communities of Faith.* 2d ed. London: Macmillan.

Courtright, Paul B. 1985. *Gaṇeśa: Lord of Obstacles, Lord of Beginnings.* New York: Oxford University Press.

Coward, Harold. 2000. "Hinduism in Canada." In *The South Asian Religious Diaspora in Britain, Canada, and the United States,* edited by Harold Coward, John H. Hinnells, and Raymond Brady Williams. Albany: State University of New York Press.

Craddock, Norma Elaine. 1994. "Anthills, Split Mothers, and Sacrifice: Conceptions of Female Power in the Mariyamman Tradition." Ph.D. dissertation., University of California, Berkeley.

Crowther, Geoff. 1984. *India: A Travel Survival Kit.* Victoria, Australia: Lonely Planet.

Cutler, Norman. 1984. "The Fish-eyed Goddess Meets the Movie Star: An Eyewitness Account of the Fifth International Tamil Conference." In *Cultural Policy in India,* edited by Lloyd I. Rudolph. New Delhi: Chanakya.

Davis, Richard H. 1991. *Ritual in an Oscillating Universe: Worshiping Śiva in Medieval India.* Princeton: Princeton University Press.

de Certeau. Michel 1984. *The Practice of Everyday Life.* Translated by Steven Rendall. Berkeley: University of California Press.

Dehejia, Vidya. 1990. *Art of the Imperial Cholas.* New York: Columbia University Press.

Desai, Madhavi. 1995. "The Adaptation and Growth of the Bungalow in India." In "European Houses in Islamic Countries," edited by Attilio Petruccioli. *Journal of the Islamic Environmental Design Research Centre, Rome.* 104–121.

Dirks, Nicholas. 1987. *The Hollow Crown: Ethnohistory of an Indian Kingdom.* Cambridge: Cambridge University Press.

———. 1993. "Colonial Histories and Native Informants." In *Orientalism and the Postcolonial Predicament,* edited by Carol A. Breckenridge and Peter van der Veer. Philadelphia: University of Pennsylvania Press.

Doniger [O'Flaherty], Wendy. 1980. *Women, Androgynies, and Other Mystical Beasts.* Chicago: University of Chicago Press.

Driver, Edwin D., and Aloo E. Driver. 1987. *Social Class in Urban India: Essays on Cognition and Structures.* Leiden: E. J. Brill.

Dumont, Louis. 1970. *Homo Hierarchicus: An Essay on the Caste System.* Translated by Mark Sainsbury. Chicago: University of Chicago Press.

Eck, Diana L. 2001. *A New Religious America.* San Francisco: HarperCollins.

Egnor, Margaret Trawick. 1984. "The Changed Mother or What the Smallpox Goddess Did When There Was No More SmallPox." *Contributions to Asian Studies* 18: 24–45.

Eliade, Mircea. 1957. *The Sacred and the Profane.* Translated by Willard R. Track. New York: Harper and Row.

———. [1958] 1996. *Patterns in Comparative Religion.* Lincoln: University of Nebraska Press.

Ellmore, W. T. [1915] 1984. *Dravidian Gods in Modern Hinduism.* New Delhi: Asian Educational Services.

Frank, André Gunder. 1998. *ReOrient: Global Economy in the Asia Age.* Berkeley: University of California Press.

Frank, André Gunder, and Barry K. Gillis, eds. 1993. *The World System: Five Hundred Years or Five Thousand?* London: Routledge.

Fryer, John. [1681] 1909. *A New Account of East India and Persia, being Nine Years Travel 1672–1681.* Edited with Notes and Introduction by William Crooke. London: Hakluyt Society.

Fuller, C. J. 1992. *The Camphor Flame: Popular Hinduism and Society in India.* Princeton: Princeton University Press.

———, ed. 1997. *Caste Today.* New Delhi: Oxford University Press.

———. 2001. "Vinayaka Chaturthi Festival and Hindutva in Tamil Nadu." *Economic and Political Weekly* 36 (May 12): 1607–1616.

———. 2003. *The Renewal of the Priesthood: Modernity and Traditionalism in a South Indian Temple.* Princeton: Princeton University Press.

Ganapathi Sthapati, V. 1988. "Symbolism of the Vimana and Gopura." In *Śiva Temple and Temple Rituals.* Madras: Kuppuswami Sastri Research Institute.

Gopinatha Rao, T. A. [1914] 1993. *Elements of Hindu Iconography,* 2 vols. Delhi: Motilal Banarsidass.

Grier, Katherine C. [1988] 1997. *Culture and Comfort: Parlor Making and Middle-class Identity, 1850–1930.* Rev. ed. Washington, D.C.: Smithsonian Institution Press.

Guha-Thakurta, Tapati. 1992. *The Making of a New "Indian" Art: Artists, Aesthetics and Nationalism in Bengal, c.1850–1920.* Cambridge: Cambridge University Press.

Habermas, Jürgen. [1962] 1989. *The Structural Transformation of the Public Sphere: An Inquiry into a Category of Bourgeois Society.* Translated by Thomas Burger. Cambridge: MIT Press.

Hadaway, W. S. 1914–1915. *Arts and Crafts in Southern India; Its History, People, Commerce and Industrial Resources.* Complied by Somerset Playne. London: Foreign and Colonial Compiling and Publishing Co.

Hancock, Mary 1998. "Unmaking the 'Great Tradition': Ethnography, National Culture and Area Studies." *Identities* 4.3–4: 343–388.

———. 1999. *Womanhood in the Making: Domestic Ritual and Public Culture in Urban South India.* Boulder, Col.: Westview.

Hansen, Thomas Blom. 1999. *The Saffron Wave: Democracy and Hindu Nationalism in Modern India.* Princeton: Princeton University Press.

Hanson, R. Scott. 2002. "Flushing: City of God, 1945–2002." Ph.D. dissertation, University of Chicago.

Harman, William. 1998. "Negotiating Relations with the Goddess." Paper presented at the annual meeting of the American Academy of Religion, November 23, at Orlando, Florida. Paper kindly supplied by the author.

Hawley, John Stratton. 2001. "Modern India and the Question of Middle-Class Religion." *International Journal of Hindu Studies* 5.3:217–225,

Historicus [pseud.]. 1951. *Sawmy Naick and His Family.* Madras: Caxton.

Hodgson, Marshall G. 1993. *Rethinking World History: Essays on Europe, Islam, and World History.* Cambridge: Cambridge University Press.

Hudson, Dennis. 1992. "Winning Souls for Siva: Arumuga Navalar's Transmission of the Saiva Religion." In *A Sacred Thread: Transmission of Religious Traditions in Times of Rapid Social Change,* edited by Raymond B. Williams. New York: Colombia University Press.

Hudson, Gail. 2000. Editorial review of *How to Know God: The Soul's Journey into the Mystery of Mysteries,* by Deepak Chopra. Web page of Amazon.com

Irschick, Eugene F. 1969. *Politics and Social Conflict in South India: The Non-Brahman Movement and Tamil Separatism, 1916–1929.* Berkeley: University of California Press.

———. 1994. *Dialogue and History: Constructing South India, 1795–1895.* Berkeley: University of California Press.

Ishimatsu, Ginni. 1994. "Ritual Texts, Authority, and Practice in Contemporary Śiva Temples in Tamil Nadu" Ph.D. dissertation, University of California at Berkeley.

Jacobs, Jane. [1961] 2000. "The Uses of Sidewalks: Contact." In *The City Cultures Reader,* edited by Malcolm Miles, Tim Hall, and Iain Borden. London: Routledge. Originally published in Jane Jacobs, *The Death and Life of Great American Cities.*

Jameson, Fredric. 1991. *Postmodernism, or, The Cultural Logic of Late Capitalism.* Durham, N.C.: Duke University Press.

Jouveau-Dubreuil, G. [1916] 1987. *Dravidian Architecture.* Edited with a preface by S. Krishnaswami Aiyangar. New Delhi: Asian Educational Services.

Jowett, Alfred. 1985. "Swan on Religion: A Comment." *New Community* 12.3:464–469.

Kailasapathy, K. 1966. *Tamil Heroic Poetry*. Oxford: Clarendon Press.

Kanitkar, Hemant. 1979. "A School for Hindus." *New Community* 7.2:178–183.

Kantowky, Detlef. 1980. *Sarvodaya: And Other Development*. Delhi: Vikas.

———. 1984. "Max Weber on India and Indian Interpretation of Weber." *Contributions to Indian Sociology* ns 18.2:307–317.

———, ed. 1986. *Recent Researches on Max Weber's Study of Hinduism: Papers Submitted to a Conference Held in New Delhi in 1984*. Munich: Weltforum.

Kapaleeswara Temple. [1978?]. Sri Kapaleeswarar Temple [brochure for visitors]. Mylapore: Kapaleeswara Temple.

———. 1994. The Divine Seat of the Creator Supreme: Arulmigu Kapaleeswarar Temple [brochure]. Mylapore: Kapaleeswara Temple

Kapp, K. William. 1963. *Hindu Cultures and Economic Development in India*. New York: Asia Publishing House.

Karashima, Noboru. 1997. *Towards a New Formation: South Indian Society under Vijayanagar Rule*. New Delhi: Oxford University Press.

Kelly, Michael, ed. 1994. *Critique and Power: Recasting the Foucault/Habermas Debate*. Cambridge: MIT Press.

Keuneman, Herbert 1983. *Insight Guides: Sri Lanka*. Edited by John Gottberg Anderson. Hong Kong: Apa Productions.

Khandelwal, Madhulika S. 1995. "Indian Immigrants in Queens: Patterns of Spatial Concentration and Distribution, 1965–1990." In *Nation and Migration: The Politics of Space in the South Asian Diaspora*, edited by Peter van der Veer. Philadelphia: University of Pennsylvania Press.

Kilde, Jean Halgren. 2002. *When Church Became Theatre: The Transformation of Evangelical Architecture in Nineteenth-Century America*. New York: Oxford University Press.

King, Anthony D. 1995. *The Bungalow: The Production of a Global Culture*. 2d ed. New York: Oxford University Press.

King, Ursula. 1980. "Hinduism in a Western Context." In *Hinduism in England*, edited by David G. Bowen. Bradford, UK: Bradford College.

Knott, Kim. 1987. "Hindu Temple Rituals in Britain: The Reinterpretation of Tradition." In *The Perpetuation of Religion in an Alien Cultural Milieu*, edited by Richard Burghart. London: Tavistock.

Kober, Kelli Michele. 1998. "Orientalism, the Construction of Race, and the Politics of Identity in British India, 1800–1930." Ph.D. dissertation, Department of History, Duke University.

Krishnaswami Aiyangar, S. [1939] 1994. "The Character and Significance of the Foundation of Madras." In *The Madras Tercentenary Commemorative Volume*, edited by the Madras Tercentenary Committee. New Delhi: Asian Educational Services.

Kuriyan, George. [1939] 1994. "Growth of the City of Madras" in *Madras Tercentenary Commemorative Volume*. New Delhi: Asian Educational Services.

Lamb, Helen B. 1959. "The Indian Merchant." In *Traditional India: Structure and Change*, edited by Milton Singer. Philadelphia: American Folklore Society.

Larson, Gerald James. 1995. *India's Agony over Religion*. Albany: State University of New York Press.

Lessinger, Johanna. 1995. *From the Ganges to the Hudson: Indian Immigrants in New York City.* Needham Heights, Mass.: Allyn and Bacon.

Lewandowski, Susan. 1980. "The Hindu Temple in South India." In *Buildings and Society: Essays on the Social Development of the Built Environment.* London: Routledge and Kegan Paul.

Livezey, Lowell W., ed. 2000. *Public Religion and Urban Transformation: Faith in the City.* New York: New York University Press.

London, Christopher W. 1994. *Architecture in Victorian and Edwardian India.* Bombay: Marg Publications.

Loomis, Charles P., and Zona K. Loomis. 1969. *Socio-Economic Change and the Religious Factor in India: An Indian Symposium of Views on Max Weber.* New Delhi: Affiliated East-West Press.

Lorenzen, David N. 1972. *The Kāpālikas and Kālāmukhas.* New Delhi: Thomson Press.

Lutgendorf, Philip. 1994. "My Hanuman Is Bigger Than Yours." *History of Religions* 33.3:211–245.

———. 1997. "Monkey in the Middle: The Status of Hanuman in Popular Hinduism." *Religion* 27:311–332.

Madras Mahajana Sabha. 1885. *Proceedings of the Conference of Native Gentlemen Held at Patcheappa's Hall.* Madras: National Press.

Madras Native Association, 1852. *Supplementary Petition to the Imperial Parliament.* Madras, Hindu Press.

———. 1859. *Letter to the Right Honorable Sir Charles Wood . . . on the Subject of Government Interference with the Religions of the Natives.* Madras: Hindu Press.

Martindale, Don. 1958. "Prefatory Remarks: The Theory of the City." In *The City* by Max Weber, translated and edited by Don Martindale and Gertrud Neuwirth. New York: Free Press.

Mazumdar, Sucheta. 1998. *Sugar and Society in China: Peasants, Technology, and the World Market.* Cambridge: Harvard University Asia Center.

McAuley, Ian. 1993. *Guides to Ethnic London.* 2d ed. London: Immel Publishing.

McCutchen, Russell T. 2001. *Critics Not Caretakers: Redescribing the Public Study of Religion.* Albany: State University of New York Press.

Michell, George, ed. 1993. *Temples Towns of Tamil Nadu.* Bombay: Marg Publications.

———. 1995. *Art and Architecture of Southern India: Vijayanagar and the Successor States.* Vol. 1.6 of the *New Cambridge History of India.* Cambridge: Cambridge University Press.

Mikula, Paul, Brian Kearny, and Rodney Harber. 1982. *Traditional Hindu Temples in South Africa.* Durban: Hindu Temple Publications.

Miles, Malcolm, Tim Hall, and Iain Borden. 2000. "Introduction." In *The City Cultures Reader,* edited by Malcolm Miles, Tim Hall, and Iain Borden. London: Routledge.

Mines, Mattison. 1984. *The Warrior Merchants: Textiles, Trade and Territory in South India.* Cambridge: Cambridge University Press.

———. 1994. *Public Faces, Private Voices: Community and Individuality in South India.* Berkeley: University of California Press.

Misra, B. B. 1961. *The Indian Middle Classes: Their Growth in Modern Times.* London: Oxford University Press.

Moorthy, K. K. 1986. *The Mother of Melmaruvathur and Her Miracles*. Tirupati: Tirupati Temple Devastanam.

———. 1992. *Mata Kanakadurga of Vijayawada*. Tirupati: Message Publications.

Mudaliar, A. S. 1972. *The Siva Agamas and Their Relationship to Vedas*. Madras: Kapaleeswara Temple.

Mukerji, Chandra. 1983. *From Graven Images: Pattern of Modern Materialism*. New York: Columbia University Press.

Munshi, Surendra. 1988. "Max Weber on India: An Introductory Critique." *Contributions to Indian Sociology* ns 22.1.

Murugesa Mudaliar, N. [1970] 1984. *Arulmigu Kapaleeswarar Temple at Mylapore: A Short Descriptive Account*. Reprint. Mylapore: Kapaleeswara Temple.

Muthiah. S., ed. 1985. *Madras: A TTK Guide*. Madras: Tamilnadu Printers and Traders.

———. 1990. *Madras: The Gracious City*. With photographs by Ajay Khullar. Madras: Affiliated East-West Press.

———. 1992. *Madras Discovered: A Historical Guide to Looking Around, Supplemented with Tales of "Once Upon a City."* 3d ed. Madras: Affiliated East-West Press.

Nambiar, P. K., and N. Krishnamurthy. 1965. *Temple Directory of Madras City*. Census of India 1961. Report vol. no. 9, part IX D, part II.

Neild-Basu, Susan. 1984. "The Dubashes of Madras." *Modern Asian Studies* 18.1:1–31.

———. 1993. "Madras in 1800: Perceiving the City." In *Urban Form and Meaning in South Asia: The Shaping of Cities from Prehistoric to Precolonial Times*, edited by Howard Spodek and Doris Meth Srinivasan. London: National Gallery of Art.

Nowikowski, Susan, and Robin Ward. 1979. "Middle Class and British? An Analysis of South Asians in Suburbia." *New Community*, 7(1):1–10.

Oppert, Gustav. [1893] 1972. *On the Original Inhabitants of Bhartavraṣa or India*. 2d ed. Reprint. Delhi: Oriental Publishers.

Orr, Leslie C. 2000. *Donors, Devotees, and Daughters of God: Temple Women in Medieval Tamilnadu*. New York: Oxford University Press.

Orsi, Robert A., ed. 1999. *Gods of the City: Religion and the American Urban Landscape*. Bloomington: Indiana University Press.

Panikkar, Raimundo 1991. "There Is No Outer Without Inner Space." In *Concepts of Space Ancient and Modern*, edited by Kapila Vatsyayan. New Delhi: Indira Gandhi National Center for the Arts.

Parker, Samuel K. 1992. "The Matter of Value Inside and Outside: Aesthetic Categories in Contemporary Hindu Temple Arts." *Ars Orientalis* 22:97–107.

Peterson, Indira Vishwanathan. 1989. *Poems to Śiva: The Hymns of the Tamil Saints*. Princeton: Princeton University Press.

———. 2001. "Eighteenth-Century Madras through Indian Eyes: Urban Space, Patronage, and Power in the Sanskrit text *Sarvadevavilāsa*." Paper presented at the annual meeting of the Association for Asian Studies. Chicago, March 25, 2001.

Prasad, Bhagwan. 1968. *Socio-Economic Study of Urban Middle Classes*. Delhi: Sterling Publishers.

Prentiss, Karen Pechilis. 1999. *The Embodiment of Bhakti*. New York: Oxford University Press.

Presler, Franklin A. 1987. *Religion under Bureaucracy: Policy and Administration for Hindu Temples in South India.* Cambridge: Cambridge University Press.

Price, Pamela G. 1996. *Kingship and Political Practice in Colonial India.* Cambridge: Cambridge University Press.

Raghavan, V. [1939] 1994. "Notices of Madras in Two Sanskrit Works." In *The Madras Tercentenary Commemorative Volume,* edited by the Madras Tercentenary Committee. New Delhi: Asian Educational Services.

———, ed. 1958. The *Sarvadevavilāsa.* Edited with critical introduction and notes. Madras: Adyar Library and Research Center.

Raghaveshananda, Swami. 1990. *Temples of Madras City.* Madras: Sri Ramakrishna Math.

Rājā, M. N. 1978. *Tirumayilai Ceṉṟu Pārppōm* (Approaching Mylapore, let's take a look) [brochure sold in the Kapaleeswara temple for visitors]. Mylapore: Kiri Ṭirēṭiṉ Ejaṉsi.

Ramachandra Dikshitar, R. [1939] 1994. "Around the City Pagodas." In *The Madras Tercentenary Commemorative Volume.* New Delhi: Asian Educational Services.

Ramakrishna Aiyer, V., ed. [1960] 1995. *Acharya's Call: H. H. Jagarguru's Madras Discourses (1957–1960).* 2 vols. 2d ed. Kanchipuram: Sri Kamakoti Peetam.

Raman, K. V. 1957. *The Early History of the Madras Region.* With a Forword by K. A. Nilakanta Sastri. Madras: University of Madras Press.

Raman, M. K. 1983. *Tirumayilai Ulā.* Madras: International Institute of Tamil Studies.

Ramanujan, A. K., trans. 1985. *Poems of Love and War: From the Eight Anthologies and the Ten Long Poems of Classical Tamil.* New York: Columbia University Press.

Ramaswami, Kavali Venkata. 1837. *A Digest of the Different Castes of India, with Accounts of Them.* Madras: Courier Press.

Ramaswami Naicker, E. V. 1994. *Religion and Society: Selections from Periyar's Speeches and Writings.* Compilation and introduction by K. Veeramani. Translated by R. Sundara Raju. Madras: Emerald Publishers.

Rao, T. A. Gopinatha. [1914] 1985. *Elements of Hindu Iconography.* 2 vols. 2d ed. New Delhi: Motilal Banarsidass.

Rudner, David West. 1994. *Castes and Capitalism: The Nattukkottai Chettiars.* Berkeley: University of California Press.

Rudolph, Lloyd I., and Susanne Hoeber Rudolph. 1967. *The Modernity of Tradition: Political Development in India.* Chicago: University of Chicago Press.

Rudolph, Susanne Hoeber, and James Piscatori, eds. 1997. *Transnational Religion and Fading States.* Boulder, Col.: Westview.

S.K.P.D. (Sri Kanyaka Parameswari Devasthanam). 1967. *Golden Jubilee Souvenir: Vysya Student's Home, 1917–1967.*

Sanderson, Stephen K, ed. 1995. *Civilizations and World Systems: Studying World-Historical Change.* Walnut Creek, Calif.: AtlaMira Press (Sage Publications).

Sastri, K. H. [1916] 1986. *South Indian Images of Gods and Goddesses.* New Delhi: Asian Educational Services.

Sax, William Sturman, ed. 1997. *The Gods at Play: Lila in South Asia.* New York: Oxford University Press.

Schechner, Richard. 1986. *Between Theater and Anthropology.* Philadelphia: University of Pennsylvania Press.

Schluchter, Wolfgang, ed. 1984. *Max Weber's "Studie über Hinduismus and Buddhismus."* Frankfurt: Sukrkamp.

Sharma, Arvind, ed. 2001. *Religion in a Secular City: Essays in Honor of Harvey Cox.* Harrisburg: Trinity International Press.

Sharma, K. L. 1994. *Social Stratification and Mobility.* Jaipur: Rawat.

Shulman, David Dean. 1980. *Tamil Temple Myths: Sacrifice and Divine Marriage in the South Indian Śaiva Tradition.* Princeton: Princeton University Press.

Shultze, Benjamin. 1750. *The Large and Renowned Town of the English Nation in the East-Indies upon the Coast of Coromandel, Madras or Fort St. George.* Hall in Saxony: Printed for the Orphan-House.

Singer, Milton B. 1972. *When a Great Tradition Modernizes: An Anthropological Approach to Indian Civilization* Foreword by M. N. Srinivas. New York: Praeger.

———. 1984. *Man's Glassy Essence: Explorations in Semiotic Anthropology.* Bloomington: Indiana University Press.

———. 1985. "Max Weber and the Modernization of India." In *Max Weber in Asian Studies* edited by Andreas E. Buss. Leiden: E. J. Brill.

———. 1991. *Semiotics of Cities, Selves, and Cultures: Explorations in Semiotic Anthropology.* Berlin: Mouton de Gruyter.

———. 1993. "Madras in 1800: Perceiving the City." In *Urban Form and Meaning in South Asia: The Shaping of Cities from Prehistoric to Precolonial Times,* edited by Howard Spodek and Doris Meth Srinivasan. London: National Gallery of Art.

Singer, Milton, and Robert Redfield, 1954. "The Cultural Role of Cities." *Economic Development and Cultural Change* 3.1:53–73.

Sivakumar, Chitra, and S. S. Sivakumar. 1993. *Peasants and Nabobs: Agrarian Radicalism in Late Eighteenth-Century Tamil Country.* Delhi: Hindustan Publishing.

Smart, Ninian. 2000. *Worldviews: Crosscultural Explorations of Human Beliefs.* 3d ed. Upper Saddle River, N.J.: Prentice Hall.

Smith, Brian K. 1994. *Classifying the Universe: The Ancient Indian Varna System and the Origins of Caste.* New York: Oxford University Press.

Smith, H. Daniel. 1995. "Impact of 'God Posters' on Hindus and Their Devotional Traditions." In *Media and the Transformation of Religion in South Asia,* edited by Lawrence A. Babb and Susan S. Wadley. Philadelphia: University of Pennsylvania Press.

Smith, H. Daniel, and M. Narasimhachary. 1997. *Handbook of Hindu Gods, Goddesses and Saints.* 2d ed. Delhi: Sundeep Prakashan.

Somalay. 1982. *Palani: The Hill Temple of Murugan.* 2d ed. Palani: Dhandayuthapani Swamy Temple.

Srinivas, M. N. 1977. *The Dual Cultures of Independent India.* Gandhi Memorial Lecture. Bangalore: Reman Research Institute.

Stein, Burton. 1960. "The Economic Foundations of a South Indian Temple." *Journal of Asian Studies* 19. 2:163–176.

———. 1978. *South Indian Temples: An Analysis Reconsidered.* New Delhi: Vikas.

———. [1989] 1994. *Vijayanagar*. Vol. 1.2 of the *New Cambridge History of India*. Cambridge: Cambridge University Press. Indian edition, 1994.

———. 1993. "City and State in Late Precolonial Madras." In *Urban Form and Meaning in South Asia: The Shaping of Cities from Prehistoric to Precolonial Times*, edited by Howard Spodek and Doris Meth Srinivasan. London: National Gallery of Art.

Stern, Robert W. 1993. *Changing India: Bourgeois Revolution on the Subcontinent*. Cambridge: Cambridge University Press.

Subrahmanyam, Sanjay. 1990. *The Political Economy of Commerce: South India 1500–1650*. Cambridge: Cambridge University Press.

Swami Raghaveshananda. 1990. *Temples of Madras City*. Madras: Sri Ramakrishna Math.

Tamilnadu. 1955. *Hindu Religious and Charitable Endowments. Administrative Report for the year from 1 April 1953 to 31 March 1954*. Madras: Government Press.

———. 1962. *Hindu Religious and Charitable Endowments. Administrative Report from 1 April 1960 to 31 March 1961*. Madras: Government Press.

Taylor, Donald. 1987a. "The Community of Many Names: A Saiva Ashram in Rural Wales." In *Hinduism in Great Britain Hinduism in Great Britain: The Perpetuation of Religion in an Alien Cultural Milieu*, edited by Richard Burghart. London: Tavistock.

———. 1987b. "Charismatic Authority in the Sathya Sai Baba Movement." In *Hinduism in Great Britain Hinduism in Great Britain: The Perpetuation of Religion in an Alien Cultural Milieu*, edited by Richard Burghart. London: Tavistock.

———. 1991. "The Role of Religion and the Emancipation of an Ethnic Minority: The Case of the Sri Lankan Hindu Tamils in Britain." In *The Integration of Islam and Hinduism in Western Europe*, edited by W.A.R. Shadid and P. S. van Koningsveld. Kampen, Netherlands: Kok Pharos.

———. 1994. "The Symbolic Construction of the Sri Lankan Hindu Tamil Community in Britain." Ph.D. dissertation, School of Oriental and African Studies, University of London.

Thurston, Edgar. [1909] 1972. *Castes and Tribes of South India*. 7 vols. Delhi: Cosmo Publications.

University of Madras. 1936. *Tamil Lexicon*. 6 vols. Madras: University of Madras.

van der Veer, Peter. 2001. *Imperial Encounters: Religion and Modernity in India and Britain*. Princeton: Princeton University Press.

Vanmikanathan, G. 1985. *Periya Puranam, a Tamil Classic on the Great Saiva Saints of South India by Sekkizhaar*. Condensed into English Version. Madras: Sri Ramakrishna Math.

Varma, Pavan K. 1998. *The Great Indian Middle Class*. New Delhi: Penguin.

Vertovec, Steven. 1992. "Community and Congregation in London Hindu Temples: Divergent Trends." *New Community*, 18.2:251–264.

———. 1995. "Hindus in Trinidad and Britain: Ethnic Religion, Reification, and the Politics of Public Space." In *Nation and Migration: The Politics of Space in the South Asian Diaspora*, edited by Peter van der Veer. Philadelphia: University of Pennsylvania Press.

———. 2000. *The Hindu Diaspora: Comparative Patterns*. London: Routledge.

Visram, Rozina. 1987. *Indians in Britain*. London: Chrysalis Books.

Voll, John Obert. 1994. "Islam as a Special World System." *Journal of World History*, 5.2:213–226.

Wach, Joachim. 1944. *Sociology of Religion*. Chicago: University of Chicago Press.

Waghorne, Joanne Punzo. 1985. *Images of Dharma: The Epic World of C. Rajagolapachari*. Delhi: Chanakya.

———. 1992. "Dressing the Body of God: South Indian Bronze Sculpture in Its Temple Setting." *Asian Art* (Summer): 8–33.

———. 1994. *The Raja's Magic Clothes: Re-visioning Kingship and Divinity in England's India*. In the series Hermeneutics: Studies in the History of Religions, edited by Kees Bolle. University Park: Pennsylvania State University Press.

———. 1999a. "The Hindu Gods in a Split-level World: The Sri Siva-Vishnu Temple in Suburban Washington, D.C." In *Gods of the City*, edited by Robert Orsi. Bloomington: Indiana University Press.

———. 1999b. "The Hindu Gods in an American Landscape: The Sr i Siva-Vishnu Temple in Suburban Washington, DC." In *The Expanding Landscape: South Asian and the Diaspora*, edited by Carla Petievich. New Delhi: Manohar.

———. 1999c. "The Divine Image in Contemporary South India: The Renaissance of a Once Maligned Tradition." In *Made on Earth, Born in Heaven: Making the Cult Image in the Ancient Mediterranean and Contemporary India*, edited by Michael B. Dick. Winona Lake, In.: Eisenbrauns, 1999.

———. 2002. "Chariots of the God/s: Riding the Line between Hindu and Christian in South India." In *Popular Christianity in India: Riding between the Lines*, edited by Corrine Dempsey and Selva J. Raj. Albany: State University of New York Press.

Wagoner, Phillip B. 1996. " 'Sultan among Hindu Kings': Dress, Titles, and the Islamicization of Hindu Culture at Vijayanagara." *Journal of Asian Studies* 55.4:851–881.

Wallerstein, Immanuel. 1974. *The Modern World-System I: Capitalist Agriculture and the Origins of the European World-Economy in the Sixteenth Century*. New York: Academic Press.

———. 1980. *The Modern World-System II: Mercantilism and the Consolidation of the European World-Economy, 1600–1750*. New York: Academic Press.

———. 1991. *Geopolitics and Geoculture: Essays on the Changing World System*. Cambridge: Cambridge University Press.

Weber, Max. [1921] 1958a. *The City*. Translated and edited by Don Martindale and Gertrude Neuwirth from *Die Stadt*, in *Archiv für Sozialwissenschaft und Sozialpolitik* 47: 621ff. New York: Free Press.

———. [1920] 1958b. *The Religion of India: The Sociology of Hinduism and Buddhism*. Translated by Hans H. Gerth and Don Martindale. New York: Free Press.

Weller, Robert P. 2000. "Living at the Edge: Religion, Capitalism, and the End of the Nation-State in Taiwan." *Public Culture* 122:477–498.

Whitehead, Henry [1921] 1976. *The Village Gods of South India*. 2d ed., rev. Delhi: Sumit Publications.

Wiebe, Paul D. 1975. *Social Life in an Indian Slum*. New Delhi: Vikas.

———. 1981. *Tenants and Trustees: A Study of the Poor in Madras*. New Delhi: Macmillan.

Williams, L. F. Rushbrook. 1982. *A Handbook for Travellers in India, Pakistan, Nepal, Bagladesh and Sri Lanka (Ceylon)*. 22d ed. New York: Facts on File, Inc.

Williams, Raymond Brady. 1988. *Religions of Immigrants from India and Pakistan: New Threads in the American Tapestry*. Cambridge: Cambridge University Press.

Younger, Paul. 1980. "A Temple Festival of Mariyamman." *Journal of the American Academy of Religion* 48.4:494–517.

———. 1982. "The Family of Siva in a South Indian Grove." *Sciences Religieus/Studies in Religion* 11.3:245–263.

———. 1995. *The Home of the Dancing Śivaṇ: The Traditions of the Hindu Temple in Citamparam*. New York: Oxford University Press.

Yule, Henry, and A. C. Burnell. [1902] 1984. *Hobson-Jobson: A Glossary of Colloquial Anglo-Indian Words*. 2d ed. New Delhi: Mushiram Manoharlal.

Index